Artists of Early Michigan

Grateful acknowledgment is made to the Michigan Council for the Arts, and the Division of Michigan History, Michigan Department of State, for financial assistance in publishing this volume.

Artists of Early MICHIGAN

A Biographical Dictionary of Artists Native To or Active In Michigan 1701-1900

compiled by Arthur Hopkin Gibson

Research Assistants: Beverly Bassett and Jean Spang

Wayne State University Press, Detroit, 1975

Library of Congress Cataloging in Publication Data

Gibson, Arthur Hopkin.
 Artists of early Michigan.

 Bibliography: p.
 1. Artists—Michigan—Biography. I. Bassett,
Beverly. II. Spang, Jean. III. Title.
N6530.M5G52 709'.2'2 B] 74-32480
ISBN 0-8143-1528-3

A portion of the preface previously appeared, in slightly different form, in an article by Arthur Hopkin Gibson, "Artists of Early Michigan," in the Detroit Historical Society Bulletin *27 (1): 4-9, Fall 1970. We thank the Society for allowing us to reprint it here.*

Appreciation is extended to the following for permission to reproduce works from their collections:

 Adrian College
 Archives of American Art, Smithsonian Institution
 Wilfred V. Casgrain
 K. R. Conely
 Detroit Historical Museum
 Detroit Institute of Arts
 Dossin Great Lakes Museum
 Mr. and Mrs. James L. Greaves
 F. W. Lapham III
 Michigan State University/Pewabic Pottery
 A. E. Peters, Jr.
 Mrs. Edward Quint
 Frank E. Storer
 George Waltensperger

Contents

Illustrations

8

Foreword

Of Time and Place

Time and place nourish artists and the culture that we call regional. In the words of D. H. Lawrence, "Every continent has its own great spirit of place. Every people is polarized in some locality, which is home, the homeland. Different places on the face of the earth have different vital influence, different vibration, different chemical exhalation, different polarity with different stars: call it what you like. But the spirit of place is a great reality" (*Studies on Classic American Literature* [1923]).

Taking a regional approach to art enables us to examine the art of a particular place within a given duration of time and provides us an opportunity to develop a fresh cultural perspective. We may ask: what were the influences that made a regional art possible in Michigan and what conditions encouraged its growth? In the Great Lakes area, life in the eighteenth and nineteenth centuries was heightened by the experience of nature. Among the seminal influences were light in its interplay with water, sky, and earth. These natural influences on the artist were reflected in the landscapes created by Michigan painters. In our own time the artist works in an industrial environment, and the creativity of Michigan artists issues in works that reflect it.

But more than the spirit of *place* is needed for the flourishing of a regional art. Arthur Hopkin Gibson writes: "Detroit was founded in 1701, and through that century and until the War of 1812 continued to be only a 'far-west' trading post, although a major one. The surrounding vast wilderness, known as The Northwest Territory, was without white settlements except a few widely scattered small trading posts, the centers for barter and exchange with the fur trappers and native Indians. It was at once evident that creative art in that period was practically non-existent among the settlers" (Detroit Historical Society *Bulletin,* Vol. 27, No. 1, 1970).

It was not until the nineteenth century that impetus came in the form of economic growth and settled communities. The frontier pushed westward; the lakes and waterways of Michigan facilitated the movement of natural resources to their markets. As the country grew, the lumber of Michigan's forests built towns and cities; copper and iron enriched the state as the industrial revolution gained speed. As the forests were cleared, open land became easily available to farmers, and a rich agricultural base was established.

Arthur Gibson describes the nineteenth century as a period when "Detroit blossomed and became a real metropolis, physically and culturally. In fact, the whole Northwest Territory expanded tremendously. Michigan became a state and was divided into counties; and cities, towns, villages, and hamlets sprang up in the vicinity of the lush farmlands. With the influx of workers, tradesmen and teachers and their families, education and many art forms came also. Itinerant painters and other artists came, stayed awhile, and moved on to other fields. But many others settled, and established permanent residence in the cities and towns."

During these years of economic growth, portrait painting flourished— affluent businessmen and farmers desired portrait images of themselves and their families. They sought not only a likeness of themselves but a concrete, detailed representation which captured their sense of accomplishment, pride, and individual integrity. The artist of the time thus worked within a limited range of expression. In the words of a contemporary art historian, "Whether you like it or not, American painters could not stray too far from the taste of their public. As Alexis de Tocqueville observed in the 1830's . . . the will of the customer placed certain limits on the inventions of the creators" (Matthew Baigell, *History of American Painting* [1971], p.88). Typical stylistic features of the art of that time were tight, easily distinguished contours, clear light, sharply defined detail, and a simple, uncluttered presentation easily perceived as a whole. Although working within limitations, artists were at the same time broadening the base of American taste.

In the twentieth century, despite complex mass communications and a highly mobile population, the spirit of *place* continues to manifest itself in regionalism; in *A God Within* (1972), René Dubos pinpoints this reality: "International styles in materials and methods obviously facilitate some of the operations common to the whole planet, but human beings search for distinctiveness in their surroundings. Regionalism has an enduring justification in the cosmic, terrestrial, and historical characteristics of each particular place. Because it is rooted both in human and in physical nature, environmental diversity will persist. . . ."

12

About the Book

Artists of Early Michigan is a checklist of over 1,800 native Michigan artists, or artists active in Michigan, during the period between 1701 and 1900. Arthur Hopkin Gibson, who compiled it, was not a professional art historian but an author, artist, and businessman, to whom it was a labor of love. He began to gather the data for it in 1962, after having completed and published the biography of his grandfather, Robert Hopkin, a nineteenth-century Michigan artist. The incredible amount of researching and cross-referencing that went into the checklist occupied him for almost seven years. Of the artists listed, those who achieved recognition or fame during their lifetime presented the fewest problems in preparing the condensed bibliographies. He found his greatest reward in uncovering hidden or forgotten references about lesser known artists.

It is particularly significant that *Artists of Early Michigan* will be published just before the two-hundredth anniversary of our country's birth. This book will assist us in celebration of our regional heritage with a sense of pride. Art historians, museum workers, and students who consult it will thereby discover and experience significant Michigan works and document the contributions of the artists. Museums and collectors will find it a useful reference guide for additional information about artists already in their collections.

Artists of Early Michigan will spur the publication of individual studies, provide the impetus for future exhibitions, and stimulate the rediscovery of "lost" works of art. Touring exhibitions could be planned to broaden our exposure to Michigan's cultural heritage, and interpretive materials prepared for local, regional, and statewide use in schools, libraries, and other public places. Since much of the material presented here is in need of conservation, this work may well stimulate the preservation of art work for future generations.

The publication of *Artists of Early Michigan* should also help to rectify the lopsided view of American art that has developed through decades of concentration by art critics on the older Eastern centers. At this point we have taken an inventory of our late artists; now we can begin to analyze, authenticate, conserve, and evaluate individual work and groups of works. Qualitative study and preservation are our new goals. The seventies assert that it is time to reflect on what has occurred and is occurring within each section of the country as well as across the whole United States.

In the dynamic culture of today no place or person can exist in isolation. Regional culture is a reality that deserves recognition; this book exposes the outlines of a body of creative work which, I hope, will be

brought fully into public light as the decade progresses. The publication of *Artists of Early Michigan* comes at a significant time when we need to search within ourselves to examine our own creative directions and goals.

For the biographical data in this book, Arthur Hopkin Gibson alone is responsible. On April 11, 1973, during the time in which the manuscript was being prepared for publication, he died. I am sure that he would want credit to be given to people and institutions who gave invaluable assistance in bringing his work to fruition.

Richard J. Hathaway, from the Michigan Division of the State Library, originally brought the manuscript to the attention of the Michigan Council for the Arts, which has underwritten the cost of publication. Financial assistance for the research project was also given by the Department of Michigan History, Michigan Department of State; the Detroit Historical Museum; the Michigan State Library, and the National Endowment for the Arts.

Beverly Bassett worked diligently through the Detroit Historical Museum to assemble the photographs herein; the archives which she developed included not only photographs of the artists, their studios and homes, but also photographs of their work, which were sometimes most difficult to locate.

The manuscript editor at the Wayne State University Press, Mrs. Jean Spang, researched and arranged the reference list and prepared the manuscript for publication. Mr. Gibson's son, Dr. Colvin Gibson, worked patiently with her during the manuscript's final editorial stages, and helped to make publication possible at this time.

During the years in which Mr. Gibson worked on the manuscript, generous cooperation was given him by the staffs of the Burton Historical Collection at the Detroit Public Library, the Library of the Detroit Institute of Arts, the Archives of American Art, and the Detroit Historical Museum. Michael P. Church, Director of Cultural Activities, University of Michigan Extension Service, Ann Arbor, kindly furnished editorial advice and assistance and shared information about early Michigan artists from his own research. Included in the "Sources Consulted" section of the book are bibliographical essays prepared by Garnet McCoy, Archives of American Art; Alice Dalligan, Burton Historical Collection; Holly Ulseth, Detroit Historical Museum, and Shirley Solvick, Fine Arts Department, Detroit

Public Library. Others who lent their professional expertise are Irene Townsend Dudley, Bernice Sprenger, James M. Babcock, Lynda Heaton, Robert E. Lee, Warren Peters, Roger Ault, and Richard R. Kinney.

James Alan Crawford
Michigan Artist
Visual Arts Coordinator
Michigan Council for the Arts

Preface

The lack of a biographical dictionary of early Michigan artists prompted the research for this volume. The primary task was to search as many sources as possible for information on the more than 1,800 artists finally selected, thus providing a sound basis for a comprehensive yet condensed biographical sketch of each.

During the period under consideration, 1701 to 1900, the term *artist* was loosely applied to many occupations. Even today the word is used in reference to musicians, actors, and even to persons who attain perfection in their employment. Consequently, the term as used in this dictionary is limited to persons actively engaged to some degree in the following categories:

Painting, including landscape, marine, portrait and figure, miniature, still life, animal, historical and religious, allegorical and heraldic paintings, and creative designs on panels, tablets, and banners. Not included are building, boat, sign, or related craft work.

Drawing and Sketching in pencil, ink, charcoal, and pastel. Not included are mechanical and map drawing and the making of prints.

Sculpture, including carving of representations of figures, natural objects, or ornamental designs, in stone or wood.

Modeling in wax and clay, making of plaster busts and figures, and cameo cutting.

Engraving on copper or other metals and wood, including seals and dies for metal stamping or minting. Not included are commercial engravings for the printing of reproductions.

Lithography, other than commercial.

Photographers, colorists, draftsmen, and other craftsmen are not included unless research disclosed some supplemental activity in one or more of the above categories.

This is a directory of Michigan artists only. Therefore, references to cities and towns are to Michigan localities exclusively, unless another state

or country is so indicated. Exceptions are references to cities such as Paris, London, Rome, Munich, New York, or other well-known art centers.

Insofar as available information allows, each biographical entry contains the artist's full name, his specialty, active years, place of residence, exhibits, awards, career details, and place and year of birth and death. In some cases, birth or death dates were inferred by an artist's age at death and, therefore, *may* be a year earlier or later than cited.

Reference sources, coded by number, are listed after each entry, and specific volumes or dates are indicated in parentheses. The key to the code numbers is given in the list of sources consulted. A list of abbreviations also precedes the main text.

Sources Consulted

Sources are symbolized by code numbers in the Reference sections of the biographical entries.

A. Books, Catalogs, Periodicals

Code
Number

1 *Adrian (Mich.) City Directory.* 1870– .

2 *Alpena (Mich.) City Directory.* 1883– .

3 *American Art Annual.* Vols. 1–31. Washington, D.C., 1898–1934.

4 *American Biographical History of Eminent and Self-Made Men: Michigan.* Parts 1 & 2. Cincinnati: Western Biographical Pub. Co., 1878.

5 Angell's Art Gallery. *Fall Exhibition of Detroit Artists, 1877.* Detroit: Angell's Art Gallery, 1877.

6 *Ann Arbor (Mich.) City Directory.* 18– .

7 *Appleton's Cyclopaedia of American Biography.* Edited by J. G. Wilson and John Fiske. 7 vols. 1887–1900. New York: Appleton, 1901.

8 Arnold, John Nelson. *Art and Artists in Rhode Island.* Providence: n.p., 1905.

9 *Art Digest.* Hopewell, N.J. Nov. 1926–July 1954.

10 Askin, John. *Papers.* Edited by Milo M. Quaife. Detroit: Detroit Library Commission, 1928–31.

11 Baxter, Albert. *History of the City of Grand Rapids.* New York: Munsell, 1891.

12 *Bay City (Mich.) City Directory.* 18– .

13 Bénézit, Emmanuel. *Dictionnaire Critique et Documentaire des Peintres, Sculpteurs, Dessinateurs et Graveurs.* 8 vols. Paris: Librairie Grund, ca. 1948–55.

14 Bloomfield Art Association. [*Catalog,* 1964.] Bloomfield Hills, Mich.: Bloomfield Art Association, 1964.

15 *Broken Fetter* (published during the Ladies' Michigan State Fair for the relief of destitute freedmen and refugees). Nos. 1–7, Feb. 28–Apr. 1, 1865. Detroit: Detroit Advertiser and Tribune Co., 1865.

16 Bryan, Michael. *Bryan's Dictionary of Painters and Engravers.* 5 vols. London: Bell, 1903–05.

17 Burnet, Mary Q. *Art and Artists of Indiana.* New York: Century, 1921.

18 Burroughs, Clyde H. *Painting and Sculpture in Michigan.* Detroit: Detroit Institute of Arts, n.d. Reprinted from *Michigan History Magazine,* 1936/37.

19 Burton, Clarence Monroe, ed. *City of Detroit, Michigan, 1701–1922.* 5 vols. Detroit: S. J. Clarke Pub. Co., 1922.

20 ____, comp. *Democratic Free Press (Free Press Digest), May 29-Sept. 29, 1845.* Typescript. Detroit: Detroit Public Library, Burton Historical Collection, n.d.

21 ____, comp. *Detroit Gazette Digest, 1817–1828.* 3 vols. Detroit: Detroit Public Library, Burton Historical Collection, 1929.

22 ____, ed. *Detroit in 1814–63.* Detroit: S. J. Clarke Pub. Co., 1930.

23 ____, ed. *Detroit in 1872.* Detroit: S. J. Clarke Pub. Co., 1930.

24 ____, comp. *Digest of the Detroit Courier, Apr. 3, 1833–Jan. 14, 1835.* Typescript. Detroit: Detroit Public Library, Burton Historical Collection, n.d.

25 ____, comp. *Digest of the Detroit Daily Advertiser, 1836–1858.* Typescript. Detroit: Detroit Public Library, Burton Historical Collection, n.d.

26 ____, comp. *Digest of the Detroit Free Press.* 18 vols. 1843–71. Typescript. Detroit: Detroit Public Library, Burton Historical Collection, n.d.

27 ____, comp. *Digest of the Michigan Herald, May 10, 1825-Apr. 10, 1828.* Typescript. Detroit: Detroit Public Library, Burton Historical Collection, n.d.

28 ____, ed. *History of Wayne County and the City of Detroit, Michigan.* Detroit: S. J. Clarke Pub. Co., 1930.

29 ____, comp. *Michigan Christian Herald Digest, 1842-1849.* Typescript. Detroit: Detroit Public Library, Burton Historical Collection, 1928.

30 Chapman Co., comp. *History of Washtenaw County, Michigan.* Chicago: C.C. Chapman, 1881.

31 *Charleston Courier.* Charleston, S. C. 1870–1912.

32 *Chicago Evening Post.* Chicago, Ill. Feb. 3, 1866–Jan. 10, 1874.

33 Cist, Charles. *Sketches and Statistics of Cincinnati in 1851.* Cincinnati: W. H. Moore, 1851.

34 Clement, Clara Erskine and Laurence Hutton. *Artists of the Nineteenth Century.* Vol. 1. Boston: Houghton, Osgood & Co., 1879.

35 *The Club Woman.* Detroit: Detroit Federation of Women's Clubs. ca. 1923– ? .

36 Coke, Van Deren. *Taos and Santa Fe, the Artist's Environment, 1882–1942.* Albuquerque: University of New Mexico Press, 1963.

37 *Coldwater Daily Reporter.* Coldwater, Mich. 1895– .

38 *Compendium of History and Biography of the City of Detroit and Wayne County, Michigan.* Chicago: H. Taylor & Co., 1909.

39 Conrad, Howard Louis. *History of Milwaukee.* Vol. 2. Chicago: American Biographical Pub. Co., 1895.

40 *Critic.* Detroit, 1889– ? .

41 Daughters of the American Revolution, Michigan, Louisa St. Clair chapter, Detroit. *Birth Records, from Archives of Wayne County, Michigan.* Michigan Works Progress Administration, Vital Records Project. Michigan State Library and DAR, Louisa St. Clair chapter, sponsors. 4 vols. Detroit, 1936.

42 ____. *Death Records.* Detroit Board of Health, Michigan Works Progress Administration, Vital Records Project. Michigan State Library and DAR, Louisa St. Clair Chapter, sponsors. 5 vols. Detroit, 1936.

43 ____. *Death Records.* Elmwood Cemetery . . . Michigan Works Progress Administration, Vital Records Project. Michigan State Library and DAR, Louisa St. Clair chapters, sponsors. 4 vols. Detroit, 1936.

44 ____. *Early Land Transfers, Detroit and Wayne County, Michigan.*

Michigan Works Progress Administration, Vital Records Project. Michigan State Library and DAR, Louisa St. Clair chapter, sponsors. 53 vols. Detroit, 1936.

45___ *Marriage records, from Detroit and Wayne County, Michigan.* Michigan Works Progress Administration, Vital Records Project. Michigan State Library and DAR, Louisa St. Clair chapter, sponsors. 12 vols. Detroit, 1936.

46 ___. *Probate Records, from Archives of Wayne County, Michigan.* Michigan Works Progress Administration, Vital Records Project. Michigan State Library and DAR, Louisa St. Clair chapter, sponsors, 5 vols. Detroit, 1936.

47 ___. *Vital Records, Detroit Free Press.* Michigan Works Progress Administration, Vital Records Project. Michigan State Library and DAR, Louisa St. Clair chapter, sponsors. 14 vols. 1831-65. Detroit, 1939–52.

48 ___. *Vital records of Wayne County, Michigan.* Michigan Works Progress Administration, Vital Records Project. Michigan State Library and DAR, Louisa St. Clair chapter, sponsors. 2 vols. Detroit, n.d.

49 DeLand, Charles Victor. *History of Jackson County, Michigan.* Logansport, Ind.: B. F. Bowen, 1903.

50 *Detroit Advertiser and Tribune.* Detroit, Mich. 1849–Oct. 1877.

51 *Detroit (Mich.) City Directory.* 1837– .

52 *Detroit Courier.* Detroit, Mich. Jan. 2, 1892–Dec. 29, 1950.

53 *Detroit Daily Advertiser.* Detroit, Mich. June 11, 1836–July 7, 1862.

54 *Detroit Daily Post.* Detroit, Mich. Mar. 27, 1866– Oct. 14, 1877.

55 *Detroit Daily Union.* Detroit, Mich. July 4, 1865–July 27, 1876.

56 *Detroit Free Press.* Detroit, Mich. Sept. 28, 1835– .

57 *Detroit Gazette.* Detroit, Mich. July 25, 1817–Apr. 22, 1830.

58 Detroit Institute of Arts (formerly Detroit Museum of Art). *Bulletin.* Detroit, Mich. 1904– .

59 Detroit Institute of Arts. *Exhibition of Painters in Detroit Before 1900.* Detroit: Detroit Institute of Arts, 1949.

60 *Detroit Journal.* Detroit, Mich. 1883– .

61 *Detroit News.* Detroit, Mich. Aug. 23, 1873– .

62 *Detroit News Tribune* (Sunday edition, *Detroit News*). Detroit, Mich. Feb. 1, 1915–16.

63 *Detroit of Today.* Detroit: Phoenix Pub. Co., 1893.

64 *Detroit Post.* Detroit, Mich. 1869–77; 1884–85.

65 *Detroit Post and Tribune.* Detroit, Mich. 1877–83.

66 *Detroit Saturday Night.* Detroit, Mich. Mar. 2, 1907–Apr. 8, 1939.

67 *Detroit Times,* Detroit, Mich. Oct. 1, 1900– .

68 *Detroit Tribune.* Detroit, Mich. Apr., 1933– .

69 Detroit Water Color Society. [*Catalogs.*] Detroit, Mich. 1890– .

70 *Detroit Weekly Advertiser.* Detroit, Mich. 1845–47.

71 *Dictionary of American Biography.* 20 vols. New York: Scribners, 1928–37.

72 *Dilettant; a journal of art and music.* Detroit, Mich. 1885.

73 *Educators of Michigan.* Chicago: J. H. Beers & Co., 1900.

74 Edwards, Richard. *Industries of Michigan: City of Detroit.* New York: Historical Pub. Co., 1880.

75 Eldredge, Robert F. *Past and Present of Macomb County, Michigan.* Chicago: S. J. Clarke Pub. Co., 1905.

76 Elson, Henry William. *The Civil War Through the Camera.* Springfield, Mass.: Patriot Pub. Co., 1912.

77 *Ensign, Bridgman & Fanning's Guide Through the States of Ohio, Michigan.* New York: Ensign, Bridgman & Fanning, 1854–56.

78 Farmer, Silas. *History of Detroit and Michigan.* 3d ed. Detroit: Munsell, 1890.

79 Fielding, Mantle. *Dictionary of American Painters, Sculptors and Engravers.* New York: Struck, 1945.

80 *Flint (Mich.) City Directory.* 18– .

81 *Fremont Times–Indicator.* Fremont, Mich. 1884– .

82 Gallery of Fine Arts, Firemen's Hall. *Catalogue, February, 1852.* Detroit, 1852.

83 Gannser, Augustus H. *History of Bay County.* Chicago: Richmond & Arnold, 1905.

84 Gibson, Arthur Hopkin. *Robert Hopkin, Master Marine and Landscape Painter.* Ann Arbor, Mich.: The Author, 1962.

85 Goss, Charles Frederic. *Cincinnati, the Queen City.* Chicago: S. J. Clark, 1912.

86 *Grand Rapids (Mich.) City Directory.* 18– .

87 *Grand Rapids Herald.* Grand Rapids, Mich. 1855–57; 1884– .

88 Great Lakes Historical Society. *Inland Seas.* Cleveland: Great Lakes Historical Society, 1945– .

89 Hathaway, Charles S. *Our Firemen.* Detroit: J.F. Eby & Co., 1894.

90 Heineman, David Emil. *Jewish Beginnings in Michigan Before 1850.* Baltimore: American Jewish Historical Society, 1905.

91 Hinsdale, Burke A. *History of the University of Michigan.* Ann Arbor, Mich.: University of Michigan, 1906.

92 *History of Jackson County, Michigan.* Chicago: Inter-state Pub. Co., 1881.

93 *History of Macomb County, Michigan.* Chicago: M. A. Leeson & Co., 1882.

94 *History of Tuscola and Bay Counties, Michigan.* Chicago: H. R. Page & Co., 1883.

95 *Holly Advertiser,* Holly, Michigan. 18– .

96 Hook, Harry H. *Detroit Illustrated.* Detroit: Hook, 1891.

97 Jackson, Emily. *Ancestors in Silhouette, cut by August Edouart.* London: John Lane Co., 1921.

98 *Jackson (Mich.) City Directory.* 18– .

99 *Kalamazoo (Mich.) City Directory.* 18– .

100 Karpinski, Louis Charles. *Bibliography of the Printed Maps of Michigan, 1804–1880.* Lansing, Mich.: Michigan Historical Commission, 1931.

101 Kenny, Sister M. Kilian. *A History of Painting in Michigan, 1850 to World War II.* Thesis, Wayne State University, 1965.

102 *Lansing (Mich.) City Directory.* 18– .

103 Leake, Paul. *History of Detroit.* 3 vols. Chicago: Lewis Pub. Co., 1912.

104 Leonard, J. W. *Industries of Detroit.* Detroit: J. M. Elstner & Co., 1887.

105 Loomis, Frances. *Michigan Biography Index.* 11 vols. Typescript. Detroit: Detroit Public Library. Burton Historical Collection, 1946.

106 Loubat, Joseph Florimond. *The Medallic History of the United States of America, 1776–1876.* New York: The Author, 1878.

107 McIntosh, W. H. *History of Monroe County, New York.* Philadelphia: Everts, Ensign & Everts, 1877.

108 *Main Sheet.* Algonac, Mich.: Detroit Yacht Club. ca. 19– .

109 Mallett, Daniel Trowbridge. *Mallett's Index of Artists.* New York: Peter Smith, 1948.

110 Marquis, Albert Nelson, ed. *The Book of Detroiters.* Chicago: A. N. Marquis Co., 1908 and 1914.

111 *Men Who Have Made Michigan.* Edited by Edwin Gustav Pipp. Detroit: Pipp's Magazine, 1908.

112 *Michigan Farmer.* Detroit, Mich. 1843– .

113 *Michigan History Magazine.* Lansing, Mich. July 1917–Dec. 1945.

114 *Michigan Library Bulletin.* Lansing, Mich.: Michigan State Library. 1910–1938.

115 Michigan Pioneer and Historical Society. *Collections.* 40 vols. Lansing, Mich.: Michigan Pioneer and Historical Society, 1877–1929.

116 Michigan State Fair. *Catalogue of Oil Paintings and Art Specialties Exhibited at the Thirty-fifth Annual State Fair.* Detroit: A. J. Brow et al., 1883.

117 Michigan State Fair. *Catalog of [Works] Exhibited, 1880.* Detroit, 1880.

118 *Michigan State Gazetteer.* Lansing, Mich. 1838–1901.

119 Michigan State Library. *Biographical Sketches of American Artists.* Lansing, Mich.: State Library, 1916 and 1924 editions.

120 *Missouri Republican.* St. Louis, Mo. Mar. 20, 1822–Dec. 4, 1919.

121 Moore, Charles. *History of Michigan.* Chicago: Lewis Pub. Co., 1915.

122 Moore, Julia Gatlin. *History of the Detroit Society of Women Painters and Sculptors, 1903–1953.* River Rouge, Mich.: The Author, 1953.

123 Moore, Vivian Elsie Lyon. *The First Hundred Years of Hillsdale College.* Ann Arbor, Mich.: Ann Arbor Press, 1944.

124 Mosher, Edith R. and Nella Dietrich Williams, eds. *From Indian Legends to the Modern Book-Shelf.* Ann Arbor: George Wahr, 1931.

125 *New Century Cyclopedia of Names.* Edited by Clarence E. Barnhart. New York: Appleton- Century-Crofts, Inc., 1954.

126 *New York City Directory.* 18– .

127 *New York Herald-Tribune.* New York, N.Y. Apr. 10, 1841– .

128 New York Historical Society. *Dictionary of Artists in America,*

1564-1860. Compiled by George C. Groce and David H. Wallace. New Haven: Yale University Pr., 1957.

129 *New York Times*. New York, N.Y. Sept. 18, 1851– .

130 Palmer, Friend. *Early Days in Detroit*. Detroit: Hunt & June, 1906.

131 *Pontiac Gazette*. Pontiac, Mich. Feb. 7, 1844–1910.

132 *Port Huron (Mich.) City Directory*. 18– .

133 Porter, James Amos. *Modern Negro Art*. New York: Dryden, 1943.

134 *Portrait and Biographical Album of Hillsdale County, Michigan*. Chicago: Chapman Bros., 1888.

135 *Portrait and Biographical Album of Oakland County, Michigan*. Chicago: Chapman Bros., 1891.

136 *Portrait and Biographical Record of Kalamazoo, Allegan and Van Buren Counties, Michigan*. Chicago: Chapman Bros., 1892.

137 Putnam, Daniel. *History of the Michigan State Normal School (now Normal College) at Ypsilanti, Michigan, 1840–1899*. Ypsilanti, Mich.: The Author, 1899.

138 Ross, Robert Budd. *Detroit in 1837: A Series of Articles Published in the News-Tribune, Aug. 12, 1894–Sept. 15, 1895*. Detroit: News-Tribune, 1895.

139 Ross, Robert Budd and George B. Catlin. *Landmarks of Detroit, a History of the City*. Detroit: Evening News Assn., 1898.

140 *Royal Oak Tribune*. Royal Oak, Mich. 1904– .

141 Russell, J. A. *The Germanic Influence in the Making of Michigan*. Thesis, University of Detroit, 1927.

142 *Saginaw (Mich.) City Directory*. 18– .

143 Scarab Club. *Scrapbook*. Detroit: Scarab Club, n.d.

144 *Scribner's Magazine*. New York, N. Y. Jan. 1887–May 1939.

145 *Scribner's Monthly*. New York, N.Y. 1870–81.

146 Smith, Ralph C. *Smith's Index of American Artists*. Baltimore: Williams & Wilkins, 1951.

147 Stauffer, Ezra Nelson, comp. *Stauffer Genealogy of America, and History of the Descendants of Jacob Stauffer*. Scottsdale, Pa.: Mennonite Pub. House, ca. 1917.

148 *Svenskt Konstnärslexikon*. 5 vols. Malmö, Sweden: Allhems Förlag, 1952–67.

149 Thieme, Ulrich and Felix Becker. *Allgemeines Lexikon der*

bildenden Künstler von der Antike bis zur Gegenwart. 37 vols. Leipzig: Seemann, 1907–50.

150 United State Census Office. *Census Reports.* 1st–10th. Washington, D.C.: Government Printing Office, 1790–1880.

151 Van Buren, Anson DePuy. *Artist Life of William B. Conely.* Detroit: Wm. Graham, 1863.

152 *Western Statesman.* Marshall, Mich. Jan. 30, 1840–Oct. 5, 1843.

153 *Who's Who in American Art.* New York: Bowker, 1935– .

154 *Who's Who in Art and Music in Michigan.* Milwaukee: Educator Pub. Co., 1929.

155 *Who's Who in Detroit.* Detroit: W. Romig & Co., 1935/36– .

156 Young, William, ed. *Dictionary of American Artists, Sculptors and Engravers.* Cambridge, Mass., 1968.

B. Special Sources

157 Archives of American Art, Smithsonian Institution, Washington, D.C. 20560. Various materials from this collection were used.

The Archives of American Art is the major national repository of manuscript material on art and artists in America. In nearly a thousand collections of personal papers and institutional records are the correspondence of artists, dealers, collectors, critics, museums, and art societies. The collections also include journals, notebooks, draft writings and speeches, sketchbooks, scrapbooks, photographs of the artists and their work, and auction and exhibition catalogs.

Among collections with a specific Michigan association are the records of the Scarab Club, the Hanna Galleries, and the Society of Arts and Crafts in Detroit, as well as several hundred personal and business letters from various Michigan born artists.

These documentary resources, available at the Archives for scholarly research, are duplicated on microfilm. A complete set of the film is maintained at each of five regional offices: Boston, New York, Washington, D.C., Detroit, and San Francisco.

Guides to the collections include card catalog records of holdings, and a published guide, Garnett McCoy's *Archives of American Art: A Directory of Resources* (New York: Bowker, 1972).

—Garnett McCoy

158 Baché, Martha Moffett. Landscape and still life artist, resident of Washington, D. C. Supplied autobiographical information.

159 Berkery, Winifred. Resident of Grosse Pointe, Mich. Supplied information on Roger Joseph Echlin and Hermann Geyer.

160 Coen, Mrs. Edward. Minneapolis Institute of Arts, Minneapolis, Minn. Supplied information on the works of Edward Kirkbride Thomas.

161 Cumming, John. Director, Clarke Historical Library. Central Michigan University, Mt. Pleasant, Mich. Supplied information on the works of Mae Aitkens, William M. Cary, Dr. Edward Dorsch, Henry Kanzler, Edward Leavens, and Julia Crawford Sanborn.

162 Detroit Historical Museum, 5401 Woodward Avenue, Detroit, Michigan 48202. Various materials from this collection were used.

All accessioned items in the collections of the Detroit Historical Museum and its branch museums, Dossin Great Lakes Museum and Fort Wayne Military Museum, are recorded in the master catalog kept in the Registrar's office at the main Museum. When an item such as a painting is cataloged, an effort is made to learn as much as possible about its history. Significant information related by the donor is recorded on catalog cards and is also kept in bound volumes containing the permanent accession records. Accessioned items are listed by donor's name as well as catalog number. Items associated with particular people are listed in the biographical association file which contains a brief biographical sketch and a listing of pertinent items in the Museum's collection.

The Museum also maintains general biographical reference files of clippings, photographs, and other biographical data.

Bound volumes of the Detroit Historical Society *Bulletin,* published from January 1945 to December 1971, are kept in the Museum's library. The *Bulletin* contains articles of local historical interest. The volumes are indexed and are of use in gathering information on local artists.

All the Museum's general reference materials are maintained for the convenience of the Museum staff, but the public is welcome to use these sources by appointment with the Registrar.

—Holly Ulseth

163 Detroit Institute of Arts, Research Library, 5200 Woodward Ave., Detroit, Michigan 48202. Various materials from this collection were used.

The Library maintains a number of sources devoted to artists of Michigan, principally the Detroit area. A card file lists those exhibitions sponsored by the former Detroit Museum of Art and by the Detroit Institute of Arts, in which a given artist participated. This file leads researchers to bound exhibition catalogs, 1886 to date, which give titles of work exhibited. An informal file of Michigan artists' names reveals bibliographical sources of information and lists the years of participation in the Annual Exhibition of Michigan Artists.

The indexes to the *Detroit Institute of Arts Bulletin* and the *Detroit Museum of Art Bulletin* are directories to articles on works in the permanent collection, some of which are by Michigan artists.

The catalog of microfilmed clipping material on artists consists of newspaper and magazine articles, dealers' announcements, and catalogs of exhibitions, obituary notices and other information.

—Warren Peters

164 Detroit Public Library, Burton Collection, 5201 Woodward Ave., Detroit, Michigan 48202. Various materials from this collection were used.

In common with other historical libraries, the Burton Historical Collection contains many non-book materials unique within the subject field, as well as books and published items long out of print. It is difficult to list all of these things in standard bibliographic form, so a word of explanation is in order.

First, in the Burton catalog room are many special card indexes. The biography, picture, and genealogy indexes are the ones most important for materials on early Michigan artists. These, plus the catalog cards, are the means for reaching additional sources. The catalog and card index to the manuscript collection also refer to papers and letters by or about some local artists.

The biography index cards refer to articles in books, periodicals, and newspapers, and in some cases have a newspaper obituary or other short item pasted on a card. When there is a file of clippings available, that is indicated. Those boxes of files may also contain photographs, invitations, calling cards, handwritten notes, or anything else pertinent to the subject.

The Burton Historical Collection keeps many scrapbooks, resulting from the hobby some Detroiters had before the advent of radio and television. The scrapbooks of Clarence M. Burton and Friend Palmer are full of biographical items which can be located through

the cards in the biography index. The two scrapbooks of Mina Humphrey Varnum, a local newspaperwoman, contain clippings from the *Detroit Tribune* and the *Detroit Journal* on art and musical events in Detroit for the years 1892–93.

Realizing the importance to historical research of early Detroit newspapers, Clarence M. Burton, founder of the Collection, embarked on a program of indexing them. On the shelves of the Burton reading room are typescript digests and indexes of some of The *Detroit Free Press, Detroit Daily Advertiser, Detroit Gazette,* and others, covering the period 1817–72.

Along with the newspaper indexes are typescripts of Elmwood and Mt. Elliott Cemetery records, early Detroit Board of Health death records, and an index to vital records in the *Detroit Free Press,* 1831–68.

A former librarian of the Burton Historical Collection, Helen Ellis, compiled a record of Detroit artists, noting biographical references and listing their known works and where they might be found. These seven looseleaf notebooks also are kept in the Burton reading room.

With the extensive finding aids available, pertinent information on artists of early Michigan can be readily located in the Burton Historical Collection.

—Alice Dalligan

165 Detroit Public Library, Fine Arts Department, 5201 Woodward Ave., Detroit, Michigan 48202. Various materials from this collection were used.

Many subjects pertinent to Michigan artists are represented in the Department's vertical file; however, the "Biography" files were the chief ones used in this study. These files are arranged alphabetically by the artist's surname. Main sources of the clippings are Detroit newspapers and announcements of one-man and other art shows.

—Shirley Solvick

166 Dubin, Mrs. Tela. Owner, Artists Unlimited Gallery, Silver Spring, Maryland. Supplied information on Martha Moffett Baché.

167 Dudley, Irene Townsend. Former Librarian, Burton Historical Collection, Detroit Public Library. Supplied information on Charlotte Elizabeth Watkins.

168 Edwards, Nina. Resident of Detroit, Mich. Supplied information on Floyd Sherman Nixon.

Artists of Early Michigan

Note: The Key to reference source code numbers is located in the "Sources Consulted" (pp. 19).

A

AARONS, JACOB D. (or JOHN D.) Artist in Detroit, 1890–93. *—Ref.: 51 (1890–93); 118 (1891, 1893)*

ABRAHAM, ALFRED W. (1836–1896). Photographer and amateur painter in Detroit, 1864. Born on the Isle of Wight, England. Settled in Detroit, 1864. For twenty years, operated photographic galleries and exhibited at local art stores and at state fairs. Died in Detroit, Apr. 3, 1896. *—Ref.: 51 (1864+); 68 (Apr. 5, 1896); 96; 112 (Oct. 16, 1883)*

ADAMS, (Miss) A. M. Artist in Ann Arbor, 1895. *—Ref.: 118 (1895)*

ADAMS, EVA BELLE. Artist in Detroit, 1898–1911. Exhibits Detroit Society of Women Painters, 1906, 1907, and 1911. *—Ref.: 51 (1896, 1898–1900); 118 (1897, 1899); 163*

ADAMS, LOUISE. Art student at Detroit School of Arts, June 1893. *—Ref.: 60 (June 24, 1893)*

ADAMS, W. N. Artist in Jackson, 1886. Award: premium for an oil painting of birds, Michigan State Fair, 1886. *—Ref.: 112 (Nov. 2, 1886)*

ADAMSON, ANDREW D. Charcoal and India ink artist in Bay City, 1893. *—Ref.: 118 (1893)*

ADOMEIT, OTTO. Crayon artist in Detroit, 1888–90. Operated a picture and book store in Detroit. Moved to St. Louis, Mo., 1890. *—Ref.: 51 (1888–90)*

AERTS, JOSEPH. Wood-carver and modeler in Detroit, 1869–76. In partnership with Charles Vanderpoele (q.v.), 1870–71, as Aerts & Vanderpoele (q.v.), sculptors and carvers. *—Ref.: 51 (1869–70, 1875–76)*

AERTS & VANDERPOELE. Sculptors and carvers in Detroit, 1870–71:

Joseph Aerts (q.v.) and Charles Vanderpoele (q.v.). *—Ref.: 51 (1870–71)*

AIKEN, CHRISTOPHER K. Scenic artist in Jackson, 1895–1912. *—Ref.: 98 (1912); 118 (1895, 1899)*

AITKENS, MAE. Artist in Alpena. *—Ref.: 161*

ALBERTS, CHARLES. Artist in Saginaw, 1899. *—Ref.: 118 (1899)*

ALBRIGHT, CAROL M. Watercolor artist in Detroit, 1886–94. Studied under Paul Dumond in Paris. Exhibits: Keppel Gallery, New York City; and New York Water Color Society, 1893. Moved to New York, 1894. *—Ref.: 51 (1887–94); 60 (May 24, Nov. 9, Dec. 22, 1893); 61 (Dec. 1, 1889); 68 (Oct. 10, 1886)*

ALEXANDER, ARTHUR L. Artist in Ann Arbor, 1897–99. *—Ref.: 6 (1899); 118 (1897, 1899)*

ALEXANDER, HENRY V. (1866–1940). Amateur artist in Detroit, 1891–1940. Died in Detroit. *—Ref.: 51 (1894–1900); 56 (Oct. 26, 1940; 118 (1897)*

ALEXANDER, Mary A. Artist (probably ceramics) in Detroit, 1895–97, *—Ref.: 51 (1895–97)*

ALEY, WILLIAM. Artist in Carsonville, 1893–95. *—Ref.: 118 (1893, 1895)*

ALLEN, ARCHIBALD. Artist in Port Huron, 1895. *—Ref.: 118 (1895)*

ALLEN, CHARLES (1864–1892). Artist in Detroit, ca. 1885–92. Studied at Detroit School of Art and Design, and later became a teacher there. Exhibit: still life works, Detroit Artists' Association, 1891. Died in Detroit about Aug. 10, 1892. *—Ref.: 51 (1892–93); 60 (Oct. 22, 1894)*

ALLEN, CHARLES H. Photographer and artist (probably crayon) in Jackson, 1895. *—Ref.: 98 (1912); 118 (1895)*

ALLEN, CHARLES L. Crayon artist in Detroit, 1892–97. *—Ref.: 51 (1892, 1894, 1896, 1897); 118 (1897)*

ALLEN, ETHEL. Art student from Plymouth. Studied watercolor under Maud Mathewson (q.v.) in Detroit. Some of her work was shown at a studio exhibit in June 1893. *—Ref.: 60 (June 24, 1893)*

ALLEN, JESSIE. Artist in Otsego, 1893–95. *—Ref.: 118 (1893, 1895)*

ALLEN, JULIA H. Art student from Grosse Ile. Enrolled in the Detroit Art Academy, 1896. *—Ref.: 60 (Oct. 17, 1896)*

ALLIS, C. HARRY (? –1938). Landscape artist in Detroit, 1891–1902. Produced a great number of oil and watercolor paintings. Born in Dayton, Ohio. Studied at the Detroit Museum of Art School, where he later was an instructor in drawing and painting. Conducted private classes in painting and sketching. Art critic, *Detroit Free Press.* Went to Paris, and later resided in various towns in France and Holland. Later

established residence in New York City. Exhibits: Paris Salon; Royal Academy, and Royal Society of Arts, London; National Academy of Design, and American Water Color Society, New York; Carnegie Institute, Pittsburgh; Chicago Art Institute; DIA; Corcoran Gallery, Washington, D. C.; Society of Western Artists, Kansas City, Mo.: John Herron Institute, Indianapolis, Ind.; PAFA; Connecticut Academy; Cincinnati Museum of Art; Buffalo Museum of Fine Arts; Louisiana Purchase Centennial Exposition, St. Louis, Mo., 1904; Panama-Pacific International Exposition, San Francisco, 1915. Memberships: Federation of American Artists; Munich Society of American Painters; National Arts Club, Salmagundi Club, New York; Society of Western Artists; American Art Association, Paris; Painters Club, Bohemian Club, and Imperial Arts League, London; Detroit Water Color Society (vice president). Represented in collections and museums throughout Europe, the United States, and Puerto Rico. Member of many American and foreign art clubs. Died June 8, 1938. *—Ref.: 3 (1898, 1933); 13; 51 (1894–1902); 60 (Dec. 28, 1895; Jan. 15, Sept. 12, Sept. 19, 1896; Jan. 9, 1897); 66 (Nov. 4, 25, 1911); 79; 109; 118 (1895–99); 153 (vols. 1, 2, 1936–39; vol. 3, 1940/41); 163; 164*

ALLMOND, KATHERINE D. *See* HULBERT, KATHERINE ALLMOND.

ALMY, OSCAR F. (ca. 1818–1862). Painter of murals, scenic and panoramic works. Born in the West Indies. In New York City, 1850, 1859–60. In 1862, completed scenic work for Young Men's Hall in Detroit, and followed this with mural decorations on the ceiling of the First Presbyterian Church. While executing these murals, the scaffolding collapsed and death resulted from his injuries, Mar. 15, 1862. *—Ref.: 56 (Mar. 16, 18, 1862); 126 (1860); 128*

ALTEN, MATHIAS JOSEPH (1871–1938). Figure, portrait, and mural painter in Grand Rapids and Detroit, 1890s+. Born in Gusenberg, Germany, Feb. 13, 1871. As a youth, studied at Julien Academy, Paris, under Jean Paul Laurens and Benjamin-Constant. Came to America in 1889. Studied under Edward A. Turner (q.v.) in Grand Rapids. Returned to Europe in 1899 for study under Prinet, Girardot, and James McNeill Whistler in Paris, and under Sorolla in Spain. Exhibits: Academy Colarossi, Paris; National Academy, New York; Society of Western Artists; Pennsylvania Academy; Chicago Art Institute; Grand Rapids Art Association; Detroit Institute of Arts; Corcoran Gallery, Washington, D.C. Memberships: National Art Academy, New York; Allied Artists' Association; Scarab Club of Detroit; and Chicago Gallery Association. Awards: Bronze Medal of Academy Colarossi, Paris, 1899; Gold Medal, Scarab Club, 1920; Second Prize, Detroit Institute of Arts,

1919, and Founders' Prize, 1922; Grand Rapids Art Association Popular Prize, 1916, and First Portrait Prize, 1933. Represented in collections of Detroit Institute of Arts; Syracuse (N. Y.) Museum of Fine Arts; Michigan State Capitol, Lansing; United States Circuit Court of Appeals, Cincinnati, Ohio; the Armory, Flint; Library of Port Huron; and the armory and various colleges and schools in Grand Rapids. Death was caused by heart trouble, Mar. 8, 1938. *–Ref.: 3 (1933) 13; 61 (Mar. 13, 1938); 79; 81 (Sept. 11, 1953); 87 (Dec. 3, 1911); 109; 118 (1897); 119; 149; 153 (vols. 1–2, 1936–39, vol. 3, 1940/41); 157*

AMERICAN PORTRAIT CO. *See* HARPER & WILSON.

AMSDEN, LILLIAN C. Artist in Detroit, 1898-1901. *–Ref.: 51 (1898–1901)*

ANDERSON, BERTHA. Artist in Flint, 1891-93. *–Ref.: 118 (1891, 1893)*

ANDERSON, JAMES A. Wood-carver and furniture designer in Grand Rapids, 1886–1922. Partners with Andrew B. Gibson (q.v.) under the firm names of James A. Anderson & Co., (q.v.), 1893–97, and with Charles E. De Van (q.v.) under the name of Anderson & De Van (q.v.), 1897–99, manufacturers of wood carvings and designers of furniture. *–Ref.: 86 (1886+); 118 (1889–93)*

ANDERSON, JAMES A., & CO. Manufacturers of wood carvings, and furniture designers in Grand Rapids, 1893–97: James A. Anderson (q.v.) and Andrew B. Gibson (q.v.). *–Ref.: 86 (1893–97); 118 (1895, 1897)*

ANDERSON & DE VAN. Furniture designers in Grand Rapids, 1899: James A. Anderson (q.v.) and Charles E. De Van (q.v.). *–Ref.: 86 (1899)*

ANDRE, ANETTE (or ANETTA C.) (Mrs. James A.). Artist and vocal instructor, Detroit School of Music, 1891–1912. *–Ref.: 51 (1891–1912)*

ANDREWS, EMMA (Mrs. W. W.). Artist in Jackson, 1880–1912. Award: best India ink drawing, Michigan State Fair, 1882. *–Ref.: 112 (Oct. 17, 1882); 98 (1880, 1912)*

ANDRIAZZI, HERCULES. *See* ANDRIOZZI, HERCULES.

ANDRIEU, MATHUREN ARTHUR (? –1896). Scenic and panoramic artist. Born Bordeaux, France. Student of the French Royal Academy. In 1840, was in New Orleans, La. Exhibited in Charleston, S.C., 1851; and in St. Louis, Mo., 1853. In 1855, married Martha Walling of Macon, Ga. In 1862, settled in Providence, R. I. Painted large panoramic views of numerous cities and waterways, and exhibited them to the public for a nominal fee. Usually showed his "Western Life" series, with music

and singing entertainment, while working on the local scenic views for the later exhibitions. In Detroit, June through Oct. 1854, producing and showing his "Grand Panorama of the City of the Straits." Among his scenic panoramics were "Southern Life," "Sugar Plantation," "Naragansett Bay," "Penobscot River," "City of Chicago," and "City of Providence." Did some portraits and solicited sign painting work while engaged in executing the local panorama. Died in Providence, R. I. —*Ref.: 8; 31 (Sept. 8, 1851); 53 (July 1, 25, Oct. 7, 19, 20, 1854); 56 (Oct. 4, 14, 1854); 120 (Apr. 22, May 5, June 2, 1853); 128*

ANDRIOZZI (or ANDRIAZZI), HERCULES. Sculptor in Detroit, 1889–91. —*Ref.: 51 (1889–91)*

ANNIN, LILLIAN G. Artist in Grand Rapids, 1892–93. —*Ref.: 86 (1892–93); 118 (1893)*

ANTISDEL, LA VERNE ROGERS (Mrs. Wm. W.) (1842–1907). Landscape, portrait, animal, and still life artist in Detroit, 1871–1907. Originally from Decatur, but lived in Detroit most of her adult life. Exhibited consistently between 1871 and 1886 in the local galleries and at the Michigan State Fairs. Awards: first and second prizes, and bronze medal, Michigan State Fair, 1878; awards in the fairs of 1879, 1880 and 1886. Died in Detroit, Oct. 29, 1907. —*Ref.: 50 (Mar. 3, 1871); 51 (1908); 56 (Apr. 10, 1877, Apr. 16, 1878, Apr. 17, 1879, Oct. 28, 1907,); 65 (Sept. 21, 1878, Sept. 18, 1879, Sept. 16, 1880); 112 (Oct. 24, 1878, Feb. 10, 1880, Oct. 12, 1880, Nov. 2, 1886); 163; 164*

ANTOINNISEN, E. Artist in Detroit, 1854. Exhibited six paintings at the Michigan State Fair, 1854. —*Ref.: 112 (Nov. 1854)*

ANTROBUS, BIRDY (or SUSANNE) (later Mrs. Susanne Antrobus Robinson of New York) (ca. 1974– ?). Painter in Detroit. Daughter of John Antrobus (q.v.). Exhibited at Michigan State Fair, 1878; given first and second awards for the best drawings by a person under age fourteen. Exhibited at the first showing of the Detroit Art Association, 1895. —*Ref.: 60 (Oct. 18, 1907); 112 (Oct. 24, 1878); 163*

ANTROBUS, JOHN (ca. 1837–1907). Portrait, landscape, and allegorical painter and poet. Born in Warwickshire, England. Came to America as a boy. Was in New Orleans at the outbreak of the Civil War, and after the war married Miss Jeannie Watts of that city. Thereafter, lived in Washington, D. C., Chicago, and in 1870, Iowa. Settled in Detroit, 1875. Wrote articles frequently for the *Detroit Free Press.* Also wrote a number of poems, illustrated by paintings. The gold medal presented to General U. S. Grant, pursuant to a joint congressional resolution, was designed by him. Exhibited locally, and at the Michigan State Fairs. Member: Detroit Art Association. Died in Detroit, Oct. 18, 1907.

—*Ref.: 3 (1907–8); 56 (Apr. 6, 1876, Oct. 19, 1907, obit.); 65 (Sept. 21, 1878); 78; 106; 112 (Oct. 24, 1878); 163; 164*

ANWAY, IDA A. Artist in Grand Rapids, 1892–95. —*Ref.: 86 (1892–95); 118 (1895)*

ARMSTRONG, ESTELLE RICE. A student at Detroit School of Arts, 1893–94. In 1894 showed watercolors at its annual spring exhibition. Student of Maud Mathewson (q.v.). —*Ref.: 60 (June 24, 1893, June 20, 1894)*

ARNOLD, ALONZO. Wood-carver in Bay City, 1893–1905. —*Ref.: 12 (1905); 118 (1893–99)*

ARNOLD, CLARIS. Artist in Charlotte. Award: first premium for pencil drawing of an animal, Michigan State Fair, 1876. —*Ref.: 112 (Nov. 14, 1876)*

ARNOLD, HERBERT R. Artist in Detroit, 1892–94. —*Ref.: 51 (1892–94); 118 (1893)*

ASHLEY, CHARLES G. Artist in Grand Rapids, 1899. —*Ref.: 118 (1899)*

ASHLEY, MARY S. Artist in Grand Rapids, 1895–99. —*Ref.: 118 (1895, 1899)*

ASHLEY, ? (Mrs. William A.). Watercolor artist in Grand Rapids, 1881. —*Ref.: 118 (1881)*

ASPINALL, JAMES P. Picture frame and mirror dealer in Detroit, 1859. Associated with John Atkinson (q.v.) in the firm of Atkinson & Company (q.v.). Probably Philip Aspinall (q.v.) —*Ref.: 56 (May 7, 1859)*

ASPINALL, PHILIP. Dealer in frames and mirrors in Detroit, 1852. Associated with John Atkinson (q.v.) under the firm name of Atkinson & Company. Probably James P. Aspinall (q.v.) —*Ref.: 53 (Dec. 17, 1852)*

ATKINS, ALBERT W. Portrait painter in Ovid, 1891–1911. —*Ref.: 118 (1891–1911)*

ATKINSON, JOHN (1805–1890). Amateur artist, and house, sign, ship, and ornamental painter in Detroit 1844–90. Familiarly referred to as the "Old Painter" to distinguish him from a prominent attorney of the same name. Pioneer member of Detroit's Hand Fire Engine Company No. 1, 1844. Partner in several commercial enterprises: Atkinson & Baird (q.v.); Atkinson & Godfrey (q.v.); Atkinson & Parker (q.v.); and Atkinson & Company (q.v.). Award: prize for still life painting, Michigan State Fair, 1851. Died in Detroit, Oct. 27, 1890. —*Ref.: 22; 56 (Sept. 23, 26, 1851, May 7, 1859, Aug. 5, 1870); 89; 112 (Dec. 1851); 115 (vol. 18)*

ATKINSON, LULU G. Artist in Detroit, 1891. *–Ref.: 51 (1891)*

ATKINSON & BAIRD. House, sign, ship, and ornamental painters in Detroit: John Atkinson (q.v.) and Robert Wallace Baird (q.v.). *–Ref.: 56 (Aug. 2, 1850, Sept. 23, 1851)*

ATKINSON & COMPANY. Dealers in picture frames, mirrors, and paintings in Detroit, 1852–59: John Atkinson (q.v.) and Philip Aspinall (q.v.), and later John Atkinson and James P. Aspinall (q.v.). *–Ref.: 53 (Dec. 17, 1852); 56 (May 7, 1859)*

ATKINSON & GODFREY. Interior and ornamental decorators, Detroit, 1850: John Atkinson (q.v.) and Jeremiah Godfrey (q.v.). *–Ref.: 56 (Aug. 2, 1850)*

ATKINSON & PARKER. Sign and decorative painting artists in Detroit, 1870: John Atkinson (q.v.) and Julius G. Parker (q.v.). *–Ref.: 56 (Aug. 5, 1870)*

ATWOOD, JOHN M. (ca. 1818– ?). Engraver. Born in Washington, D. C. Active in New York City, 1838–52. Associated with Thomas C. Story as Story & Atwood, portrait, historical and landscape engravers, New York, 1844. As early as 1845, engraved several maps of Michigan and contiguous territory. One of that date appeared in J. Meyer's *Grosser Hand-Atlas,* published at Hildburghausen, Germany, ca. 1860. *–Ref.: 77; 100; 128; 164*

ATWOOD, WILLIAM A. Portrait artist in Detroit, 1892–97. *–Ref.: 51 (1892–97); 118 (1895)*

AUSTIN, CHARLES W. Photographer and portrait painter in Rockford, 1887. *–Ref.: 118 (1887)*

AVERBECK, FERDINAND. Wood-carver and modeler in Detroit, 1874. In partnership with Theodore E. Crongeyer (q.v.), under the firm name of Crongeyer & Averbeck (q.v.). *–Ref.: 51(1874)*

AVERILL, ELIPHALET. Artist in Jackson, 1885–87. Associated with his son, Perry J. Averill (q.v.), under the firm name of Averill & Son (q.v.), artists. *–Ref.: 118 (1885, 1887)*

AVERILL, PERRY J. Portrait artist in Jackson, 1876–87. Exhibited and awarded premiums, Michigan State Fairs, 1876, 1877, 1886. Partner of his father Eliphalet Averill (q.v.) under the name of Averill & Son (q.v.), artists. *–Ref.: 112 (Nov. 1876, Oct. 1877, Nov. 1886); 118 (1879, 1883)*

AVERILL & SON. Artists in Jackson, 1885–87: Eliphalet Averill (q.v.) and Perry J. Averill (q.v.). *–Ref.: 118 (1885, 1887)*

AVERY, KENNETH NEWELL (1883– ?). Artist of the American

school. Born in Bay City, but active in Pasadena, Calif., by 1934. Exhibit: DIA, 1930. —*Ref.: 109; 156; 163*
AYERS, George B. Portrait painter in Detroit. —*Ref.: 51 (1871/72); 54 Oct. 23, 1871; 56 (July 30, 1871)*

B

BABCOCK, CLARA M. Artist in Greenville, 1891–95. —*Ref.: 118 (1891–95)*
BACHÉ, MARTHA MOFFETT (1883–). Landscape and still life artist in oils and watercolor. Born in Flint, Oct. 26, 1893. Studied at University of Michigan, Pratt Institute and Chicago Art Institute. Exhibits: Corcoran Gallery of Art; Smithsonian Institution. Resident of Washington, D. C. —*Ref.: 158; 166*
BACHMAN, LEOPOLD F. Wood-carver in Detroit, 1892–95. —*Ref.: 51 (1892–94); 118 (1893–95)*
BACKUS, ANNIE ELIZABETH FOX (Mrs. Wm. W.). Artist in Detroit. In 1876, exhibited a portrait of Governor Woodbridge, and a landscape. —*Ref.: 56 (Nov. 19, 1876)*
BACKUS, FRONIE EDMAN (Mrs. Dwight) (ca. 1860– ?). Artist in Potterville. Came to Michigan when very young. Executed some 600 works, ranging from still life to landscapes. —*Ref.: 61 (Jan. 24, 1937)*
BACON, IRVING REUBEN (1875–1962). Artist in Detroit, 1894–ca. 1950. Born in Fitchburg, Mass., Nov. 29, 1875. Moved to Detroit with parents about 1880. Educated in the public schools. Student of Joseph Gies (q.v.) at Detroit Museum of Art School, and F. Luis Mora at Chase School, New York. Illustrator for *Detroit Tribune* and *Detroit Evening News,* 1894–97; *Detroit Free Press,* 1897–1900; *Harper's Weekly, McClure's* and *New York American,* 1900–02. Art director for *Business Men's Magazine,* Detroit, 1902–06. At Royal Academy of Munich, studied animal painting under Heinrich von Zugel and portraiture under Carl von Marr, 1906–09 and 1913–15. On return from Europe, became personal artist for Henry Ford. Associated with the Ford Motor Company for thirty-three years as artist, scenario writer, motion picture director, manager of photographic department, scenery and portrait painter, and sculptor. Married second wife, Margaret Elizabeth Wilson of Grosse Pointe, June 10, 1933. Exhibits: Glast Palest and Kunst Verein, Munich; Paris Salon; National Association of Fine Arts, New York; PAFA; Chicago Art Institute; Society of Western Artists' tours; and DIA. Member: Scarab Club, Detroit. Represented: Royal Castle Museum, Sweden; Edison Institute and Greenfield Village, Dearborn;

Book Tower, Detroit; Cody Collection, Cody, Wyo.; Art Museum, Louisville, Ky.; and many others. Died at El Cajon, Calif., Nov. 21, 1962. Buried in Woodmere Cemetery, Detroit. *—Ref.: 3 (1933); 13; 19; 56 (Nov. 24, 1962); 60 (Jan. 15, June 6, 1896); 61 (July 23, 1940); 66 (Oct. 9, 1909); 109; 153 (1947); 157; 163*

BACON, LUCY. Artist in Detroit, 1875—80. Exhibits: Free Art Gallery, Detroit, 1875; Michigan State Fair, 1880. *—Ref.: 56 (June 26, 1875); 117*

BAER, ORA H. (Orrie or Odie). Artist in Detroit, 1889—95. *—Ref.: 51 (1889—94); 118 (1891— 95)*

BAILARD, IDA. Artist in Grand Rapids, 1892—94. *—Ref.: 86 (1892—94); 118 (1893)*

BAILEY, BESSIE. Artist in Detroit, 1892—97. *—Ref.: 51 (1892—97)*

BAILEY, GEORGE H. Artist in Grand Rapids, 1890—94. Partners with William L. Beebe (q.v.), under the name of Beebe & Bailey (q.v.), 1890—93. *—Ref.: 86 (1890—94); 118 (1893)*

BAILEY, ROBERT. Artist in Jackson, 1887. *—Ref.: 98 (1887)*

BAIRD, ? (Mrs. Robert W.). Artist in Detroit. Exhibit: Detroit Gallery of Fine Arts, 1852 and 1853. *—Ref.: 82; 51 (1852—54); 78*

BAIRD, JOHN. Portrait painter in Detroit, 1856—59. Portraits of two early Detroiters, Richard and Bridget Ash, painted in 1858, are in the Detroit Historical Museum's permanent collection. Partners with George Watson (q.v.), under the firm name of Watson & Baird (q.v.), 1857—58. *—Ref.: 51 (1856—59); 162*

BAIRD, ROBERT WALLACE. House, sign, ship, and ornamental painter in Detroit, 1850. Associated with John Atkinson (q.v.), in the firm of Atkinson & Baird (q.v.). *—Ref.: 56 (Aug. 2, 1850)*

BAIRD, SYLVIA A. Artist in Detroit, 1877. Exhibited at Angell's Gallery, 1877. *—Ref.: 5*

BAKER, CATHERINE E. Artist in Grand Rapids, 1889. *—Ref.: 86 (1889); 118 (1889)*

BALDWIN, (Mrs.) A. C. Watercolor artist in Pontiac, 1856. Award: premium for a painting of flowers, Michigan State Fair, 1856. *—Ref.: 112 (Nov. 1856)*

BALDWIN, A. J. Artist in Detroit. Associated with Albert Jenks (q.v.) and Frank M. Peebles (q.v.), portrait painters, as Jenks, Peebles and Baldwin (q.v.), in Detroit, 1873. *—Ref.: 56 (May 10, Oct. 16, 1873)*

BALL, GEORGE A. Artist in Detroit, 1895. *—Ref.: 51 (1895)*

BALLARD, DORA. *See* HARRIS, DORA BALLARD

BALLS, WILLIAM S. Wood-carver in Detroit. *—Ref.: 51 (1891—1901); 118 (1893, 1895)*

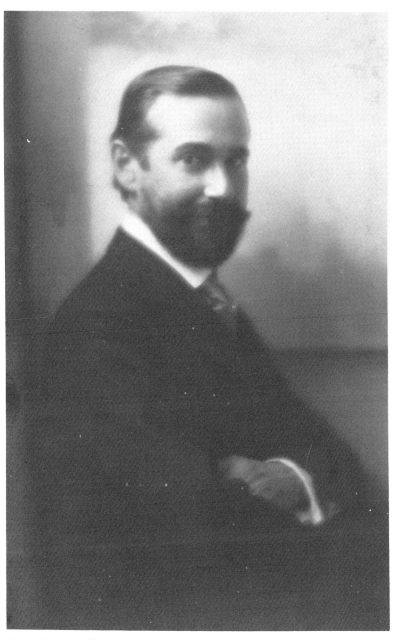

Myron Barlow, Photograph. From the collection of Mrs. Edward D. Quint, Detroit.

42

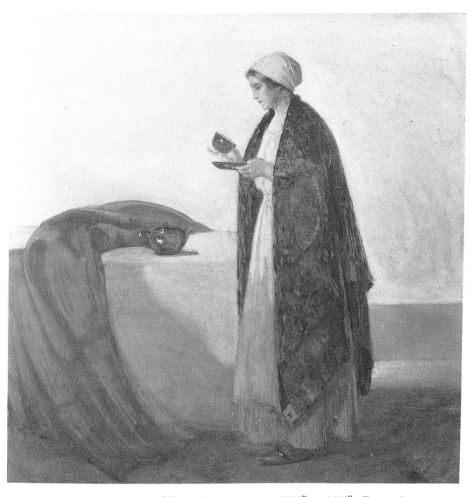

Myron Barlow, *A Cup of Tea*. Oil on canvas, 39½″ x 39¾″. From the collection of the Detroit Institute of Arts. Purchase, contributions from Philip, David and Paul R. Gray and Mrs. William R. Kales.

BANCROFT, (Mrs.) F. L. Artist in Northville, 1880–81. Exhibit: India ink drawing, Michigan State Fair, 1880. *–Ref.: 117, 118 (1881)*

BANDEL, AUGUSTUS. Landscape and portrait painter in Adrian, 1867–1870. *–Ref.: 1 (1870); 118 (1867/68)*

BANKS, A. F. Artist in Detroit, 1851–53. Exhibited two paintings, Gallery of Fine Arts, 1852–53. *–Ref.: 78; 82*

BARBOR, O. P. Artist in Saginaw, 1875. Award: first premium for a crayon drawing, Michigan State Fair, 1875. *–Ref.: 112 (Oct. 12, 1875)*

BARKER, MARY B. (Mrs. William P.). Artist in Grand Rapids, 1886–89. *–Ref.: 86 (1886, 1889)*

BARLOW, MYRON G. (1873–1937). Art student and genre painter in Detroit, ca. 1890 and early 1900s. Born in Ionia, the son of Adolph Barlow. The family moved to Detroit when he was a young boy. Started career as a newspaper artist. Studied under Joseph Gies (q.v.) at Detroit Museum Art School, and later at the Art Institute of Chicago. At the age of twenty-one, went to Paris and was a pupil of Gerome at the École des Beaux Arts. Also studied under Whistler, and was a protégé of Bougereau. In 1907, was the only American artist elected to the Société Nationale des Beaux Arts. In 1932, was made a Knight of the Legion of Honor by the French Government. Spent most of his time at a home established at Etaples, France, but made frequent trips to Detroit. Painted much of the peasantry and countryside of northern France. Awards: Medal, Colarossi Academy, Paris, 1894; Gold Medal, Paris Salon; Gold Medal, St. Louis Exposition, St. Louis, 1904; Gold Medal, Panama-Pacific Exposition, San Francisco, 1915. Memberships: Société Nationale des Beaux Arts, Paris; American Art Association, Paris; Paris Society of American Painters; Internationale Society of Painters and Sculptors, Paris; Royal Institute of Oil Painters, London; Philadelphia Art Club; Honorary Member, Fine Arts Society, Detroit. Represented: four murals in Temple Beth El, Detroit; Detroit Institute of Arts; Palais des Beaux Arts, Douai, France; Municipal Collection, Etaples, France; Municipal Gallery, Milan, Italy; and many public and private collections. Died Aug. 14, 1937 at Etaples. *–Ref.: 3 (1933); 13; 35 (Feb. 1923); 56 (Aug. 16, 1937); 60 (Aug. 4, 1915); 61 (Mar. 22, 1925, Aug. 16, 1937,); 79, 109, 119*

BARLOW, NICHOLAS L. Crayon artist in Detroit, 1877–84. Exhibited portraits at Angell's Gallery, 1877. *–Ref.: 5; 51 (1878–84); 118 (1879, 1881)*

BARLOY, PAUL. Artist in Marquette, 1889. Partner in the firm of M. G. Johnson & Co. (q.v.). *–Ref.: 118 (1889)*

BARNARD, ADA. Artist in Detroit, 1882–83. —*Ref.: 51 (1882); 118 (1883)*

BARNES, ERNEST HARRISON (1873–1955). Landscape artist in Ann Arbor, and professor of free-hand drawing and painting at University of Michigan, for fifteen years. Born in Portland, Chautaugua County, N. Y., the son of Reverand Nathaniel and Sarah Elizabeth Harrison Barnes. Education: Hillsdale College (A.B.,honorary A.M., 1923); Chicago Art Institute; Art Students League, New York. Studied under Will Howe Foote and Charles H. Davis. Exhibits: almost annually, DIA; Grand Rapids, Jackson, Ann Arbor and Birmingham; National Academy of Design, New York City; Corcoran Gallery, Washington, D.C.; and more than sixty cities in twenty Western states. Awards: Scarab Club, Detroit, 1916; DIA, Michigan Artists Exhibition, 1923; William P. Silva Prize, best painting of a southern subject, Southern States Art League Exhibition, 1928. Memberships: Connecticut Academy of Fine Arts; Scarab Club of Detroit. Represented: Collection of the State of Michigan, Lansing; DIA; Hillsdale College; and Western Michigan University. Died in Detroit, Dec. 29, 1955. —*Ref.: 13; 109; 153 (1936–37); 155 (1935–36); 164*

BARNETT, SOLOMON. Portrait artist in Detroit, 1895–99. —*Ref.: 51 (1895–96); 118 (1897, 1899)*

BARNUM, (Miss) E. N. Artist in Adrian, 1886. Award: premium for best flower presentation in oils, Michigan State Fair, 1886. —*Ref.: 112 (Nov. 2, 1886)*

BARR, LOUISE E. Artist in Muskegon, 1899. —*Ref.: 118 (1899)*

BARROWS, JEANETTE E. Artist in Ludington, 1893–95. —*Ref.: 118 (1893, 1895)*

BARSE, GEORGE RANDALL, JR. (1861–1938). Landscape, still life, and portrait artist, and architectural designer. Born in Detroit, July 31, 1861. Studied in Paris for five years at Ecole des Beaux Arts and Academie Julien, under Cabanel, Boulanger, and Lefebvre; and in Italy for four years. Returning to America, settled in New York City. Exhibits: Art Institute of Chicago; Cincinnati, Ohio, Museum, 1908; Fine Arts Museum Institute, Kansas City, Mo., 1911–12. Awards: Prize, Academy, Paris, 1882; New England Prize, Boston, 1885; First Prize, National Academy of Design, New York; Academy of National Arts in 1898; National Academy, 1899; Silver Medal, Pan-American Exposition, Buffalo, 1901. Memberships: Architectural League, Century and Salmagundi clubs, New York City; ANAD, 1898; SAA, 1899. Died Feb. 25, 1938, presumably in Katanah, N.Y., his last known address. Repre-

sented: eight panels in the Library of Congress; Vanderpool Collection, Chicago, Ill.; Carnegie Institute, Pittsburg, Pa.; Minneapolis Institute of Arts; Kansas City Art Institute; Syracuse Museum of Fine Arts; Art Club of Providence, R. I.; Art Club of Philadelphia, Pa. *—Ref.: 3 (1933); 13; 79; 109; 119; 149; 163; 164; 169*

BARTHOLOMEW, L. M. Artist in Jackson, 1883. *—Ref.: 118 (1883)*

BARTLETT, DANA. (1878– ?). Painter, illustrator, and teacher. Born in Ionia. Pupil of Art Students League and William M. Chase, New York City; Coussens in Paris. Memberships: California Arts Club; California Women's Color Club; Print Makers of California. Resident of Los Angeles for many years. Represented: California State Library; Los Angeles Museum of Art; Southwest Museum; Huntington Collection, San Marino, Calif.; Los Angeles Public Library; Gardena, Hollywood, Garfield, Virgil, and George Washington High Schools, Los Angeles; Public Library, Boston, Massachusetts. Illustrator for *The Bush Aflame.* *—Ref.: 3 (1933); 13; 79; 109; 165*

BARTLETT, MARY E. Artist in Jackson, 1886, where she later was a school teacher. Awards: first premiums for a pencil landscape and best pencil drawing by a person under fourteen years of age, Michigan State Fair, 1886. *—Ref.: 98 (1912); 112 (Nov. 2, 1886)*

BARTON, JAMES C. Photographer and portrait painter in Port Huron 1887–88. *—Ref.: 132 (1887/88); 118 (1887)*

BASCOM, LOUISA. Artist in Detroit, 1868. Exhibit: Michigan State Fair, 1868. *—Ref.: 56 (Sept. 16, 1868)*

BASSETT, MELVIN EUGENE (1880–). Artist and art instructor. Born in Ypsilanti, Apr. 11, 1880. Attended Detroit public schools and graduated from Central High School. Received bachelor's degree, University of Michigan, 1903; master's degree, Princeton University, 1922; Diplome d'Études Universitaires, University of Bordeaux, France, 1923. Instructor, Mercersburg Academy, Mercersburg, Pa., 1903–20; assistant professor, Princeton University, 1920–27; and head, Department of Romance Languages, University of Western Ontario, London, Ontario. Exhibit: Scarab Club, Detroit, 1916. *—Ref.: 163; 164.*

BATCHELDER, NELLIE C. Artist in Detroit, 1890–91. *—Ref.: 51 (1890–91); 118 (1891)*

BATCHELLOR, ANNA S. Director, Art Department, Olivet College, 1899. *—Ref.: 118 (1899)*

BATES, EUGENE F. Painter and amateur artist in Detroit, 1871–1916. Exhibits: local galleries, 1875. *—Ref.: 51 (1871–1916+); 56 (July 4, Aug. 8, Dec. 7, 1875)*

BATESON, PLUM. Artist in Detroit, 1887–92. *–Ref.: 51 (1888–90, 1892); 118 (1891)*

BAUER, FREDERICK C. Artist in Detroit, 1898–1900. Possibly the lithographer, Frederick Bauer, who was in Louisville, Ky., 1848. *–Ref.: 51 (1898–1900); 118 (1897, 1899); 128*

BAUM, LIBBIE H. Artist in Three Oaks, 1887–91. *–Ref.: 118 (1887–91)*

BAUMAN (or BAUMANN), JACOB. Amateur artist in Detroit, 1875+. Studied at the German-American Seminary, Detroit, 1875. One of his schoolboy drawings of a tollgate in that year is a part of the Burton Historical Collection, Detroit. *–Ref.: 61 (July 26, 1925); 164*

BAYLISS, LILLIAN (1875– ?). Miniature painter. Born in Massillon, Ohio, Feb. 20, 1875. Studied in Paris under Mlle. N. Schmitt, and in 1901 under Lucius F. Fuller. *–Ref.: 13; 40 (Dec. 1905); 79; 109; 119; 165*

BEARD, MINNIE A. (Mrs. Frank E.). Artist in Port Huron, 1887–1900+. *–Ref.: 118 (1889, 1891); 132 (1887/88, 1913)*

BEARD, GEORGE. (1814–1889). Artist in Detroit, 1854. Exhibit: crayon drawing of a head, Michigan State Fair, 1854. Possibly the miniature artist of the same name active in Cincinnati, Ohio, in 1840. Died in Wayne County, Oct. 15, 1889. *–Ref.: 79; 112 (Nov. 1854); 115 (vol. 17); 128*

BEAUBIEN, CHARLES. Painter and artist in Detroit, 1866–68. *–Ref.: 51 (1866/67); 118 (1867/68)*

BEAULIEU, JOSEPH H. Artist in Bay City, 1891–1905. *–Ref.: 12 (1905); 118 (1891, 1893)*

BECK, HARRY L. Artist in Vineland, 1897. *–Ref.: 118 (1897)*

BECKER, DAYTON S. Crayon artist in Detroit, 1884–91. *–Ref.: 51 (1884–91)*

BECKER, WESLEY G. Artist in Jackson, 1895. *–Ref.: 118 (1895)*

BECKETT, EDMUND or EDMOND. Cabinet maker and amateur artist in Detroit, 1890–98. *–Ref.: 51 (1890 –98)*

BEDDOW, JOHN. (1847– ?). Painter and wood-carver in Detroit, 1863–70. Born in England. Married Elizabeth McEwen in Detroit, Oct. 7, 1867, at the age of twenty. In 1869, executed a wood carving, a pier scene, showing the steamer *Detroit.* *–Ref.: 51 (1869/70); 56 (Dec. 9, 1869)*

BEEBE, WILLIAM L. Artist in Grand Rapids, 1888–97. Partners with George H. Bailey (q.v.) under the firm name of Beebe and Bailey (q.v.), 1890–93. Moved to Chicago, Ill., 1897. *–Ref.: 86 (1888–97); 118 (1895, 1897)*

BEEBE & BAILEY. Artists in Grand Rapids, operating as partners, 1890–93: William L. Beebe (q.v.) and George H. Bailey (q.v.). –Ref.: 86 (1890–92); 118 (1893)

BEECHER, EDWARD C. Artist in Lansing, 1892–93. –Ref.: 102 (1892); 118 (1893)

BEEDZLER, CAROLINE (Carrie). Artist and teacher of oil and water-color painting and crayon drawing, in Detroit, 1875–1900. Studied at New York School of Design. Opened a studio-school in Detroit, 1875. Exhibits: DIA; various local showings, including the art societies of which she was a member. Memberships: Detroit Society of Women Painters, Detroit Water Color Society. Sister of Ruth Beedzler (q.v.). –Ref.: 51 (1880–1900); 56 (July 4, Aug. 14, 1875); 60 (Dec. 13, 1895); 163; 164

BEEDZLER, RUTH. Art teacher in Detroit, 1880–1900. Taught in Detroit Public Schools, and Detroit Museum of Art School, where she taught classes in modeling. Credited with producing the first pieces of glazed pottery in Detroit. Sister of Caroline Beedzler (q.v.). –Ref.: 51 (1880–1900); 60 (Oct. 12, 1895); 164

BEGGS, JULIA. Crayon artist in Detroit, 1886. –Ref.: 51 (1886)

BEHN, ALBERT C. Carver, modeler, and sculptor in Detroit, 1880–84. –Ref.: 51 (1880–84); 118 (1881, 1883)

BELFORD, GERTRUDE (Mrs. Robert) (1850–1938). Amateur artist in Detroit, 1860–1938. Came to Detroit from Centerville, Ind., ca. 1860. Born Nov. 19, 1850. Died in Detroit, Dec. 8, 1938. –Ref.: 51 (1887–1901+); 61 (Dec. 8, 1938); 118 (1889, 1891)

BELL, DELIA H. (Cordelia). Artist in Detroit, 1882–90. Exhibited two oil paintings, Michigan State Fair, 1883. –Ref.: 51 (1882, 1890); 164

BELL, DELOS C. Artist in Detroit, 1883–99. Exhibit: Great Art Loan, Detroit, 1883. Award: premium for the best fancy painting in oil, Michigan State Fair, 1883. –Ref.: 51 (1883–99); 78; 112 (Oct. 16, 1883); 118 (1889–99)

BELLI, CAMITTO. Artist in Detroit, 1864–65. –Ref.: 51 1864/65

BELLIN, JACQUES NICOLAS (1703–1772). Engraver and author. Made an engraved map of the Detroit River from Lake St. Clair to Lake Erie, with a plan of the Fort of Detroit. Published in Paris in 1764, it is the earliest printed representation of the settlement of Detroit. Author of various histories of travels to North America, and a maritime atlas of most of the known world. –Ref.: 163; 164

BEMENT, ALON (1878– ?). Artist, a resident of New York City, who showed works in several exhibitions at the Detroit Museum of Art. Born in Ashfield, Mass., Aug. 15, 1878. Pupil of Boston Museum

School; Bennat and Constable in Paris; Naas School, Sweden; and Ecole des Beaux Arts, Paris. Instructor, College of the City of New York; Director, Art Center, New York; Professor of Fine Arts, Teachers College, Columbia University, 1906; director, Maryland Institute, Baltimore, 1920–25. Memberships: Salmagundi Club, New York. Author of *Figure Construction* (New York: Gregg Co, 1921). *–Ref.: 3 (vol. 28); 13; 79; 109; 163*

BENEDICT, ? (Mrs. Charles). Pastel artist in Jackson, 1876. Awards: first and second prizes for pastel paintings of an animal and a fruit piece, Michigan State Fair, 1876. *–Ref.: 112 (Nov. 14, 1876)*

BENEKER, GERRITT ALBERTUS (1882–1934). Illustrator. Born in Grand Rapids. Was in Truro, Mass., in 1934. Exhibit: DIA, 1930. Awards: New York Easter Prize, 1905; Scarab Club, Detroit, 1916; Cleveland Museum, 1919. Memberships: Cleveland Art Students, Inc.; Provincetown Art Association. Represented: Provincetown Art Association; Youngstown Museum of Art; and Grand Rapids Central High School. *–Ref.: 109, 129; 156; 163*

BENNETT, WILLIAM JAMES (1787–1844). Watercolor landscape painter, aquatint engraver, and etcher. Born in London. Studied at the Royal Academy. Memberships: Society of Aquatint Artists, London, 1808; Associate, Water Colour Society, London, 1820. Exhibited in London galleries, 1808–25. In 1816, came to America and married. His aquatint "Liverpool," in 1817, was his farewell to his native country. In 1826–47, engraved in aquatint some twenty-seven views of American cities, including "A View of Detroit from the Canadian Shore" in 1836. Memberships: ANAD, 1827; NAD, 1828; and curator of the Academy for some years. Died in New York, May 1844. *–Ref.: 13; 16; 61 (Apr. 6, 1934); 79; 109; 128; 147; 157; 163; 164*

BENOIT, PAULINE (Mrs. Charles). Artist in Detroit, 1877–80. Exhibit: Michigan State Fair, 1878. *–Ref.: 51 (1877–80); 65 (Sept. 21, 1878)*

BERNART, ADELE M. (ADELIA) (1868– ?). Watercolor artist in Detroit. Born in Detroit June 19, 1868. Exhibit: Detroit Museum of Art, 1890, 1913. *–Ref.: 163; 164*

BERRY, (Miss) F. H. Artist in Detroit, 1894–95. Exhibit: Detroit Water Color Society, 1895. *–Ref.: 60 (Jan. 26, 1894, Dec. 13, 1895)*

BERRYHILL, MARY A. Artist in Alpena, 1897–1903. *–Ref.: 2 (1902–03); 118 (1897, 1899)*

BESSEMER, RUTH N. Artist in Detroit, 1896–1900. *–Ref.: 51 (1896–1900); 118 (1897)*

BEST, M. E. Artist in Kalamazoo, 1873. *–Ref.: 118 (1873)*

BETHARD, JACOB. Artist in Detroit, 1866–67. *–Ref.: 51 (1866/67)*

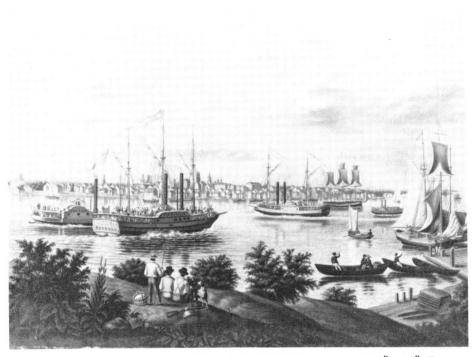

William James Bennett, *Detroit in 1836.* Oil on canvas, 17½″ x 25″. From the collection of the Detroit Institute of Arts. Gift of Fred Sanders Co.

BETHEL, (Mrs.) F. Artist in Detroit, 1879. Exhibited a flower panel; also awarded second premium for the best crayon landscape, Michigan State Fair, 1879. *—Ref.: 65 (Sept. 18, 1879); 112 (Feb. 10, 1880)*

BETTS, E. C. (1856—1917). Mural, fresco, and landscape painter. Born in Hillsdale. Spent some years in Denver, Colo., where he died. Best known for his painting "The Valley of the Housatonic."*—Ref.: 13; 79; 109*

BETTS, EDWIN D. (1847—1915). Artist in Muskegon 1885. Some of his works were exhibited in Hackley Gallery, Muskegon, 1929. Father of H. Harrington Betts (q.v.) and Theon Betts (q.v.). *—Ref.: 79; 118 (1885); 163*

BETTS, H. HARRINGTON. Artist in Muskegon. Son of Edwin D. Betts (q.v.). Exhibit: twenty-three paintings, Hackley Art Gallery, Muskegon, 1929. *—Ref.: 163*

BETTS, THEON. Artist in Muskegon. Son of Edwin D. Betts (q.v.). Exhibited paintings of scenes in and near Le Puy, France, at the Hackley Art Gallery, Muskegon, 1929. *—Ref.: 163*

BEWICK, BESSIE E. (ca. 1872—1942). Artist in Detroit, 1900—42. *—Ref.: 51 (1900—04); 56 (Feb. 6, 1942)*

BEYER, ALFRED L. Figure painter and lithographic designer in Detroit, 1891—93. Studied under Joseph Gies (q.v.) at the Detroit Museum of Art School, and under Vanderpool at the Chicago School of Art. Exhibited at Harris Art Store, Detroit, 1893. *—Ref.: 51 (1891—93); 60 (July 20, 1893); 68 (Feb. 12, Feb. 20, Mar. 19, 1893)*

BEYER, FREDERICK A. C. (1835—1878). Painter of decorative designs and banners in Detroit, 1850—78. Associated in several partnerships, Beyer & Gram (q.v.), Beyer & Stoebbe (q.v.), and Beyer & Natus (q.v.), all of which were engaged in interior decoration, banners, and signs. Painted a banner which was sent by the City of Detroit to the Vienna International Exposition, 1873. Died in Detroit, Mar. 2, 1878. *—Ref.: 51 (1863—77); 56 (Mar. 3, 1878)*

BEYER, & GRAM. Banner and decorative painters, Detroit, 1866—68; Frederick A. C. Beyer (q.v.), and Charles F. Gram (q.v.). *—Ref.: 51 (1866/67, 1867/68)*

BEYER & NATUS. Artists and painters of banners, Detroit, 1873; Frederick A. C. Beyer (q.v.), and John Natus, Sr. (q.v.). *—Ref.: 51 (1873)*

BEYER, & STOEBBE. Fresco and banner painters, Detroit, 1876—77; Frederick A. C. Beyer (q.v.), and Fred Stoebbe (q.v.). *—Ref.: 51 (1876—77)*

BIDELL, DELIA B. Artist in Jackson, 1887. Awarded prizes for each of three oil paintings exhibited at the Michigan State Fair, 1887. *—Ref.: 112 (Oct. 31, 1887)*

William Thurston Black, *Portrait of Theodore Campau.* Oil on canvas. From the collection of the Detroit Historical Museum.

BIGELOW, LYMAN G. Photographer and amateur crayon artist. In Grand Rapids, 1870–73, and in Detroit, 1875–79. Awarded first prize for a crayon drawing of a face, Michigan State Fair, 1878. *–Ref.: 51 (1875–79); 112 (Oct. 24, 1878); 118 (1870–73)*

BINGHAM, EDITH FARNUM (Mrs. Harry L.). Watercolor and ceramic painter in Detroit, 1891–97. Exhibit: Art Club of Detroit, 1895. Treasurer, Detroit Ceramic Club, 1894. *–Ref.: 60 (Oct. 16, 1893, Apr. 30, 1894); 118 (1897); 163*

BINET, ELLEN. Painter of landscapes, animals, still life, and portraits in Jackson, 1872–1912. Born in New York State. Went to Jackson, 1872. Her portrait of Grover Cleveland's father hung in the White House. *–Ref.: 98 (1912); 118 (1897); 165*

BISBEE, J. J. Portrait painter in Adrian, 1867–68. *–Ref.: 118 (1867–68)*

BISCHOFF, FRANZ A. (1864–1929). Painter and teacher of ceramics and watercolors in Detroit, 1888–1900 and later in South Pasadena, Calif. Born in Steinshonau, Bohemia. Came to America, 1885. Opened the Bischoff Art School in Detroit, Sept., 1894, teaching ceramics and watercolor painting. Later had classes in Dearborn, Cincinnati, and New York City. In 1895, moved to a studio in Dearborn, where he established his studio, operated a pottery, and manufactured China painting colors. Both before and after moving to California, exhibited in Detroit, in New York, and at the Chicago World's Columbian Exposition, 1893. Died in South Pasadena, Calif., early in 1929. *–Ref.: 9(Feb. 15, 1929); 51 (1889–1900); 60 (May 3, May 17, Nov. 17, 1893, Mar. 17, May 7, Aug. 25, Sept. 18, 1894, Jan. 12, 1895); 61 (Dec. 1, 1899); 68 (Dec. 18, 1892); 109; 118 (1891); 163; 164*

BISSELL, (Mrs. Alonzo). Landscape, flower, and animal painter in Jackson, 1877–87. *–Ref.: 98 (1887); 112 (Oct. 30, 1877, Oct. 17, 1882)*

BLACK, CHARLES S. Artist in Berne, 1899. *–Ref.: 118 (1899)*

BLACK, W. W. Artist in Battle Creek, 1883. Award: premium for an oil painting, Michigan State Fair, 1883. *–Ref.: 112 (Oct. 16, 1883)*

BLACK, WILLIAM THURSTON (ca. 1810– ?). Crayon portraitist, pastelist, and portrait painter in Detroit, 1866–84. Born in New Jersey. Exhibits: National Academy, 1845, 1850, and 1851; Pennsylvania Academy, 1850. In Detroit, executed numerous portraits and exhibited in local galleries and at Michigan State Fair. *–Ref.: 13; 50 (Nov. 23, 1866, July 23, Aug. 23, 1867, Feb. 17, 1870); 55 (May 10, 1872); 56 (Mar. 24, 1867, Jan. 1, 1870, Sept. 30 and Dec. 29, 1875, Feb. 9, 1877, Dec. 1, 1878, Jan. 19 and Sept. 18, 1879, Apr. 3, 1880); 64 (May 14, 1872); 65, (Sept. 18, 1879); 68 (June 1, 1872); 79; 112 (Feb. 10, 1880); 118 (1879, 1883); 128; 157; 163; 164*

Charles V. Bond, *Self Portrait*. Oil on canvas, 17″ x 14″. From the collection of the Detroit Institute of Arts. Gift of Henry M. Utley.

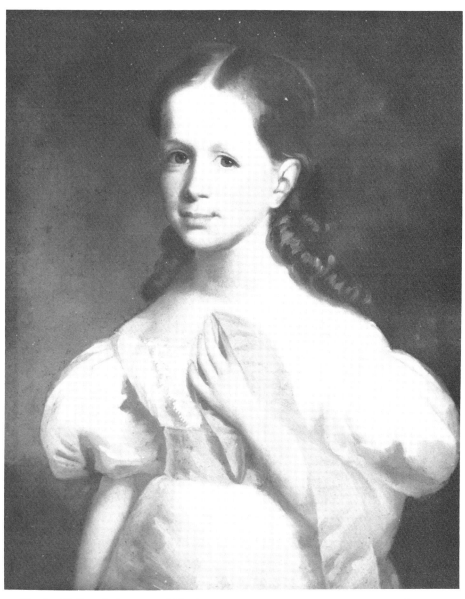

Charles V. Bond, *Portrait of Charlotte Chase as a Child.* Oil on canvas, 28″ x 25″. From the collection of Wilfred V. Casgrain, Grosse Pointe Farms.

BLACKMORE, J. EDWARD. Artist in Grand Rapids, 1886–91.. –*Ref.: 86 (1886–90); 118 (1891)*

BLAKE, ? (Mrs. Arthur S.) Artist in Detroit, 1885–87. Moved to Boston, Mass., 1887. –*Ref.: 51 (1885–87); 118 (1885)*

BLISS, NETTIE G. Artist in Detroit, 1887–88. –*Ref.: 51 (1887–88)*

BLUEMM, HARRIET A. (Mrs. Charles W.). Artist in Grand Rapids, 1888–1900+. –*Ref.: 86 (1888–1900); 118 (1893, 1897)*

BOCK, ADELINE H. (Mrs. Henry M.). Artist in Detroit, 1899–1902. Resident of Detroit for many years. Her husband, a pictureframe maker, died in 1892. –*Ref.: 51 (1880–1923)*

BODELACK, ADOLPH C. Wood-carver and designer in Grand Rapids, 1883–1920+. The principal in several partnerships: Bodelack & Frayer (q.v.), 1889, Bodelack & Vanselow (q.v.), 1892–97, and Bodelack & Co. (q.v.) 1897–1919. –*Ref.: 86 (1883–1920+); 118 (1891, 1893, 1899)*

BODELACK, LOUISE A. Sculptor in Grand Rapids, 1897–1919. Associated with Adolph C. Bodelack (q.v.) as Bodelack & Co. (q.v.). –*Ref.: 86 (1897–1919)*

BODELACK & CO. Wood-carvers and sculptors, Grand Rapids, 1897–1919; Adolph C. Bodelack (q.v.) and Louise A. Bodelack (q.v.). –*Ref.: 86 (1897–1919); 118 (1899)*

BODELACK & FRAYER. Wood-carvers and designers in Grand Rapids, 1889; Adolph C. Bodelack (q.v.) and David E. Frayer (q.v.). –*Ref.: 118 (1889)*

BODELACK & VANSELOW. Wood-carvers and sculptors in Grand Rapids, 1892–1897; Adolph C. Bodelack (q.v.) and Otto Vanselow (q.v.). –*Ref.: 86 (1892–96); 118 (1895, 1897)*

BOND, CHARLES V. (ca. 1825– ?). Portrait and landscape artist in Detroit, ca. 1846–53. Native of Livingston County. In Marshall, at the age of fifteen, became a self-taught portrait painter, and was hailed as a prodigy. Later moved to Detroit. His admirers raised a fund to send him to Italy for study. After several years abroad and in Boston, returned to Detroit and opened a studio. From about 1846 to 1853, painted portraits of former mayors, prominent citizens and church dignitaries. Made a brief trip to Brooklyn, N. Y., 1852. Lived in Chicago about 1853–57. About 1858, was in Milwaukee, Wis. Last reported in Louisville, Ky., 1860. Exhibited portraits and landscapes, Illinois State Fair, 1855. Represented: Chicago Historical Society. –*Ref.: 39; 51 (1852–54); 53 (June 6, 1843, July 7, July 26, Sept. 8, 1852, Sept. 19, 1855, Nov. 1, 1856); 56 (Jan. 31, 1855, Jan. 22, 1860, May 6, 1891); 78; 128; 152 (July 16, 23, 1840); 163; 164*

BOOTH, KATE L. Artist in Kalamazoo, 1884–86, and in Detroit, 1899. Exhibited, Michigan State Fair, 1884 and 1886, winning several premiums, 1886. *–Ref.: 51 (1899); 112 (Nov. 4, 1884, Nov. 2, 1886)*

BOOTH, NINA. Artist in Fenton, 1891–93. *–Ref.: 118 (1891, 1893)*

BOOZER, HENRY W. Photographer and portrait artist in Grand Rapids, 1860–93. *–Ref.: 11; 86 (1880–1910+); 118 (1881)*

BOSE, BIRDIE. Child artist of Saginaw, 1875. Award: first premium for a pencil drawing, Michigan State Fair, 1875. *–Ref.: 112 (Oct. 12, 1875)*

BOULDEN, JAMES (J. ELLIOTT). Artist in Detroit, 1859. *–Ref.: 51 (1859)*

BOURKE, HENRY OLIVER (1861–1939). Artist in Detroit, 1878–82. Born in Detroit. Award: premium for the best specimen of marble statuary, Michigan State Fair, 1878. Died, Feb. 9, 1939. *–Ref.: 51 (1881–82); 56 (Feb. 11, 1939); 112 (Oct. 24, 1878)*

BOVEE, MARY E. Artist in Detroit, 1862–63. *–Ref.: 51 (1862/63)*

BOWEN, THOMAS M. Artist in Lansing, 1894–95. *–Ref.: 102 (1894); 118 (1895)*

BOWERS, ? (Mrs. William). Artist in Kalamazoo, 1893. *–Ref.:118 (1893)*

BOWERS, EDWARD (1822– ?). Portrait, genre, and still life painter in Detroit, 1866–68. Born in Maryland. In Baltimore, 1850–52; in Philadelphia, 1854–59; and again in Baltimore 1860–70, except for a short stay in Detroit. Exhibits, 1850–61: Maryland Historical Society; Pennsylvania Academy; National Academy; Washington Art Association. *–Ref.: 13; 51 (1866/67); 79; 109; 118 (1867–68); 128*

BOWES, JOHN A. T. Artist in Cadillac, 1893. *–Ref.: 118 (1893)*

BOWLES, ESTHER A. Photographer and portrait painter in crayon, pastel and oils, in Wyandotte, 1893. *–Ref.: 118 (1893)*

BOWLING, (Mrs.) H. D. Artist in Dowagiac, 1885. Winner of several premiums for oil paintings, Michigan State Fair, 1885. Unknown whether the initials are hers or those of her husband. *–Ref.: 112 (Oct. 27, 1885)*

BOWMAN, JAMES (1793–1842). Portrait painter in Detroit, 1835. Born in Alleghany County, Pa. At sixteen, learned the rudiments of painting from a Mr. Turner (probably J. T. Turner) and became an itinerant portrait artist in Pittsburgh, Philadelphia, Washington, and smaller towns. About 1822, went to Europe for further study, and, after returning in 1829, had a gallery in Pittsburgh for a short time. From there, went to Charleston, S. C., and in 1831 to Boston. In 1835, after executing portraits of several prominent persons in Canada, opened a studio in Detroit and gave lessons to students, among whom was John

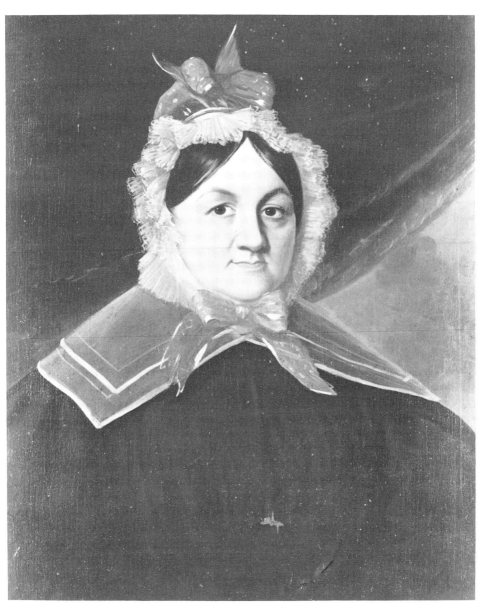

James Bowman. *Portrait of Mrs. Solomon Sibley.* Oil on canvas, 30″ x 24$\frac{7}{8}$″. From the collection of the Detroit Institute of Arts. Gift of the Estate of Miss Frances W. Sibley.

Mix Stanley (q.v.). While in Detroit, married Julia M. Chew, and after one year, moved to Green Bay, Wis. While there, executed a portrait of Governor Dodge of Wisconsin Territory, which is in the Wisconsin State Historical Society. A few years later, opened a studio in Rochester, N. Y., where he died suddenly, May 18, 1842. *—Ref.: 78; 128; 139, 163, 164*

BOWMAN, WILLIAM A. Young artist in Jackson, 1887. Award: premium for a pencil drawing, Michigan State Fair, 1887. *—Ref.: 112 (Oct. 31, 1887)*

BOWRING, WILLIAM P. Secretary, Detroit Etching Club, 1893. *—Ref.: 51 (1891–1900)*

BOYD, (Miss) F. Amateur artist in Monroe, 1880. Awards: watercolor and pen and ink work, Michigan State Fair, 1880. *—Ref.: 112 (Oct. 12, 1880)*

BRACY, FRANK C. (1851–1931). Photographer and watercolor artist in Detroit, 1882–1931. Born at Watertown, N. Y., Feb. 12, 1851, of New England ancestry. Settled with family in Augusta, Mich., about 1857. At the age of sixteen, left there with an itinerant photographer. In 1882, settled in Detroit and opened a photographic studio in partnership with Ambrose J. Diehl (q.v.) and Abraham Lapham (q.v.), as Bracy, Diehl & Co. (q.v.) and later was a partner of J. Jefferson Gibson (q.v.) under the firm name of Bracy & Gibson (q.v.). During this period, did portraits in watercolors and crayon, and later watercolor landscape painting. Married Olive Monchamp, 1884. Died in Detroit, Sept. 27, 1931. *—Ref.: 51 (1882–1900+); 61 (July 24, 1953); 118 (1883, 1893–99); 163*

BRACY, DIEHL & CO. Photographers and portraitists in Detroit: 1882–84; Frank C. Bracy (q.v.), Ambrose J. Diehl (q.v.) and Abraham Lapham (q.v.). *—Ref.: 51 (1882–84)*

BRACY & GIBSON. Photographers and portraitists in Detroit, 1888: Frank C. Bracy (q.v.) and J. Jefferson Gibson (q.v.). *—Ref.: 51 (1888)*

BRADISH, ALVAH (1806–1901). Portrait painter in Detroit, intermittently 1837–1901. Born in Sherburne, N. Y., Sept. 4, 1806. Worked in Rochester, N. Y., at various times, 1837–47, with some time in Detroit, 1839, and Cleveland, Ohio, 1840. Also did portraits elsewhere, including St. Paul, Minn., and in the West Indies. From 1852 to 1865, professor, Fine Arts, University of Michigan, and was the author of several literary works. Credited with at least 500 portraits, including ones of Millard Fillmore and Washington Irving, as well as numerous governors, mayors, judges, military officers of high rank, ecclesiastical celebrities, and other prominent national and local citizens, and the

Governor-General of Canada, Sir John Metcalf. Exhibits: National Academy, 1846, 1847, and 1851; various galleries, Detroit and other cities. Died in Detroit, after many years of residence, Apr. 19, 1901. —*Ref.: 13; 51 (1837–1901); 53 (Apr. 19, May 2, 1856, Nov. 22, 1858, Feb. 6, 1861); 56 (Sept. 17, 1879, Apr. 20, 1901); 60 (June 8, 1893); 61 (Apr. 20, 1901); 62 (Mar. 27, 1893, May 20, 1894, Jan. 17, 1897); 65 (Sept. 18, 1879); 78; 79; 91; 101; 107; 109; 112 (Oct. 1852, Nov. 1854, Nov. 1855); 118 (1891–99); 128; 138; 163; 164*

BRADY, F. C. Artist in Detroit, 1894. —*Ref.: 51 (1894)*

BRADY, SUSAN. Amateur artist in Detroit, 1891. —*Ref.: 118 (1891)*

BRAINARD, (Mrs.) M. N. Amateur artist in Detroit, 1871. Exhibited at one of the local galleries, 1871. —*Ref.: 54(Nov. 8, 1871)*

BREITMEYER, M. V. (1889– ?). Etcher in Jackson, 1934. Born in Michigan. Exhibit: PAFA, 1922; DIA, 1934. —*Ref.: 109; 156; 163*

BRENTON, ALBERT E. Student at Detroit Art Academy, also engaged in illustrating, 1896–98. Probably later became a commercial artist. —*Ref.: 51 (1894–99); 60 (Jan. 15, 1896)*

BREWER, ELLA. Artist in Saginaw, 1875. Award: premium, Michigan State Fair, 1875, for a historical painting in oils. —*Ref.: 112 (Oct. 12, 1875)*

BREWER, F. A. Artist in Saginaw, 1875. Exhibit: marine scene in oils, Michigan State Fair, 1875, awarded a premium. —*Ref.: 112 (Oct. 12, 1875)*

BROCKS, THEODORE F. A. Artist in Saginaw, 1899. —*Ref.: 118 (1899)*

BROMLEY, JOSEPHINE. Artist in Flat Rock, 1893–99. —*Ref.: 118 (1893–99)*

BROOKS, ? (Mrs. George). Artist in Port Huron, 1889. —*Ref.: 118 (1889)*

BROOKS, FRANK D. Photographer and portrait artist in Detroit, 1886–1905. In 1888, partners with Mauritz Kaufer (q.v.), under the firm name of Kaufer & Brooks (q.v.). Evidently engaged in some commercial art in later years, having shown some work in the Michigan Exhibit of Advertising Art, DIA, 1936. —*Ref.: 51 (1886–1905); 118 (1891–99); 163*

BROOKS, GENEVIEVE. Resident of Grand Rapids, 1889–1900+, active as an artist, 1897–99. —*Ref.: 86 (1889–1900); 118 (1899)*

BROW, ANDREW J. (1831–1905). Artist and prominent art dealer in Detroit, ca. 1855–76+. Born in Mass., Sept. 25, 1831. Married in Detroit, Feb. 28, 1855, to Frances J. Brisco. In 1875, one of founders of the Detroit Artists Association, its vice-president, 1875–76. Secretary, Western Art Association at its organization, 1870, and its permanent secretary, 1872. For a number of years, supervisor of art exhibits

at the Michigan State Fairs. From 1866 to 1869, associated with Horace W. Dean (q.v.) and Robert Hopkin (q.v.) as Dean, Brow & Co. (q.v.), ornamental and interior decorators. Died in Flint, Dec. 15, 1905. *—Ref.: 18; 19; 51 (1866—76); 55 (Feb. 16, 1872); 56 (Feb. 2, Sept. 18, 1879); 113 (vol. 20, 1936); 164*

BROWER, EMMETT H. Wood-carver in Carson City, 1895—99. *—Ref.: 118 (1895—99).*

BROWN, BELLE. Artist in Detroit, 1893. *—Ref.: 51 (1893)*

BROWN, HENRY F. Crayon artist and photographer in Northville, 1897. Possibly H. F. Brown, of Clinton County, who married Lucy A. Noble, of Plymouth, Jan. 12, 1860. *—Ref.: 118 (1897); 164*

BRUCE, AUGUSTA. Artist in Clinton, 1880—81. Awards: prizes for drawings in crayon and ink, and for a historical painting in oils, Michigan State Fair, 1880 and 1881. *—Ref.: 112 (Oct. 12, 1880, Oct. 25, 1881)*

BRUMMITT, WILLIAM H. (1837— ?). Photographer in Detroit and Pontiac, 1869—91+. Born in Nottingham, England, Feb. 13, 1837. Came to America, 1855. Married Paulina De Heiter in Philadelphia; she died there in 1865. Later married Ella R. Woodward of Pontiac. Prior to moving to Pontiac, was associated in Detroit with portrait artist George Watson (q.v.) as Watson & Brummitt (q.v.), photographers and portrait painters 1869—71. From Detroit, moved to Pontiac and operated photographic galleries until at least 1891. *—Ref.: 51 (1869—71); 135*

BRUSH, JAMES A. (1846— ?). Artist and photographer in Detroit, 1850—74. Son of Thomas C. and Amanda Brush. Married Alice B. Sprague in Detroit June 1, 1865. *—Ref.: 51 (1862—74); 118 (1863/64); 164*

BRUSSE, HENDRICK (Henry). Artist in Grand Rapids, 1886—95, after which he removed to Toledo, Ohio. *—Ref.: 86 (1886—95); 118 (1893)*

BRYAN, ROLLO K. Lecturer and artist in Lansing, 1892—1904. *—Ref.: 102 (1892—1904); 118 (1895)*

BUCY, ARTHUR W. Artist in Detroit, 1895. Probably the son of Estelle Bucy (q.v.). *—Ref.: 51 (1895)*

BUCY, ESTELLE (Mrs. Alexander W.). Crayon and watercolor portrait artist in Detroit, 1890—1906. Probably the mother of Arthur W. Bucy (q.v.) and Frank Bucy (q.v.). Exhibit: Michigan Artists Exhibitions, Detroit Museum of Art 1880 and 1890. *—Ref.: 51 (1890—1906); 101; 118 (1891, 1893); 163*

BUCY, FRANK. Artist in Detroit, 1896—99. Probably the son of Estelle Bucy (q.v.). *—Ref.: 51 (1896—99); 118 (1897)*

BUELL, JOHN. Artist (in Detroit ?), 1877. Award: premium for an

India Ink drawing, Michigan State Fair, 1877. Possibly the John H. Buell who died in Detroit, Feb. 21, 1894, at the age of 70. *–Ref.: 51 (1892–94); 112 (Oct. 13, 1877)*

BUELOW, HUGO V. Carver, modeler, and sculptor in stone and wood in Detroit, 1891–1913. In 1894–95, operated alone as H. V. Buelow & Co.; in 1898, as a partner in A. G. Giardini & Co., manufacturers of plaster ornaments; and in 1904–11, as secretary, treasurer and general manager of Modern Manufacturing Co., which in 1905 became the Detroit Sign Co., makers of signs and display equipment, and operators of a scenic studio. *–Ref.: 51 (1891–1913); 118 (1895)*

BUGGIE, (Mrs.) ? . Oil and watercolor animal painter in Coldwater, 1882. Award: prize, Michigan State Fair, 1882. *–Ref.: 112 (Oct. 17, 1882)*

BUGLEMUINGTON, A. Artist in Lansing, 1861. *–Ref.: 51 (1861)*

BULLOCK, HENRY S. (Harry) (ca. 1845–1924). Landscape, genre,and portrait artist in Detroit and Grand Rapids, 1880–1924. Painted in both oils and watercolors. Born in Plymouth. A brother of Nathaniel C. (Nate) Bullock (q.v.). Married Mary Seifer in Detroit, Nov. 18, 1867. Memberships: Detroit Artists' Association; Art Club of Detroit; one of the organizers of the Detroit Water Color Society, 1883. Exhibited at showings of these organizations almost annually, as well as at Cleveland, Ohio, 1884; the Rochester (N.Y.) Art Club, 1893. Most of his summers were spent in sketching and painting aboard his floating studio *The Mist*. After many years in Detroit, moved to Grand Rapids. Died there on Sept. 11, 1924. *–Ref.: 51 (1880–1916); 60 (Apr. 18, May 11, May 24, July 6, Sept. 15, Nov. 4, 1893; Apr. 14, 1894, May 21, Dec. 13, 1895, June 2, Sept. 12, 1896); 61 (Dec. 1, 1889, Sept. 12, 1924;) 64 (Aug. 17, 1884); 68 (May 24, 1893); 163; 164*

BULLOCK, NATHANIEL C. (Nate) (ca. 1848–1901). Marine and landscape artist in oils and watercolors in Detroit, 1882–1901. Born and educated in Detroit. Brother of Henry S. Bullock (q.v.). Exhibits: First annual exhibition, Detroit Museum of Art 1886; and Detroit Artists' Association, 1891. Known works include "Along Shore," "A Bit of Beach, Lake Superior," "Off Lexington, Lake Huron," "A Ten Knot Breeze," and "A Bit of Shore." Died in Denton, Aug. 15, 1901. *–Ref.: 51 (1882–1901); 56 (Aug. 16, 1901,); 60 (Apr. 18, 1893, Aug. 16, 1901); 118 (1893, 1899); 163*

BURCK, HENRY. (1823–1900). Portrait artist and, in later life, a painter and decorator. Active in Detroit, 1852–1900. Died Oct. 28, 1900. *–Ref.: 51 (1852–1901); 118 (1875, 1881– 93)*

BURDICK, NELLIE G. Artist in Lansing, 1892–1904. *–Ref.: 102 (1892–1904); 118 (1893–99)*

BURGER, ROBERT. Lithographer in early Detroit, 1851–86. Associated with Cuno Dix (q.v.), printer, as Burger & Dix (q.v.), in 1853–54; and in 1855–56 with Frederick A. Schober (q.v.), also a printer, as Burger & Schober (q.v.). A number of lithographic views and maps bear his signature, showing scenes on the Detroit River and its environs. —*Ref.: 51 (1853–88); 56 (Oct. 29, 1851); 100; 164*

BURGER & DIX. Lithographers in Detroit, 1853–54; Robert Burger (q.v.) and Cuno Dix (q.v.). —*Ref.: 51 (1853/54); 128*

BURGER & SCHOBER. Lithographers in Detroit, 1855–56; Robert Burger (q.v.) and Frederick A. Schober (q.v.). —*Ref.: 51 (1855/56)*

BURGET, C. J. Wood-carver in Banner, 1899. —*Ref.: 118 (1899)*

BURKS, MAX. Artist in Detroit. 1899–1900. —*Ref.: 51 (1899; 1900)*

BURN, LEE. Artist in Detroit, 1895. —*Ref.: 51 (1895)*

BURNHAM, T. H. O. P. (or THOMAS M.). Artist in Detroit, 1836–39. Name preserved by his painting of the 1837 election scene in Detroit during Michigan's first state election. Many believe the confusion over his name was caused by the misreading of "Thos." His brother George P. Burnham, cofounder of the *Detroit Evening Spectator* in 1836, referred to him as "Thomas Burnham" in the *Detroit Morning Post* of May 26, 1838, and as "Thomas M. Burnham" in the *Detroit Daily Advertiser* of Nov. 30, 1839. Possibly he is the Thomas M. Burnham of Boston, Mass., who first exhibited at the Boston Athenaeum and Apollo Association of New York, 1840; appeared in Boston City Directory, 1842; and continued exhibiting at the Athenaeum until 1872. —*Ref.: 19; 78; 163; 164*

BUROW, ALFRED H. Artist, and manager, Metropolitan Portrait Co. in Detroit, 1893–94. —*Ref.: 51 (1893–94)*

BURR, LAURA E. (Mrs. Hosea S.). Artist in Lansing, 1873–95. Possibly the Mrs. L. E. Burr listed in the Buffalo (N.Y.) city directory, 1855. —*Ref.: 102 (1873–87); 118 (1895); 128*

BURR, ANNETTE W. (Mrs. Theodore). Artist in Detroit, 1889–1911. Exhibits: Detroit Artists' Association exhibit, 1893; Detroit Society of Women Painters exhibit at DIA, 1906, 1907, and 1909–11. —*Ref.: 51 (1889–93); 60 (Apr. 18, 1893); 163*

BURROWS, (Mrs.) J. C. Artist in Kalamazoo, 1871. Award: flower piece in oils, Michigan State Fair, 1871. —*Ref.: 112 (Oct. 7, 1871)*

BURT, ADDIE. (1861–1936). Artist in Battle Creek, 1889–91. Died there, Dec. 18, 1936. —*Ref.: 56 (Dec. 20, 1936); 118 (1889–91)*

BURT, HARRIET AMSBRY (Mrs. Alvin C.) (1818–1888). Artist in Detroit and Pontiac, 1835–88, except for 1836–38 and 1840-46, when in New York and Dubuque, Iowa. Born in Cardiff, Onondaga County, N.Y., Feb. 12, 1818. Went to Detroit with her sister, 1835, and met

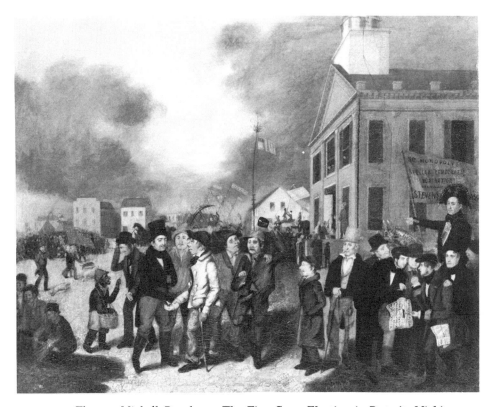

Thomas Mickell Burnham, *The First State Election in Detroit, Michigan.*
Oil on canvas, 24½" x 30¾". From the collection of the Detroit Institute
of Arts. Gift of Mrs. Samuel T. Carson.

Alvin Burt. Returned to New York, 1836. Married, 1838. Upon return to Michigan, lived at Mt. Vernon, in Macomb County, for about two years, and then went to Dubuque, Iowa, where Burt was a government surveyor until his death, 1846. She then returned to Detroit, and in 1849 married A. B. Cudworth. Exhibited under the name of Mrs. Alvin C. Burt at Western Art Association, 1870. Died in Pontiac, Feb. 5, 1888. *—Ref.: 131 (Feb. 10, 1888); 164*

BUSY, ESTELLE. Artist in Detroit, 1890. *—Ref.: 51 (1890)*

BUTTERFIELD, WELLS DUANE (1859—1936). Architect and artist in Detroit, ca. 1890—1936. Born in Algonac. Married Helen Hosie of Sarnia, Ontario, 1882; and Ida Ripley of Sault Ste. Marie, 1921. First mayor of Farmington. As architect, designed some sixty-five churches. Exhibits: Art Club of Detroit, 1895; Society of Associated Artists, Detroit, 1894; Detroit Water Color Society, 1895 and 1897; Cleveland (Ohio) Art Club exhibition, 1894. Membership: Detroit Artists' Association. Died in Detroit. *—Ref.: 60 (Apr. 18, 1893, Mar. 24, Dec. 13, 15, 21, 1894, May 21, 1895, Feb. 24, June 2, 1896); 163; 164*

BUTTRICK, FRANK. Amateur sculptor in Detroit, 1878—79. *—Ref.: 56 (Feb. 24, 1878, Apr. 11, 1879)*

BYRAM, HENRY. Artist in Niles, 1879. *—Ref.: 118 (1879)*

C

CABROSKI, CHARLES. Artist in Detroit, 1891. *—Ref.: 51 (1891)*

CAHILL, CLARA B. Watercolor artist in Lansing, 1892—93. Exhibits: Angell's Art Gallery, Detroit, 1892; Detroit Artists' Association, 1893. *—Ref.: 60 (Apr. 18, 1893); 68 (Dec. 18, 1892)*

CALL, CHARLES. Artist in Boyne City, 1889. *—Ref.: 118 (1889)*

CALMUS, CASTILLIO J. Artist in Detroit, 1896—1900. *—Ref.: 51 (1896—1900); 118 (1897, 1899)*

CAMERON, BELLE M. (or N.). Portrait artist in Detroit, 1882—95. *—Ref.: 51 (1882—99); 118 (1887, 1893)*

CAMPBELL, DOUGLAS H. Landscape artist in Detroit, 1883—86. Exhibits: Great Art Loan of Detroit, 1883; first annual exhibition of Michigan Artists, 1886, while a high-school teacher. *—Ref.: 15; 51 (1882—86); 163*

CAMPBELL, V (asey) FLOYD (? —1906). Cartoonist and pen-and-ink artist. Born in Port Austin. Studied at Detroit Museum of Art School. With the *North American* of Philadelphia, Pa., and the *New York Herald.* Died at Morton, Pa. *—Ref.: 109; 118 (1893)*

CANDLER, MARIAM L. (? —1931). Landscape and ceramic artist in

Detroit. Charter member, Detroit Society of Women Painters. President, Detroit Keramic Club, 1896. Exhibited many times, 1905–25 at DIA. Died at Richmond, Va., Apr. 26, 1931, survived by two sisters and three brothers. –*Ref.: 51 (1894–1900+); 60 (Nov. 13, 1896); 61 (Apr. 26, 1931); 118 (1897, 1899); 122; 163; 164*

CAPPER, HUGH (ca. 1852–1897). Newspaper artist, later did commercial art work in Detroit, 1887– 94. Died in Detroit, Sept. 13, 1897. –*Ref.: 51 (1887–98); 118 (1891)*

CARDONI, FRANK A. (1838–1901). Sculptor in marble and stone in Detroit, 1879–1901. Designer and modeler of figures and decorative motifs on statues, monuments and other marble and stone works. Native of Lombardy, Italy. Studied under eminent Italian sculptors. Came to the United States, 1857, first to New York, later to South Dakota, and then to Louisville, Ky. Moved to Detroit, 1879. Exhibited, Great Art Loan, Detroit, 1883. Proprietor, Cardoni Monumental Works from 1880 until his death, Apr. 10, 1901. –*Ref.: 51 (1879–1901); 56 (Apr. 12, 1901); 74; 118 (1899); 163; 164*

CAREY, NEWTON J. Artist in Saginaw, 1893. –*Ref.: 118 (1893)*

CARLISS, ? (Mrs. Thomas). Artist in Detroit, 1891–93. –*Ref.: 51 (1891, 1893)*

CARPENTER, DUDLEY SALTONSTALL (1870– ?). Art teacher in Detroit, 1896. As a resident of New York he was vice-president of the Art Student's League. Instructor of life classes for men and women at the Detroit School of Arts, 1896. –*Ref.: 13; 60 (Sept. 19, 1896); 79; 149; 157*

CARPENTER, WILLIAM N. (1816–1885). Prominent Detroit business executive and merchant. Questionable whether he did any art work; however, there was a complaint in the *Detroit Free Press* that a landscape by W. N. Carpenter was the only work of a Michigan artist shown in the *Art Union* for 1850. –*Ref.: 56 (Dec. 30, 1850)*

CARR, (Mrs.) M. E. Crayon artist in Clinton, 1897. –*Ref.: 118 (1897)*

CARRIER, ANNA. Portrait artist in Bay City, 1885–99. Partner of Jennie Rockwell (q.v.), also a portrait artist, under the firm name of Carrier & Rockwell (q.v.), 1897–99. –*Ref.: 118 (1885, 1887, 1893, 1897, 1899)*

CARRIER & ROCKWELL. Portrait artists in Bay City, 1897–99: Anna Carrier (q.v.) and Jennie Rockwell (q.v.). –*Ref.: 118 (1897, 1899)*

CARVER, (Miss) MARION A. Artist in Grand Rapids, 1886–99. –*Ref.: 86 (1886–99); 118 (1889)*

CASE, T. W. (THOMAS?). Possibly Thomas Case, Detroit tailor, 1894–96. Credited with a painting, "Cadoro-Venice," shown in an exhibition of the Detroit Water Color Society, 1893(?). –*Ref.: 51 (1894, 1896); 164*

CASSADAY, GEORGE. Artist in Standish, 1893–95. –Ref.: 118 (1893, 1895)

CATHCART, ADDIE. Portrait painter active in Buchanan, 1875–87. –Ref.: 118 (1875–87)

CATON, BELLE. Artist in Detroit, 1891–92. –Ref.: 51 (1891, 1892)

CAULKINS, HORACE JAMES (1850–1923). Pottery manufacturer and art enthusiast. Related to art in Detroit for many years. Born at Oshawa, Ontario, July 12, 1850, the son of William and Elizabeth (Burns) Caulkins. Educated in the public schools of Canada. Began his career in Niagara Falls, Ontario. Settled in Detroit, 1871. Became prominent in commercial and industrial circles as president of the H. J. Caulkins & Co., manufacturers of china kilns, enamel furnaces, and high-heat furnaces, and dealers in dental supplies. President, Pewabic Pottery Company, manufacturers of artistic pottery and tile. Active in arrangements of art exhibitions at the Michigan State Fairs. Was twice married: originally to Frances Leadbeater, and in 1888 to Minnie F. Peck. Died in Detroit, July 15, 1923. –Ref.: 28, 66 (Sept. 2, 1916); 110; 164

CHAMBERLAIN, CHARLES. Amateur artist in Detroit. Exhibited in the Detroit Museum of Art annually, 1908–12. Member of the Hopkin Club. –Ref.: 163; probably one of many of the same name listed in 51 (1863–1913), with various middle initials.

CHANDLER, HATTIE M. Crayon artist and preserver of natural flowers, in Detroit, 1880–98+. Manufactured a sheet wax used in the preservation of flowers. –Ref.: 51 (1880–98+)

CHAPEL, GUY MARTIN (1871– ?). Landscape artist. Born in Detroit. Active in Chicago at least from 1894 to 1933. Pupil of the Art Institute of Chicago; George G. Hopkins; R. S. Robbins; and Smith's Academy, Chicago. Exhibited landscapes in Chicago, 1894 and 1898. Memberships: Palette & Chisel Club; Illinois Academy of Fine Arts. –Ref.: 3 (1898, 1933); 13; 79; 109; 149

CHAPMAN, HERBERT. Artist in Rowland, 1887. –Ref.: 118 (1887)

CHAPOTON, ALEXANDER, JR. (1839–1906). Architect, builder, contractor, and banker. Born in Detroit, Oct. 13, 1839, the son of Alexis/ Alexander Chapoton, Sr. and Felice Montreuil Chapoton. Educated in Detroit schools and at Notre Dame. Married Marion P. Peltier, Apr. 29, 1868. Active in business for many years and at one time a partner of Nehemiah C. Hinsdale (q.v.), under the firm name of Chapoton & Hinsdale (q.v.), monument designers and builders. Died in Detroit, Sept. 22, 1906. –Ref.: 28; 56 (Apr. 30, 1868); 118 (1899)

CHAPOTON & HINSDALE. Monument designers and builders: Alexander

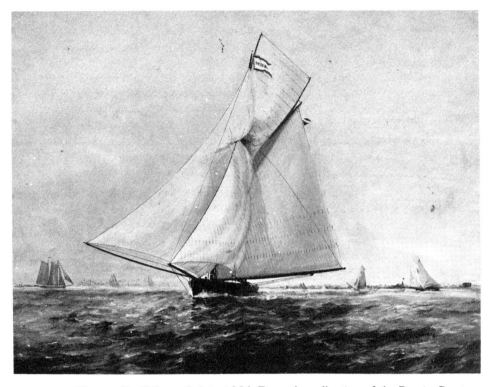

Thomas H. Chilvers, *Sylvia,* 1856. From the collection of the Dossin Great Lakes Museum, Detroit.

Chapoton, Jr. (q.v.) and Nehemiah C. Hinsdale (q.v.). *—Ref.: 118 (1899)*

CHAPPEE, ROBERT (? −ca. 1883). Negro artist in Detroit, 1862–81. Employed by Gottschalk Grelling (q.v.), (artist) 1863; and as a retoucher at Randall's photographic gallery, 1881. Died in Detroit, 1882 or 1883. *—Ref.: 51 (1862–81)*

CHAPPEL, (Mrs.) M. A. Artist in Detroit, 1879. Award: premium for the best portrait, Michigan State Fair, 1879. *—Ref.: 112 (Feb. 20, 1880)*

CHEENEY, L. MARIA. Artist in Detroit, 1884. Later dealer in embroideries and fancy goods. *—Ref.: 51 (1884–86)*

CHEVALIER, EDWARD J. (or JOHN E.). Artist in Detroit, 1881–83. In 1881, employed as a painter of scenic decorations on Pullman cars, by the Pullman Palace Car Co., under the name of Edward J. Chevalier. In 1882 and 1883, sources show that a John E. Chevalier had the same address, which would indicate that he was either Edward John or John Edward Chevalier. Probably a brother of Lewis (or Louis) B. Chevalier (q.v.), also of the same address. *—Ref.: 51 (1881–83); 118 (1883)*

CHEVALIER, LEWIS B. (or LOUIS B.). Artist in Detroit, 1880–84. Probably a brother of Edward J. (or John E.) Chevalier (q.v.). Employed by the Pullman Palace Car Co. as a decorative artist, 1880–81. Exhibited at Angell's Art Gallery, 1877. Award: prize for a historical painting in oils, Michigan State Fair, 1878. *—Ref.: 51 (1880–84); 56 (Feb. 28, Apr. 19, 22, 1877); 112 (Oct. 24, 1878)*

CHEVALIER, PAUL (1801–1866). Artist in Detroit. Better known as "Gavarni, the French Artist." Died Nov. 24, 1866. *—Ref.: 56 (Dec. 14, 1866)*

CHILDS, LOTTA. Watercolor artist in Calumet, 1894. Exhibited a number of floral pieces, Harris Art Store, Detroit, December 1894. *—Ref.: 60 (Dec. 29, 1894)*

CHILVERS, THOMAS H. Musician and amateur artist in Detroit, late 1800's. Supervisor of music, Detroit Public Schools, for twenty-six years. Born in Detroit. Received music diploma from the Leipzig (Germany) Conservatory, 1883. As an amateur artist, specialized in paintings of yachts in Detroit and vicinity. Painted only as a hobby; never exhibited. *—Ref.: 65 (Oct. 5, 1879); 68 (Oct. 10, 1886); 154, 164*

CHOPE, EDWARD B. (1815–1901). Blacksmith, carriage and wagon maker, and amateur artist in Detroit, 1837–1901. Born in Bideford, Devonshire, England, Mar. 25, 1815. Came to America, 1835. Settled in Detroit, 1837. Entered the blacksmithing and wagonmaking industry with his own shop and continued until his death. In 1837, married to

F. S. Church, Photograph by Napoleon Sarony. MacBeth Gallery Papers, Archives of American Art, Smithsonian Institution, Washington, D. C.

Mary Ann Raney, who died in 1851; and in 1852 married Elizabeth Anscomb. In 1862–63, partners in blacksmithing and wagonmaking with James Paget, as Chope & Paget; and later, when his sons Charles H. and Frank F. completed their training under his supervision, he took them into partnership under the firm name of E. Chope & Sons. Undoubtedly did other art work as an amateur, but the only official recognition was an award for two watercolor paintings exhibited at the Michigan State Fair, 1856. Died (apparently in Detroit), Dec. 24, 1901. —*Ref.: 51 (1852–1900); 53 (Apr. 8, 1852); 68 (Jan. 25, 1859); 112 (Nov. 1856); 164*

CHRISTIAN, WILLIAM E. Artist in Bay City, 1879–85. —*Ref.: 118 (1879–85)*

CHURCH, FREDERICK STUART (1842–1924). Painter, illustrator, and engraver. Born Dec. 1, 1842 at Grand Rapids, the son of Thomas B. and Mary Elizabeth (Stuart) Church. As a boy, was taught to draw by a local painter and engraver named Hartung, a native of Holland. (Perhaps this was Marinus Harting (q.v.), who settled in Grand Rapids, 1854.) Served in the Civil War, then went to New York to study under Walter Shirlaw and L. M. Wilmarth of the Art Student's league and the National Academy of Design. Had a studio in New York and spent most of his life in New York. First made black and white drawings and illustrations for *Harper's Weekly, Scribner's* and other publications. Later did oil and watercolor paintings generally of animal life or figures. Furnished illustrations for *Uncle Remus, His Songs and His Sayings* (N.Y.: Appleton) and natural history subjects in H. W. Shaw's *Josh Billings Trump Kards* (1877). Exhibits: Chicago; St. Louis; NAD; Michigan State Fairs; Art Club of Detroit; Detroit Art Association; and DIA. Awards: a medal, World's Columbian Exposition, Chicago, 1893; and a silver medal, Louisiana Purchase Centennial Exposition, 1904. Memberships: NAD, 1885; SAA; American Water Color Society; New York and Philadelphia Etching Clubs; Society of Painters-Etchers, London; Lotus Club, Union League Club, Architectural League, and Society of Illustrators, New York. Represented: National Gallery, Washington, D.C.; Metropolitan Museum, New York; City Art Museum, St. Louis; DIA; and many other public and private collections. Died in New York, Feb. 18, 1924. —*Ref.: 3 (1898); 7; 13; 15; 56 (June 24, 26, 1875, Feb. 10, Mar. 17, 1878); 60 (Jan. 12, 1894); 66 (Sept. 9, 1916); 68 (Dec. 18, 1892); 71; 79; 101; 119 (1924); 129 (Feb. 20, 1924); 149; 163; 164*

CHURCH, (Mrs.) M. E. Artist in Detroit, 1869–70. Exhibited several paintings at a local gallery, which were distributed to the purchasers of tickets at a drawing. —*Ref.: 50 (Apr. 15, 1869, Feb. 15, 1870)*

Frederick E. Cohen, *Self Portrait*. Canvas, 28" x 23¾". From the collection of the Detroit Institute of Arts. Gift of Mrs. Robert Hopkin.

CLARK, F. Artist in Prairieville, 1883. Exhibit: Michigan State Fair, 1883. *—Ref.: 118 (1883)*

CLARK, FRANK SCOTT (1865–1937). Portrait photographer and artist in Detroit, 1892–1937. Born in Peru, Ind., Sept. 17, 1865, the son of Joseph Caledon and Charlotte Ann (Ward) Clark. Educated in the public schools of Kingston, Ontario. Started his working career as a shoemaker, boat builder, sign and coach painter, and scenic artist. Went to New York to learn photography at the Mora Studios, then moved to Detroit, where he operated a photograph gallery for many years. Later studied art at the Cooper Union, New York. Spent the latter part of his life painting wild flowers and wild life, exhibiting frequently at DIA and the Scarab Club. One of the chief organizers of the Scarab Club, serving as president, 1922. Member, Boston Art Club. Died in Detroit, Oct. 16, 1937, and was buried in Battle Creek. *—Ref.: 56 (June 19, 1919, Oct. 27, 1937); 61 (May 12, 1932, Oct. 26, 1937); 110; 163; 164*

CLARK, G. H. Artist (in Detroit?) 1895. Exhibited at a showing of the Detroit Water Color Society, 1895. *—Ref.: 60 (Dec. 13, 1895)*

CLARK (or CLARKE), GEORGE W. (? –1862). Portrait painter and landscape artist in Detroit, 1851–56. Exhibits: the Gallery of Fine Arts, 1852 and 1853. Buried at Detroit, June 1862. *—Ref.: 51 (1853–56); 56 (Dec. 18, 1851, Dec. 10, 1852, Feb. 8, 1856); 78; 164*

CLARK, GEORGE W. Artist in Ionia, 1865. *—Ref.: 118 (1865)*

CLARK, JOHN (or JAMES) M. Portrait artist in Detroit 1871–76. Exhibits: Michigan State Fair, 1875; local gallery, 1876. *—Ref. 51 (1871–74); 56 (Mar. 5, 1876); 112 (Oct. 12, 1875)*

CLARK, (Mrs.) M. WALDEN. Artist in Saginaw, 1899. *—Ref.: 118 (1899)*

CLARKE, GEORGE W. *See* CLARK, GEORGE W.

CLARKE, MYRTELL A. Artist in Jackson, 1897. *—Ref.: 118 (1897)*

CLARKSON, JAMES F. Artist in Hastings, 1877. *—Ref.: 118 (1877)*

CLEAVE, WALTER E. Artist in Howell, 1889–91. *—Ref.: 118 (1889, 1891)*

CLEMENTS, PHOEBE T. *See* TABER, PHOEBE CLEMENTS.

CLEVELAND, AGNES. Watercolor artist in Detroit, 1898–1906. Exhibited at Detroit Water Color Society. Charter member, Detroit Society of Women Painters and Sculptors. *—Ref.: 51 (1898–1902); 118 (1899); 122*

COBB, HELEN McCALL (Mrs. James B.). Landscape artist in Kalamazoo, at least 1851–84. Married, Jan. 23, 1851. Award: premium for the best winter piece in oils, Michigan State Fair, 1884. *—Ref.: 112 (Nov. 4, 1884); 136*

COBURN, A. J. Artist in Frankfort, 1883. *—Ref.: 118 (1883)*

William Brewster Conely, Photograph. From the collection of K. R. Conley, Ferndale.

74

COFFEE, P. H. Young artist in Detroit, 1874. Completed a plaster bust of a Detroit physician. *—Ref.: 56 (Dec. 8, 1874)*

COHEN, FREDERICK E. (ELMOUR?) (? —1858). Portrait, miniature, historical, and genre painter in Detroit, 1837—55. An English Jew, who moved to Detroit in 1837 from Woodstock, Ontario. Married in 1850 to Maria ? , of Mt. Vernon, Ohio. Moved to Mt. Vernon, Ohio, 1855. Executed portraits of many notable Michigan citizens. Exhibits: Gallery of Fine Arts, Detroit, 1852; the American Art Union, 1848; and several Michigan State Fairs. Represented: DIA and many historical collections. Died at Mt. Vernon, Ohio, Dec. 1858. *—Ref.: 51 (1846—54); 53 (Jan. 8, Mar. 17, Apr. 26, 1849, and Dec. 28, 1858); 56 (June 18, 1853, Jan. 8, 1859); 60 (Apr. 8, 1893); 78; 90; 112 (Dec. 1851, Oct. 1852, Nov. 1853); 128; 163; 164*

COHEN, SAMUEL (1874—1956) Amateur artist in Detroit, 1894—99. Had various other occupations. Resided in Detroit for sixty-seven years. Died Mar. 28, 1956. *—Ref.: 51 (1894—99); 164*

COLE, FREDERICK A. Portrait artist in Detroit, 1888—92, when he moved to Plymouth. In 1889, was associated with J. Jefferson (or Jefferson J.) Gibson (q.v.), a photographer, under the firm name of Gibson & Cole (q.v.), photographers and portraitists. *—Ref.: 51 (1888—92); 118 (1891)*

COLGROVE, ADA. Artist in Stony Point, 1899. *—Ref.: 118 (1899)*

COLLIN, MARTIN. Artist in Alpena, 1887. *—Ref.: 118 (1887)*

COLLINS, ANNIE B. Artist in Fruitport, 1897. *—Ref.: 118 (1897)*

COLLINS, MARY SUSAN (1880— ?). Artist. Born at Bay City. Active in Cleveland, Ohio, 1934. Exhibit: DIA, 1930. *—Ref.: 109; 163*

COLTON, A. F. Artist in Detroit, 1867. Possibly a pupil of John Mix Stanley (q.v.). In 1867, completed a portrait of Captain F. H. Brown of the 18th Regulars. Presumed to have moved to Toledo, Ohio. *—Ref.: 56 (Feb. 3, 4, 1867)*

COMPARET, JOHN B. (JEAN BAPTISTE) (1796—1844). Artist and commercial painter in Detroit. Pupil of Abraham G. D. Tuthill (q.v.). Born in Apalachicola, Fla. Arrived in Detroit about 1822 and remained until 1826 or 1827. Married to Mrs. Mary Stidger in Canton, Ohio, Dec. 25, 1827. *—Ref.: 57 (May 17, July 5, 1822, Oct. 8, 1824, Feb. 11, Oct. 11, 1825); 164*

COMSTOCK, A. G. (probably Mrs. Alexander G.). Artist in Detroit, 1879—93. Exhibits: Michigan State Fair, 1879; Detroit Artist's Association, 1891 and 1893; and at local galleries. *—Ref.: 51 (1880—96); 56 (Sept. 18, 1879); 60 (Apr. 18, 1893); 65 (Sept. 18, 1879); 164*

CONE, JOHN A. Bookseller and amateur artist in Detroit, 1880—87. *—Ref.: 51 (1880—87); 118 (1883)*

CONELY, KATHERINE I. *See* MARGAH, KATHERINE CONELY.

CONELY, WILLIAM BREWSTER (1830–1911). Portrait, still life, animal, and landscape painter in Detroit, 1847 and 1873–1911. Born in New York City, Dec. 15, 1830. At seven, moved with his parents to Brighton, where he attended the local school. A self-taught artist, except for a few months study at the National Academy of Design, New York, which he attended after serving in the Civil War. Wounded in the war and crippled the rest of his life. At seventeen he opened an art school in Detroit. Later moved to Lincoln, Ill., and still later to Atlanta, Ill., opening art schools in both cities. First exhibited at the Illinois State Fair at age eighteen, and won a blue ribbon for crayon drawings. Spent some time in Kalamazoo and Peoria, Illinois, painting portraits of prominent citizens. Married to Anna McCallum of Ann Arbor, 1860. Father of Katherine Conely Margah (q.v.). In 1873, settled in Detroit and remained there the rest of his life. Produced many portraits and other paintings. Charter member, Detroit Art Association, 1875. Represented in DIA and many public buildings. Died at his summer home in Algonac, Oct. 12, 1911. *–Ref.: 50 (May 12, 1874); 51 (1872–1900+); 56 (Oct. 13, 1911); 60; 61 (Dec. 6, 1891); 64 (Aug. 17, 1884); 65 (Apr. 7, 1878); 66 (Apr. 17, 1909); 68 (Dec. 6, 1885, Oct. 22, 1894); 78; 101; 108 (vol. 12, March 1925); 109; 112; 113 (vol. 20); 118 (1865–1899+); 128; 151; 163; 164*

CONKEY, SAMUEL (1830–1904). Sculptor and landscape painter of New York, in Detroit 1876–81. Born in New York City. Spent some years in Chicago, Ill. Lost all his property in the fire of 1871 and then moved to Detroit, and later returned to New York. While in Detroit, executed a number of busts of prominent citizens. Charter member, Detroit Art Association, 1875–76. Exhibits: DIA, 1883; Detroit Art Association and local galleries; and NAD, 1867–90. In Michigan, represented by a marble bust of James V. Campbell, State Supreme Court Judge, in the Capitol at Lansing. Died in Brooklyn, N.Y., Dec. 2, 1904. *–Ref.: 13; 51 (1876–81); 56 (June 6, 1876, Mar. 25, 1877, June 8, 1879); 109; 113 (vol. 20); 128; 149; 163; 164*

CONLEY, ALONZO G. Commercial painter and amateur artist in Detroit, 1882–91. Then moved to Chicago, Ill. *–Ref.: 51 (1882–91)*

CONNOLLY, P. H. Artist in Detroit, 1855–58. *–Ref.: 51 (1855–58)*

CONWAY, ELLA. Artist in Detroit, 1895. *–Ref.: 51 (1895)*

COOK, WILLIAM D. Probably the William Cook who signed an advertisement of Cook & Winchester, daguerrian miniaturists, Detroit, 1845. *–Ref.: 51 (1845/1846)*

COOLEY, SARAH A. (Mrs. Elihu). Artist in Jackson, 1887. Awards:

premiums for a marine scene in oils and the best painting on silk, Michigan State Fair, 1887. —*Ref.: 98 (1887); 112 (Oct. 31, 1887); 164*

COPELAND, S. Teacher of monochromatic painting in Detroit, 1851. —*Ref.: 56 (Oct. 23, 1851)*

COPPENS, EDITH M. Artist in Grand Rapids, 1890. Exhibit: oil paintings, Detroit Museum of Art, 1890. —*Ref.: 163*

COPPENS, EMMA M. Artist and teacher of drawing and painting in Grand Rapids, at least 1886—99. —*Ref.: 86 (1886—99); 118 (1889—93, 1897, 1899)*

COPSON, OCTAR H. Artist in Grand Rapids, 1896—99. —*Ref.: 86 (1896—99); 118 (1897)*

CORBISHLEY, HARRIET (Mrs. John G.). Artist in Port Huron, 1887—1913. —*Ref.: 132 (1887/1888, 1913); 118 (1889)*

CORDEN, WALTER J. Artist in Jackson, 1887—97. Exhibited and was awarded several premiums for works in oils and watercolor, Michigan State Fair, 1887. —*Ref.: 98 (1887); 118 (1895, 1897); 112 (Oct. 31, 1887)*

COREY, CARRIE C. Artist in Grand Rapids, 1893—95. —*Ref.: 86 (1893—94); 118 (1895)*

CORNELL, EDNA E. (or Edna A.). Crayon artist in Detroit, 1893—97. —*Ref.: 51 (1893—97); 118 (1897)*

CORNWELL, J. C. Artist in Ann Arbor, 1880. Award: premium for the best pencil drawing of a landscape, Michigan State Fair, 1879. —*Ref.: 112 (Feb. 10, 1880)*

CORNWELL, MATTIE P. Art teacher in Ann Arbor, at least 1886—99. —*Ref.: 6 (1886/1887, 1899); 118 (1891, 1893)*

COSTON, CLARA M. Artist in Jackson, 1886—87. Awards: prizes for oil, watercolor and pastel works, Michigan State Fairs, 1886 and 1887. —*Ref.: 98 (1886); 112 (Nov. 2, 1886, Oct. 13, 1887)*

COTCHETT, VALENTINE. Amateur artist in Detroit. In 1877, exhibited a painting at a local gallery. —*Ref.: 51 (1875—82); 164*

COTHARIN, KATE LEAH (1866— ?). Artist in Detroit, 1890—1900+. Specialized in minature landscapes of scenes in America and various European countries. Born in Detroit, Oct. 27, 1866. Studied under James M. Dennis (q.v.), Detroit. After 1900, resided in Boston, Mass. Exhibited extensively in Boston. Memberships: Detroit Society of Women Painters, 1903; and Copley. Represented in the Springfield, Mass. Art Museum. —*Ref.: 3 (1933); 51 (1890—1900+); 79; 109; 118 (1891); 122; 163*

COTTER, NELLIE. Young artist in Jackson, 1887. Exhibit: Michigan State Fair, 1887, and awarded premiums for the best crayon and pencil

drawings by a person under sixteen years of age. *—Ref.: 112 (Oct. 31, 1887)*

COURTE, F. C. *See* COURTI, F. C.

COURTER, FRANKLIN C. (1854– ?). Artist in Greenville, Battle Creek, and Albion. Specialized in landscapes and portraits. Born in Caldwell, Essex County, N. J., July 20, 1854, the son of Henry and Alice Ann (Bowden) Courter, of pioneer ancestry. In 1868 the family moved to Michigan and settled near Greenville, where he was educated. In 1878 he located at Battle Creek, where he had married Minnie A. Foote, Sept. 5, 1877. In 1888, appointed professor of drawing and painting, Albion College. Exhibited in the Michigan Building, World's Columbian Exposition, Chicago, 1893. *Ref.: 118, (1881–89); 163*

COURTI (or COURTE), F. C. *—Ref.: 118 (1879)*

COUSE, EANGER IRVING (1866–1936). Painter of American Indian subjects, 1886–1921+. Born in Saginaw, Sept. 3, 1866. A pupil of the National Academy of Design, also a student of Bougereau, Robert: Fleury, and the École des Beaux Arts, Paris. Had a studio in New York and at Taos, N. M. Executed great numbers of paintings of American Indians in their native habitat, showing their daily lives, dances, and works of art. Exhibits: DIA, 1886, 1906, 1908–12, 1914, 1916, 1917, 1919, 1922. Awards: Salmagundi Club, 1899 and 1900; NAD, 1900 and 1902, Gold Medal, 1911; Paris Exposition, 1900; Pan-American Exposition, Buffalo, 1901; two Bronze medals, St. Louis Exposition, 1904; Pennsylvania Academy of Fine Arts, 1921. Memberships: Salmagundi Club, 1898; New York Water Color Club, 1902; NAD, 1911; Life Member, Lotus Club; Taos Society of Artists; Allied American Artists. Represented: National Gallery, Washington; Brooklyn Museum; DIA; Smith Collection Museum; Metropolitan Museum, New York; Cleveland Museum; Milwaukee Art Institute. *—Ref.: 3 (1898, 1933); 13; 36; 79; 101; 109; 119 (1924 ed.); 157; 163*

COUSEN, ALFRED. Pottery maker in Detroit, 1890–94. *—Ref.: 51 (1890–94)*

COUSEN, MARIAN E. Portrait artist in Detroit, 1893. *—Ref.: 51 (1893); 118 (1893)*

CRANE, CAREBELL. Artist in Jackson, 1887. Awards: premium for the best crayon drawing of an animal, Michigan State Fair, 1887. *—Ref.: 112 (Oct. 31, 1887)*

CRANE, CLARIBEL. Artist in Grand Rapids, 1893–97. *—Ref.: 86 (1893–96); 118 (1897)*

CRANE, JANE I. (or JANE L.). Portrait artist in Detroit, 1873–77. *—Ref.: 51 (1873); 56 (Feb. 4, 1877); 118 (1873)*

CRANE, U. EUGENE. Artist in Kalamazoo, 1881. Partner of George W. Reed (q.v.) under the firm name of Reed & Crane (q.v.), portrait artists 1881. —*Ref.: 118 (1881)*

CRAPO-SMITH, LETITA. *See* SMITH, LETITA CRAPO.

CRESSY, (Mrs.) F. A. Landscape artist in Hillsdale, 1856. Award: diploma, Michigan State Fair, 1856. —*Ref.: 112 (Nov. 1856)*

CRITTENDEN, ELIZABETH C. Art teacher in Grand Rapids, 1900. In 1924, exhibited at the National Association of Women Painters and Sculptors, New York. Resided at Flushing, Long Island, New York, 1945. —*Ref.: 51 (1900); 79*

CRONGEYER, THEODORE E. Designer, sculptor, and wood-carver in Detroit, 1870-1900+. Associated with other wood-carvers for short periods: Henry Schmitz (q.v.), as Schmitz & Crongeyer (q.v.), 1873; Ferdinand Averbeck (q.v.), as Crongeyer & Averbeck (q.v.), 1874; and Henry Kuntze (q.v.), as Crongeyer & Kuntze (q.v.), 1875—76. Carved wooden Indians for cigar stores in early 1870s. —*Ref.: 51 (1870—1900+); 118 (1883—91); 144 (Oct. 1928)*

CRONGEYER & AVERBECK. Wood-carvers and modelers in Detroit, 1874; Theodore E. Crongeyer (q.v.) and Ferdinand Averbeck (q.v.). —*Ref.: 51 (1874)*

CRONGEYER & KUNTZE. Modelers and wood-carvers in Detroit, 1875—76; Theodore E. Crongeyer (q.v.) and Henry Kuntze (q.v.). —*Ref.: 51 (1875/76)*

CRONK, (Mrs.) D. Artist in Middleville, 1891—93. —*Ref.: 118 (1891, 1893)*

CROSS, LEWIS L. Still life artist in Burr Oak and Spring Lake, 1872—90. Married Sibbel Powers, Apr. 5, 1872. Exhibit: Detroit Museum of Art, 1890. —*Ref.: 163; 164*

CROUFFOND, GEORGE HENRI. Sign painter and portrait and scenic artist in Detroit, 1885—1900+. In 1885, associated with J. Charles Hemming (q.v.), under the firm name of Hemming & Crouffond (q.v.). —*Ref.: 51 (1885—1900+); 118 (1885, 1891)*

CRUICKSHANK, COLLIN J. (or J. S.). Artist in Port Huron, 1895—1930. In 1895, associated with Martin J. Lempke (q.v.) as Cruickshank & Lempke (q.v.), portraits and landscapes in oils and pastel. Exhibits: DIA, 1914, 1916, and 1930. —*Ref.: 118 (1895); 163*

CRUICKSHANK & LEMPKE. Portrait and landscape artists in Port Huron, 1895; Collin J. S. Cruickshank (q.v.) and Martin J. Lempke (q.v.). —*Ref.: 118 (1895)*

CRUM, (Mrs.) L. P. Artist in Kalamazoo, 1885. Award: prize for a painting on silk, Michigan State Fair, 1885. —*Ref.: 112 (Oct. 27, 1885)*

Eanger Irving Couse, *Portrait of Chief Shoppenegons.* Oil on canvas, 78″ x 36″. From the collection of the Detroit Institute of Arts. Gift of Charles Willis Ward.

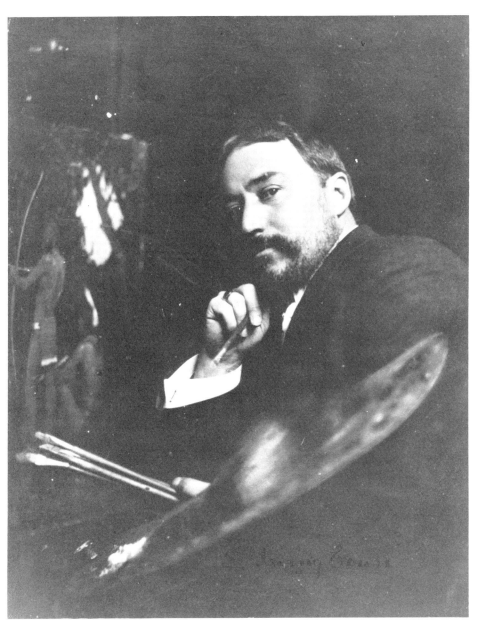

Eanger Irving Couse, Photograph. From the collection of the MacBeth
Gallery Papers, Archives of American Art, Smithsonian Institution, Wash-
ington, D. C.

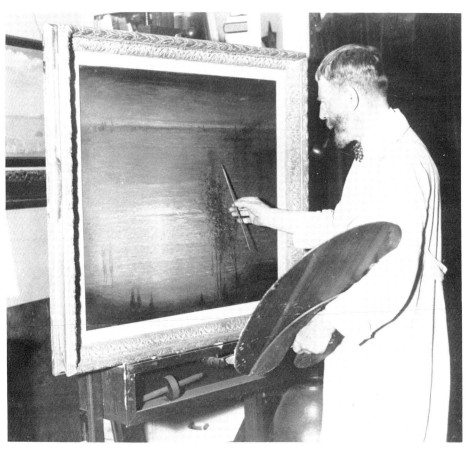

Leon Dabo, Photograph. From the collection of the Ferargil Galleries Papers, Archives of American Art, Smithsonian Institution.

CUDWORTH, HARRIET AMSBRY BURT. *See* BURT, HARRIET AMSBRY.

CULLIN, JOHN F. Wood-carver in Detroit, 1895. –*Ref.: 118 (1895)*

CURRIER, ALBERT WORL (or WORRALL). Artist in Detroit, 1881– 1900+. Exhibit: Michigan Artists' showing, 1890. –*Ref.: 51 (1881– 1900+); 118 (1889–99); 163*

CURTIS, BESSIE M. Amateur artist in Detroit, 1883. Award: prize, Michigan State Fair, 1883. –*Ref.: 112 (Oct. 16, 1883)*

CURTIS, EDMOND L. Artist in Grand Rapids, 1898.. –*Ref.: 86 (1898)*

CUSICK, CORNELIUS C. Exhibited several oil paintings at a local Detroit gallery, 1878. –*Ref.: 56 (July 10, 1878)*

CUSTER, JOHN W. Artist in Hastings, 1877. –*Ref.: 118 (1877)*

CUTCHEON, ANNA M. Art teacher in Ypsilanti, 1872–76, and Detroit, 1884–97. Also taught for eight years in Tennessee and Illinois. Joined the faculty of the Michigan State Normal College, Ypsilanti, 1872. After four years, went to the Minnesota Normal College, 1876–84. Then became Senior Principal at the Detroit Female Seminary, remaining for thirteen years. Joined Harriet Bissell Pope (q.v.) in founding the Pope & Cutcheon Art School (q.v.). Later, a resident of Ypsilanti, prominent in social and literary circles. –*Ref.: 51 (1884–97); 137*

CUYLER, HARRIET E. (1853– ?). Photographic artist in Attica and Mt. Clemens, 1880s and 1890s. Born in Norwich, Canada, Apr. 15, 1853, the daughter of Eli and Catherine (Rooney) Woodrow. Educated at Attica. Married William B. Cuyler there, Apr. 19, 1872. Conducted a gallery in Mt. Clemens for many years. –*Ref.: 75; 118 (1891)*

D

DABO, LEON (1868–1960). Landscape and mural painter, writer, and lecturer. Born in Detroit, July 9, 1868, of French parents, and attended St. Anne's School there. Brother of Theodore Scott Dabo (q.v.). In 1884, at sixteen, went to New York and entered church decoration with J. and R. Lamb. While there, met John LaFarge, who became his employer and friend, and who furnished him with letters of introduction to leading French artists when he went to France to study. In Paris, worked for a firm of decorators while attending evening classes at the École des Arts Décoratifs. Studied under Daniel Urabietta Vierge in Paris, and Galliardi in Rome and Florence. Lived in Sardinia and Corsica before returning to America in 1892, settling in New York. Produced many paintings of Hudson River scenes, besides his murals. Memberships: original member, Association of American Painters and

Sculptors; member, the Pastellists; Hopkin Club, Detroit; life member, National Arts Club; Allied Artists, London; Royal Society of Arts and Sciences, London; Les Mireillos, Avignon, France; Les Amis des Arts, Arles, France; Société des Amis du Louvre, Paris; School Art League, New York; Brooklyn Society of Arts; Mural Painters; Three Arts Club, Cincinnati, Ohio; a Chevalier de la Légion d'Honneur in 1934. Represented in museums of Berlin and Dresden; London National Gallery; National Gallery, Washington, D.C.; Metropolitan Museum, New York; The Luxembourg in Paris; DIA; and many others. Died in New York, Nov. 7, 1960. *—Ref.: 3 (1933); 13; 66 (Sept. 9, 1916); 79; 101; 109; 114 (vol. 7, 1916); 119; 129 (Nov. 9, 1960); 149; 163; 164*

DABO, THEODORE SCOTT (1870– ?). Artist (in Detroit?). Born in Detroit, 1870, according to local and state references. References such as Fielding, Mallett and Thieme-Becker, however, all indicate that he was born in New Orleans, La., in 1877. Local references show him to be a brother of Leon Dabo (q.v.). Represented: École des Arts Décoratifs and École des Beaux Arts in Paris; DIA. *—Ref.: 79; 101; 109; 114 (vol. 7, 1916); 119; 149; 163; 164*

DAKER, R. GRACE. Artist in Detroit. *—Ref.: 51 (1899, 1900)*

D'ALMAINE, GEORGE (? –1893). Painter of portraits in oil, crayon and wash drawings, and a silhouettist. Came from England about 1840. Was in Detroit, 1844 and 1851, where he executed portraits of many prominent residents. Worked mainly in Baltimore from 1855 to 1884, but did some painting in Boston, Pittsburgh, and in Illinois and New York. Represented in Portsmouth Athenaeum, Portsmouth, N.H., and the Detroit Public Library. *—Ref.: 53 (Sept. 19, 1844, July 21, 1851); 56 (July 31, 1851, Oct. 3, 1851); 78; 128; 164*

DAPPER, MARTHA. Amateur artist in Grand Rapids. *—Ref.: 86 (1898, 1899)*

DART, CORA D. Crayon artist in Detroit, 1886–95. *—Ref.: 51 (1886–1900); 118 (1889, 1895)*

DART, MICHAEL S. Sculptor and marble designer in Detroit, 1885–1900. Probably the father or brother of Cora D. Dart (q.v.), who had the same address. *—Ref.: 51 (1885–1900); 118 (1897)*

DAVENPORT, (Dr.) LOUIS (1829–1879). Physician and amateur artist in Detroit. Son of Lewis and Sarah Horner Davenport. Exhibited and awarded a premium, Michigan State Fair, 1853. Lived all his life in Detroit, where he died October 22, 1879. *—Ref.: 38; 51 (1852–79); 112 (Dec. 1853, Supp); 130*

DAVENPORT, PERRY M. (1848– ?). Portrait artist in Detroit. Partner

of Rollin W. Davenport (q.v.), a brother, in the firm of Davenport Brothers (q.v.), established in Detroit, 1876. Born in Randolph, N. Y. Moved to Detroit, 1872. —Ref.: 51 (1873–82); 74

DAVENPORT, ROLLIN W. Portrait artist in Detroit. Partner of brother, Perry M. Davenport (q.v.), in the firm of Davenport Brothers, established 1876. Exhibit: Angell's Art Gallery, 1877, showing works in India ink and watercolors. Moved to New York City, 1894. —Ref.: 51 (1876–94); 60 (Aug. 3, 12, 1893); 118 (1879); 164

DAVENPORT BROTHERS. Art emporium established in Detroit, 1876: Perry M. Davenport (q.v.) and Rollin W. Davenport (q.v.). Specialized in portraits in India ink, watercolors, crayon, and oils. —Ref.: 74

DAVIS, ANNA B. (1866–1941). Amateur artist in Michigan, ca. 1883–1900+. Born at Fort Erie, Ontario. Died in Detroit. —Ref.: 51 (1883–1900+); 56 (Feb. 9, 1941).

DAVIS, CALEB F., SR. (1810– ?). Artist and commercial painter in Detroit, 1832–63. Father of Caleb F. Davis, Jr. (q.v.). Born in Boston, Mass., Feb. 9, 1810. His parents moved to Albany, N. Y., 1819, where he was educated in the common schools. Studied under John Lehman in New York. Married Ann Eliza Calhoun, 1830. Served in the Civil and Mexican Wars. Moved to Washington, D. C., 1863. Designed the State of Michigan Coat of Arms, the State Seal, and the first diploma of the Michigan State Agricultural Society. Produced many paintings and exhibited in Detroit galleries. —Ref.: 51 (1845–63); 52 (Sept. 25, 1833); 128; 130; 138; 163; 164

DAVIS, CALEB F., JR. (ca. 1831– ?). Artist in Detroit, 1849– ? . Son of Caleb F. Davis, Sr. (q.v.) and Ann Eliza (Calhoun) Davis. Exhibited in local galleries at eighteen. —Ref.: 50 (Dec. 27, 1849); 51 (1852/53); 78; 164

DAVISON, DARIUS JARVIS (1828–1904). Attorney and amateur artist in Detroit, 1855–1900+. Born near Dundee, Yates County, N. Y., Jan. 5, 1828, the son of Peter and Thankful (Wilson) Davison. The family moved to Michigan about 1833, first near Union City, and then near Ann Arbor. Educated in district schools and at Albion Seminary (now Albion College). Admitted to the bar, 1856. Married Josephine Alvard of Ypsilanti, Dec. 2, 1858. Exhibited at local galleries. Died in Detroit, Dec. 9, 1904. Buried in Ann Arbor. —Ref.: 51 (1855–1900+); 56 (Dec. 10, 1904); 60 (Dec. 10, 1904); 103 (vol. 2); 164

DEACON, JANE M. Artist in Detroit, 1887–92. —Ref.: 51 (1887–92)

DEAN, CHARLES S. Portrait painter in Detroit, 1880–83. —Ref.: 51 (1880–83)

DEAN, HORACE W. Ornamental and interior decorator in Detroit, 1866–91. Associated with Robert Hopkin (q.v.) and Andrew J. Brow (q.v.) in the firm of Dean, Brow & Co. (q.v.). –*Ref.: 51 (1866–69)*

DEAN, BROW & CO. Ornamental and interior decorators in Detroit, 1866–69: Horace W. Dean (q.v.), Andrew J. Brow (q.v.), and Robert Hopkin (q.v.). –*Ref.: 51 (1866–69)*

DEBO, LEON. *See* DABO, LEON

DEBO, THEODORE SCOTT. *See* DABO, THEODORE SCOTT.

DE COCK, HENRY. Artist in Detroit, 1897. –*Ref.: 51 (1897)*

DE FERNELMONT, LEONARD H. Sculptor, modeler, wood-carver, and decorator in Detroit, 1881–95. First arrived in Detroit in 1881 and, as a member of the first faculty of the art school, taught modeling and wood carving at the Detroit Museum of Art. Later, in 1892–93, professor of sculpture, Detroit School of Arts. Educated in Europe. In Detroit exhibitions in 1889 and 1894, showed busts of Pope Leo XIII and General Pike and the original models of statues of St. Paul in St. Cecilia Church, Holland, and St. Peter in another Holland church; statues of History and Sculpture now in the Grand National Museum, Amsterdam; an Italian beggar; and one of George Washington, which was to be placed in the Masonic Temple, Detroit. Moved to New York, 1895. –*Ref.: 18; 51 (1889–95); 60 (June 8, 1893; Jan 5 and 12, Feb. 10, Aug. 13, 1894); 101; 118 (1891); 163*

DE HART, MARY G. Artist in Detroit, 1885–87. Made enlargements of photographs. –*Ref.: 51 (1885– 86); 118 (1887)*

DEIMEL, JOSEPH. Crayon and lithographic artist in Detroit, 1883–88. Moved to Toledo, Ohio, 1888. –*Ref.: 51 (1883–1888)*

DELAVAN, (or DELEVAN) WILLIAM. Sculptor in Detroit, 1868–89. A deaf mute. In 1868, after completing a life-size medallion, was reported going to Europe to study. In 1889, came to Detroit from the West, with Indian artifacts and other memorabilia to aid him in painting a panorama, which apparently was never completed. –*Ref.: 50 (Feb. 5, 1868, Mar. 9, 1889); 51 (1867/68)*

DELORME, STEPHEN. Artist in Detroit. –*Ref.: 51 (1862–63)*

DE MONTAIGU (AMIEL, EMIL or EMILE). Artist in Detroit, 1880–85. –*Ref.: 51 (1880–83); 118 (1885)*

DEMOREST, ? (Mrs. Clyde S.). Amateur artist in Detroit, 1886–87. –*Ref.: 51 (1886); 118 (1887)*

DE MURANYI, GUSTAVE. Artist in Detroit, 1894. Born in Turkey. Went with family to Hungaria, 1876. Studied under Minkacsy for two years in Paris, and with Lietzenmayer of Munich for four years. While in

Detroit, painted portraits of Mayor Hazen S. Pingree, and of Ludwig Bleuer of the Detroit Philharmonic Club. Expected to go to Mexico and then return to Paris. *—Ref.: 60 (Sept. 7, 1894)*

DENNIS, JAMES M. (1841–1918). Portrait and landscape artist in Detroit, 1883–1900+. Born in Dublin, Ind. Studied under J. O. Eaton and Alexander Wyant, at NAD. In Indianapolis, 1865; New York City, 1873. Exhibits: Michigan State Fairs, 1885, 1886, 1894; DIA, 1905 and 1912. Memberships: Hopkin Club, Detroit; Society of Western Artists. Represented by portraits of John C. New, Treasury Department, Washington, D. C.; Governor James A. Mount, State Capitol of Indiana; Jefferson Davis, Capitol of Tennessee; General Robert E. Lee, City Hall, Savannah, Ga.; Capt. John Wheaton, Chatane Artillery Club; Murals, Hotel Cadillac, Detroit; and many others. Died in Detroit, May 6, 1918. *—Ref.: 17; 51 (1880–1900+); 60 (Nov. 17, 1893), May 21, Sept. 18, 1894; May 21, 1895, Jan. 15, 1896); 112 (Oct. 27, 1885, Nov. 2, 1886); 118 (1883–95); 128; 146; 163; 164*

DENSMORE, EVA. Artist in Niles, 1887–89. *—Ref.: 118 (1887–89)*

DENTON, ALONZO. Artist in Saginaw, 1889. Partner of Robert S. Elliott (q.v.) in the firm of Elliott & Denton (q.v.). *—Ref.: 118 (1899)*

DEPUY, MINNIE. Artist in Jackson, 1877. Award: premium for an oil painting by a person under sixteen, Michigan State Fair, 1877. *—Ref.: 112 (Oct. 30, 1877)*

DETROIT SIGN COMPANY. *See* BUELOW, HUGO V.

DE VAN, CHARLES E. Wood-carver and furniture designer in Grand Rapids, 1899. Partner in Anderson & De Van (q.v.). *—Ref.: 86 (1899)*

DEVLIN, ? (Mrs. GEORGE M.). Artist in Jackson, 1886–87. Awards: prizes for watercolors and oils, Michigan State Fair, 1886 and 1887. *—Ref.: 112 (Nov. 2, 1886; Oct. 31, 1887)*

DEXTER, MARIE C. Artist in Detroit, 1896–97. Opened a studio in Detroit, after studies in New York City, 1896–97. *—Ref.: 60 (Oct. 3, 1896); 118 (1897)*

DIEHL, AMBROSE J. Portrait photographer in Detroit, 1880–91. Member of five photographic and portrait partnerships, apparently as photographer rather than artist. *—Ref.: 51 (1880–91)*

DIKEMAN, AARON B. Amateur artist and jeweler in Grand Rapids 1870–97. *—Ref.: 86 (1870–97)*

DIKEMAN, OLIVE. Amateur artist in Three Rivers. Awards: premiums for crayon drawings, Michigan State Fair, 1885 and 1886. *—Ref.: 112 (Oct. 27, 1885, Nov. 2, 1886)*

DIX, CUNO. Printer in Detroit, 1853–54. Partner of Robert Burger (q.v.), Detroit lithographer, under the firm name of Burger & Dix (q.v.). –*Ref.: 51 (1853/54); 128*

DIX, EULABEE (Mrs. Alfred LeRoy Becker) (1878–1961). Painter of miniatures in Grand Rapids, 1890–1900+; and in New York and Europe, ca. 1910–58. Born in Greenfield, Ill., Oct. 5, 1878. Studied at St. Louis School of Fine Arts and also in New York, London, and Paris. After studies in New York, established a studio in Carnegie Hall, but considered Grand Rapids her real home and maintained family connections there. Married in New York Dec. 22, 1910. Exhibited in this country and abroad, her last exhibit being at the National Museum of Lisbon, Spain, 1958. Awarded silver medals: French Salon, 1927; American Society of Miniature Painters, New York, 1929; and Pennsylvania Society of Miniature Painters, 1929. Miniature of Samuel Clemens, painted in 1908, is in the National Portrait Gallery. Also painted Lady Paget, Countess Fabricotti, Countess of Granard, and Ethel Barrymore. Died in Waterbury, Conn., June 15, 1961. –*Ref.: 3 (vol. 20); 13; 79; 86 (1898–1900+); 109; 118 (1899); 127 (June 17, 1961); 146; 170; 175*

DODGE, ANNA J. Artist in Grand Rapids, 1886–1900+. Also a decorator and music teacher. –*Ref.: 86 (1886–1900+); 118 (1893, 1897)*

DOERING, FRIEDERICK (or FREDERICK). Artist and photographer in Detroit, 1862–66. –*Ref.: 51 (1862/63–1865/66)*

DOHMSTREICH, LOUIS. Wood-carver in Plymouth, 1897. Wife's name, B. Anna. –*Ref.: 118 (1897); 164*

DOLPH, JOHN HENRY (or J. Henri) (1835–1903). Artist in Detroit, 1859–61. Born in Fort Ann, N. Y., Apr. 18, 1835. Began career by painting portraits. Later went to New York City. In later years, specialized in paintings of cats and dogs. Studied in Antwerp with L. von Kuyck. In Paris, 1880–82, where he exhibited in the Salon. Award: Bronze Medal, Pan-American Exposition, Buffalo, 1901. Memberships: NAD, 1898; Lotus and Salmagundi clubs; American Artists Association; President, Kit Kat Club. Represented in PAFA. Died in New York City, Sept. 28, 1903. –*Ref.: 3 (1903–04); 7; 13; 34 (vol. 1); 50 (June 13, 1861); 51 (1859–61); 53 (Oct. 25, 1858); 56 (Jan. 30, Oct. 5, 1859, Nov. 7, 1860); 64 (Sept. 19, 1885); 79; 109; 112 (Oct. 22, 1859); 119; 128; 149 (vol. 9); 163; 164*

DOLWING, HENRY F. J. Artist in Detroit, 1863–64. –*Ref.: 51 (1863/64)*

DONALDSON, JOHN M. (1854–1941). Artist, sculptor, and architect in

Detroit, 1879–1935. Designed many of Detroit's largest and finest buildings, both private and public. Born in Stirling, Scotland, Jan. 17, 1854, the son of John W. and Isabella (McNaughton) Donaldson. Family arrived in Detroit in 1856. Graduated from the Detroit Public Schools and Polytechnic College; Art Academy of Munich; École des Beaux Arts, Paris; and Academy of Fine Arts, Venice. Headed the architectural firm of Donaldson & Meier. Married Mrs. Charlotte G. (Grosvenor) Brush, Nov. 30, 1882. Memberships: National Sculptors' Society, New York; National Council of Fine Arts; National Institute of Arts and Letters. Died in Detroit, Dec. 20, 1941. *–Ref.: 56 (Mar. 4, 1879, Mar. 1, 1884, Dec. 22, 1941); 61 (Jan. 17, 1935, Dec. 22, 1941); 110; 121 (vol. 2); 139 (pt. 2); 155*

DONGEROW, WILLIAM (ca. 1858–1922). Artist in Detroit prior to 1900. Represented by a painting in the DIA. *–Ref.: 59 (1949)*

DORSCH, (Dr.) EDWARD (1822–1887). Physician, writer, poet, and artist in Monroe. Born in Wuerzburg, Bavaria, Germany, Jan. 10, 1822, the son of Francis L. and Elizabeth (Hartung) Dorsch. Came to America about 1849, first settling in New York, later in Detroit, and finally in Monroe. Died in Monroe on his sixty-fifth birthday, Jan. 10, 1887. *–Ref.: 161*

DOSCH, HENRY. Wood-carver in Grand Rapids, 1886–1900+. Partner of Charles A. Greenman (q.v.), 1890, under the firm name of Greenman & Dosch (q.v.). Later, vice-president, Grand Rapids Wood Carving Company. *–Ref.: 86 (1886–1900+)*

DOSCH, NICHOLAS. Wood-carver in Grand Rapids, 1878–99. Partner of Charles A. Greenman (q.v.) in the firm of Greenman & Dosch (q.v.), wood-carvers, 1888–89. *–Ref.: 86 (1878–99)*

DOUGLAS, KATE (or CATHERINE). (? –1937). Amateur artist in Ann Arbor, 1897–99. Probably Catherine L. Douglas, a teacher in the Southeastern High School, Detroit, daughter of Kate Terhune Douglas. Died in 1937; buried in Ann Arbor. *–Ref.: 56 (Jan. 27, 1937); 61 (Jan. 26, 1937); 118 (1897, 1899)*

DOW, WILLIAM F. (1844–1906). Watercolor artist in Detroit, 1880–1900+. Employed in various capacities in Detroit, devoting spare time to the painting of local scenes of historic interest. Exhibited in the Detroit Museum of Art, and at local galleries. Memberships: Detroit Water Color Society; Detroit Artists' Association. Died in Detroit, May 18, 1906. *–Ref.: 51 (1880–1900+); 60 (Dec. 8, 1893, June 2, 1896); 163; 164*

DREHER, FREDERICK W. (1867– ?). Lithographic artist in Detroit,

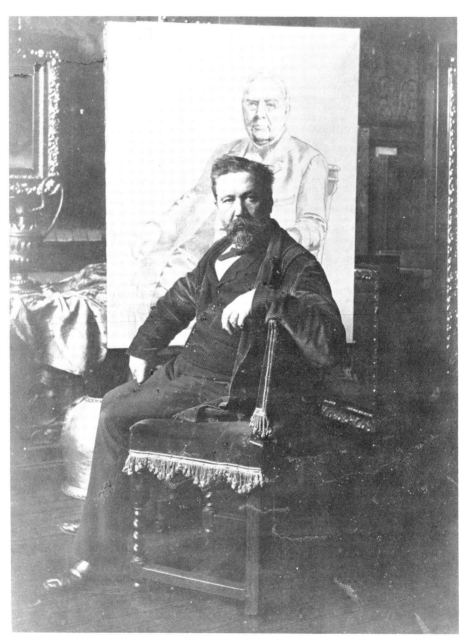

John Henry Dolph, Photograph. From the collection of the Archives of American Art, Smithsonian Institution, Washington, D.C.

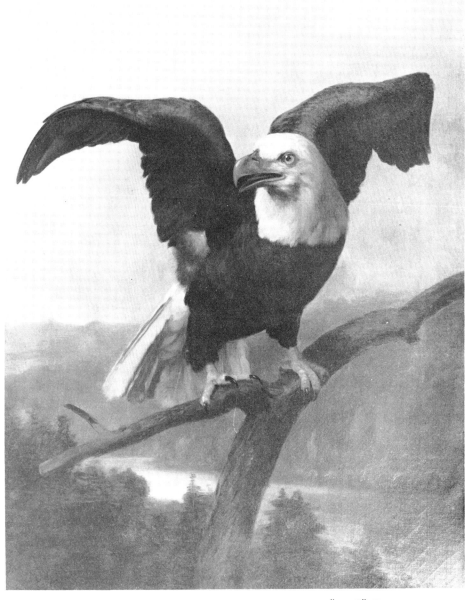

John Henry Dolph, *American Bald Eagle*. Oil on canvas, 24″ x 18″. From the collection of F. W. Lapham III, Shoreham, Vermont.

1880–89. Born in Germany. Settled in Detroit, 1880. In 1889, moved to New York City. Married Henrietta W. ? in 1915. *–Ref.: 51 (1880–89); 61 (Oct. 23, 1945)*

DRIGGS, (Mrs.) M. L. Artist in Saginaw. Won award for a watercolor painting exhibited at the 1875 Michigan State Fair. *–Ref.: 112 (Oct. 12, 1875)*

DROESE, LIZZIE L. Artist in Grand Rapids, 1893. *–Ref.: 86 (1893)*

DROLSHAGEN, HENRY B. Artist in Detroit, 1882–1900+. Employed in scenic painting on Pullman Palace Cars, 1883–87; advanced to foreman in the latter year. Thereafter, retired and engaged in painting and interior decorating. *–Ref.: 51 (1880–1900+)*

DRURY, N. S. Portrait painter in Detroit, 1846. *–Ref.: 51 (1846)*

DUCKET, MAXIM A. Artist in Monroe, 1889. *–Ref.: 118 (1889)*

DUDLEY, JUSTIN Z. Artist in Grand Rapids, 1876. *–Ref.: 86 (1876)*

DUNBAR, FREDERICK A. T. (1849– ?). Sculptor in Detroit, 1894–1896. Born in Guelph, Ontario. Studied in Florence, Italy, under Bortona, and in Vienna, Austria, under Tilgner. Married an Austrian prima donna in Florence. Executed busts of U.S. Senator Thomas W. Palmer, of Michigan; Hazen S. Pingree, Mayor of Detroit; and numerous other prominent citizens. Designed and executed the Scripp's Newsboy Fountain on Belle Isle. Reported to have returned to Canada. *–Ref.: 51 (1895–97); 60 (July 21, Oct. 13, 1894, Jan. 12, Nov. 9, Nov. 11, 1896, Dec. 12, 1896); 109; 164*

DUNCANSON, ROBERT S. (1817–1872). Portrait, landscape, genre and allegorical painter. Negro artist active in Detroit intermittently, 1846–72; at other times usually in Cincinnati, Ohio. Born in New York State of a Negro or mulatto mother and a Scotch-Canadian father. In 1846 the family moved from Cincinnati to Detroit. He stayed two years, but his Negro ancestry retarded his acceptance as a portrait painter, so he went to Canada, where the Anti-Slavery League discovered his talent. They sent him to Italy, France, and England to study, and he exhibited all over Europe. American exhibitions include his first, at Cincinnati in 1842; Michigan State Fair, 1849; Gallery of Fine Arts, Detroit, 1852; Western Art Association, 1871; and Detroit Art Association, 1875–1876. Produced a large number of paintings, many of them portraits of prominent people. First important commission was for a series of murals for "Belmont," the home of Nicholas Longworth I (now the Taft Museum). Returned to Detroit in poor health in 1872, and after a few months suffered a mental and physical breakdown. Died Dec. 21, 1872, and was buried in Detroit. *–Ref.: 33; 54 (Dec. 23, 1872); 56*

(Sept. 15, 1871); 61 (June 15, 1952, Feb. 24, 1953); 68 (Dec. 26, 1872); 78, 85; 101; 109; 112 (Oct. 1, 1849); 128; 133; 163; 164

DUNSMORE, CORRINE (Mrs. John W.) Amateur artist in Detroit. Exhibited stilllife studies, Detroit Artists' Association, 1891 and 1893. In 1894 had charge of an elementary drawing class for public school teachers at the Detroit School of Arts, of which her husband, John Ward Dunsmore (q.v.), was the director. In 1894, they moved to Cincinnati, Ohio. *—Ref.: 51 (1892—1893); 60 (Apr. 18, 1893, Mar. 17, 1894); 164*

DUNSMORE, JOHN WARD. (1856—1945). Artist and etcher in Detroit, 1890—94. Painter and etcher of portraits, early history and Revolutionary War subjects, and original themes. Born in Riley, Butler County, Ohio, Feb. 29, 1856. Pupil of Cincinnati Art Academy, and of Thomas Couture in Paris. Director Detroit Museum of Art (now Detroit Institute of Arts), Detroit School of Arts, and the art department of *Critical Review;* also president of Rembrandt Etching Club, Detroit. Exhibits: Paris Salon, 1878; Suffolk Street Gallery, London; NAD, 1878; DIA, 1889, 1911; Chicago World's Fair, 1893; California Mid-Winter Exhibition, 1893; World's Fair Prize Winners Exhibition, New York, 1893; Rochester Art Club 1893; Detroit Artists' Association, 1891. Memberships: a founder and member of the Professional Artists' League, New York; NAD; AIC; New York Architects' League, 1903; Salmagundi Club, 1903; Boston Art Club, 1881; AWCS; Cincinnati Art Club; AFA. Numerous awards. Represented in NAD; Salmagundi Club; Ohio Mechanics' Institute, Cincinnati; Lassell Seminary, Auburndale, Massachusetts; thirty-five historical paintings at the Sons of the American Revolution, New York; Cincinnati Art Museum; Wagnals Memorial Library, Lithopolis, Ohio. He and his wife Corrine Dunsmore (q.v.) moved to Cincinnati, 1894 (and subsequently to New York?). Died at Dover, N. J., Oct. 7, 1945. *—Ref.: 3 (1898, 1933); 9 (vol. 20, Oct. 15, 1945); 13; 51 (1890—94); 60 (Jan. 16, 18, 22, Feb. 20, Mar. 31, May 11, Sept. 22, Nov. 9, Dec. 8, 22, 1893, Mar. 17, 24, Apr. 21, 1894); 68 (Nov. 26, 1893, Jan. 1, 8, 16, 22, Feb. 20, Mar. 19, 27, 1893); 79; 101; 109; 118 (1891, 1893); 149; 153 (vol. 3, 1940—41); 164*

DUVAL, IDA. Artist in Detroit, 1861. *—Ref.: 51 (1861)*

DVORAK, FRANZ (or FRANK A.) (1862— ?). Artist in Detroit, summers of 1894 and 1895. A native of Prague, Bohemia. Genre painter of considerable note in Europe; formerly with the Royal Academy of Munich. Studied at the Vienna Academy. Instructor in a life class at a Detroit art school. Exhibits: Paris Salon, 1893, 1898, 1900, 1903,

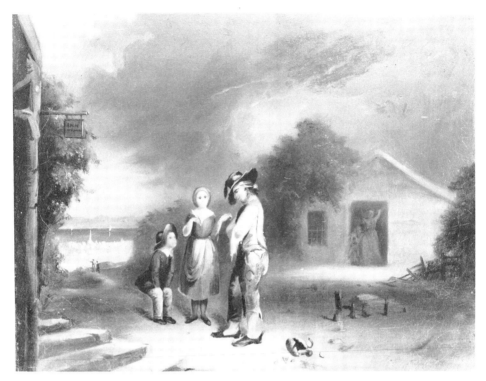

Robert S. Duncanson, *The Drunkard's Plight.* Oil on board, 15¼″ x 19¾″. From the collection of the Detroit Institute of Arts. Gift of Miss Sarah M. Sheridan.

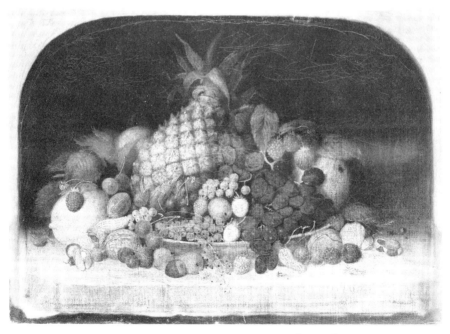

Robert S. Duncanson, *Fruit Bowl.* Oil on Canvas, 14″ x 20″. From the collection of the Detroit Institute of Arts.

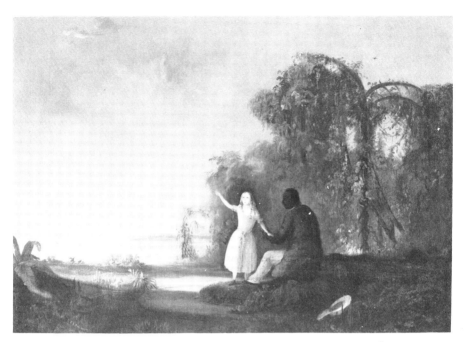

Robert S. Duncanson, *Uncle Tom and Little Eva*. Oil on canvas, 27¼″ x 38¼″. From the collection of the Detroit Institute of Arts.

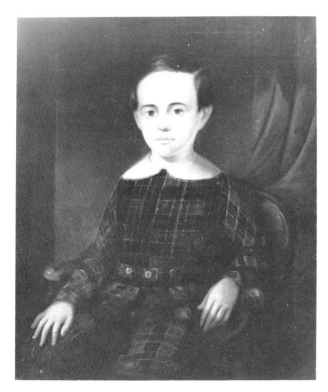

Robert S. Duncanson, *Portrait of William Berthelet*. Canvas, 30″ x 25″. From the collection of the Detroit Institute of Arts. Gift of W. T. Berthelet.

1904, and 1905; Royal Academy, London, 1909 and 1911; Society of Associated Artists, Detroit. —*Ref.: 13; 60 (June 20, 24, Aug. 13, 25, Nov. 3, 22, Dec. 15, 29, 1894, Oct. 19, 1895); 109; 149*

DWYER, MARGUERITE M. Amateur artist in Detroit, 1894–95. Exhibits: local art school, 1894; Great Art Loan, 1895. —*Ref.: 60 (June 20, 1894, May 21, 1895); 163*

DWYER, MARY. Artist in Port Huron, 1887–91. —*Ref.: 118 (1887–91); 132 (1887/88)*

DWYER, SUSIE. Artist in Port Huron, 1887. —*Ref.: 118 (1887)*

E

E.H. Possibly Lieutenant Edward Henn, British Army, active in Detroit, 1794. A watercolor painting titled "A View of Detroit, July 25, 1794," was discovered in 1923 in Plymouth, England, by Lady Nancy Astor, and presented by her to the people of Detroit. It is the earliest authenticated view of the fortifications and settlement of Detroit. Though the actual identity of the artist is not known, the initials E. H. appearing in the lower left corner of the painting could be those of Lieutenant Henn. —*Ref.: 163; 164*

EARL, M.E. Artist in Michigan, 1891. —*Ref.: 118 (1891)*

EARL, TARLETON B. Artist in Bay City, 1883–91. —*Ref.: 118 (1883, 1885, 1889, 1891)*

EARLE, LAWRENCE CARMICHAEL (1845–1921). Landscape, genre, and portrait artist. Born in New York City, Nov. 11, 1845. Studied in Munich, Florence, and Rome. Resided in New York and later at Grand Rapids. Specialized in portraiture, but also exhibited other works at the Detroit Museum of Art, 1909. Memberships: Associate of the NAD, and member of American Water Color Society; Artists' Fund Society; Art Institute of Chicago (honorary); N. Y. Water Color Club. Represented in Art Institute of Chicago and Chicago Natl. Bank. Died in Grand Rapids, Nov. 20, 1921. —*Ref.: 3 (vol. 18, 1921); 13; 79; 86 (1920, 1921); 109; 146; 149; 163*

EATON, CHARLES HARRY (1850–1901). Landscape artist and illustrator in Detroit, 1867–78. In 1878, moved to Holly, and still later to Leonia, N.J., although continued to exhibit in Detroit. Born at or near Akron, Ohio, Dec. 13, 1850. In 1874/75, associated in Detroit with James E. Maxfield, Jr., (q.v.), a portrait painter, under the firm name of Maxfield & Eaton (q.v.). Married Sylvia Bird, of Holly, Apr. 2, 1879. Exhibits: NAD, 1881; Paris Exposition, 1889; and Chicago World's Fair, 1893. Awards: Silver Medal, Boston, 1887; Gold Medal, American

Art Assn. 1888; Evans Prize, American Water Color Society, 1898; Gold Medal, Pennsylvania Art Club, 1900. Memberships: American Art Association, 1898; President, American Water Color Society, 1901; ANAD, 1893; Salmagundi Club; Boston Art Club; Detroit Artists' Association; Western Art Association. Died at Leonia, N. J., Aug. 4, 1901. —*Ref.: 3 (1898, 1903); 13; 51 (1867–78); 56 (Feb. 16, 1868; Feb. 1, 1876, Feb. 2, Apr. 17, Sept. 18, 1879, Mar. 14, 1880); 59; 60 (Apr. 18, 1893); 65 (Sept. 21, 1878, Sept. 18, 1879); 68 (Nov. 21, 1886); 79; 95 (Mar. 25, 1926); 101; 109; 112 (Oct. 24, 1878, Feb. 10, 1880); 118 (1870/71, 1879); 119; 146; 149; 163; 164*

EATON, HATTIE. Artist in Grand Rapids. —*Ref.: 86 (1900)*

EATON, MARY B. Artist in Detroit, 1883–89. —*Ref.: 51 (1883–89)*

EAVENS, ELLA A. (Mrs. Edward I.). Artist in Detroit, 1894. —*Ref.: 51 (1894)*

EBERLEIN, MICHAEL. Wood-carver in Newport, 1893. —*Ref.: 118 (1893)*

ECHLIN, ROGER JOSEPH (ca. 1838–1920). Painter of signs and banners, scenic and allegorical panels for interior decoration of vessels, business places and dwellings, and marine and other oil paintings in Detroit, 1863–1900+. Born in Dublin, Ireland. Wife's maiden name was Mary Monaghan. Exhibits: Michigan State Fair of 1880, and at local art galleries. His last banner was presented to General Pershing. Died in Detroit, Aug. 16, 1920, and was buried there. —*Ref.: 51 (1863 –1900+); 56 (Mar. 22, Apr. 14, 1878, Aug. 17, 1920); 61 (Aug. 16, 1920); 65 (Apr. 16, 1878, Sept. 16, 1880); 112 (Oct. 12, 1880); 159; 163; 164*

ECKHARDT, OTTO J. Artist in Bay City, 1899. —*Ref.: 118 (1899)*

ECKLIFFE, ? (Mrs. CHARLES). Amateur artist in Jackson, 1887. Award: premium for a flower piece in oils, Michigan State Fair, 1887. —*Ref.: 112 (Oct. 31, 1887)*

EDDY, MARY W. Artist in Cheboygan, 1889. —*Ref.: 118 (1889)*

EDGAR, Miss H. N. Amateur artist in Jackson, 1887. Award; prize for a bird study in oils, Michigan State Fair, 1887. —*Ref.: 112 (Oct. 31, 1887)*

EDGECOMB, ARTHUR B. (or ARTHUR D.). Decorator in Grand Rapids, 1888; and artist, 1895. —*Ref.: 86 (1888); 118 (1895)*

EDMONDS, (Mrs.) J. H. Artist in Detroit, 1859. Award: prize for water-color painting, Michigan State Fair, 1859. —*Ref.: 112 (Oct. 22, 1859)*

EDOUART, A.C.F. (1779–1861). Silhouettist to the French Royal Family. Born at Dunkirk, France, and named Augustin Amant Constance Fidèle Edouart. Served under Napoleon and was decorated, but

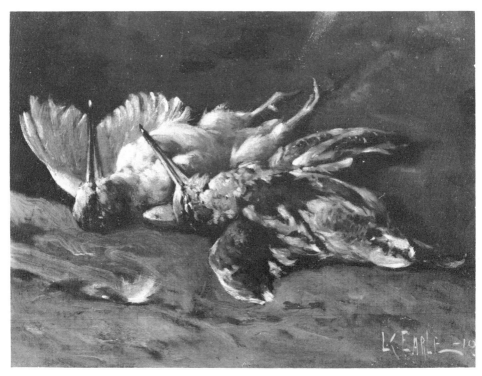

Lawrence Carmichael Earle, *Woodcocks,* 1910. Oil on canvas, 12″ x 16″. From the collection of Mr. and Mrs. James L. Greaves, Detroit. Photograph by Joseph Klima, Jr.

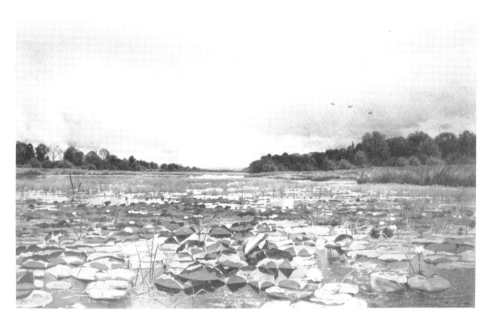

Charles Harry Eaton, *The Lily Pond*. Oil on canvas, 40" x 70". From the collection of the Detroit Institute of Arts.

fled to England in 1813, where he started making landscapes, figures, and miniatures of animals out of human and animal hair. The delicate and exacting work affected his eyesight, forcing him to try cutting silhouettes in 1825. His skill attracted patrons from all over Europe. From 1839 to 1849, in America, opened studios or galleries in various cities. Probably made as many as 100,000 "likenesses," as he called them. Whether he was actually in Detroit is not known, but he made many silhouettes of persons prominent in Detroit and Michigan. Died in Guinnes, near Calais, France, 1861. *–Ref.: 97; 109*

EDWARDS, CHARLOTTE E. Amateur artist in Detroit, 1896–97. *–Ref.: 51 (1896–97); 118 (1897)*

EDWARDS, GEORGE D. Painter of floral, fruit, and game pieces in Detroit, 1870–74. Exhibits: Western Art Association, 1870; Michigan State Fair, 1872, where he won an award for the best floral painting. *–Ref.: 56 (Dec. 20, 1874); 112 (Oct. 24, 1872); 164*

EGBERT, SMITH (or SMITH J.). Commercial painter in Detroit, 1879; later, 1892–94 practiced as a crayon artist. *–Ref.: 51 (1892–94); 118 (1893)*

EGGLESTON, (Mrs.) L. Artist in Jackson, 1876. Exhibit: Michigan State Fair, 1876. *–Ref.: 112 (Nov. 14, 1876)*

EHRENBERG, OTTO. Artist in Saginaw, 1891. *–Ref.: 118 (1891)*

EICHMAN, ALEXANDER A. Partner of Albert Steinmetz (q.v.), Grand Rapids, 1896, under the firm name of Eichman and Steinmetz (q.v.). *–Ref.: 86 (1896)*

EICHMAN & STEINMETZ. Artists in Grand Rapids, 1896; Alexander A. Eichman (q.v.) and Albert Steinmetz (q.v.). *–Ref.: 86 (1896)*

EISENBACH, PETER N. Artist in Detroit, 1895–1900+. *–Ref.: 51 (1895–1900+)*

ELBERT, (Mrs.) C.J. Amateur artist in Detroit, 1878. Exhibit: watercolor landscape, Michigan State Fair, 1878. *–Ref.: 112 (Oct. 24, 1878)*

ELBERT, LAURETTE DE TOUSARD (1847–1930). Artist in Detroit, 1879–83. Life-long resident of Detroit, where she was born. Great grand-daughter of the Chevalier A. Louis de Tousard, French nobleman who served with General Lafayette in the Revolutionary War. Exhibits: Michigan State Fairs, 1879, 1880; Great Art Loan, 1883. Died in Detroit, Jan. 27, 1930. *–Ref.: 56 (Jan. 28, 1930, Feb. 13, 1934); 61 (Oct. 15, 1926, Jan. 28, 1930); 112 (Feb. 10, Oct. 12, 1880); 163; 164*

ELDRED, LENA T. Artist in Benton Harbor, 1887–93. *–Ref.: 118 (1887–93)*

ELDRIDGE, GEORGE H. Crayon and oil artist in Adrian, 1879–99. Exhibits: Michigan Art Association, 1879; Annual Michigan Artists'

Exhibition, 1880. —*Ref.: 56 (Apr. 13, 1879, Apr. 13, 1880); 118 (1897, 1899); 157*

ELLINGWOOD, NANETTE B. Watercolor artist in Hillsdale, 1856. Awards: diploma and premium for the best watercolor painting of flowers, Michigan State Fair, 1856. Married at Hillsdale, Apr. 4, 1858, to Miles T. Gardner. —*Ref.: 112 (Nov. 1856); 164*

ELLIOTT, ROBERT S. Artist in Saginaw, 1899. Partner of Alonzo Denton (q.v.) in the firm of Elliott & Denton (q.v.) 1899. —*Ref.:188(1899)*

ELLIOTT & DENTON. Artists in Saginaw, 1899: Robert S. Elliott (q.v.) and Alonzo Denton (q.v.). —*Ref.: 118 (1899)*

ELLIS, MATTIE (Mrs. A. A.). Artist in Ionia, 1891–99. —*Ref.: 118 (1891–99)*

ELLSWORTH, GEORGE. Artist in Greenville, 1891–97. —*Ref.: 118 (1891–97)*

ELMORE, WILLARD P. Photographic portraitist in the vicinity of Jackson, 1893–1912. —*Ref.: 98 (1912); 118 (1893, 1899)*

ELWOOD, MATTIE C. Teacher of drawing and painting, Albion College, 1889. —*Ref.: 118 (1889)*

ELY, (Mrs.). ? . Artist in Flint, 1880. Exhibit: three oil paintings at a Detroit gallery, 1880. —*Ref.: 56 (Apr. 13, 1880)*

EMMONS, HATTIE (Harriet). Artist in Grand Rapids, 1891–97. —*Ref.: 86 (1891–1900+); 118 (1893)*

ENDICOTT, GEORGE R. Variously a pen-and-ink artist and bookkeeper in Detroit, 1885–95. —*Ref.: 51 (1883–95); 118 (1891)*

ENSWORTH, AUGUSTA. Teacher (of art?) in Detroit, 1852–63. Received honorable mention for several monochromes, Michigan State Fair, 1852. —*Ref.: 51 (1862/63); 112 (Oct. 1852)*

ERTZ, BRUNO (1873–1956). Painter of landscapes and portraits in Detroit, 1896–98; and of bees, butterflies, birds for many years thereafter. Born in Manitowoc, Wis., Mar. 1, 1873, the son of Mr. and Mrs. C.C. Ertz. Educated there. At fifteen began as a painter, entirely self-taught. In 1896 and 1897, associated with Percy Cuthberg Nash (q.v.), in Detroit, under the firm name of Nash & Ertz (q.v.), portrait artists. Remained in Detroit until 1898. Thereafter, specialized in bird and insect paintings, which now hang in the collection of art connoisseurs of England and on the continent, as well as in America. Died June 20, 1956. A posthumous exhibit at the Rahr Civic Center, Manitowoc, Wis., in August 1962, showed 121 of his works. —*Ref.: 51 (1896–98); 157*

ESTELLE, WESLEY WILLIAM. Reporter-artist in Detroit, 1875. Executed a painting of the ferry steamer Fortune in 1875. —*Ref.: 56 (Sept. 23, 1875)*

ETTER, J. ULRICH. Artist in Detroit, 1890–97. Moved to Appenzell, Switzerland, 1897. —*Ref.: 51 (1890–97); 118 (1893)*

ETZOLD, THEODORE WILLIAM. Commercial engraver and artist in Detroit, 1884–1900. Studied at Detroit School of Art. Exhibits: local galleries; Detroit Museum of Art. —*Ref.: 51 (1884–1900); 60 (June 24, 1893, Jan. 15, June 2, June 6, 1896); 163*

F

FAIRCHILD, MARTHA A. Artist in Detroit, 1873–1901. Possibly involved in the commercial lithographic or photographic fields. —*Ref.: 51 (1873–1901+); 118 (1885–99)*

FAIRMAN, LILLIAN M. Artist in Plymouth, 1889–97. —*Ref.: 118 (1889–97)*

FALLAS, MARY E. Artist in Detroit, 1880. Award for the best crayon drawing of a face, Michigan State Fair, 1880. —*Ref.: 112 (Oct. 12, 1880)*

FANNING, WILLIAM SANDERS (1887– ?). Artist in Detroit. Born in Detroit and still active there in 1934. Exhibit: DIA, 1930. —*Ref.: 109; 163*

FARRAR, HARRIET M. (Hattie) (1833–1912). Amateur artist in Detroit, 1858. Daughter of pioneer John Farrar, who settled in Detroit after the War of 1812. Long-time resident of Detroit. Award: prize for the best crayon drawing, Michigan State Fair, 1858. Died in Detroit, July 10, 1912. —*Ref.: 51 (1874–1912); 56 (July 12, 1912); 112 (Nov. 1858)*

FAUCETT (or FAWCETT), ROBERT. Amateur artist and maker of boots and shoes in Livonia, 1857–91. Exhibits: landscapes and animal paintings, in oils, Michigan State Fairs, 1879, 1882. Moved to Chicago, 1891. —*Ref.: 51 (1857–91); 56 (Sept. 18, 1879); 65 (Sept. 18, 1879); 112 (Feb. 10, 1880, Oct. 17, 1882)*

FAULCONER, LILLIE EMMONS (1877–1910). Artist in Detroit, 1890s. Born May 17, 1877, the daughter of Robert C. and Elizabeth Williams (Emmons) Faulconer. Student of Maud Mathewson (q.v.); later studied in Rome, Italy. Died in Rome June 19, 1910. —*Ref.: 60 (June 24, 1893); 164*

FAY, SUSAN (or SARAH). Amateur artist in Detroit. Award: prize for a collection of water colors, Michigan State Fair, 1876. —*Ref.: 112 (Nov. 14, 1876)*

FAY, BENJAMIN F. Artist in Detroit, 1891–1900+. —*Ref.: 51 (1891–1905)*

FICK, AUGUST C. Wood-carver in Grand Rapids, at least 1883–85. In

1885, was in partnership with D. William Ingersoll (q.v.), as Fick & Ingersoll (q.v.), wood-carvers. —*Ref.: 86 (1883); 118 (1885)*

FICK & INGERSOLL. Wood-carvers in Grand Rapids, 1885: August C. Fick (q.v.) and D. William Ingersoll (q.v.). —*Ref.: 118 (1885)*

FILLANS, WILHELMINA. Amateur artist and music teacher in Detroit, 1874. Exhibited two portraits, Howard Dramatic Club, Detroit, 1874. —*Ref.: 51 (1874/75); 56 (Sept. 24, 1874)*

FINCH, BYRON. Crayon artist in Imlay City (or Black's Corners), 1881. —*Ref.: 118 (1881)*

FINCH, EDWARD BRUSH (1872–1954). Lithographic designer with Calvert Lithographic Co. in Detroit; later in the manufacture of bicycles and novelties. Born in Holly, Oct. 16, 1872, the son of Nathaniel A. and Mary (Hadley) Finch. Educated at Owosso High School and the University of Michigan. Married May Pungs in Detroit, Jan. 17, 1900. Died in Detroit, May 24, 1954. —*Ref.: 51 (1896–1900+); 56 (May 24, 1954); 60 (Jan. 15, 1896); 110*

FINLAYSON, HUGH R. (ca. 1852–1896). Artist in Detroit, 1893–96. Died Dec. 4, 1896. —*Ref.: 51 (1893–97); 118 (1893)*

FINLEY, LOTTIE K. (Doly) (Mrs. Homer P. Finley). Amateur artist in Detroit. Exhibited two crayon works, Angell's Art Gallery, Detroit, 1877. —*Ref.: 51 (1875–81); 164*

FINNEY, MARY ALICE. Art student in Detroit under Maud Mathewson (q.v.). Exhibited at studio showings, 1891 and 1894. —*Ref.: 60 (June 20, 1891, June 20, 1894)*

FINNEY, MAY F. Art student in Detroit under Maud Mathewson (q.v.). Showed some of her work at a studio exhibition, June 1893. —*Ref.: 60 (June 22, 1893)*

FISH, NENJAMIN NYE. Artist in Detroit, 1895–1901. In 1901, moved to St. Louis, Mo. —*Ref.: 51 (1892–1901); 118 (1897); 164*

FISH, (Mrs.) W. S. Artist in Saginaw, 1875. Awards: prizes for oil paintings, Michigan State Fair, 1875. Uncertain whether the initials W. S. are hers or her husband's. —*Ref.: 112 (Oct. 12, 1875)*

FISHER, ? (Mrs. William). Artist in Saginaw, 1887. —*Ref.: 118 (1887)*

FISHER, JOSEPH GURNER. Artist in Grand Rapids, 1888–1905. Reputed to have won distinction in crayon sketching in New York. —*Ref.: 10; 86 (1886–1905); 118 (1893, 1897, 1899)*

FISHER, TRUMAN S. Portrait artist in Detroit, 1886–95. In 1888, associated with Joseph L. Hansel (q.v.) as Fisher & Hansel (q.v.), artists. In 1894 and 1896, in two other partnerships, both identified as photographers. —*Ref.: 51 (1886–1900); 118 (1893)*

FISHER & HANSEL. Portrait artists in Detroit, 1888: Truman S. Fisher

(q.v.) and Joseph L. Hansel (q.v.) *—Ref.: 51 (1888); 188 (1889)*

FISK, NETTIE. Amateur artist in Jackson, 1876. Awards: premium for an oil landscape, Michigan State Fair, 1876. *—Ref.: 112 (Nov. 14, 1876)*

FITCH, JEANETTE E. (ca. 1874–1963). Art teacher for thirty years in the public schools in Detroit. Graduate, Philadelphia School of Fine Arts. Member, Detroit Society of Women Painters, 1907. Died in Detroit, Jan. 22, 1963.*—Ref.: 51 (1895–1905+);61 (Jan. 23, 1963); 122*

FITZGIBBON, ELIZABETH T. Artist in Detroit, 1900–01. *—Ref.: 51 (1900–1901)*

FLEMING, JESSIE H. Amateur artist in St. Louis, 1881. *—Ref.: 118 (1881)*

FLETCHER, EDWIN P. Artist in Detroit, 1896–1904. *—Ref.: 51 (1894– 1912); 118 (1897)*

FLIERL, FRANK (Franklin) (ca. 1855–1892). Wood-carver in Detroit, 1875–1892. Associated with Joseph F. Haigermoser (q.v.), 1882–92, as Haigermoser & Flierl (q.v.), carvers. Died in Detroit, June 1, 1892. *—Ref.: 51 (1875–1912); 118 (1881)*

FLIERMANS, CONSTANT. Artist in Grand Rapids, 1897–1900. In 1898 moved to Germany. In 1900 again lived in Grand Rapids. *—Ref.: 86 (1897–1900)*

FLOWERS, ELIZABETH. Portrait artist in Portland, 1889–91. *—Ref.: 118 (1889, 1891)*

FOOTE, WILL HOWE (William) (1874– ?). Landscape artist in Grand Rapids. Born in Grand Rapids, June 29, 1874. In about 1901 moved to New York, and later to Old Lyme, Conn., where still active in 1934. Studied at Art Institute of Chicago; Art Students' League, New York; Julien Academy, Paris, under Paul Laurens and Benjamin-Constant. Instructor, Art Students' League in New York. Awards: Honorable Mention, Pan-American Exposition, Buffalo, 1901; Hallgarten Prize, NAD, 1902; Bronze Medal, St. Louis Exposition, 1904; Silver Medal, Panama-Pacific Exposition, San Francisco, 1915; Eaton Prize, Lyme Association, 1926 and 1927. Memberships: NAD; American Art Association, Paris. Represented in Grand Rapids Art Association and University of Nebraska collections. *—Ref.: 3 (vol. 30, 1933); 13; 79; 86 (1892–1900); 101; 109; 119 (1916 ed.); 157; 163; 164*

FORCE, FRANCES P. Artist in Grand Rapids, 1899–1900. *—Ref.: 86 (1899–1900)*

FORD, GEORGE H. Artist in Muskegon, 1889–93. *—Ref.: 118 (1889, 1891, 1893)*

FORD, GRACE W. Young art student in Jackson, 1886–87. Awards for oil and crayon work, Michigan State Fair, 1886 and 1887. *—Ref.: 112 (Nov. 2, 1886, Oct. 31, 1887)*

FORD, W. A. Artist in Saugatuck, 1887. *—Ref.: 118 (1887)*

FORSDICK, HORACE (c. 1840 – ?). Variously painter, from 1871–91; and artist, 1892–93, in Detroit. Married Cornelia Sutherland in Detroit, Dec. 19, 1865. *—Ref.: 51 (1871–96); 118 (1893); 164*

FORSTER, ERNEST. Portrait artist in Mt. Clemens, 1899. *—Ref.: 118 (1899)*

FOSSETT, ROBERT. Artist in Pike's Peak (Perrinsville), 1889. Person of this name was living in Detroit, 1874 and 1879, but no record of art activities. *—Ref.: 51 (1874, 1879); 118 (1889)*

FOSTER, FREDERICK L. (ca. 1842– ?). Amateur artist in Detroit, 1875–79. Exhibited at various galleries, 1875–79. Married Ada Q. Grose in Detroit, June 6, 1865. *—Ref.: 56 (Mar. 9, Apr. 14, Apr. 20, 1879); 164*

FOSTER, MYRTLE F. Artist in Grand Rapids, 1897–1900+. *—Ref.: 86 (1892–1900+)*

FOWLER, EVANGELINE (Eva) (? –1934). Painter and lithographer in Hillsdale and Birmingham. Born in Kingsville, Ohio, the daughter of Spencer J. Fowler, one of the founders of Hillsdale College. Studied at Art Students' League, New York; PAFA; and in France with Delaye and Carl. Art teacher at Hillsdale College. Exhibits: Great Art Loan, Detroit, 1883; DIA, 1932; Society of Independent Artists, 1933; in the east and abroad. Awards; Gold Medal, Cotton Centennial, New Orleans, 1885; Saint-Gaudens Bronze Medal, World's Columbian Exposition, Chicago, 1893; First Prize, Southern States Art League, New Orleans, 1930. Memberships: Detroit Society of Women Painters and Sculptors; Southern States Art League, New Orleans. Represented in collections at Hillsdale College and the Public Library of Sherman, Tex. Died in Birmingham, May 5, 1934; buried in Hillsdale. *—Ref.: 3 (vol. 30, 1933); 13; 56 (May 6, 1934); 109; 163*

FOWLER, GEORGE H. Portrait and animal painter in Charlotte, 1879–99. Worked in oils, watercolors, pen and ink, and crayons. Husband of Mrs. George H. Fowler (q.v.). *—Ref.: 118 (1879–99)*

FOWLER, (Mrs.) GEORGE H. Portrait and animal painter in Charlotte, 1879–99. Worked in oils, watercolors, pen and ink, and crayons. Wife of George H. Fowler (q.v.). *—Ref.: 118 (1879–99)*

FOX, MATTIE E. Artist in Grand Rapids, 1890–93. *—Ref.: 86 (1890–92); 118 (1893)*

FRASER, FRANCES S. Artist in Detroit, 1884–86. Exhibited, Detroit Water Color Society, Nov. 1886. *—Ref.: 51 (1884); 64 (Aug. 17, 1884); 118 (1885); 164*

FRASER, JESSIE L. Artist in Saginaw, 1895 and 1897. *—Ref.: 118 (1895, 1897)*

Frederick Frieseke, Photograph. From the MacBeth Gallery Papers, Archives of American Art, Smithsonian Institution, Washington, D.C.

Frederick Frieseke, *The Blue Gown*. Canvas, 39" x 60". From the collection of the Detroit Institute of Arts. Gift of Philip, David and Paul R. Gray and Mrs. William R. Kales.

FRAYER, DAVID E. Wood-carver in Grand Rapids, 1889. In partnership with Adolph C. Bodelack (q.v.) as Bodelack & Frayer (q.v.). *–Ref.: 86 (1889)*

FRAZER, FRED. Artist in Hannah, 1897 and 1899. *–Ref.: 118 (1897, 1899)*

FREELAND, W. B. Artist in Alger, 1891. *–Ref.: 118 (1891)*

FREEMAN, JESSIE B. Amateur artist in Detroit, 1882–1900+. *–Ref.: 51 (1882–1900+); 118 (1883)*

FRENCH, MARY L. Art student in Kalamazoo, 1884. Award: prize, Michigan State Fair, 1884. *Ref.: 112 (Nov. 4, 1884)*

FRIESEKE, FREDERICK (or FREDERIC) CARL (1874–1939). Painter of figures, garden scenes, landscapes, and murals, especially noted for rendering of sunlight and brilliant colors. Born in Owosso, Apr. 7, 1874, of German parents. Studied at Chicago Art Institute; in Paris under Benjamin-Constant, Laurens, and Whistler; Modern Gallery, Munich. Exhibited extensively in Europe and America. Resided at Giverney, France, most of the time. His "Before the Glass" was purchased by the French Government for the Luxembourg Gallery. Memberships: Société Nationale des Beaux Arts, Paris, (secretary), 1908; Chevalier of the Legion of Honor, 1920; Scarab Club of Detroit; ANAD 1912; NAD 1914; International Society of Artists; New York Water Color Club. Awards: Gold Medal, Munich, 1904; Silver Medal, Carnegie Institute; Corcoran Gallery prize, Washington, D.C., 1908; Grand Prize, Panama-Pacific Exposition, San Francisco, 1915; Silver Medal, St. Louis Exposition, 1904; Temple Gold medal, PAFA, 1913; Silver Medal and prize, 1916 and two Gold Medals and prize, 1920, Art Institute of Chicago; Philadelphia Art Club, 1922. Represented: City of Owosso; Museum of paintings, Odessa; Brooklyn Institute Museum; Corcoran Gallery of Art; Pennsylvania Academy; Syracuse Museum of Fine Arts; City Art Museum, St. Louis; Metropolitan Museum of Art, New York, Toledo Museum of Art. Died, Aug. 27, 1939, in France. *–Ref.: 3 (vol. 20, vol. 30); 13; 14; 56 (May 5, 1924, Jan. 24, 1937, Aug. 31, 1939); 61 (Aug. 31, 1939); 79; 101; 109; 114 (1916); 119; 121; 141; 146; 149; 153 (vol. 13, vol. 14); 163; 164*

FRISBIE, M. ANNETTE. Artist in Detroit, 1889–92. *–Ref.: 51 (1889–92); 118 (1891)*

FROST, ALICE L. Artist in Grand Rapids. *–Ref.: 118 (1899)*

FROST, MILDRED (1865–1946). Artist in oils and ceramics. Spent most of her life in Pontiac, but for a few years, ca. 1900–15, had a studio in Detroit. Died June 10, 1946. *–Ref.: 51 (1900–1915+); 61 (June 11, 1946)*

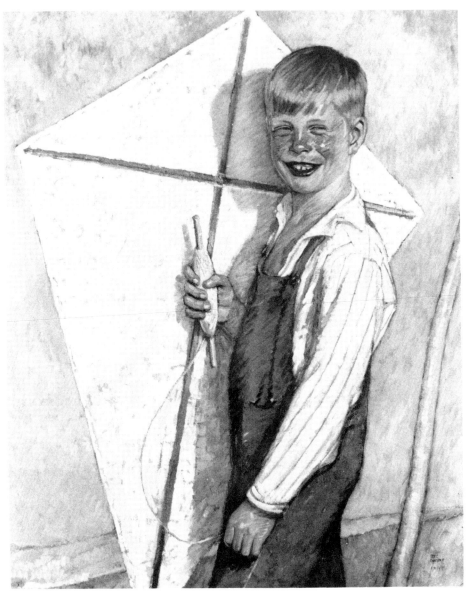

Roy C. Gamble, *Freckles*. Canvas, 36″ x 30″. From the collection of the
Detroit Institute of Arts. Purchase, City Appropriation.

George B. Gardner, *West Street from the College Campus, Hillsdale, Michigan.* Canvas, 9 1/8″ x 17 1/8″. From the collection of the Detroit Institute of Arts. Gift of Mrs. H.C. Miller.

FRY, LENA J. (Mrs. Stephen Fry). Amateur artist in Detroit, 1895–98. *–Ref.: 51 (1897–98); 118 (1895)*

FULLER, ADELLA RYAN. Artist in Lansing, 1899. *–Ref.: 118 (1899)*

FUNK, GEORGE C. Artist and lithographer in Detroit. Employed as a lithographer, 1887–92. Then moved to Chicago, Ill. Returned as an artist, 1896–1916. Studied at Julien School in Paris, and at the Société des Beaux Arts annually from 1913 to 1916, and again in 1918. *–Ref.: 51 (1887–92, 1896–1916); 60 (Feb. 28, 1896); 118 (1891)*

FUNK, WILLIAM. Crayon artist and photographer in Bangor, 1897. *–Ref.: 118 (1897)*

FURLONG, ATHERTON. Poet, tenor singer, and artist in Detroit, Odin, and Petoskey. Exhibited numerous paintings in local Detroit galleries, 1893 and 1894. *–Ref.: 51 (1894); 60 (Mar. 17, Apr. 14, May 11, June 24, Nov. 9 and 25, 1893); 68 (June 15, 1893); 118 (1895)*

G

GAGNON, THOMAS C. Portrait artist in Saginaw, 1899. *–Ref.: 118 (1899)*

GALE, (Mrs.) A. Oil and watercolor artist in Albion, 1882–83. Awards: prizes, Michigan State Fair, 1882 and 1883. *–Ref.: 65 (Sept. 20, 1883); 112 (Oct. 17, 1882, Oct. 16, 1883); 164*

GALE, AUGUSTA. Artist in Eaton Rapids, 1891. *–Ref.: 118 (1891)*

GALLAGHER, THOMAS L. Artist in Saginaw, 1885–91. *–Ref.: 118 (1885, 1887, 1889, 1891)*

GAMBLE, ROY C. (1887–1972). Portrait, landscape, and mural painter in Detroit. Born in Detroit, June 12, 1887. Studied at Detroit Fine Arts Academy; Art Students' League, N.Y.; Julien Academy, Paris. Founding member, Hopkin Club, where he won the Gold Medal in 1920. Represented in DIA, in which he exhibited for twenty-eight years; PAFA; and many public buildings. Died in Detroit, Mar. 30, 1972. *–Ref.: 51; 56 (Aug. 2, 1914, Dec. 12, 1920); 61 (July 23, 1940); 79; 101; 162; 163; 164; 165*

GARDNER, GEORGE BALTHAZAR (1835–1905). Professor of art at Hillsdale College, 1867–1900. Born in Grossegarten, Germany. Came to America as a boy, residing first at Pittsburgh, later in Buffalo and Port Huron. Married Henrietta Sares at Great Bend, Ohio, Sept. 16, 1855. Principal, Department of Art, Hillsdale College, 1867 until his resignation in Dec. 1900. Died at Hillsdale, Mar. 25, 1905. *–Ref.: 51 (1864/ 65); 56 (Sept. 16, 1868, Apr. 13, 1879); 64 (Sept. 11, 13, 14, 1867); 65 (Apr. 14, 1879); 73; 118 (1867–68); 123. 163; 164*

GARDNER, (Mrs.) MILES T. *See* NANETTE B. ELLINGWOOD.

GARDNER, (Mrs.) R. Artist in Jonesville, 1850. *—Ref.: 56 (Dec. 30, 1850)*

GARDNER, SARAH M. Artist in Ann Arbor, 1891–93. *—Ref.: 118 (1891, 1893)*

GARNER, LOTA H. Crayon and oil artist in Detroit, 1894. *—Ref.: 51 (1894)*

GARRETSON, (Mrs.) D. Watercolor artist in Kalamazoo, 1884. Award for a landscape exhibited, Michigan State Fair, 1884. *—Ref.: 112 (Nov. 4, 1884)*

GARRETSON, DELLA (Dillie) (1859–1940). Oil and watercolor artist in Detroit before 1892 and in Dexter, ca. 1892–1940. Twin sister of Lillie Garretson (q.v.). Born in Logan, Ohio, Oct. 3, 1859. Educated in Detroit Public schools. She and her sister always studied and worked together, first in Detroit and later, about 1892, in Dexter. Studied in Bruges and Paris. Exhibits: Art Institute of Chicago; St. Louis; Philadelphia; New York; for many years, DIA. Awards: two paintings accepted by the Paris Salon in 1902 won a Bronze Medal; Silver Medal, National Academy of Design, New York, 1893; a painting of Bruges admitted to the Paris Salon, 1934. Memberships: NAD, New York; Detroit Society of Women Painters and Sculptors; Scarab Club of Detroit. Died Feb. 27, 1940. *—Ref.: 13; 35 (Mar. 1925); 51 (1885–92); 56 (Feb. 28, 1940); 61 (Dec. 1, 1889, Feb. 28, 1940, June 22, 1952); 101; 118 (1887, 1889, 1891); 122; 149; 162; 163; 164*

GARRETSON, LILLIE (1859–1939). Oil and watercolor artist in Detroit before 1892, and in Dexter, ca. 1892–1939. Twin sister of Della Garretson (q.v.). Born in Logan, Ohio, Oct. 3, 1859. Educated in Detroit public schools. Studied in Bruges and Paris. For many years exhibited at the Detroit Institute of Arts. Memberships: Detroit Society of Women Painters and Sculptors; Scarab Club of Detroit. *—Ref.: 35 (Mar. 1935); 51 (1887–91); 60 (Dec. 8, 1893); 61 (Dec. 1, 1889, June 22, 1952); 112 (Nov. 2, 1886); 118 (1889, 1891); 122; 163; 164*

GATES, EDWIN A. (ca. 1875–1950). Amateur artist in Detroit. Works include landscapes, marines, and still life. Born in Detroit. Died in Detroit, Nov. 4, 1950. *—Ref.: 51 (1895–1905+); 61 (Nov. 5, 1950)*

GATES, MITTIE, (1861– ?). Amateur artist in Saginaw, 1875. She was a fourteen year old exhibitor and prize winner, Michigan State Fair, 1875. *—Ref.: 112 (Oct. 12, 1875)*

GAVOTT, W. C. Artist in Montogomery, 1895. *—Ref.: 118 (1895)*

GAWLEY, ISMENE H. Art student in Detroit, ca. 1890. Studied at Detroit School of Art and under Francis Paulus (q.v.) before going to

Della Garretson, *Portrait of Miss G.* Canvas, 28¾" x 19¾". From the
collection of the Detroit Institute of Arts. Gift of Mr. and Mrs. Ernest W.
Moreau.

Paris to continue studies. *–Ref.: 51 (1882–93); 60 (Oct. 13, 1894)*

GEDDES, JENNIE L. Artist in Battle Creek, 1893. *–Ref.: 118 (1893)*

GEER, LILLIE R. Artist in Greenville, 1870–79. Exhibits: Western Art Association, Detroit, 1870; Michigan State Fair, 1879. *–Ref.: 112 (Feb. 10, 1880); 164*

GEER, ROZETTA (Rosa). Portrait artist in Detroit, 1866–78. Exhibit: Western Art Association, Detroit, 1870. Professor of art, Coldwater Female Seminary, 1868–70. *–Ref.: 51 (1866–78); 112 (Oct. 8, 1870); 118 (1867); 164*

GENEST, LOUIS (1852–1895). Artist in Detroit, 1886–95. Associated with photography, and was probably a color portraitist. Died in Detroit, Aug. 30, 1895. *–Ref.: 51 (1886–96); 118 (1887, 1889, 1895)*

GEORGE, LENA. Artist in Benton Harbor, 1887–89. *–Ref.: 118 (1887, 1889)*

GERRY, VINA. Crayon artist in Detroit, 1895. *Ref.: 51 (1895)*

GIARDINI, ADOLPH G. Artist and ornamental plaster decorator in Detroit, 1893–94. Partner of Paul F. Martelli (q.v.), under the firm name of Martelli & Giardini (q.v.). *–Ref.: 51 (1893–94); 64; 118 (1893).*

GIBBONS, HELEN THORBURN (Mrs. Robert). Amateur artist in Detroit. Married Robert Gibbons in Detroit, 1866. *–Ref.: 164*

GIBBS, ANNIE. Art and music teacher in St. Johns, 1899. *–Ref.: 118 (1899)*

GIBBS, EDWARD T. Artist in Detroit, 1892–1900. Employed by a wholesale manufacturer of and dealer in picture frames and framed pictures, 1892–97. *–Ref.: 51 (1892–1900)*

GIBBS, WILLIAM W. (1821–1902). Portrait and landscape artist in Romeo, 1853–1900+. Born in Livonia, Livingston County, N. Y., Dec. 21, 1821, of New England origin, the son of David and Ruth (Woodruff) Gibbs. Worked as apprentice to a gunsmith and studied art with a local artist of his home town. Moved to Kalamazoo in 1848, to Armada in 1852, and to Romeo in 1853. In Sept. 1867, married Jane Lewis of Dryden. Designed and executed painting, "Father Marquette at St. Ignace in 1670," which was adopted by the United States government for a postage stamp, and later by the Michigan State Pioneer Society as the frontispiece to its 1903 volume. Died in Romeo, Dec. 29, 1902. *–Ref.: 75; 93; 118 (1863/64–1899); 164*

GIBSON, ANDREW B. Wood-carver and furniture designer in Grand Rapids, 1893–97. Partner in James A. Anderson & Co. (q.v.). *–Ref.: 86 (1893–97)*

GIBSON, ARTHUR HOPKIN (1888–1973). Artist, author, and businessman in Detroit, 1900–68. Born in Detroit, July 20, 1888, the son of

Joseph W. Gies, *Portrait of Robert Hopkin.* Canvas, 30″ x 22″. From the collection of the Detroit Institute of Arts. Gift of William C. Weber.

Frank B. and Sophronia A. (Hopkin) Gibson. Grandson of Robert Hopkin (q.v.). Spent early childhood in San Francisco. Returned to Detroit with mother, 1900, when parents were divorced. Self-educated beyond seventh grade. Self-taught in art except for mechanical and architectural drawing courses at Cass Technical High School, Detroit. Began working at age twelve, serving variously as errand boy, clerk, accountant, insurance salesman, contractor for residential buildings, insurance broker, and government auditor. Married Ella M. Andros in Detroit, 1910. One son, Colvin L. Gibson. Painted sporadically from boyhood, but after retirement from business in 1961, produced 102 marine and landscapes. Moved to son's home in Wheaton, Md., 1968. Memberships: honorary member, Scarab Club, Detroit; Montgomery County (Md.) Art Association. Represented in the permanent collections of the Detroit Historical Museum, Dossin Great Lakes Museum, and Burton Historical Collection. Author of *Robert Hopkin, Master Marine and Landscape Painter* (Ann Arbor, The Author, 1962). Died in Wheaton, Md., Apr. 11, 1973. Buried in Detroit. *—Ref.: Notes prepared by Arthur Hopkin Gibson, edited by Colvin Gibson.*

GIBSON, J. JEFFERSON (or Jefferson J.). Photographer in Detroit, 1888–90. Associated as partner in Bracy & Gibson (q.v.), 1888; Gibson & Cole (q.v.), 1889; and Diehl, Ladd & Co., 1890. *—Ref.: 51 (1888–90)*

GIBSON, (Mrs.) W. K. Amateur artist in Jackson, 1870–86. Exhibited and received awards at several Michigan State Fairs, 1870–86. *—Ref.: 112 (Oct. 8, 1870, Oct. 30, 1877, Sept. 22, 1881, Oct. 17, 1882, Nov. 2, 1886)*

GIBSON & COLE. Portrait artists in Detroit, 1889; J. Jefferson (or Jefferson J.) Gibson (q.v.) and Frederick A. Cole, (q.v.). *—Ref.: 51 (1889)*

GIDDEY (or GIDDAY), WILLIAM J. Amateur artist in Detroit, 1872–99. Exhibited a landscape in a local gallery, 1877. *—Ref.: 51 (1872/73–1899)*

GIES, JOHN H. Painter and artist in Reese, 1889–97. *—Ref.: 118 (1889, 1893, 1895, 1897)*

GIES, JOSEPH W. (1860–1935)). Portrait artist and painter of portraits, landscapes and genre-scenes, in Detroit, 1890–1935. Born in Detroit, June 18, 1860, the son of Conrad and Madeleine (Dinser) Gies. Educated in St. Mary's parochial school and at Detroit Business University. Studied at the Cooper Union, NAD, and Art Students' League in New York. Later studied under Bougereau and Robert-Fleury in Paris, and at the Royal Academy of Munich. After some years in Europe, returned

to Detroit, 1890, and joined the staff of the Detroit Museum of Art School, continuing there until it was abandoned in 1895. In September 1895, founded the Detroit Fine Arts Academy with Francis P. Paulus (q.v.) and continued as its director until 1911. Was also co-director with Paulus of the Ann Arbor Art School. Painted many portraits of prominent Michigan residents, some of which are now in the permanent collection of the Detroit Institute of Arts. Memberships: Scarab Club of Detroit and winner of the Scarab Medal in 1918; Society of Western Artists; Detroit Water Color Society; Detroit Artists' Association; and Society of Associated Artists. Unmarried. Died of a fall in his studio at Dearborn July 5, 1935. —Ref.: 3 (1915, 1923); 13; 19; 51 (1891–1900+); 56 (Oct. 30, 1898, Oct. 26, 1935); 60 (May 3, 24, Dec. 8, 1893; Mar. 19, Apr. 14, June 5, Sept. 18, Dec. 15, 21, 1894; Sept. 21, Dec. 3, 1895; Feb. 24, June 2, Sept. 12, Oct. 31, Dec. 12, 1896); 61 (Sept. 23, Dec. 4, 1928, June 18, 1934, Dec. 8, 1940, July 6, 1935); 66 (Feb. 18, 1928); 68 (Jan. 1, 8, 22, Mar. 5, 27, 1893); 79; 101; 109; 110; 118 (1891–97); 119; 146; 149; 163; 164

GILBERT, MAGGIE T.; GILBERT, MARGARET E. Amateur artists in Ypsilanti. Assumed to be daughter and mother respectively. Maggie T. was 16 when she exhibited at the Michigan State Fair, 1884. Margaret E. exhibited at the Michigan State Fair, 1887. —Ref.: 112 (Nov. 4, 1884, Oct. 31, 1887)

GILBERT, N. Amateur artist in Jackson, 1876. Exhibited some paintings and a crayon drawing, Michigan State Fair, 1876. —Ref.: 112 (Nov. 14, 1876)

GLASS, ALICE F. Artist in Flint. Maintained a studio there, 1889–1922. —Ref.: 80 (1922); 118 (1889–99)

GLASS (or GLAESS), H. Credited with an oil painting (1876) of The Dove, a side-wheel steamer built in 1865 which operated on the Detroit River for some years. Painting in collection of Dossin Great Lakes Museum, Detroit. —Ref.: 162; 164

GLASSMIRE, BEATRICE E. Artist in Grand Rapids, 1899. —Ref.: 86 (1899)

GLEESON, AGNES. Artist in Detroit, 1885–93. —Ref.: 51 (1885, 1893)

GLEN, OLIVE B. Amateur artist in Detroit. Variously artist or dressmaker, 1886–99. —Ref.: 51 (1886, 1899)

GLOVER, DENNET. Artist in Detroit. Moved before 1893 to Philadelphia, Pa. Invited to exhibit by the Detroit Artists' Association, 1893. —Ref.: 68 (Jan. 29, 1893)

GLOVER, (Mrs.) M. J. Amateur artist in Kalamazoo, 1885. Award: premium, Michigan State Fair, 1885. —Ref.: 112 (Oct. 27, 1885)

GODFREY, JEREMIAH. Interior and ornamental decorator in Detroit, 1850. Associated with John Atkinson (q.v.) (artist) under the firm name of Atkinson and Godfrey (q.v.). *—Ref.: 56 (Aug. 2, 1850)*

GODFREY, JOSEPH. Interior and ornamental decorator in Detroit (1866–67). Associated with Robert Hopkin (q.v.) in the firm of Godfrey, Dean & Co. (q.v.) *—Ref.: 51 (1866/67)*

GODFREY, DEAN & CO. Interior and ornamental decorators in Detroit, 1866–1867; Joseph Godfrey (q.v.), Horace W. Dean (q.v.) and Robert Hopkin (q.v.) *—Ref.: 51 (1866/67)*

GOODISON, JOHN (1834–1892). Professor of drawing and geography at the Michigan State Normal College in Ypsilanti, 1857–92. Born in Sheffield, England, Oct. 25, 1834. Came to America in 1852. In 1853 established a drawing academy in Detroit. About 1857, went to Ypsilanti to join the college staff. In Aug. 1861, married Harriet H. Hawkins and moved to Eaton Rapids, later returning to the Normal College at Ypsilanti. Exhibits: Michigan State Fairs; Detroit Artists' Association; and local galleries. Died in Ypsilanti, Oct. 19, 1892. *—Ref.: 15 (Feb. 28, 1865); 51 (1853–56); 53 (Sept. 7, 1853); 112 (Nov. 1854); 118 (1863/64); 137; 164*

GOODMAN, ARTHUR J. Portrait artist in Detroit, 1877–78. Exhibited at local galleries. Went to Boston for further study. *—Ref.: 56 (Nov. 8, 1877; Mar. 27, May 30, Aug. 11, 18, Sept. 22, 1878)*

GOODMAN, CLARA M. Artist in Detroit, 1895–99. *—Ref.: 51 (1895–99); 118 (1897, 1899)*

GOODMAN, JULIUS EARLE (Jules). Amateur artist in Detroit, 1882–98. Exhibited, Detroit Artists' Association, Apr., 1893. *—Ref.: 51 (1882–98); 60 (Apr. 18, 1893); 68 (Jan. 29, 1893)*

GOODRICH, WALLACE L. Pastel portraitist in Saginaw, 1871–75. Exhibited, Michigan State Fair, 1875.*—Ref.: 112 (Oct. 12, 1875); 142 (1871/72)*

GORDON, FREDERICK. Artist in Flushing, 1887–91. *—Ref.: 118 (1887–91)*

GOUTINK, EDWARD. Sculptor in Detroit, 1872–73. *—Ref.: 51 (1872/73)*

GRAM, CHARLES F. Decorative painter in Detroit, 1866–68. Associated with Frederick A. C. Beyer (q.v.), artist, in the firm of Beyer & Gram (q.v.). *—Ref.: 51 (1866/67, 1867/68)*

GRANGER, LEE W. Artist in Detroit, 1895–96. In 1900, an electrician. *—Ref.: 51 (1895, 1896, 1900)*

GRAVES, AMELIA M. (Mrs. Reuben C.). Artist in Grand Rapids, 1886–97. *—Ref.: 86 (1886–97); 118 (1887, 1893)*

GRAY, ALICE E. Artist in Detroit, 1890. —*Ref.: 51 (1890)*

GRAY, ANDREW TENNANT. Sign painter and amateur artist in Detroit, 1883–97. —*Ref.: 51 (1883–97); 118 (1891, 1893)*

GRAY, DANIEL J. Landscape painter in Detroit, 1875–84. Exhibits: Great Art Loan, 1883; various local galleries, 1877–79. —*Ref.: 51 (1875–84); 56 (Apr. 18, 1877, Apr. 16, 1878, Apr. 17, 1879); 65 (Apr. 13, 1879); 163*

GRAY, SYDNEY. Artist in Detroit, 1883. —*Ref.: 51 (1883)*

GREEN, BENJAMIN F. Artist in Detroit, 1895. Employed as a baggage-man for many years. —*Ref.: 51 (1895)*

GREEN, DANIEL WOOD (1848–1927). A lumber dealer and amateur artist in Saginaw 1875–89 and later Detroit, 1880–1927. Born in Portland, Maine, July 19, 1848. Awards: premiums for a pencil drawing of flowers and for a pastel of animals, Michigan State Fair, 1875. Died in Detroit, Aug. 23, 1927. —*Ref.: 51 (1880–1926); 56 (Aug. 24, 1927); 112 (Oct. 12, 1875); 142 (1875–79): 164*

GREEN, LUCY A. Amateur artist in Grand Rapids, 1895–98. —*Ref.: 86 (1886–1900)*

GREENING, JOSIE A. Artist in Bay City, 1897–1900+. —*Ref.: 12 (1905); 118 (1897, 1899)*

GREENMAN, CHARLES A. Wood-carver in Grand Rapids, 1873–1900+. Partner in Greenman & Dosch (q.v.), 1888–90, later its secretary and treasurer. In 1900, President, Grand Rapids Wood Carving Co. —*Ref.: 86 (1873–1900+); 118 (1889)*

GREENMAN & DOSCH. Carvers, ornament and mantel makers in Grand Rapids, 1888–90: Charles A. Greenman (q.v.) and Nicholas Dosch (q.v.) in 1888 and 1899, and Henry Dosch (q.v.) in 1890. —*Ref.: 86 (1888–90)*

GREENWOOD, IDA. Artist in Detroit, 1893. —*Ref.: 51 (1893)*

GREGORY, C. Portrait painter in Detroit, 1845. Possibly the Charles Gregory who exhibited in 1848, 1854, and 1873 in London, England. May have exhibited in Detroit also. —*Ref.: 13; 51 (1845); 164*

GRELLING, GOTTSCHALK. Photographer and artist in Detroit, 1863–73. Apparently worked originally as photographer, subsequently becoming identified as artist. Associated with Robert Chappee (q.v.), 1863. —*Ref.: 51 (1863/64+); 118 (1873)*

GRENIER, JOHN B. Wood-carver and carpenter in Detroit, 1885–1900+. —*Ref.: 51 (1885–1900+); 118 (1887)*

GRIDLEY, LOUISE M. Artist in Jackson, 1897. —*Ref.: 118 (1897)*

GRIFFIN, EDWARD J. Sculptor in Detroit, 1874–76. Exhibited a marble bust at a local gallery, 1876. —*Ref.: 51 (1874–76); 56 (July 18, 25, 1876)*

GRIFFIN, ELMORE L. (1849– ?). Businessman and amateur artist-engraver in Napoleon. Born in Napoleon, May 1, 1849, the son of Joshua Carpenter and Julia Ann (Burge) Griffin. Married Elizabeth Hill of Wellsville, N.Y., Sept. 1, 1866. Exhibited a steel plate engraving at the Michigan State Fair, 1877. *–Ref.: 49; 112 (Oct. 30, 1877)*

GRIFFIN, SYDNEY B. Lithographic artist; later a cartoonist in Detroit, 1873–88. Left lithographic work to become a cartoonist for the *Detroit News*. In 1888, went to New York, where his pen pictures were a popular feature of the leading comic weeklies of the period. *–Ref.: 3 (1933); 51 (1873–88); 61 (Jan. 4, 1931)*

GRIFFITH, ARMAND HAROLD (1860–1930). Artist, sculptor, and art critic in Detroit, 1891–1913. Born in Kingston, Ind., June 11, 1860, of English and Welsh ancestry, the son of Collins W. and Katherine (Conway) Griffith. Educated at home by his father, in the public schools of Cincinnati, at Wesleyan College and at Wittenberg College, Springfield, Ohio. Studied art at Dusseldorf, Germany. As a youth, was a sign painter, photographer, fresco painter, and actor. Director, Detroit Museum of Art for twenty-two years, 1891–1913. Then toured extensively, lecturing on art subjects. Finally settled in Santa Barbara, Calif., where he died Sept. 24, 1930. Memberships: Société des Sauveteurs du Dernier Adieu, of France, by which he was decorated; Salmagundi Club, New York; Society of Western Artists; Detroit Scientific Assn.; honorary member, Photographic Society of America. *–Ref.: 51 (1891–1913); 60 (Aug. 13, 1894); 61 (Sept. 25, 1930); 110; 118 (1899); 127 (Sept. 25, 1930); 139; 164*

GRIGGS, FANNY (1852– ?). Youthful art student in Detroit, 1867. Exhibited two paintings, at the age of 15, Michigan State Fair, 1867. *–Ref.: 64 (Sept. 12, 1867)*

GRINNELL, FRANK J. Crayon artist in Centreville, 1889. *–Ref.: 118 (1889)*

GROSS, EDWARD M. Artist and engraver in Detroit, 1875–80. Executed the illustrations for a historical atlas of Frontenac, Lennox, and Addington Counties, Ontario, Canada, 1878. *–Ref.: 51 (1875–80); 56 (Feb. 18, 1877, Apr. 19, 1878)*

GROTTKAU, PAUL. Photographer and crayon artist in Detroit, 1890–91. Moved to San Francisco, Calif., 1891. *–Ref.: 51 (1890–91); 118 (1891)*

GROVER, OLIVER DENNETT (1861–1927). Artist in Detroit, 1866–87, after which he moved to Englewood, Ill. Born in Earlsville, Ill., Jan. 29, 1861. Studied at University of Chicago; Royal Academy of Munich; Duveneck School, Florence; and with Laurens, Boulanger, and Lefebvre in Paris. Awards: Yerkes Premium, Chicago, 1892; Silver and Bronze

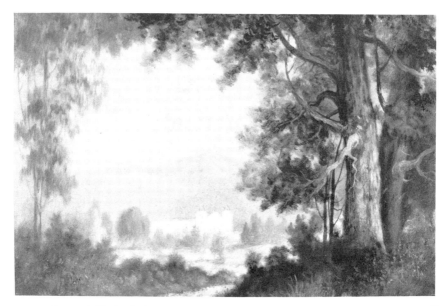

Armand H. Griffith, *Santa Barbara Mission.* Oil on composition board, 10″ x 13″. From the collection of the Detroit Institute of Arts. Gift of Mrs. C. A. Burck and Mrs. George E. Korten.

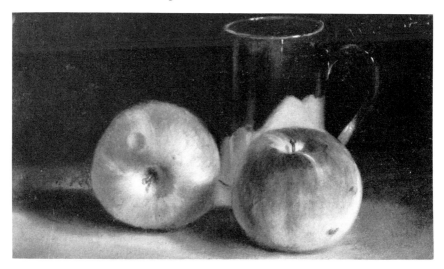

Armand H. Griffith, *Still Life.* Oil on composition board, 10″ x 13″. From the collection of the Detroit Institute of Arts. Gift of Mrs. C.A. Burck and Mrs. George E. Korten.

medals, Louisiana Purchase Centennial Exposition, St. Louis, 1904; Silver Medal, Panama Pacific Expo., San Francisco, 1915; French Memorial Gold Medal, 1918. Memberships: ANAD, 1913; Salmagundi Club, New York; National Association of Portrait Painters; National Arts Club; Arts Club of Chicago; Painters & Sculptors Association, Chicago; Alumni Association, Art Institute of Chicago; Society of American Artists; Society of Western Artists. Represented in Memorial Library, Branford, Conn.; Blackstone Memorial Library, Chicago; Art Institute, Chicago; City Art Museum, St. Louis; DIA; Cincinnati Museum; Chicago Public Library; Union League Club, Chicago. Died in Chicago, Feb. 14, 1927. —*Ref.: 3 (1898, 1927); 13; 51 (1886–87); 79;*

GRYLLS, (Miss) ? CECIL (possibly 1864–1958). Cecil Grylls, artist in Marquette, 1897–99. Possibly was the woman of the same name who died in Milford, May 23, 1958, at the age of 94, a former resident of Detroit. —*Ref.: 56 (May 24, 1958; 61 (May 24, 1958); 67 (May 24, 1958); 118 (1897, 1899)*

GUEST, ALBERT WALDO. Portrait artist in Detroit, ca. 1870–76. Probably born at Dexter, where his father was a pioneer settler. Son of Albert and Catherine (Waldo) Guest. Moved from Detroit, Grand Rapids, and then to Chicago. —*Ref.: 30; 51 (1873/74); 56 (July 26, 1876); 164*

GUHLE, CHARLES. Woodcarver and ornamental designer in Detroit, 1888. Moved to Toronto, Ontario, 1889. —*Ref.: 51 (1888)*

GUILD, (Mrs.) O.C. Artist in Detroit, 1855. Exhibit: two paintings, Michigan State Fair, 1855. Probably the wife of James Halsey Guild (q.v.). —*Ref.: 112 (Nov. 1855)*

GUILD, JAMES HALSEY (1797–ca. 1891). Artist in Detroit, 1855–56. Born in Halifax, Nova Scotia. Died in New York. —*Ref.: 51 (1855/56); 163*

GUNNISON, ? (Mrs. JOHN O.) Artist in Jackson, 1886. Award: prizes for oil paintings, Michigan State Fair, 1886. —*Ref.: 112 (Nov. 2, 1886)*

GUYETTE, (Miss) PERSIS A. Amateur artist in Cass City, 1899. —*Ref.: 118 (1899)*

GUYSI, ALICE VIOLA (1863–1940). Artist and art teacher in Detroit, 1896–1940. Born in Cincinnati, Ohio, Mar. 15, 1863, daughter of George W. and Harriet Susan (Kelly) Guysi. Sister of Jeanette Guysi (q.v.). Educated by resident governess and private tutors. Studied with William Sartain, New York, and for four years in Paris, with Colarossi Academy and Harry Thompson. About 1896, organized a class in pastel and miniature painting at the Detroit Museum of Art (now DIA). Exhibits: Paris Salon, 1891 and 1892. Director of Art in the Detroit public schools for 31 years. Subsequently was a teacher. Memberships:

Eastern Artists Association; Western Artists Association; Detroit Arts and Crafts Society; Detroit Society of Women Painters and Sculptors; Fine Arts Club, Detroit. Died at Birmingham, Mar. 23, 1940. *—Ref.: 3 (1898, 1933); 60 (Oct. 3, Dec. 7, 12, 1896, Jan. 9, 1897); 61 (Mar. 24, 1940); 79; 101; 122; 155 (1935–36); 171*

GUYSI, JEANETTE (1873–1966). Artist-craftsman in Detroit, 1896–1966. Born in Cincinnati, Ohio, Mar. 1, 1873, daughter of George W. and Harriett Susan (Kelly) Guysi. Sister of Alice Viola Guysi (q.v.). Educated by resident governess and private tutors. Studied with William Sartain, New York, and for four years in Paris under Colarossi Academy and Harry Thompson. Painting accepted and hung in the Paris Salon, 1891, an unusual honor for one so young. Memberships: Society of Arts & Crafts, Detroit; Western Artists Association; Detroit Society of Women Painters and Sculptors; Detroit Artists Association. Died in Birmingham, Jan. 6, 1966. *—Ref.: 3 (1898); 60 (June 2, Dec. 7, 1896, Jan. 9, 1897); 66 (Sept. 9, 1916); 79; 109; 122; 155 (1935–36); 163; 164; 171*

H

HACKETT, C. A. Artist in Napoleon, 1897–99. *—Ref.: 118 (1897, 1899)*

HADLEY, L. F. (or S. F.) Artist in Bear Lake, 1873–75. *—Ref.: 118 (1873–75)*

HAEFEKER, WILLIAM A. Transient portrait and figure painter in Detroit, 1893–95. Assistant to Joseph W. Gies (q.v.) at the Detroit Museum of Art School. Studied a number of years in Munich. Upon his return to the U.S., exhibited at the Cleveland Art Club and Detroit Society of Associated Artists. Later went to Chicago. *—Ref.: 51 (1894–95); 60 (Sept. 22, 1893, Dec. 15 and 21, 1894); 118 (1895); 163*

HAGUE, EDMOND H. (or EDMUND H.). Portrait artist in Jackson, 1877–91, and later in Detroit, 1894–1900+. *—Ref.: 51 (1894–1900+) 118 (1877, 1891)*

HAIGERMOSER, JOSEPH F. (ca. 1859–1947). Wood and stone carver in Detroit, 1874–1940. Born in Detroit. Associated with Frank Flierl (q.v.), 1888–92 as Haigermoser & Flierl (q.v.), wood-carvers. Died in Detroit, Mar. 24, 1947. *—Ref.: 51 (1874–1941); 118 (1887–89, 1893–99); 164*

HAIGERMOSER, PETER M. Wood-carver in Detroit, 1888–96. Probably a son or younger brother of Joseph F. Haigermoser (q.v.). *—Ref.: 51 (1888–98)*

HAIGERMOSER & FLIERL. Woodcarvers in Detroit, 1888—92: Joseph F. Haigermoser (q.v.) and Frank Flierl (q.v.). —*Ref.: 51 (1888—92); 118 (1891)*

HAIGH, MATTIE. Sculptress in Detroit, ca. 1893—94. Studied four years in Rome under Professor Guglieme. Exhibited marble and plaster bas-relief and bust pieces at the Detroit Museum of Art. —*Ref.: 60 (Nov. 9, 17, 25, 1893; Jan. 5, 1894)*

HAIST, CHARLES. Artist in Croswell, 1895. —*Ref.: 118 (1895)*

HALL, (Miss) ? . Amateur artist in Detroit, 1854. Exhibited a pencil drawing of a bust of Lord Byron, Michigan State Fair, 1854. —*Ref.: 112 (Nov. 1854)*

HALL, DAISY A. Artist in Bay City, 1899. —*Ref.: 118 (1899)*

HALL, HENRY M. Artist and designer in Detroit, 1878—1900+. Born in Ohio. Settled in Detroit about 1877. First painted scenic panels on Pullman Passenger Cars, and later was an artist and designer for Detroit's largest lithographing company. For several years he and his son, Roswell E. Hall (q.v.), were in business as fresco painters, producers of flags and banners, sign writers and decorators, under the firm name of Hall & Son (q.v.). Awarded several prizes for paintings, Michigan State Fair, 1883. —*Ref.: 51 (1878—1900+); 63; 112 (Oct. 16, 1883); 164*

HALL, JAMES (or JAMES L.). Portrait and miniature painter in Detroit, 1841—54. Exhibit: Gallery of Fine Arts, Detroit, 1852. —*Ref.: 51 (1853/54); 53 (July 24, Sept. 20, 1841); 164*

HALL, JOHN T. (or JONATHAN T.) Portrait artist in Detroit, 1895—98. —*Ref.: 51 (1895—98); 118 (1897)*

HALL, ROSWELL E. Artist in Detroit, 1879—85. For a few years, a partner with his father, Henry M. Hall (q.v.), under the firm name of Hall & Son (q.v.), fresco and general decorators. —*Ref. 51 (1879—85)*

HALL, WARREN A. Artist in Detroit, 1875—91. Credited with an oil painting of the ferry steamer *Fortune*. —*Ref.: 51 (1875—99); 56 (Sept. 7, 1875); 118 (1889)*

HALL, WILLIAM. Crayon portrait artist in Adrian, 1877—83. —*Ref.: 1 (1878); 118 (1877, 1881, 1883)*

HALL & SON. Portrait and landscape artists, fresco and general decorators in Detroit, 1884—85: Henry M. Hall (q.v.) and Roswell E. Hall (q.v.). —*Ref.: 51 (1884—85)*

HALLETT, JAMES. Artist in Grand Rapids, 1895—1900+ —*Ref.: 86 (1895—1900+); 118 (1897, 1899)*

HAMBY (or HAMLEY), CHARLES. Artist in Detroit, 1883. —*Ref.: 118 (1883)*

HAMILTON, ALEXANDER R. Artist in Detroit, 1890—1900+. —*Ref.: 51 (1890—1900+); 118 (1891)*

HAMMOND, MAGGIE. Amateur artist in Detroit, 1896. *–Ref.: 51 (1896)*

HANLEY, (Mrs) L. C. Member, Detroit Water Color Society, 1897. *–Ref.: 164*

HANNA, JAMES EDWARD (1858–1920). Art dealer and expert on paintings and art objects, in Detroit, 1876–1900+. Born in Meaford, Ontario, Mar. 23, 1858, the son of Constantine and Jane (Johnson) Hanna. Educated in Detroit public schools. Married Apr. 7, 1881, to Jennie Kerr in Detroit. Began career with Andrew J. Brow (q.v.), Detroit art dealer, 1876–80, then became a partner in Hanna & Ives, later Hanna & Noyes, to which he succeeded in 1899. Made numerous extensive trips to the art centers of Europe, returning with valuable paintings and other art treasures. Died in Detroit, May 6, 1920. *–Ref.: 51 (1881–1900+); 61 (May 7, 1920); 110*

HANSEL, JOSEPH L. Portrait artist in Detroit, 1883–1937. Associated with Truman S. Fisher (q.v.) in 1888, under the firm name of Fisher & Hansel (q.v.), artists. Wife's name was Ida. *–Ref.: 51 (1883–1940); 118 (1891–99)*

HARDING, ELIZABETH M. Oil painter in Detroit, 1887–99. *–Ref.: 51 (1887–99); 118 (1897)*

HARDING, FANNIE. Artist in Detroit, 1885–87. *–Ref.: 51 (1885, 1887)*

HARDING, SPENCER S. (1808– ?). Portrait painter in Jonesville, 1870–85. Born in Madison County, N.Y. Apr. 23, 1808, of Scotch and English ancestry, the son of Abiel and Olive (Smith) Harding. Exhibits: Athenaeum, Boston, 1835; at Charleston, South Carolina, Dec. 1839; Apollo Club, New York, 1840; and Boston, 1844/45 and 1848. Married Louisa T. Dana, of Athens, Ohio, on Apr. 6, 1847. Established residence in Jonesville, 1870. *–Ref.: 118 (1885); 128; 134; 164*

HARDY, ? . Artist presumably in Detroit, 1879. Painting "Coming In of the Tide" exhibited at Michigan State Fair, 1879. *–Ref.: 65 (Sept. 18, 1879)*

HARPER, FRANK J. Portrait artist in Detroit, 1890–94. In 1890, in partnership with Emery (or Emory) J. Wilson (q.v.) as proprietors of the American Portrait Co. *–Ref.: 51 (1890–94)*

HARPER, HOBART W. Artist in Detroit and Grand Rapids, 1887–89. In 1887, partner of William L. Knowles (q.v.), under the firm name of Knowles & Harper (q.v.), artists, in Detroit. Thereafter moved to Grand Rapids. *–Ref.: 51 (1887); 86 (1888–89)*

HARPER & WILSON. Portrait artists in Detroit, 1890. Proprietors of the American Portrait Co.: Frank J. Harper (q.v.) and Emery J. Wilson (q.v.). *–Ref.: 51 (1890)*

HARRINGTON, NELLIE. Amateur artist in Detroit, 1890. Exhibit: still

life work, Michigan Artists' annual exhibit, Angell's Gallery, 1880. —*Ref.: 56 (Apr. 13, 1880); 157*

HARRIS, DORA BALLARD (Mrs. Frederick C.). Oil and watercolor artist in Detroit, 1890s. Exhibited in Detroit and Cleveland. Memberships: Detroit Art Association, Detroit Water Color Society, and Art Club of Detroit. —*Ref.: 51 (1890–91); 60 (Dec. 21, 1894, May 21, 1895, Dec. 13, 1895); 101; 118; 163; 164*

HARRIS, HENRY H. Artist in Detroit, 1875–79. Member: Detroit Art Association. Exhibits: Angell's Gallery, 1875, 1876, 1877. —*Ref.: 51 (1875–79); 56 (Feb. 1, 1876, Mar. 25, 1877); 164*

HARRIS, JANE (Jenny) M. (Mrs. Roswell) (1846–1936). Artist originally in Saginaw and for over fifty years in Detroit. Born in Castleton, Vt. Died in Detroit, Feb. 7, 1936. —*Ref.: 51 (1890–1900+); 56 (Feb. 9, 1936); 118 (1887–99); 164*

HARRIS, LANDER S. (1868–1920). Amateur artist and businessman in Detroit, 1886–1900+. Born in New York State, Sept. 6, 1868. Son of Edward M. and Jane (Valette) Harris. Brought to Detroit at age ten. Educated in public schools of New York and Detroit. Married Blanche Burton. Exhibited at Detroit Museum of Arts, first annual exhibit, 1886. Died in Detroit, Oct. 27, 1920. —*Ref.: 19; 51 (1889–1901+); 163; 164*

HARRISON, ADDIE. Artist in Eaton Rapids, 1899. —*Ref.: 118 (1899)*

HARRISON, LOUISE (or LOUISA) T. (Mrs. Russell) (? –1911). Artist and china decorator in Detroit, ca. 1882–1900+. Studied oils and drawing in Chicago and New York, and watercolor under Sanderson of Boston, and John Owen (q.v.) of Detroit. Taught oils, watercolor and drawing at the Ottawa Normal School in Kentucky, and in Detroit. Charter member, Detroit Society of Women Painters. Died in Detroit. —*Ref.: 51 (1857–1900+); 61 (Jan. 19, 1896); 118 (1897–99); 122*

HARROUN, HATTIE M. Artist in Grand Rapids, 1894–1900. —*Ref.: 86 (1894–1900); 118 (1899)*

HART, MIRIAM. Artist in Detroit, 1896–99. Student at Detroit Art Academy under Joseph W. Gies (q.v.). Exhibits: oil and watercolor landscapes and portraits, Detroit Water Color Society and the Chicago Art Institute. Several works reproduced in *Truth* magazine. Member: Detroit Artists' Association. —*Ref.: 51 (1897–1899+); 60 (Jan. 15, June 2, Oct. 31, 1896); 118 (1897, 1899); 164*

HARTING, H. *See* HARTING, MARINUS.

HARTING, MARINUS (? –1861). Landscape and portrait painter in Grand Rapids, 1854–61. Native of Delft, Holland. Early education in Rotterdam. Settled in Grand Rapids in 1854. Exhibited Dutch land-

scapes: National Academy, New York; American Art Union; Pennsylvania Academy; Maryland Historical Society. Died in Grand Rapids, Mar. 8, 1861. —*Ref.: 11; 53 (Mar. 11, 1861); 56 (Mar. 23, 1861); 112 (Nov. 1858); 128; 164*

HARTMAN, CARROLL S. Artist in Grand Rapids, 1885. —*Ref.: 118 (1885)*

HARTSELL, PHILIP (or PHILIP U.) *See* HARTSWELL, PHILIP H.

HARTSON, ADDIE. Crayon artist in Eaton Rapids, 1895–97. —*Ref.: 118 (1895, 1897)*

HARTSWELL, PHILIP H. (or PHILIP U.) (ca. 1844–1902). Landscape and portrait artist in Detroit, 1870–95. Exhibits: at Angell's Gallery, Detroit, 1877; Detroit Museum of Art (now DIA), 1886. City directory listings frequently refer to him as Hartsell. Died in Detroit, Feb. 26, 1902. —*Ref.: 51 (1870–95); 68 (Feb. 26, 1902); 118 (1875–93); 163; 164*

HARVEY, ARCHIBALD. Artist in Detroit, 1893. —*Ref.: 51 (1893)*

HARWOOD, CONRAD. Artist in Detroit, 1857–58. —*Ref.: 51 (1857/58)*

HASBROOK, (Miss) K. Young art student in Jackson, 1876. Under age 14, awards: several premiums for paintings in oil and drawings, Michigan State Fair, 1876. —*Ref.: 112 (Nov. 14, 1876)*

HASKELL, JOSEPH ALLEN. Artist in Detroit, 1852–53. Received honorable mention for portrait, Michigan State Fair, 1852. —*Ref.: 56 (Mar. 16, 1853); 112 (Oct. 1852)*

HASLETT, LILLIAN E. Amateur artist in Detroit, 1891–99. —*Ref.: 51 (1891–99); 118 (1899)*

HATHAWAY, ABBY WATKINS (Mrs. James C.). Miniature artist active in Detroit at the turn of the century. Studied under Joseph W. Gies (q.v.) and at Detroit Museum of Art School in Detroit; in Dresden under Wilhelm Ritter and Claudius, 1893; later under Franz Till and Herr Lamm. Studied in Paris at Vitti Studios, 1895–98. Exhibits: two miniatures in the Paris Salon, 1907; and landscape, portrait, and miniature works, Detroit Water Color Society. —*Ref.: 51 (1898–1900+); 56 (Feb. 12, 1899)*

HAWKS, (Rev.) MATTHEW C. (1851– ?). Minister and amateur artist in Detroit, 1879–1900+. Born in Wheeling Township, Cook County, Ill., Aug. 18, 1851. Showed two landscapes, Detroit Water Color Society exhibitions 1893 and 1895. —*Ref.: 51 (1887–1900+); 60 (Dec. 8, 1893, Dec. 13, 1895); 164*

HAWLEY, GEORGE R. (? –1886). Photographer and portrait artist in Detroit, 1880–86. Associated with Charles W. Earle as commercial photographers in 1883 and 1884. Executed portraits in watercolors,

crayon and India ink. Died in Detroit, Nov. 14, 1886. *–Ref.: 51 (1880–87); 118 (1885)*

HAWORTH, EDITH E. Artist in Detroit, 1897–1900+. Exhibits: Detroit Water Color Society and DIA numerous times, 1905–24. Member: Detroit Society of Women Painters and Sculptors. *–Ref.: 51 (1897–1900+); 163; 164*

HAYDEN, CATHERINE (Kate). Amateur artist in Saginaw, 1871–75. Award: premium for paintings, Michigan State Fair, 1875. *–Ref.: 112 (Oct. 12, 1875); 142 (1871/72)*

HAYDEN, MARY P. (Mrs. Hanry A.) Artist in Jackson, 1876–77. Exhibits: landscapes and other work in oils, Michigan State Fairs, 1876 and 1877. *–Ref.: 112 (Nov. 14, 1876, Oct. 30, 1877)*

HAYWARD, FRANK HAROLD (1861–1945). Portrait painter with studios in Mt. Clemens and Detroit. Born in Romeo, June 30, 1861, the son of Abner and Alice (Smith) Hayward. Educated in public schools of Mt. Clemens. Studied under W. B. Conley of Detroit, at the Art Institute of Chicago under Vanderpool and Frier, and in Paris under Whistler, Jean Paul Laurens and Benjamin-Constant. Married Olive Bell Hull of Albion, July 12, 1898. Painted portraits of many United States governors and European notables. Exhibits: Paris Salon, 1900; Royal Academy of England, 1901; Pan-American Exposition, Buffalo, N.Y., 1901; Louisiana Purchase Centennial Exposition, St. Louis, Mo., 1904. Memberships: life member, Paris American Art League and the Art Institute of Chicago. President, Hayward Academy of Fine Arts, Detroit. Died in Detroit, July 2, 1945. *–Ref.: 3 (vol. 12, 1935); 51 (1926–39); 56 (July 1, 1941, July 1, 1945); 61 (Jan. 22, 1939, July 3, 1945); 75; 109; 111; 112 (Nov. 1886, Nov. 1887); 118 (1891–99); 164; 165*

HAYWOOD, HENRY D. Portrait artist in Ypsilanti, 1863–64. *–Ref.: 118 (1863/64)*

HAYWOOD, S. GRANT. Young artist in Ypsilanti, 1878–79. Exhibits: Michigan State Fairs, 1878 and 1879. *–Ref.: 56 (Sept. 18, 1879); 112 (Oct. 24, 1878, Sept. 18, 1879, Feb. 10, 1880)*

HEALY, THERON. Artist in Battle Creek, 1893–95. *–Ref.: 118 (1893, 1895)*

HECKSHER, LYDIA A. Artist in Grand Rapids, 1891–93. *–Ref.: 86 (1891–93); 118 (1893)*

HEINEMAN, DAVID E. (1865–1935). Lawyer, politician, and publicist in Detroit. Born in Detroit, Oct. 17, 1865, the son of Emil and Fanny (Butzel) Heineman. Educated in Detroit public schools, and at the University of Michigan. Responsible for the development of the Civic

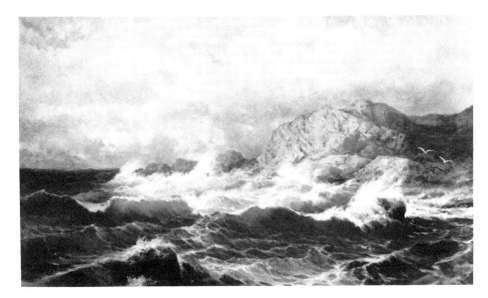

Joseph A. Hekking, *The Coast of Maine,* Oil on Canvas, 22" x 38". From the collection of the Detroit Institute of Arts. Gift of Percy K. Loud.

Art Center of Detroit. Designed official Flag of the City of Detroit, first flown on the City Hall, June 12, 1908. Married Mrs. Tessa Demmon in 1919. Died Feb. 21, 1935. *—Ref.: 56 (Feb. 23, 1935); 61 (Feb. 22, 1935); 110; 164*

HEINEMAN, OTTO. Artist in Saginaw, 1889. *—Ref.: 118 (1889)*

HEINRICH, ROY FREDERICK (1881–1943). Artist in Detroit, ca. 1900 (?). Moved to New York and became known as a commercial illustrator. Born in Goshen, Ind. Married Ruth Myer of Detroit about 1930. Died in New York, Dec. 15, 1943. *—Ref.: 56 (Dec. 17, 1943); 109*

HEKKING, JOSEPH ANTOINE (1830– ?). Landscape and marine artist in Detroit at various times, 1865–1903+. Born in the Netherlands. Exhibited at the National Academy, New York, in 1859. Subsequently worked in Connecticut. Served in the Civil War with a New York regiment. After war service, exhibited in Detroit at the Ladies' Michigan State Fair of 1865. Then went to Paris for further studies, returning to Detroit in 1878, but announcing his intention of residing in London, England. It is not known whether he did leave at that time, since he exhibited at DIA, and its predecessor, the Detroit Art Museum, 1883, 1886, 1889, and 1949, and at the Detroit Artists' Association, 1875–76 and 1893. In 1903, returned to Detroit and took up residence at his former home on Grosse Ile. *—Ref.: 15 (Feb. 28, 1865); 50 (June 23, 1878); 51 (1882–83); 56 (June 20, 21, 1878, Apr. 6, 1883); 60 (Apr. 18, 1893); 65 (Feb. 12, Dec. 17, 1882); 68 (Sept. 19, 1903); 72 (June 1885); 78; 118 (1883); 128; 163; 164*

HELLENBERG, BERNARD. Woodturner in Detroit, 1865–66. Associated with Charles B. Seitz (q.v.) as Charles B. Seitz Co. (q.v.), 1865–66. *—Ref.: 51 (1865/66)*

HELLENBERG, FREDERICK. Woodturner in Detroit, 1864–69. *—Ref.: 51 (1865–69)*

HEMENWAY, M. ESTELLE. Artist in Birmingham, 1883–85. Exhibit: three oil paintings, Michigan State Fair, 1883. *—Ref.: 118 (1885); 164*

HEMMING, J. CHARLES. Artist associated with George H. Crouffond (q.v.) in the firm of Hemming & Crouffond (q.v.), Detroit, 1885. *—Ref.: 118 (1885)*

HEMMING & CROUFFOND. Artists associated in Detroit, 1885: J. Charles Hemming (q.v.) and George H. Crouffond (q.v.). *—Ref.: 118 (1885)*

HENDRICKS, MARIE. Artist in Detroit, 1899–1900. *—Ref.: 51 (1899, 1900)*

HENN, (Lieut.) EDWARD (or Edmund). *See* E. H.

HENRICH, FREDERICK WILLIAM. Landscape artist in oils and water-

colors, in Detroit, 1880–1900+. Exhibits: Detroit Museum of Art, 1883, 1886, 1890, 1905, 1911–12, 1949; American Water Color Society, N. Y., 1894; National Academy, N. Y. The paintings of the latter exhibition were later shown at the opening of the Chicago Institute of Arts. Memberships: Hopkin Club; Scarab Club. *—Ref.: 51 (1880–1900+); 60 (Apr. 25, 1893, Mar. 24, Sept. 18, Nov. 24, Dec. 29, 1894, Oct. 30, 1895); 68 (Mar. 19, 1893); 163; 164; 165*

HENRY, D. G. & CO. Fresco artists in Grand Rapids, 1886–89: Delos G. Henry (q.v.) and Frank Selzer, Sr. (q.v.) 1886; and Delos G. Henry (q.v.) and Mary Henry (q.v.), 1889. *—Ref.: 86 (1886); 118 (1889)*

HENRY, DELOS G. Artist and fresco painter in Grand Rapids, 1883–92. In 1886, in partnership with Frank Selzer, Sr. (q.v.) under the firm name of D. G. Henry & Co. (q.v.), fresco artists, and in 1889 with Mary Henry (q.v.) under the same firm name. *—Ref.: 86 (1883–92); 118 (1885)*

HENRY, MARY. Partner of Delos G. Henry (q.v.) in D. G. Henry & Co. (q.v.), fresco artists, in Grand Rapids, 1889. *—Ref.: 118 (1889)*

HENSALL, JOSEPH. Artist in Detroit, 1885. *—Ref.: 51 (1885)*

HENSTED, NELLIE S. Amateur artist in Fenton, 1884–85. Awards: premiums for a pastel portrait and paintings on silk and velvet, Michigan State Fairs, 1884 and 1885. *—Ref.: 112 (Nov. 4, 1884, Oct. 27, 1885)*

HEUEL, ROBERT. Partner in Heuel & Ullmer (q.v.), artists of Grand Rapids, 1886. *—Ref.: 86 (1886)*

HEUEL & ULLMER. Artist partnership in Grand Rapids, 1886: Robert Heuel (q.v.) and William Ullmer (q.v.). *—Ref.: 86 (1886)*

HEWINGS, E. F. Artist in Battle Creek, 1887. *—Ref.: 118 (1887)*

HICKCOX, T. N. Painter of decorative window shades, screens and signs in Detroit, 1849. Also cut copper brand plates for merchandise packing cases. *—Ref.: 56 (Dec. 31, 1849); 164*

HICKEY, SARAH M. (or SARAH A.). Artist in Detroit, 1885–94. *—Ref.: 51 (1885–94); 118 (1891, 1893)*

HIGGINS, FRANK. Artist in Jackson, 1876. Awards: prize for a collection of ink and pencil drawings, Michigan State Fair, 1876. *—Ref.: 112 (Nov. 14, 1876)*

HIGGINS, MATIE. Artist in Jackson, 1882. Exhibit: pen-and-ink work, Michigan State Fair, 1882. *—Ref.: 112 (Oct. 17, 1882)*

HIGHAM, ADELAIDE I. Oil and watercolor artist in Detroit, specializing in floral paintings and occasional landscapes, 1883–1906. Exhibits: Detroit Museum of Art's first annual exhibit, 1886; Detroit Water Color Society, 1886, May 1889, Dec. 1889; Art Club of Detroit, 1895.

Probably a sister of Agnes G. Higham (q.v.). *—Ref.: 51 (1879—1906); 60 (May 21, 1895); 61 (Dec. 1, 1889); 68 (Oct. 10, 1886); 118 (1887—97); 163; 164*

HIGHAM, AGNES G. Watercolor artist in Detroit, 1879—89. Manager, Decorative Art Society, Detroit, 1880—89. Probably a sister of Adelaide I. Higham (q.v.). Exhibited and received a prize, Michign State Fair, 1880. *—Ref.: 51 (1879—1916); 112 (Oct. 12, 1880); 118 (1885)*

HIGHWOOD, CONRAD (? —189?). Portrait and landscape painter in Detroit, 1855—64. Born in Bavaria as Conrad von Hochholzer, but used the name Highwood after coming to America. Executed portraits of many well known persons in Detroit, and one of Henry Clay, in New York, 1850. He and his wife, Laura, sold property in Wayne County in 1861. Reported to be in Chicago, 1875. Served in the Civil War as a captain of cavalry. Exhibit: Michigan State Fair, 1856. Died in Providence, R. I., in the 1890s. *—Ref.: 51 (1855/56—1863/64); 53 (Dec. 31, 1856, July 7, 1857); 56 (Sept. 30, 1875); 79; 112 (Nov. 1856); 163; 164*

HILL, IDA (1868— ?). Young oil painter in Detroit, 1878—79. Exhibits: Michigan State Fairs, 1878 and 1879, and was awarded prizes for the best paintings by a person under sixteen. Thought to be the daughter of William P. and Fany Hill, who had a daughter born Nov. 23, 1868. *—Ref.: 112 (Oct. 24, 1878, Feb. 10, 1880); 164*

HILL, JOAN E. Artist in Battle Creek, 1893. *—Ref.: 118 (1893)*

HILL, MARY E. (? —1913). Artist in Ann Arbor, 1897—99. Lost one hand and learned to paint with the other. Died January 1913. *—Ref.: 6 (1899); 118 (1897); 164*

HILLS, JAMES W. Artist in Detroit, 1893; painter, 1895 and 1898. *—Ref.: 51 (1892—1900)*

HILLYER, HENRY L. Artist in Grand Rapids, 1883. *—Ref.: 86 (1883)*

HINCHMAN, JOHN HERBERT (1884— ?). Genre painter. Born in Detroit, Apr. 4, 1884, the son of Charles Chapin Hinchman. Pupil of John Palmer Wicker (q.v.), Detroit School of Arts; also studied at Julien Academy, Paris. Memberships: American Artists Society, Paris; California Art Club; San Diego and Laguna Beach Art Association, Calif.; American Painters League. Last known residence in Calif. *—Ref.: 3 (vol. 30, 1933); 13; 61 (Oct. 27, 1929, Oct. 14, 1934); 66 (Sept. 9, 1916); 163*

HINSDALE, NEHEMIAH C. (1834— ?). Sculptor in stone in Detroit, 1894—1900. Born in Syracuse, N. Y., Feb. 28, 1834. Apprenticed to a stone cutter in Syracuse, 1846. In 1867, moved to Chicago, Ill., as a general contractor and builder. In New Orleans, 1880—84; Indianapolis,

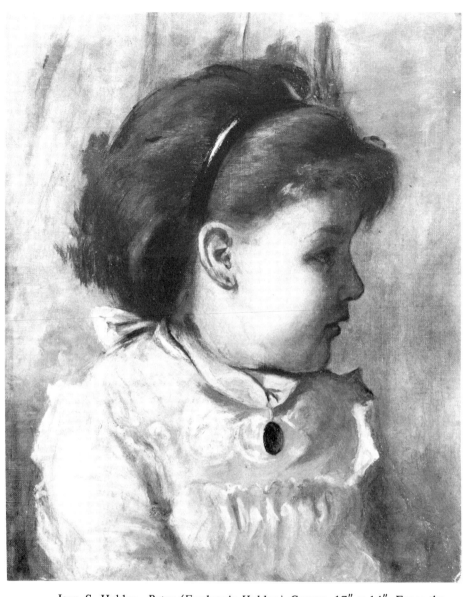

Jean S. Holden, *Patsy (Euphemia Holden)*. Canvas, 17″ x 14″. From the collection of the Detroit Institute of Arts. Gift of Miss Euphemia Holden.

1892–94. Moved to Detroit, 1894, and specialized in the designing and building of mausoleums. In 1899, associated with Alexander Chapoton, Jr. (q.v.), under the firm name of Chapoton & Hinsdale (q.v.). In 1900, returned to Chicago. –*Ref.: 51 (1897–1900); 139*

HOCHHOLZER, CONRAD VON. *See* HIGHWOOD, CONRAD.

HODGES, CHARLES CARROLL (1830–1901). Artist in oils and water-colors in Detroit, 1863–1901. Engaged in insurance and industrial manufacturing. Painted on summer vacations in New England and Canada. Born at South Hero, Grand Isle County, Vt., July 22, 1830, the son of Nathaniel and Clara (Phelps) Hodges. Educated at public schools. Moved to Battle Creek, 1852; to Detroit, 1863. Married Harriet Pew of Battle Creek in 1853. One of the organizers of the Detroit Water Color Society, and was its president at the time of his death, Dec. 28, 1901. Produced a great number of landscapes shown at exhibitions: DIA, 1886, 1889–91, 1895; Detroit Artists Association, 1891; Cleveland Art Club, 1894; and local show rooms. –*Ref.: 51 (1870/71–1902); 54 (Feb. 5, 1872); 56 (Apr. 13, 1880: 60 (May 7, Dec. 15, 21, 1894, Dec. 13, 1895); 61 (Dec. 1, 1889); 68 (Apr. 30, 1894); 103; 121; 163; 164*

HODGES, GEORGE SCHUYLER (1864–1953). Artist, etcher, inventor, and automobile manufacturer in Detroit, 1890–1915. Born in Pontiac, Mar. 3, 1864. Went to Paris in 1892 and studied three years at École des Beaux Arts, and at the Julien Academy under Gerome. Exhibits: DIA, 1890, 1898, 1911–12, 1915–1934, 1949; Society of Associated Artists, Detroit, 1894; Pan-American Exposition, Buffalo, 1901. Memberships: Art Association, Paris; one of the founders of the Scarab Club, Detroit; at time of his death, was the last surviving member of the Hopkin Club. Died Apr. 11, 1953 at Pine Lake. –*Ref.: 13; 51 (1890–1915); 56 (Apr. 14, 1953); 60 (Dec. 15, 1894); 61 (July 23, 1940, Apr. 14, 1953); 68 (Jan. 29, 1893); 109; 149; 163*

HOEK, HENRY. Fresco painter in Detroit, 1871–1917. –*Ref.: 51 (1871–1917)*

HOEY, MINNIE H. (or MARY H.) Artist in Grand Rapids, 1888–1900+. –*Ref.: 86 (1888–1900+)*

HOFFMAN, OSCAR. Art student at the Detroit School of Art. Received honorable mention in an exhibition there, 1893. Employed as a mechanic, 1877–1900. –*Ref.: 51 (1877–1900); 60 (June 24, 1893)*

HOFFMASTER, MAUD MILLER (1886– ?). Artist in Traverse City, 1934. Born in Manistee. Exhibit: DIA, 1930. –*Ref.: 109; 163*

HOLDEN, CLARENCE C. Artist in Yale, 1893–99. –*Ref.: 118 (1893–99)*

HOLDEN, JEAN STANSBURY (Mrs. Edward G.) (ca. 1843–1934). Author, poet, and artist in Detroit 1871–1907. Born in Pinckney in

1842 or 1843. Studied at Cooper Union in New York, and abroad. Married in 1874. Taught elementary classes in art, wood carving, metal work, and designing, at Detroit Museum of Art School, and later at a Chicago school for young ladies. Exhibits: Detroit Artists Association, 1876; Michigan Art Association, 1879. Died in Tryon, N. C., May 19, 1934. *—Ref.: 56 (Feb. 1, 1876, Apr. 13, 1879, May 20, 1934); 72 (Jan. 1886); 163; 164*

HOLMAN, JANE S. Artist in Kalamazoo, 1887; Detroit, 1889; Grand Rapids, 1900. Credited with the painting "United States Fort at Detroit." *—Ref.: 51 (1889); 118 (1887); 164*

HOLMES, ELIZA J. Artist in Fenville (Fenton), 1887–91. *—Ref.: 118 (1887, 1889, 1891)*

HOLMES, EMMA SHAW (Mrs. Ross H.). Artist in Detroit, 1880–81. Exhibited an oil painting, Michigan State Fair, 1880. Married Ross H. Holmes in Pontiac, May 2, 1871. *—Ref.: 112 (Oct. 12, 1880); 118 (1881); 164*

HOLSLAG, EDWARD J. (1870–1924). Painter and mural designer in Detroit, 1883–93. Born in Buffalo, N. Y. Studied art at Detroit School of Art, winning a scholarship in 1892; at NAD; and with John LaFarge, New York. President, Palette & Chisel Club. Worked in Chicago and Washington as well as Detroit. Represented by murals in the Library of Congress, and in many banks, theaters, and public buildings. Died in DeKalb, Ill. *—Ref.: 13; 51 (1883–92); 60 (June 22, 1893); 68 (Dec. 18, 1892, Jan. 15, 1893); 79; 149; 163; 164*

HOLT, WILLIAM FULLER. Artist in Detroit, 1872. Specialized in studies of wild animals, especially deer. Operated a school of design. *—Ref.: 51 (1872); 54 (Feb. 5, Sept. 20, 1872); 55 (Feb. 2, 1872)*

HOMMEL, JOSEPH M. (1855– ?). Woodturner, carver, and sculptor in Detroit, 1877. Born in Detroit. Established a business in 1877, specializing in church, school, and office fixtures, as well as sash, doors and blinds; continued this work for many years. *—Ref.: 51 (1873–90+); 74; 104; 118 (1885)*

HONORÉ, PAUL (1885–1956). Artist in Detroit. Specialized in paintings, murals, etchings, lithographs, wood-block printing, illustrating, and teaching. Born in a small Pennsylvania town, May 30, 1885. Educated at Cass Technical High School, Detroit; Detroit School of Fine Arts; Pennsylvania Academy of Fine Arts; and in Paris. Exhibits: DIA; museums in Cincinnati, Ohio, and St. Louis, Mo.; Chicago Art Institute; Municipal Art Gallery, New York; New York Water Color Society and many others. Memberships: National Arts Club; Association for Culture, New York; Fine and Industrial Art Guild; Scarab Club, Detroit.

Died in Philadelphia, Apr. 12, 1956. *—Ref.: 56 (Apr. 12, 1956); 66 (Nov. 25, 1911, Sept. 9, 1916); 109; 155; 163; 164; 165*

HOOKER, (Mrs.) ? . Artist in Detroit, 1867. Exhibit: painting, Michigan State Fair, 1867. *—Ref.: 64 (Sept. 12, 1867)*

HOPKIN, ROBERT (1832–1909). Marine and landscape painter and interior decorator in Detroit, 1843–1909. Born in Glasgow, Scotland, Jan. 3, 1832. Son of Robert and Janet (Miller) Hopkin. Family emigrated in 1843 to Detroit where he spent rest of life except 1870–71 in Chicago. Married Evaline A. Godfrey in Detroit, Dec. 31, 1851. Six children, including Robert B. Hopkin (q.v.) and William G. Hopkin (q.v.). Grandfather of Arthur Hopkin Gibson (q.v.). Self-taught in art. Educated in public schools until apprenticed at fourteen to a carriage painter. Began painting houses, signs and steamboat interiors; eventually concentrated on ornamental interior decorations, murals and theatrical drop curtains and scenery. Associated as a partner in various enterprises: Hopkin & Ralston (q.v.), 1853–56; Laible, Wright & Hopkin (q.v.), 1863–66; Godfrey, Dean & Co. (q.v.), 1866–67; Dean, Brow & Co. (q.v.), 1866–69; and Hopkin & Sons (q.v.), 1871–84. Thereafter worked alone. Did ornamental interior decorating for at least 45 churches, theatres and public buildings, including St. Anne's Cathedral, Detroit; Detroit Opera House; Houses of Parliament, Ottawa, Canada; Tabor Grand Opera House, Denver; and The Cotton Exchange, New Orleans. Painted silk banners for various organizations, including nearly all banners carried by Detroit's military units in the Civil War, and banner "Landing of Cadillac" for Detroit's Bicentennial Celebration, 1901. Also a prolific painter of marine and landscape scenes. Produced 390 known works in oils or watercolors; many more not recorded. Exhibited widely: 54 recorded exhibits (eight posthumous), including eight Michigan State Fairs, 1859–94; National Centennial Exposition, Philadelphia, 1876; watercolor exhibits, Detroit and New York, 1889–94; Art Institute of Chicago, 1896; Detroit Museum of Art, 1901, 1907, 1908, 1915; DIA, 1932 (100th anniversary exhibit); DHM, 1955; BHC, 1959. Awards: Honorable Mention, 1868, and Silver Medal, 1878, Michigan State Fair. Memberships: several art societies in Detroit; Art Institute of Chicago; Society of Western Artists. Scarab Club of Detroit originally founded by fellow artists as the Hopkin Club in his honor, 1907. Represented in permanent collections of DIA, DHM, Detroit and Michigan Artists' Memorial, Inc., and many private collections. Died in Detroit, Mar. 21, 1909. *—Ref.: 51 (1861–1909); 58 (vol. 3, no. 1); 84; 162; 163; 164*

HOPKIN, ROBERT B. (1854– ?). Carriage painter in Detroit, ca. 1871–

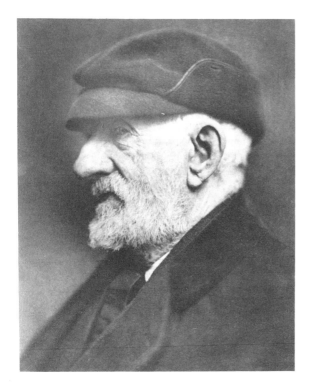

Robert Hopkin, 1905. Photograph, copyright by the Storer Spellman Studio, Detroit. From the collection of Frank E. Storer, Detroit.

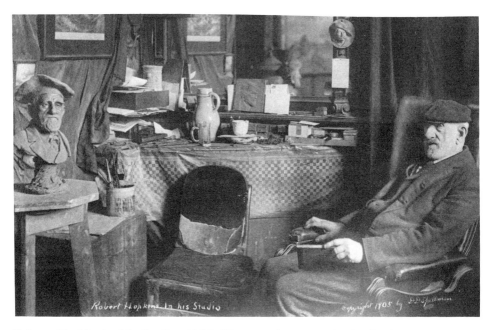

Robert Hopkin in his Studio, 1905. Photograph, copyright by D. D. Spellman. From the collection of Frank E. Storer, Detroit.

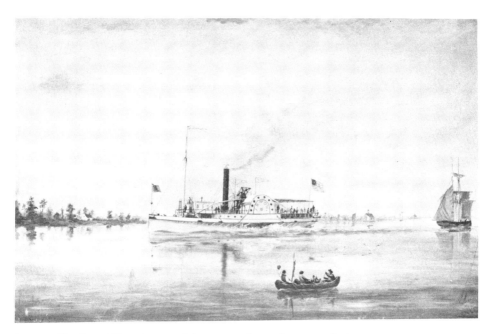

Robert Hopkin, *The Arrow*. Oil. From the collection of the Detroit Historical Museum. Photograph by Press Picture Service.

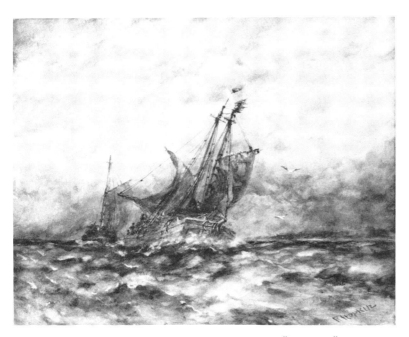

Robert Hopkin, *Scow Schooner*. Watercolor, 18″ x 22½″. From the collection of the Detroit Detroit Historical Museum. Photograph by Press Picture Service.

1900+. Son of Robert Hopkin (q.v.), with whom he and his brother, William G. Hopkin (q.v.) were associated in the firm of Hopkin & Sons (q.v.), ca. 1871–84. *—Ref.: 84*

HOPKIN, WILLIAM G. (ca. 1856–1884). Interior designer and decorator in Detroit, ca. 1871–84. Son of Robert Hopkin (q.v.), with whom he and his brother Robert B. Hopkin (q.v.) were in partnership as Hopkin & Sons (q.v.), ca. 1871–84. *—Ref.: 84*

HOPKIN & RALSTON. House, ship, sign, and ornamental painters in Detroit, 1853–56: Robert Hopkin (q.v.) and Alexander Ralston (q.v.). *—Ref.: 51 (1853/54, 1855/56); 56 (Jul. 13, 1855)*

HOPKIN & SONS. Mural, scenic and interior decorating artists in Detroit, ca. 1871–84: Robert Hopkin (q.v.), Robert B. Hopkin (q.v.) and William G. Hopkin (q.v.) Partnership continued until the death of William. *—Ref.: 84*

HOPKINS, EDNA BOIES (Mrs. James R.) (1878–1935). Artist, etcher, and wood-block engraver. Born in Hudson. Studied at Cincinnati Art Academy. Lived in Paris 1907–33. Memberships: Société Nationale des Beaux Arts; Société Internationale de la Graveure en Coleurs; Société de la Gravure Originale sur Bois, Paris. Exhibits: Cincinnati Museum, 1914; Milwaukee Art Institute, 1917; DIA, 1919. Award: Silver Medal, Pan-American Exposition, San Francisco, 1915. Represented in Library of Congress; Walker Art Gallery, Liverpool; National Museum, Stockholm; Industrial Art Museum, Berlin; Library of Art and Archaeology, Paris; Nottingham School of Art. *—Ref.: 13; 109; 149; 163; 165*

HORTON, MYRON W. Artist in Bay City, 1885, and Flint, 1893–97. *—Ref.: 12 (1885); 80 (1893–97); 118 (1885)*

HORTON, ORASMUS W. Portrait artist in Grand Rapids, 1888. Partner of William Knowles (q.v.), as Knowles & Horton (q.v.), portrait artists. *—Ref.: 86 (1888)*

HORTON, WILLIAM SAMUEL (1865–1936). Artist and writer in Grand Rapids. Born in Grand Rapids, Nov. 16, 1865. Education: Art League and National Academy, New York; Julien Academy, Paris under Paul Laurens and Benjamin-Constant. Memberships: New York Water Color Society; Salmagundi Club; Société du Salon Automne and Cercle Volney, Paris. Exhibits: PAFA and AIC, 1897–98. Awards: Gold Medal, Nantes, 1904, and Second Class medal, Orleans, France, 1905. Represented in National Gallery, Washington; National Museum, Stockholm; Old Museum Of Luxembourg and Cornavale. *—Ref.: 3 (1898); 13; 51 (1883–86); 101; 114 (vol. 7, 1916); 118 (1885); 119 (1924 ed.); 163*

HOUGHTON, THOMAS A. (ca. 1800– ?). Artist in Detroit, 1870/71. Married Martha Richards of Detroit, Apr. 25, 1858. *—Ref.: 51 (1870/71); 164*

HOUSTON, FRANCES C. LYONS (Mrs. Wm. C.) 1867–1906). Oil painter and creator of pottery; goldsmithing work. Born in Hudson, Jan. 17, 1867. Studied with Lefebvre and Boulanger in Paris. Married William C. Houston in Boston. Exhibited in Great Art Loan, Detroit, 1883. Award: honorable mention, Paris Exposition, 1900. Memberships: Boston Water Color Club; Boston Society of Arts & Crafts; New York Water Color Club. Died in Windsor, Vt. Oct. 1906. —*Ref.: 13; 119; 163*

HOWE, WILLIAM HENRY (1846–1929). Businessman in Grand Rapids, ca. 1870, who devoted his later years to painting cattle and landscapes. Engaged in cabinet work and woodturning. Born in Ravenna, Ohio, Nov. 22, 1846, the son of Elisha B. and Celestia (Russell) Howe. Educated in public schools of Ravenna. Served in Civil War, then engaged in commercial activities in Grand Rapids, and later in St. Louis. Married Julia May Clark of St. Louis, June 26, 1876. In the 1880s, studied at the Royal Academy of Dusseldorf under Otto de Thoren, and under Felix de Vuillefroy in Paris. Exhibits: Chicago World's Fair, 1893; Paris Salon, 1883. Awards: First Class medal, Paris Exposition, 1889; Temple Gold Medal, PAFA, 1890; Grand Gold Medal, Crystal Palace, 1890; DIA, 1906, 1915. Memberships: NAD, 1891; Légion d'Honneur, 1898; Society of American Artists, Paris; Lotus Club and Salmagundi Club, and National Society of Arts and Letters, New York. Represented in St. Louis Museum; Fine Arts Gallery, Cleveland; Carnegie Institute, Pittsburg; DIA; N. Y. Athletic Club; Corcoran Gallery, Washington. Died in Bronxville, N. Y., Mar. 15, 1929. —*Ref.: 32 (Mar. 26, 1929); 101; 127 (Mar. 17, 1929); 129 (Mar. 17, 1929); 157; 163; 164*

HOYT, ? (Mrs. Herbert H.). Artist in Saginaw, 1887. —*Ref.: 118 (1887)*

HOYT, HATTIE. Artist in Port Huron, 1889. —*Ref.: 118 (1889)*

HOYT, WILLIAM P. Photographic artist, 1861; artist, 1862/63, in Detroit. —*Ref.: 51 (1861, 1862/63)*

HUBBARD, JOHN T. (? –1859). Ornamental and scenic painter. Worked on theatrical scenery in Detroit, and in Columbus and Cleveland, Ohio. Died in Cleveland, June 5, 1859. —*Ref.: 56 (June 11, 1859); 164*

HUBBARD, JULIA A. Amateur artist in Detroit. Awarded a prize at the Michigan State Fair, 1857. —*Ref.: 112 (Nov. 18, 1857)*

HUDSON, EMMA LITTLE (Mrs. Thomson J.). Artist in Detroit, 1876–77. Exhibited two portraits. —*Ref.: 56 (July 14, 1876, Aug. 1, 1877)*

HUGHES, AMBROSE. Portrait artist in Romeo, 1887. —*Ref.: 118 (1887)*

HUGHES, DAVID T. Artist in Detroit, 1897. May be the same as (or son of) a person of the same name who was a carpenter and machinist in Detroit, 1870–1900+. —*Ref.: 51 (1870–1900+); 118 (1897)*

HUGHES, JOHN WESLEY (1860– ?). Photographer and portrait painter

in oils, watercolors, crayon, pastel, and India ink, in Detroit. Born in Brampton, Ontario, Feb. 9, 1860, the son of John and Maria (Sparling) Hughes. Educated in Brantford, Ontario, schools. Moved to Detroit in 1883. Married Florence Madden of Detroit, Feb. 18, 1890. Except for four years in Coldwater, was still in Detroit in 1900. *—Ref.: 51 (1889–1900+); 63; 110; 164*

HUGHES, MAY E. (or M.). Artist in Detroit, 1888–98. *—Ref.: 51 (1888–98)*

HULBERT, ? (Mrs. Henry). Artist in Armada, 1899. *—Ref.: (118) 1899*

HULBERT, CHARLES ALLEN (? –1939). Landscape and portrait artist in Detroit, ca. 1889, New York, and South Egrement, Mass. Born on Mackinac Island. Pupil of PAFA; Metropolitan Museum Art School and Artist-Artisan Institute, New York. Married in New York, 1893, to Katherine D. Allmond Hulbert (q.v.). Membership: Salmagundi Club; Brooklyn Painters Society; Pittsfield (Mass.) Art League. Represented in the State Capitol, Albany, N.Y.; and Erie (Pennsylvania) Public Library. Died Sept. 21, 1939. *—Ref.: 3 (1933); 51 (1889); 60 (Apr. 18, 1893); 61 (Dec. 1, 1889); 79; 109; 118 (1889); 153 (vol. 1, 1936/37; vol. 3, 1940/41); 157; 163; 164*

HULBERT, KATHERINE ALLMOND (Mrs. Charles Allen) (? –1937). Artist in Detroit, 1889–91, New York, and South Egremont, Mass. Painted landscape scenes in oils and watercolors. Born in the Sacramento Valley, Calif. Attended public schools. Studied at the San Francisco School of Design; NAD; and Artist-Artisan Institute, New York, where she became an instructor. Taught three years at the University of Washington, and three years in Detroit. Married Charles Allen Hulbert (q.v.) in New York, 1893. Exhibits: Detroit Artists Association, 1891; DIA, 1908; 33rd annual exhibit, National Association of Women Painters and Sculptors. Memberships: Salmagundi Club; National Association of Women Painters and Sculptors; Brooklyn Painters Society; Pittsfield (Mass.) Art League. *—Ref.: 3 (1933); 13; 51 (1889); 79; 109; 153 (vol. 1, 1936/37, vol. 3, 1940/41); 157; 163; 164*

HULL, ABIJAH. Map maker and surveyor in early Detroit. Official surveyor of the State of Michigan. DIA has "A Plan of the City of Detroit (1807)," a manuscript map, the earliest surviving representation of the plan devised by Judge Augustus B. Woodward after the city was destroyed by fire in 1805. *—Ref.: 163; 164*

HULL, MARY CHURCH (Mrs. Jacob) (? –1926). Amateur artist in Detroit, 1870–96. Married Jacob Hull, June 5, 1872. Active many years in group study and social contacts. Exhibits: Michigan State Fair, 1878, and Detroit Water Color Society, of which she was a member, 1895. Died Jan. 20, 1926, in Bay City. *—Ref.: 35 (May 1926); 51 (1895–96);*

56 (June 7, 1872, Mar. 17, 1875); 60 (Dec. 13, 1895); 65 (Sept. 21, 1878); 68 (June 6, 1872); 112 (Oct. 24, 1878)

HUMPHREY, JOSIAH. Teacher of drawing and painting in Cleveland, Ohio, 1855–57; founder and director of an academy in Detroit, 1857–59. *–Ref.: 51 (1857–59); 128; 163; 164*

HUNGERFORD, LYDIA (or LYDIA A.). Artist in Grand Rapids, 1893–94. *–Ref.: 86 (1893, 1894)*

HUNT, ? (Mrs.). Crayon artist. Awards: premiums, Michigan State Fair, 1870. *–Ref.: 112 (Oct. 8, 1870)*

HUNT, ALICE L. Artist in Ann Arbor, 1886–1914. High school teacher, and later instructor (in art?) at the University of Michigan. *–Ref.: 6 (1886–1914); 118 (1891–99)*

HUNT, LYDIA. Artist in Grand Rapids, 1879–80. *–Ref.: 86 (1879, 1880)*

HUNT, NELLIE G. Artist in Jackson, 1891. *–Ref.: 118 (1891)*

HUNTER, JAMES A. Portrait painter in Detroit, 1884–1900+. *–Ref.: 51 (1884–1925+); 118 (1889– 99)*

HUNTER, WILLIAM EDGERTON N. (1868–1947). Architect and watercolor artist in Detroit, 1891–1942. Born in Hamilton, Ontario, Feb. 16, 1868, the son of William and Dina (Sutton) Hunter. Educated at Hamilton (Ontario) Collegiate Institute. Married Elizabeth Alice Kaye at Dundas, Ontario, 1893. Established in Detroit as an architect, specializing in church design. Director, Detroit Architectural Sketch Club, 1896. Moved to Los Angeles 1942, and died there Feb. 5, 1947. *–Ref.: 56 (Feb. 5, 1947); 60 (Oct. 17, 1896); 61 (Feb. 5, 1947); 110; 155 (1935–36); 164*

HUNTING, HENRY G. Artist in Marshall, 1897. *–Ref.: 118 (1897)*

HURD, CLYDE. Young art student in Detroit, 1893. Studied at Detroit School of Arts under Miss Maud Mathewson (q.v.). *–Ref.: 60 (June 24, 1893)*

HURD, GILDERSLEEVE (ca. 1791–1859). Designer and portrait painter in Detroit, ca. 1825–59. Also did ornamental painting, signs, military standards, and landscapes. Credited with designing the official seal of the City of Detroit. Married Loisa (or Louisa) Pensley of Greenfield (now part of Detroit), June 26, 1837. Died in Detroit, Nov. 16, 1859. *–Ref.: 57 (Feb. 20, 1827); 101; 128; 130; 163; 164*

HURD, RODNEY S. Crayon and portrait artist in Benton Harbor, 1891–93; in Kalamazoo, 1895. *–Ref.: 118 (1891–95)*

HURSEN, SYLVIUS. Landscape, scenic, and cartoon painter in Vicksburg, 1891–99. *–Ref.: 118 (1891–99)*

HUSTON, ALBERT D. Crayon, watercolor and oil portrait artist in Detroit, 1896–98. *–Ref.: 51 (1896, 1898); 118 (1897)*

HUTAFF, JOHN H. Designer and ceramic artist in Detroit, prior to 1894.

Studied at Boston School of Painting and Design and Detroit Museum Art School. Moved to New York City where he was chief designer for a well known decorating firm. —*Ref.: 60 (Feb. 26, 1894)*

HUTCHENS, (Miss) ? . Artist in Detroit. Possibly Florence F. Hutchens, typist, in Detroit, 1892. A watercolor painting titled "Cherokee Roses" was exhibited by a Miss Hutchens (no first name) at the Detroit Artists' Association, 1891. —*Ref.: 51 (1892); 164*

HUTCHINS, EMMA (or EMMA S.). Artist in Grand Rapids, 1885–89. Possibly the same Emma S. Hutchins, artist, who was in Detroit, 1893. —*Ref.: 51 (1893); 86 (1889); 118 (1885)*

HUTCHINS, LYDIA A. Drawing teacher in Detroit, 1890–91. —*Ref.: 51 (1890, 1891)*

HUTTY, ALFRED HEBER (1878– ?). Painter and etcher. Born in Grand Haven, Sept. 16, 1878. Spent boyhood in lumbering towns of Michigan and frontier towns of Kansas. At 15, awarded an art school scholarship. Pupil of St. Louis School of Fine Arts and Art Students' League, New York, under Chase and Harrison. During World War I, member of the camouflage corps. Then went to Charleston, South Carolina. Director, Carolina Art Association School. Pencil drawings and etchings exhibited at Corcoran Gallery, Washington, D. C. Memberships: Woodstock Artists' Association; Carolina Art Association; British Society of Graphic Arts, London; Allied Artists; American Water Color Society; National Arts Club; Salmagundi Club; Brooklyn Society of Etchers; Print Makers of California; Washington Arts Club; Washington Water Color Club; Society of Washington Artists; North Shore (Gloucester) and Rockport Art Associations; Charleston Etchers Club; American Federation of Arts; Scarab Club (Gold Medal 1923). Represented in many museums in the United States and abroad. —*Ref.: 3 (vols. 29–30); 13; 79; 109; 119 (1924 ed.); 157; 163*

HUXLEY, MINNIE. Artist in Mason, 1892. —*Ref.: 102 (1892)*

HYDE, HARRIET L. Portrait artist in Ypsilanti, 1886–87. —*Ref.: 6 (1886/87)*

I

IAMUCCI, RICARDO. Artist, modeler, and wood-carver in Grand Rapids, 1886–1900+. Proprietor of Grand Rapids Industrial School, and teacher of industrial and artistic drawing, sculpture, modeling, casting, wood carving, and portraiture. —*Ref.: 86 (1886–1900+); 118 (1891–99)*

INGERSOLL, D. WILLIAM. Wood-carver in Grand Rapids at least 1880–85. In 1885, associated with August C. Fick (q.v.), under the firm name

of Fick & Ingersoll (q.v.), wood-carvers. —*Ref.: 86 (1880); 118 (1885)*

IVES, DAISY N. (or M.). Teacher and artist in Detroit, 1886–96. Exhibited several pieces at the first showing of the Society of Western Artists, 1896. —*Ref.: 51 (1886–90); 60 (Dec. 7, 1896); 164*

IVES, ELSIE CARON (Mrs. Percy) (1864–1915). Painter of still life, fruits and flowers in oils; also a carver of cameos in Detroit, late 1890s and early 1900s. Daughter of the mayor of Windsor, Ontario. Studied over two years in Paris, where she met her husband, Percy Ives (q.v.). Married, June 16, 1890. Exhibits: Detroit Museum of Arts, 1891; Art Club of Detroit, 1895; Detroit Artists Association, 1896; DIA, 1905. Died in Detroit, Dec. 11, 1915. —*Ref.: 56 (Sept. 24, 1874, Jan. 27, 1894, Sept. 30, 1894, Dec. 12, 1915); 60 (Dec. 15, 1893; Jan. 27, May 7, 1894; Oct. 12, 21, 1895; June 2, 1896); 61 (Dec. 13, 1915); 62 (Jan. 19, 1896, Dec. 12, 1915); 109; 163; 164; 165*

IVES, LEWIS THOMAS (1833–1894). Portrait artist in Detroit, 1852–94. Born Aug. 3, 1833, at or near Rochester, N. Y., the son of Eardly and Ann (Wood) Ives. An attorney who painted in spare time and eventually left the practice of law to devote all his time to art. Studied in Paris and Rome under William Page. Married Margaret Leggett, 1860, in Detroit. Father of Percy Ives (q.v.) and Dr. Augustus W. Ives. Painted many portraits of Detroit, Michigan, and Massachusetts dignitaries. Commissioned to do a portrait of Grover Cleveland, but died before its completion; later finished by his son, Percy Ives (q.v.). Exhibits: Western Art Association, 1870; portraits and other works at the Detroit Great Art Loan, 1883; Detroit Artists Association, 1875, 1876, 1893; Detroit Museum of Art, 1887, 1889, 1891, Michigan State Fairs, 1851, 1854, 1878, 1879, 1880, 1883. A room at DIA is named after him. Died in Detroit, Dec. 13, 1894. —*Ref.: 51 (1852/53–94); 53 (Dec. 5, 1870); 56 (1872–83); 60 (1893–96); 61 (July 2, 1881); 62 (Feb. 24, 1895); 64 (Dec. 8, 1872); 65 (Sept. 21, 1878, Sept. 18, 1879, Sept. 16, 1880, Sept. 20, 1883); 78; 101; 112 (Dec. 1851, Nov. 1854, Oct. 24, 1878, Feb. 10, 1880, Oct. 16, 1883); 118 (1881–93); 128; 162; 163; 164; 165*

IVES, PERCY (PERCIVAL) (1864–1928). Portrait and genre painter in Detroit, 1883–1928. Born in Detroit, June 5, 1864, the son of portraitist Lewis Thomas Ives (q.v.). Educated in public schools. Studied art at PAFA, 1882; in Detroit, 1883; and in Paris, 1884–90, under Bougereau, Lefebvre, Benjamin-Constant, Cormon and Gerome at École des Beaux Arts. Wife was Elsie Caron Ives (q.v.) of Windsor, Ontario; married June 16, 1890. Appointed Dean, Detroit Museum of Art School, 1890. Designed the official seal of DIA. Painted portraits of

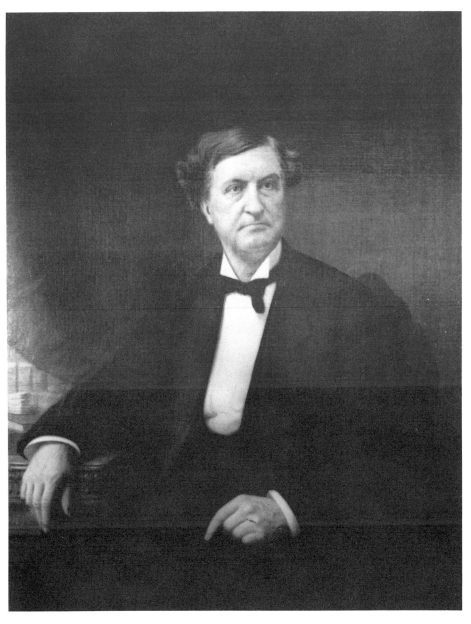

Lewis T. Ives, *Portrait of Zachariah Chandler.* Oil. From the collection of the Detroit Historical Museum. Photograph by Press Picture Service.

several American presidents and other distinguished citizens including Walt Whitman. Exhibits: Great Art Loan, Detroit, 1883; Detroit Museum of Art, numerous times 1889–98; Paris Salon, 1893; World's Columbian Exposition, Chicago, 1893; Pan-American Exposition, Buffalo, 1901; Louisiana Purchase Centennial Exposition, St. Louis, 1904; Society of Western Artists, numerous times 1898–1927; DIA, numerous times 1911–28; Cincinnati Fine Arts Museum; NAD; Chicago Art Association. Memberships: Société des Beaux Arts, Paris; Detroit Water Color Society; Scarab Club; Society of Western Artists; Fine Arts Society, Archeological Society, Hopkin Club (founder), Art Club, all of Detroit. Died in Detroit, Feb. 14, 1928. *–Ref.: 3 (1898); 13; 28; 51 (1885–1900+); 56 (many issues, 1879–1935); 60 (many issues, 1893–96); 61 (Feb. 15, 1928); 65 (Sept. 16, 1880); 66 (Sept. 9, 1916); 67 (Feb. 15, 1928); 68 (Jan. 19, 1894); 78; 79; 101; 110; 112 (Oct. 12, 1880, Oct. 16, 1883); 118 (1889–99); 119; 157; 163; 164; 165*

IVES, SARAH (or SARA) NOBLE (1864–1944). Writer and illustrator. Born at Grosse Ile, Mar. 10, 1864, the daughter of William and Sarah Maria (Hyde) Ives. Protogée of Mrs. Edna Chaffee Noble of Detroit. Christened Sarah Maria Ives. Early education received at home; at the crossroads schoolhouse on Grosse Ile; and at Port Huron High School, graduating in 1880. Further education: three years, Detroit Training School of Elocution and English Literature; watercolor study under John Owen (q.v.), Detroit, about 1885; drawing, modeling, and painting in New York City; Julien School, Paris, for three years. Exhibited pencil, crayon, pen and ink, watercolor, and oil studies in Detroit, 1892, 1895, 1916, 1922. Contributor and illustrator for the McClure Newspaper syndicate; *New York Tribune; Universalist.* After twenty-five years in New York, made home in Altadena, Calif., where she died, Nov. 27, 1944. *–Ref.: 51 (1895–1896); 60 (May 28, 1892, Oct. 19, 1895); 61 (Jan. 19, 1896); 124; 163; 164; 178*

J

JACKER, FRANCIS (ca. 1810– ?). Scholar, linguist, artist, and musician in Portage River (near Sault Ste. Marie); later in Baraga, 1876–1904. Had a particular talent for enlarging photographs to life-size portraits. Executed many watercolor portraits. Born in Württemberg, Germany. Studied three years at Munich Academy of Arts. In New York one year and in Cincinnati two years before moving to Michigan. In 1863 married Ikwesens (Little Girl), who was baptized Catherine, the daughter of an Ojibway chief. Painted large pieces for the church at L'Anse. *–Ref.: 56 (Oct. 2, 1904); 118 (1885–91); 164*

Percy Ives, *Portrait of George H. Hammond.* Oil, 30″ x 25″. From the collection of Wilfred V. Casgrain, Grosse Pointe Farms.

Percy Ives, *Self-Portrait.* Canvas, 30″ x 21″. From the collection of the Detroit Institute of Arts. Purchase, The Elliott T. Slocum Fund.

Percy Ives, *Portrait of Charlotte Chase Casgrain,* 1907. Oil, 23″ x 20″. From the collection of Wilfred V. Casgrain, Grosse Pointe Farms.

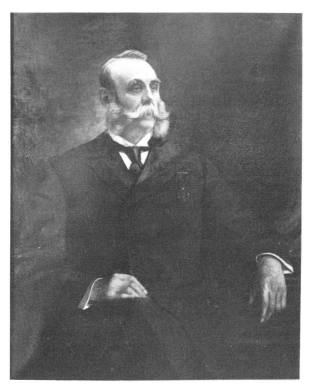

Percy Ives, *Portrait of Charles E. Casgrain,* 1907. Oil, 43½″ x 35″. From the collection of Wilfred V. Casgrain, Grosse Pointe Farms.

JACKSON, LOTTIE. Artist in Bay City, 1899. —*Ref.: 118 (1899)*

JACOBI, DIONYSIUS D. (ca. 1820–1904). Artist in Detroit, 1878–1900+. Died in Detroit, Feb. 1, 1904. —*Ref.: 51 (1878–1904); 118 (1883–93)*

JACOBI, LEOPOLD. Designer in Detroit, 1884–1900+. Employed as designer for the United States Lake Survey, 1908. —*Ref.: 51 (1884–1900+); 118 (1885)*

JAEGER & BROTHER. Artists in Niles, 1877. —*Ref.: 118 (1877)*

JAHN, ADOLPH SR. and JR. Senior was an upholsterer; Junior was an artist and regalia decorator, 1891–97. One of these, probably Senior, died Aug. 8, 1899 at age fifty-seven. —*Ref.: 51 (1884–1900)*

JAHN, ERNST. Artist, designer, and lithographer in Detroit, 1890s. Painted and taught tapestry painting. Executed two frontispieces for a Civil War history. —*Ref.: 51 (1886–1901); 60 (Sept. 21, 1895, Feb. 24, 1896); 76; 118 (1899)*

JEFFERS, A. P. Artist in Kalamazoo, 1887. —*Ref.: 118 (1887)*

JENKINS, NELLIE C. Artist in Jackson, 1877. Award: premium for a portrait in oils, Michigan State Fair, 1877. —*Ref.: 112 (Oct. 30, 1877)*

JENKS, ALBERT (1824–1901). Portrait painter, author, and illustrator in Detroit. Born in Ionia. Education: public schools; Kalamazoo College; University of Chicago; PhD., University of Wisconsin, 1899. Associated with A. J. Baldwin (q.v.) and Frank M. Peebles (q.v.), portrait painters, as Jenks, Peebles & Baldwin (q.v.), 1873; also was an author of stories for young readers. Died in Los Angeles, Calif., July 22, 1901. —*Ref.: 3 (vol. 4, 1901); 13; 56 (May 10, Oct. 16, 1873); 109; 128; 164*

JENKS, SAMUEL B. Businessman and amateur artist in Grand Rapids. —*Ref.: 86 (1876–86); 118 (1881)*

JENKS, PEEBLES & BALDWIN. Artists associated in portraiture throughout Michigan; studios in Detroit, 1873; Albert Jenks (q.v.), Frank M. Peebles (q.v.), and A. J. Baldwin (q.v.). Exhibited portraits of Michigan's Governor Bagley and Lieutenant Governor Holt; Judge Bell of Ionia, D. Darwin Hughes and C. E. Holland of Houghton, E. Breitung of Marquette; and Judge Emerson of Utah.—*Ref.: 56 (May 10, Oct. 16, 1873)*

JENNINGS, EMILY. Amateur artist in Detroit, 1893. Studied with Maud Mathewson's (q.v.) young ladies' class at the Detroit School of Arts. Probably a sister of Henrietta S. Jennings (q.v.). —*Ref.: 60 (June 24, 1893); 164*

JENNINGS, HENRIETTA S. Amateur artist in Detroit, 1893. Studied with Maud Mathewson (q.v.) at the Detroit School of Arts. Probably a sister of Emily Jennings (q.v.) —*Ref.: 60 (June 24, 1893)*

JENNINGS, JOHN S. portrait painter in Lansing, 1877. —*Ref.: 118 (1877)*

JOHNSON, ? (Mrs. W. C.). Artist in Grand Rapids, 1881. Probably the wife of William Clafflin Johnson (q.v.). —*Ref.: 118 (1881)*

JOHNSON, BRADFORD (ca. 1877–1942). Artist in Detroit. Spent many years in France, returning to Detroit often and exhibiting paintings and drawings. Executed many portraits of Detroit citizens. Died in Paris, Apr. 15, 1942. —*Ref.: 60 (Nov. 1, 1895); 61 (May 29, 1942); 163; 164*

JOHNSON, CARL O. (1864– ?). Portrait artist in Jackson in the latter years of the nineteenth century. Painted portraits and figures in oils, watercolors and pen and ink. Born in Christiana, Norway, Apr. 12, 1864, the son of John Johnson. Came to America with his parents about 1872, and to Michigan in 1875. Studied ten years with Aurelius O. Revenaugh (q.v.). —*Ref.: 56 (1887–1900+); 118 (1893); 164*

JOHNSON, DELBERT. Amateur artist in Detroit, 1896–1904. Associated with Frank D. Johnson (q.v.) in 1897 as Johnson Brothers (q.v.) artists. —*Ref.: 51 (1896–97)*

JOHNSON, FRANK D. Artist in Detroit. Associated with Delbert Johnson (q.v.) in 1897 as Johnson Brothers (q.v.), artists. —*Ref.: 51 (1896–97)*

JOHNSON, LINA M. Artist in Grand Rapids, 1878–79. —*Ref.: 86 (1878/79)*

JOHNSON, M. G. & Co. Artists in Marquette, 1899. Partners: Martin G. Johnson (q.v.) and Paul Barloy (q.v.). —*Ref.: 118 (1889)*

JOHNSON, MARTIN G. Artist in Marquette. Associated in 1889 with Paul Barloy (q.v.), under the firm name of M. G. Johnson, & Co. (q.v.). —*Ref.: 118 (1889)*

JOHNSON, MARY C. (wid. Levi H.). Artist in Detroit, 1893. —*Ref.: 51 (1892–97)*

JOHNSON, THOMAS. Artist in Detroit, 1891–98. —*Ref.: 51 (1870–98); 118 (1897)*

JOHNSON, WILLIAM CLAFFLIN (1856– ?). Crayon artist in Grand Rapids, 1880–81. Born in Detroit, Oct. 15, 1856, the son of W. M. and Jane E. Johnson. —*Ref.: 51 (1880); 118 (1881); 164*

JOHNSON BROTHERS. Artist-brothers in partnership in Detroit, 1897: Delbert Johnson (q.v.) and Frank D. Johnson (q.v.). —*Ref.: 118 (1897)*

JOHNSTON, JESSIE E. Artist in Grand Rapids, 1891; decorator, 1891–93 and 1900. —*Ref.: 86 (1891–93, 1900)*

JOHNSTON, LOUISA. Artist in Detroit, 1892. —*Ref.: 51 (1892)*

JONES, EMMA F. (Mrs. William H.) (ca. 1850–1938). Artist in Grand Rapids, 1899. —*Ref.: 86 (1899)*

JONES, MARY D. Artist and teacher in Grand Rapids, 1880–97. —*Ref.: 86 (1880–83, 1886, 1891–95, 1897)*

JUNGWIRTH, JOSEPH (or JOACHIM) (ca. 1858–1940). Wood-carver and modeler in Detroit, 1884–1900+. Born in Austria and learned trade

there. Came to America with his parents, 1882. Worked in Oshkosh, Wis., and in Grand Rapids. In 1884, moved to Detroit and worked for Wagner & Reuther (q.v.). Partner with Richard G. Reuther (q.v.) under the firm name of Reuther & Co. (q.v.), 1886–98. Treasurer, Wilton Reuther Co., (q.v.) 1899–1900, when he withdrew and started independently as J. Jungwirth & Co. Married Elizabeth Heimes, a native of Germany, in Grand Rapids. Died in Detroit, Sept. 20, 1940. *–Ref.: 19; 51 (1887–1900+); 56 (Sept. 23, 1940); 165*

JUPP, FANNIE (Fanny) BARTLET. Exhibited at the Detroit Museum of Art, 1890. *–Ref.: 163*

K

KAISER, RICHARD F. Artist in Ann Arbor, 1893. Partner with Ernst Sury (q.v.) in firm of Kaiser & Sury (q.v.). *–Ref.: 118 (1893)*

KAISER & SURY. Artists in Ann Arbor, 1893: Richard F. Kaiser (q.v.) and Ernst Sury (q.v.). *–Ref.: 118 (1893)*

KANE, GRACE E. Student artist in Detroit. Exhibited in annual spring exhibition of Maud Mathewson's (q.v.) studio, 1894. *–Ref.: 60 (June 20, 1894)*

KANE, PAUL (1810–1871). Painter of Indian life and native surroundings of western Canada. Born in Mallow, County Cork, Ireland, Sept. 3, 1810, the son of Michael Kane. Came to America at age eight or nine and settled in York (now Toronto), Canada. In 1836, moved to Detroit and worked for about five years, obtaining the means to travel to Europe, where he studied and copied the great masters in the galleries of Geneva, Paris, Milan, Venice, Verona, Bologna, Florence, Rome, and Naples. Returned to Toronto in 1844, and spent the rest of his life in Canada. Married Harriet Clinch of Coburg, Ontario, in 1853. Died in Toronto, Feb. 20, 1871. *–Ref.: 7; 51 (1837); 128; 157; 163; 165*

KANZLER, HENRY. Artist in Saginaw. *–Ref.: 161*

KARPP, DOLLIE. Artist in Detroit, 1889–93. *–Ref.: 51 (1889–92); 118 (1893)*

KAUFER, MAURITZ (Morris). Portrait artist in Detroit, 1888–90. Partners with Frank D. Brooks, (q.v.) 1888, as Kaufer & Brooks, (q.v.) artists. In 1890, moved to Cincinnati, Ohio. *–Ref.: 51 (1888–90)*

KAUFER & BROOKS. Portrait artists in Detroit, 1888: Mauritz Kaufer (q.v.) and Frank D. Brooks (q.v.). *–Ref.: 51 (1888)*

KAUMIER, GEORGE. Artist in Port Huron, 1881. *–Ref.: 51 (1881)*

KEDZIE, ELLA M. Teacher of painting and drawing at Olivet College, 1887–89. *–Ref.: 118 (1887–89)*

KEENA, JAMES TRAFTON (1850–1924). Attorney and amateur water-color artist in Detroit, 1857–93. Born in Ogdensburg, N. Y., Feb. 19, 1850. One of the founders of the Detroit Water Color Society. Died in Detroit, Jan. 8, 1924. —*Ref.: Detroit CD 1872–1900+; 56 (Jan. 9, 1924); 60 (Nov. 4, 1893); 163; 164*

KEEP, HELEN ELIZABETH (1868–1959). Artist in Detroit, 1886–59. Born in Troy, N. Y., Dec. 10, 1868. Memberships: Arts and Crafts Guild; Detroit Water Color Society; Detroit Society of Women Painters & Sculptors. Active in social organizations. Exhibits: Detroit; Norfolk, Va.; Rollins College, Winter Park, Fla.; Oberlin College Art Museum, Oberlin, Ohio. Died in Detroit, Nov. 9, 1959. —*Ref.: 60 (Apr. 18, Oct. 16, 1893, Dec. 13, 1895) 153; 155; 157; 163; 164*

KEIL, HENRY W. Wood-carver in Detroit. —*Ref.: 51 (1884–1900+); 118 (1897)*

KEIL, LOUIS O. Interior decorator in Detroit, late 1900s. Creator of interior decorative designs for homes and passenger steamer interiors. —*Ref.: 51 (1878–1918); 165*

KEILY, JANE B (Mrs. Richard). Artist in Detroit, 1899. —*Ref.: 51 (1899)*

KEITH, CASTLE (1863–1927). Painter of Dutch interiors and landscapes. Born February 18, 1863. Native of Detroit who spent most of his life abroad. Educated mostly in Munich. Had studios in Detroit and Toledo, Ohio. Married Virginia Primrose of Detroit. Died in Detroit, Jan. 14, 1927. —*Ref.: 56 (Jan. 17, 1927); 163*

KELLEY (or KELLY) JOHN S. Artist in Grand Rapids, 1889. —*Ref.: 118 (1889)*

KELLOGG, (Miss) E. Exhibitor, Michigan State Fair, 1882. —*Ref.: 112 (Oct. 17, 1882)*

KELLOGG, LAURA ELIZABETH GARDNER (Mrs. A. J.) (1846–1886). Artist and sculptor in Detroit, 1880–86. Born Aug. 23, 1846. Died December 2, 1886. —*Ref.: 51 (1883–86); 56 (Apr. 13, 1880, Dec. 9, 1886); 118 (1885); 164*

KELLY, ? (Mrs. Charles). Exhibitor, Michigan State Fair, 1878. —*Ref.: 65 (Sept. 21, 1878)*

KELLY, JOHN S. *See* KELLEY, JOHN S.

KENDALL, JOHN. Artist in Grand Rapids. Executed a painting published in the *Art Union* (later the *Art Journal*). —*Ref.: 56 (Dec. 30, 1850)*

KENDRICK, KITTIE. Artist in Mason and Lansing, 1889–92. —*Ref.: 102 (1892); 118 (1889–93)*

KENWORTHY, VITILENA (Mrs. George B.). Artist in Detroit. —*Ref.: 51 (1893); 118 (1895)*

KERN, GEORGE. Representative or owner of the International Portrait

Company in Detroit, 1890–93. Probably engaged in coloring or copying photographs. –*Ref.: 51 (1890–93)*

KERR, MARCUS H. Portrait artist in crayon and paint, in Detroit, 1881–87. –*Ref.: 51 (1881–86); 118 (1887)*

KERREMANS, WILLIAM. Artist who had a brief residence at Detroit in 1869, when he executed many portraits and religious subjects in local churches. –*Ref.: 50 (Mar. 8, 1869); 51 (1869/70); 55 (May 6, 1869); 56 (Apr. 15, 1869); 164*

KETCHUM, ABIJAH E. Photographer and portrait painter in Flint. –*Ref.: 118 (1867–68)*

KETCHUM, ELBRIDGE E. Artist in South Haven, 1891. –*Ref.: 118 (1891)*

KEYES, JASON A. Amateur artist in Detroit, 1871–76. –*Ref.: 51 (1871–76)*

KIDDLE, THOMAS. Photographer and artist in Detroit, 1885–86. Moved to Toronto, Ontario, 1887. –*Ref.: 51 (1885–87)*

KIEFER, EDWIN H. (1860–1931). Artist in Detroit and Paris, France. Painter of genre subjects and magazine illustrator. Born in Port Huron, Aug. 28, 1860. Educated in Detroit public schools; Berlin School of Design; and under Constant, Cazin and Laurens, Paris. Married Marie Ambert of Paris. Resided in Paris, with frequent returns to Detroit. Exhibits: Chicago Art Institute, 1897 and 1898; Paris Salon, 1908; DIA, 1913. Died in Detroit Apr. 24, 1931. –*Ref.: 3 (1898); 51 (1879–82); 56 (Jan. 22, 1899, Apr. 25, 1931); 163*

KIMBALL, ? (Mrs. Allen). Artist in Detroit, 1883. Exhibit: landscape in oils, Michigan State Fair, 1883. –*Ref.: 164*

KIMBALL, CARRIE. Artist in Romeo, 1889. –*Ref.: 118 (1899)*

KING, BIANCA N. (Mrs. Horace W.). Variously, dressmaker and artist in Grand Rapids, 1890–1900+. –*Ref.: 86 (1890–1900+)*

KING, CHARLES BRADY (1869–1957). Artist, etcher, automobile builder in Detroit. Born in Calif. Settled in Detroit, where in 1896 he designed and built the first automobile driven on its streets. Studied under Laurens in Paris, and Brangwyn in London. Member: Hopkin Club; Scarab Club of Detroit. Exhibits: DIA, 1908–15. Represented at New York Public Library and Library of Congress. Died in Rye, N. Y., June 23, 1957. –*Ref.: 51 (1890–1900+); 56 (Aug. 16, 1896, June 25, 1957); 62 (Apr. 19, 1896); 79; 162; 163*

KING, HENRY N. (1839– ?). Wood-carver in Adrian, 1870–89. Also did stair building. Born in Bridgewater, Washtenaw County, Mar. 26, 1839. Executed the carved work in the Omaha, Nebr., courthouse. Married Frances E. Bolles of Chelsea, Apr. 4, 1864. Served in the Civil War. –*Ref.: 1 (1870, 1878); 118 (1885–89); 164*

KING, J. F. Artist in Charlotte, 1877. Award: premium for a watercolor painting, Michigan State Fair, 1877. *—Ref.: 112 (Oct. 30, 1877)*

KING, MARY ELIZABETH (Mrs. John E.) (1818–1902). Artist in Bay City. Born Nov. 27, 1818. Died Jan. 22, 1902. *—Ref.: 53 (May 18, 1849); 118 (1897–99); 164*

KIRCHNER, SYLVESTER J. (1871–1895). Pen-and-ink and color artist in Detroit, 1887–89 and Baltimore, Md. Born in Detroit, Dec. 25, 1871. Went to Baltimore and became the top staff artist of the *Baltimore American.* Died in Baltimore, October 21, 1895. *—Ref.: 51 (1887–89); 56 (Apr. 3, 1938); 164*

KIRK, (Mrs.) M.B. Artist in Sturgis. *—Ref.: 118 (1885)*

KIRK, JULIA A. Artist in Grand Rapids, 1886–1900+. *—Ref.: 11; 86 (1886–1900+); 118 (1897)*

KNAPP, LEWIS M. Painter and wood engraver in Ann Arbor, 1868–87. *—Ref.: 6 (1868, 1872, 1886/87)*

KNEELAND, JOHN N. Wood-carver in Burr Oak, 1889. *—Ref.: 118 (1889)*

KNICKERBOCKER, HELEN. Artist in Detroit, 1889–91. *—Ref.: 51 (1889–91)*

KNIGHT, S. DUBOIS. Artist and illustrator in Detroit, 1880–87. Later moved to Los Angeles. Was in New York, 1893. *—Ref.: 51 (1880–87); 60 (June 8, 1893)*

KNIGHT, JUDSON R. (1853–1899). Portrait, mural, and fresco painter in Coldwater. Born in St. Joseph County, May 29, 1853. Married Mrs. Alice Thornton Howe, Dec. 1881. Exhibit: tapestry, Chicago World's Fair, 1893. Moved to Grand Rapids. Died in Grand Rapids, Feb. 13, 1899. *—Ref.: 37 (Jan. 13, 1962); 118 (1891–97); 164*

KNOBLOCK, HERMAN. Amateur artist in Detroit, 1883–95. *—Ref.: 51 (1883–95)*

KNOWLES, W. L. & CO. Portrait artists in Grand Rapids, 1899. No record of partners' names, probably a firm name for William L. Knowles (q.v.) operating alone after the dissolution of Knowles & Horton (q.v.). *—Ref.: 86 (1889)*

KNOWLES, WILLIAM L. Artist in Detroit, and Grand Rapids, 1887–97. In 1887, in partnership with Hobart W. Harper (q.v.) in Detroit, under the firm name of Knowles & Harper (q.v.). He moved to Grand Rapids in 1888 and associated with Orasmus W. Horton (q.v.), as Knowles & Horton (q.v.), portrait artists. Thereafter, operated as an individual. *—Ref.: 51 (1887); 86 (1888–97); 118 (1891, 1893)*

KNOWLES & HARPER. Artists in Detroit, 1887. William L. Knowles (q.v.) and Hobart W. Harper (q.v.). *—Ref.: 51 (1887)*

KNOWLES & HORTON. Artists in Grand Rapids 1888–89. Executed

portraits in oil, India ink, crayon, watercolors, and pastel; William L. Knowles (q.v.) and Orasmus W. Horton (q.v.). *—Ref.: 86 (1888); 118 (1889)*

KNOX, THOMAS E. Artist in Dundee, 1897–99. *—Ref.: 118 (1897, 1899)*

KOEHLER, PAUL R. (1866?–1909). Engraver, and landscape painter in oils and pastels in Detroit, 1891–97. Died in Colorado Springs, Colo., 1909. *—Ref.: 13; 51 (1891, 1895–97); 79; 109; 118 (1897); 163*

KOESTER, ADOLPH J. Artist in Detroit, 1889–1900. Employed by a firm of engravers. *—Ref.: 51 (1889–1900)*

KOHLHEPP, CAROLINE E. R. Student, 1894; and artist, 1899, in Grand Rapids. *—Ref.: 86 (1894, 1899)*

KOOTZ (or KOTZ), DANIEL. Artist in St. Joseph, 1897. Listed variously as Kootz and Kotz. *—Ref.: 118 (1897)*

KOST, ORA. Crayon artist in Adrian 1878, 1895–99. *—Ref.: 1 (1878); 118 (1895–99)*

KOTZ, DANIEL. *See* KOOTZ, DANIEL.

KRAEMER, JOSEPH L. (1872–1938). Illustrator, artist, sculptor, and engraver in Detroit, ca. 1887–1900+. Born in Treves, Germany, Apr. 5, 1872. Came to America at the age of seven, and to Detroit at nine. Studied at Detroit Art Academy. Art Director, *Detroit News* (daily) for many years. Teacher, Wicker School of Fine Arts, Detroit. President, Scarab Club, Detroit. Died in Detroit, Apr. 10, 1938. *—Ref.: 51 (1887–1900+); 56 (Apr. 11, 1938); 60 (June 6, 1896); 61 (Apr. 11, 1938); 164*

KRAKOW, RICHARD H., SR. (1858–ca. 1935). Stone and wood-carver in Detroit. Born in Mecklenberg, Germany, June 15, 1858. Came to America with his family, 1866; to Detroit, 1867. Married Wilhelminie Sauer in Detroit, Nov. 13, 1879. Worked under Julius Melchers (q.v.). Entered in business, 1888, with Richard Reuther (q.v.) and Joseph Jungwirth (q.v.) under the firm name of Reuther & Co. (q.v.), which continued until Reuther's death in 1913. After that, with his two sons, Richard H. Jr. and William T., established a retail furniture business, the Krakow Furniture Co. *—Ref.: 51 (1877–1900+); 164*

KRAMER, PHILIP G., JR. Artist and carver in Detroit, 1873–88. Exhibits: Michigan State Fairs, 1878 and 1879. *—Ref.: 51 (1873–79, 1886–1888); 56 (Mar. 24, 1878); 65 (Sept. 21, 1878); 112 (Oct. 24, 1878, Feb. 10, 1880); 118 (1887)*

KREUCHER, JOHN. Wood-carver in Detroit, 1873–1900+. *—Ref.: 51 (1873–1900+); 118 (1887, 1897, 1899)*

KRUGER, HENRY, JR. Artist in Detroit. Exhibit: Detroit Museum of Art, 1912–14. Membership: Hopkin Club, Detroit. *—Ref.: 163*

KUNTZE, HENRY. Modeler and wood-carver in Detroit. Associated with Theodore Crongeyer (q.v.) as modelers and wood-carvers, under the firm name of Crongeyer & Kuntze (q.v.), 1875–76. Thereafter operated alone. —Ref.: 51 (1868–78)

L

LACEY, JULIA A. WITHERELL (Mrs. Heman A.) (1833–1919). Amateur artist for many years in Detroit. Born in Detroit, Feb. 11, 1833. Married Captain Heman A. Lacey, 1855. Died in Detroit, May 7, 1919. —Ref.: 51 (1882–99); 56 (May 9, 1919); 162,; 164

LACEY, THOMAS H. Artist in Detroit, 1888–92. —Ref.: 51 (1887–95); 118 (1889, 1891)

LACROIX, WILLIAM (1846–1922). Amateur artist in Detroit, and developer of St. Clair River ship canal. Born at Cottreville, St. Clair County. Died at Harsen's Island, May 1, 1922. —Ref.: 51 (1891–93); 118 (1893); 164

LADUE, JOHN (ca. 1803–1854). Mayor, businessman and amateur artist in Detroit. Born in Lancingburgh, N. Y. Married Mary Angel, 1827. Settled in Detroit, 1847. Mayor of Detroit, 1850. Died in Detroit, Dec. 4, 1854. —Ref.: 51 (1850–54); 56 (December 30, 1850); 162; 164

LAFFEN, W. W. MACKEY. Residence unknown. Author and illustrator of "Deer Hunting in Michigan" for Scribner's Monthly. —Ref.: 56 (Jan. 22, 1878)

LAIBLE, EUGENE. Interior and ornamental decorator in Detroit. Associated for a time with Robert Hopkin (q.v.) in the firm of Laible, Wright & Hopkin (q.v.). —Ref.: 51 (1863–66)

LAIBLE, WRIGHT & HOPKIN. Interior and ornamental decorators in Detroit, 1863–66: Eugene Laible (q.v.), William Wright (q.v.) and Robert Hopkin (q.v.). —Ref.: 51 (1863/64, 1865/66)

LALONDE, EMMA (Mrs. Docite). Artist in Detroit, 1895–1900. —Ref.: 51 (1895–1900)

LAMBERT, HARRIET. Artist in Detroit, 1857. Award for painting, Michigan State Fair, 1857. —Ref.: 112 (Nov. 1857)

LA MONTAGNE, WALTER E. (1839–1915). Painter in oils, in Detroit, 1867–1915. Moved from Buffalo to Detroit, 1867. Exhibited at local art galleries. Killed by an automobile in Detroit, June 30, 1915. —Ref.: 3 (vol. 12, 1915); 51 (1867–1900+); 56 (Apr. 13, 1880); 109; 118 (1889, 1895); 128; 163; 164; 165

LANE, ANNIE E. (Mrs. William B.). Artist and decorator in Grand Rapids, 1891–1900+. —Ref.: 86 (1891–1900+)

LANG, ALOIS (1872–1954). Wood-carver. Born in Oberammergau, Bavaria; cousin of Anton Lang, famous portrayer of Christ in the Passion Play at Oberamergau. Went to Detroit in 1890, and later to Grand Rapids and Manitowac, Wisc. Gained recognition for his wood carvings of religious scenes, installed in many churches. Represented in Michigan at the Shrine of the Little Flower, St. Joseph's Episcopal Church, Sacred Heart Seminary, and St. John's Church in Detroit, Grosse Pointe Memorial Church, and Christ Church, Cranbrook. Died in Ann Arbor, Mar. 10, 1954. —*Ref.: 61 (Mar. 12, 1954); 164; 165; 174*

LANG, JOHN. Artist in Detroit, 1899–1900. —*Ref.: 51 (1900); 118 (1899)*

LANGER, ANTHONY. Photographer and portrait artist in Detroit, 1862–68. —*Ref.: 51 (1862/63, 1867/68)*

LANGLEY, EDWIN. Portraitist in Muskegon, 1895. —*Ref.: 118 (1895)*

LANMAN, CHARLES (1819–1895). Landscape painter, either in Washington, D.C. or Washington Territory. Born in Monroe, June 14, 1819. —*Ref.: 13; 109*

LAPHAM, ABRAHAM. Photographer and portraitist in Detroit, 1882–84. Associated with Frank C. Bracy (q.v.) and Ambrose J. Diehl (q.v.) as Bracy, Diehl & Co. (q.v.). —*Ref.: 51 (1882–84)*

LAPP, FERDINAND. Wood-carver, sculptor, and designer in Detroit, 1873–1900+. Later furniture designer and architect. —*Ref.: 51 (1873–1900+)*

LARNED, ELLEN SAULSBURY LESTER (Mrs. Sylvester, Jr.) (1840–1918). Artist in Detroit, ca. 1878–1915. Principal works were of birds and flowers. Exhibits: Michigan State Fairs, 1878 and 1879. Born in Stockbridge, Mass., Mar. 21, 1840, daughter of C. Edwards Lester, U. S. Consul at Genoa, Italy, where she studied painting and designing. Married Sept. 28, 1862, at Sheboygan, Wis. Lived in Detroit until 1915, then moved to New York. Died at Bronxville, N. Y., May 10, 1918. —*Ref.: 51 (1894); 56 (Sept. 18, 1879); 66 (May 25, 1918); 112 (Oct. 24, 1878, Sept. 18, 1879); 164*

LATHROP, ? (Mrs. George A.). Amateur artist in Saginaw, 1875. Exhibit: Michigan State Fair, 1875. —*Ref.: 112 (Oct. 12, 1875); 142 (1871/72)*

LATHROP, MAY C. Artist in Grand Rapids, 1888–93. —*Ref.: 86 (1888–92); 118 (1893)*

LATIMER, RALPH R. Director, Ann Arbor Art School, 1899. —*Ref.: 6 (1899); 118 (1899)*

LA TOUR, CHARLES A. (? –1888). Artist and printer in Detroit, 1883–88. Married Mrs. Sarah Jane Loomis, 1885. Exhibits: Michigan

State Fair, 1885; Detroit Museum of Art (now DIA), first annual exhibit. Member: Detroit Artists Association. Died in Detroit, Dec. 10, 1888. —*Ref.: 51 (1883–89); 60 (Apr. 18, 1893); 118 (1885); 163; 164*

LAWRENCE, A. NELSON. Artist in Detroit, 1897–1900+. —*Ref.: 51 (1897–1900+)*

LEAVENS, EDWARD. (1856–1898). Portrait artist in Decatur, ca. 1880–98. Born in Oramel, N. Y., Dec. 21, 1856, the son of D. W. and Mary L. Leavens. Moved to Decatur, Mich. in early childhood. Died in Decatur Feb. 12, 1898. —*Ref.: 161*

LEBENGOOD, CHARLES. Artist in Detroit, 1898–99. —*Ref.: 51 (1898–99)*

LE CLAIR, CHARLES (? –1849). Artist from Calais, France, who went to Detroit in 1848 to decorate St. Peter and St. Paul Cathedral. Died in Detroit of cholera, 1849. —*Ref.: 164*

LE CLEAR, ALBERT A. Photographer and portraitist in crayon, India ink, pastel and watercolors, in Detroit 1887–95. Before 1887, had been in Jackson, in partnership with brother, James M. LeClear (q.v.), under the firm name of LeClear Brothers (q.v.). From Detroit, went to Terre Haute, Ind. —*Ref.: 51 (1887–95); 118 (1883)*

LE CLEAR, JAMES M. Photographer and portrait artist in Jackson, 1883–1900+. Associated with brother, Albert A. LeClear (q.v.), as Le Clear Brothers (q.v.). —*Ref.: 98 (1887, 1912); 118 (1883)*

LE CLEAR BROTHERS. Portrait artists and photographers in Jackson: Albert A. LeClear (q.v.) and James M. LeClear (q.v.). —*Ref.: 118 (1883)*

LEE, BLANCHE. Artist in Michigan, 1895. —*Ref.: 118 (1895)*

LEGGETT, AUGUSTUS W. Portrait artist in Detroit, 1894. —*Ref.: 51 (1894)*

LEIPSIGER (or LEIPZEIGER), FREDERICK I. Artist and engraver in Detroit, 1886–1900+. Exhibit: Detroit Museum of Art, 1890. —*Ref.: 51 (1886–1900+)*

LEIPZEIGER, FREDERICK I. *See* LEIPSIGER, FREDERICK I.

LEMOND, WILLIAM. Artist in Detroit. Employed by a photo-engraving firm at the end of the nineteenth century. —*Ref.: 51 (1898–1900+)*

LEMOS, LILY. Portrait artist in Detroit, 1900. Possibly a photography colorist. —*Ref.: 51 (1900)*

LEMOS, NICHOLAS. Portrait artist in Grand Rapids, 1898–99. —*Ref.: 86 (1898–99)*

LEMPKE, MARK J. (or MARTIN J.). Artist in Marine City, 1887. Associated with Collin J. Cruickshank (q.v.) of Port Huron in the firm of Cruikshank & Lempke (q.v.). —*Ref.: 118 (1887, 1895)*

LEONARD, (Miss) ? . Artist in Saginaw, 1887. —*Ref.: 118 (1887)*
LEONARD, HARRIET NEWELL (? —1905). Artist in Detroit, 1885–1900+. Specialized in scenic, portrait, and floral works in oils and watercolors, and in china decorating. Taught art at Albion College, and had an outdoor sketching class in Detroit. Frequent exhibits: Detroit; World's Columbian Exposition, Chicago, 1893; Society of Western Artists; Cleveland Art Club. Memberships: charter member, Detroit Society of Women Painters and Sculptors; sec.-treas., Detroit Water Color Society; treas., Rembrandt Etching Club, Detroit; Chicago Palette Club; Society of Western Artists. Died in Detroit, June 20, 1905. —*Ref.: 51 (1885–1900+); 56 (June 21, 1905); 60 (Dec. 1, 1889, Apr. 18, 1893, Nov. 3, 1894, Dec. 7, 1896); 118 (1887–99); 163; 164*
LEONARD, J.V. Artist in Royal Oak, 1883. Exhibit: Michigan State Fair, 1883. —*Ref.: 60 (Mar. 27, 1893); 112 (Oct. 16, 1883); 164*
LERICH, LILIAN. Artist in Utica, 1889. —*Ref.: 118 (1889)*
LEROY, ROBERT. Artist in Flint, 1887, 1889; Detroit, 1890; and Saginaw, 1889, 1891. —*Ref.: 51 (1890); 118 (1887, 189, 1891)*
LESTER, HATTIE E. (or HATTIE L.). Artist in Albion, 1883. Award: prize, Michigan State Fair, 1883. —*Ref.: 112 (Oct. 16, 1883); 164*
LEUTY, CHANCEY (or CHAUNCEY). Artist in Detroit 1890–92. —*Ref.: 51 (1890–92); 118 (1891)*
LEVER, JAMES. Wood-carver in Grand Rapids, 1886–1900. —*Ref.: 86 (1886–1900); 180*
LEWIS, ALICE (Mrs. Joseph M.). Artist in Jackson, 1882, 1887. Award: premium for a historical painting, Michigan State Fair, 1882. —*Ref.: 86 (1887); 112 (Oct. 17, 1882)*
LEWIS, JAMES OTTO (1799–1858). Artist, engraver, and lithographer in early Detroit, 1824– ? . Born in Philadelphia. Worked in Detroit and Wisconsin. In Detroit, painted numerous portraits of noted persons. Is the first artist of Detroit for whom there is an authentic record. Credited with the first seal of the State of Michigan. Accompanied Governor Lewis Cass into the wilderness habitat of the Indian tribes, and made paintings of many chiefs, including Black Hawk. Died in New York City. —*Ref.: 13; 79; 101; 109; 128; 149; 163; 164*
LIEBOLD, OTTO. Wood-carver, modeler, and sculptor in Detroit, 1890–1900+. —*Ref.: 51 (1890–1900+); 118 (1899)*
LIGHT, SUSAN K. Artist in Detroit, 1888–99. —*Ref.: 51 (1888–99); 118 (1891–99)*
LINDEMAN, CARL. Artist in Detroit, 1883. Exhibit: two paintings, Michigan State Fair, 1883. —*Ref.: 65 (Sept. 20, 1883)*
LINDLEY, BLANCHE B. Artist in Detroit, 1894–1901+. —*Ref.: 51 (1894–95, 1901+); 118 (1895)*

LITTLE, FRANK M. Artist in Detroit, 1897–99. *–Ref.: 51 (1897–98); 118 (1899)*

LITTLE, MARY E. Artist in Detroit, 1899–1900+. *–Ref.: 51 (1899–1900+); 118 (1899)*

LLOYD, ETHEL SPENCER (1875– ?). Designer and maker of jewelry, medals, ornamental silverware, and embroidery; also a lecturer on art; in Detroit, ca. 1900. Born in Albany, N.Y., Jan. 25, 1875. Pupil of James H. Winn and George E. Garner. Exhibit: Michigan State Fair, 1916. Memberships: Boston Society of Arts & Crafts; Detroit Society of Arts & Crafts; Society of Medalists; American Federation of Arts. Represented in the University of Michigan, Ann Arbor; Dioceses of Michigan and Montana; Board of Education of the Episcopal Church (official seal); Twentieth Century Club, St. John's Church, and Elizabeth Stevens Memorial Library, Detroit; St. James Church, Birmingham. *–Ref.: 66 (Sept. 9, 1916); 153 (vol. 1, 1936–37); 164*

LOCHNER, F. Franconian pastor and artist in Detroit, 1845. Drawings of Detroit (1845) and of Frankenmuth (1859) are in the Concordia Historical Society, St. Louis, Mo. *–Ref.: 164*

LOCKLEY, GEORGE. Amateur artist in Saginaw, 1875. Exhibit: Michigan State Fair, 1875. *–Ref.: 112 (Oct. 12, 1875); 142 (1871/72)*

LODEMAN, HILDA. Artist in Ypsilanti, 1890, 1899. Detroit Museum of Art, 1890. *–Ref.: 6 (1899); 163*

LOENNECKER, LOUISA. Artist in Jackson, 1897–99. *–Ref.: 118 (1897, 1899)*

LOMBARD, WARREN PLIMPTON (1855–1939). Etcher and painter. Born in West Newton, Mass. Unknown whether he was active in Michigan prior to 1900. Exhibit: DIA, 1930. Died in Ann Arbor. *–Ref.: 109; 156; 163*

LONG, IRA M. Artist in Ann Arbor, 1889. *–Ref.: 118 (1889)*

LONGSWORTH, JENNIE. Artist in Jackson, 1887. *–Ref.: 98 (1887)*

LOOMIS, CHARLES A. (1816–1893). Lawyer and amateur artist in St. Clair. *–Ref.: 56 (Dec. 30, 1850); 113 (vol. 10); 164*

LOPEZ, SIMON. Wood-carver and designer in Grand Rapids, 1886–1900. *–Ref.: 86 (1886–1900); 118 (1885, 1887)*

LORANGER, CATHERINE (Mrs. James). Artist in Detroit, 1881–1900+. *–Ref.: 51 (1881–1900+); 118 (1889)*

LORCH, EMIL (1870–1963). Artist and architect in Detroit, 1890–1900+, and Ann Arbor 1906–63. Born in Detroit, July 21, 1870. Attended Massachusetts Institute of Technology; College de France, École des Beaux Arts and École du Louvre, Paris. Received M.A., Harvard University. Professor of Architecture, 1906, and Director, 1931–36, College of Architecture, University of Michigan. Instructor in

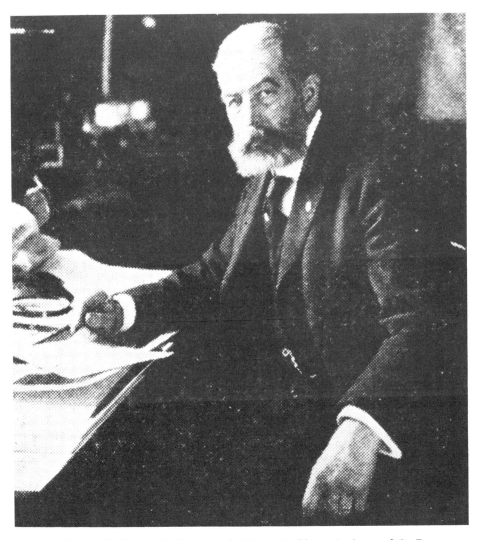

Warren P. Lombard, Photograph. From the Photo Archives of the Detroit
Historical Museum.

architecture, Detroit Museum of Art School, and assistant to Percy Ives (q.v.) in the life and antique classes. President, Detroit Architectural Sketch Club. Married Myma Elmslie, 1906. Died at Ann Arbor, June 20, 1963. —Ref.: 3 (1898); 51 (1890–1900+); 56 (June 28, 1963); 60 (Sept. 19, Oct. 3, 10, 1896); 61 (June 21, 1963); 164

LORMAN, JESSE C. Artist in Detroit, 1892–93. —Ref.: 51 (1892–93)

LOTHROP, ISABELLA GRAHAM STEWART (Mrs. Charles B.) (1857–?). Artist in Detroit, 1894–1900+. Born in Detroit Mar. 4, 1857. Charter member, Detroit Society of Women Painters and Sculptors. One painting accepted by the Paris Salon and subsequently exhibited Michigan State Fair, 1916. —Ref.: 51 (1894–1900+); 56 (July 15, 1927); 66 (Sept. 2, 9, 1916); 101; 164

LOURIE, MARION. See LOWRIE, MARION

LOUVRIER, J. D. Crayon artist in Detroit, 1870–71. Probably related to Paul Louvrier (q.v.). —Ref.: 51 (1870/71)

LOUVRIER, PAUL. Portrait painter in Detroit, 1870–71. Exhibited a painting at a local gallery. Probably related to J.D. Louvrier (q.v.), who was in Detroit at the same time. —Ref.: 51 (1870/71); 50 (Aug. 1, 1870)

LOVEJOY, E. LANSING. Amateur artist in Jackson, 1881, 1887. Exhibit: Michigan State Fair, 1881. —Ref.: 65 (Sept. 21, 1881); 98 (1887)

LOWELL, ? (Mrs. J. C., probably Judson C.). Amateur artist in Jackson, 1882, 1887. Award: premium for an oil painting of fruit, Michigan State Fair, 1882. —Ref.: 98 (1887); 112 (Oct. 17, 1882)

LOWRIE (or LOURIE), (Miss) MARION. Artist and ceramic painter in Detroit, 1886. Exhibits: first annual exhibit, Detroit Museum of Art, May 1886; Detroit Water Color Society, November 1886. —Ref.: 60 (Dec. 22, 1893); 163; 164

LOWRY, LYDIA P. H. Artist in Chicago, 1897–98. Born in Newago. Pupil of Chicago Institute of Arts; and Lasar, Delance, Langée, and Dupré, in Paris. Exhibit: Chicago Artists Exhibitions, 1897 and 1898. —Ref.: 3 (vol. 1, 1898)

LOWRY, WILLIAM S. (? –1881). Amateur artist in Detroit, 1878–81. Apparently died in Detroit, as a Margaret E. Lowry, widow of William S., still resided there, 1882. —Ref.: 51 (1878–81)

LUDWIG, HENRY. Wood-carver in Detroit, 1870–99. Perhaps related to Robert Ludwig (q.v.). —Ref.: 51 (1870–99)

LUDWIG, ROBERT. Painter and artist in Detroit, 1870–72. Possibly related to Henry Ludwig (q.v.), active in the same years. —Ref.: 51 (1870–72)

LUM, C. T. Artist in Detroit, 1893. Possibly Charles Mathieu Lum (q.v.). —Ref.: 118 (1893)

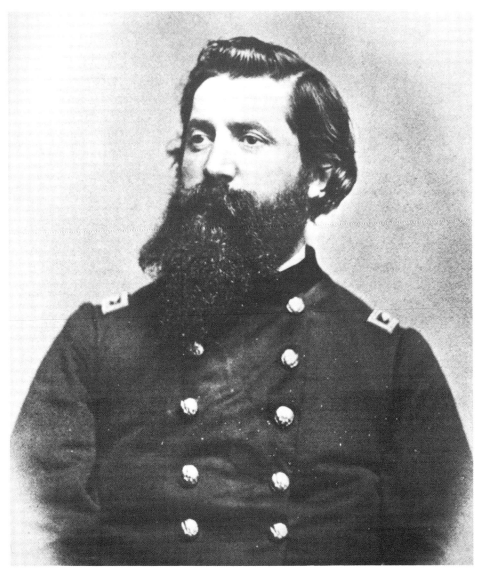

Colonel C. M. Lum, ca. 1863, Photograph. From the collection of Frank
E. Storer, Storer Spellman Studio, Detroit.

LUM, (Colonel) CHARLES MATHIEU (1830–1899). Artist in Detroit, 1851–99. Painted animals and scenic pieces, also banners, decorations on railroad coaches, and architectural, hotel and church designs. Born in Canandaigua, N. Y., Mar. 1, 1830. Served in the Civil War and was later active in the Light Guards. Exhibits: Michigan State Fairs, 1852 and 1854; Detroit Gallery of Fine Arts, 1852; Detroit Art Association, 1875 and 1876. Died in Detroit, Sept. 18, 1899. —*Ref.: 51 (1852–1900); 56 (Nov. 17, 1893, Sept. 19, 1899); 112 (Oct. 1851, Oct. 1852, Nov. 1854); 118 (1889–99); 128; 162; 163; 164*

LYLE, JENNIE (Mrs. Frank W.) Artist in Dowagiac, 1885–1900+. Awards: premiums at several Michigan State Fairs. —*Ref.: 118 (1885–1900+); 164*

LYND, MATTIE. Artist in Michigan, 1887. —*Ref.: 118 (1887)*

LYON, MAGGIE E. (Widow of Charles). Artist in Grand Rapids, 1888–90. —*Ref.: 86 (1888–90)*

M

McCALL, SYLVIA H. Drawing teacher in Grand Rapids public schools, 1878–81. —*Ref.: 11; 86 (1878–90); 118 (1881)*

McCANN, JOHN A. Variously, artist and photographer in Detroit, 1889–1900+. —*Ref.: 51 (1889–1900+); 118 (1893, 1895, 1899)*

McCLELAND (or McLELLAND, M'LELLAND), ?. Portrait painter in Detroit, 1830–31. Possibly Thomas McCleland, New York portrait painter. Advertised in Detroit newspapers. —*Ref.: 128; 156; 163; 164*

McCORMICK, DAVID A. (1850–1934). Electrician and amateur artist in Detroit. Born in Detroit. Member, Detroit Volunteer Firemen for many years. Made paintings, now in the Detroit Historical Museum, of the early engines and fire houses. Died in Detroit, Feb. 14, 1934. —*Ref.: 51 (1870–1900+); 56 (Feb. 15, 1934); 61 (Feb. 14, 1934); 163; 164*

McCREADY, ? (Mrs. W. Harry). Landscape artist in Grand Rapids, 1881. —*Ref.: 86 (1877–90); 118 (1881)*

McCURDY, WILLIAM H. Partner in the firm of Revenaugh & McCurdy (q.v.) in Jackson, 1879. —*Ref.: 118 (1879)*

McDONALD, ELIZABETH A. Artist in Detroit, 1862–77. —*Ref.: 51 (1862/63, 1867/68, 1877)*

McDONALD, JOHN B. Portrait artist in Grand Rapids, 1877–80. —*Ref.: 86 (1877, 1879, 1880)*

McEACHRAN, STUART L. (ca. 1883–1949). Artist and director of the *Detroit New's* art department. Born at St. Thomas, Ontario. Studied under Joseph Gies (q.v.) at Detroit School of Art. Died in Detroit, Nov. 15, 1949. —*Ref.: 51 (1899–1900+); 61 (Nov. 16, 1949); 164; 165*

McELHENY, EMMA J. Artist in Detroit, 1891. —*Ref.: 51 (1891)*

McENTEE, FRANCES B. Artist in Saginaw, 1871–1914. —*Ref.: 118 (1895); 142 (1871–1914)*

McENTEE, WILLIAM H. (1857–1917). Portrait and landscape artist in Almont and Detroit, 1890s. Born in Almont. Studied in England and Germany; and in Paris under Bougereau. Two paintings accepted by the Paris Salon. While in Paris, married Rosa Fox. Died in Detroit, Nov. 12, 1917. —*Ref.: 51 (1894–96); 60 (Dec. 22, 1893, Aug. 13, 1894, Sept. 21, 1895); 62 (May 10, 1896); 118 (1877, 1895); 163; 164*

McEWEN, ALEXANDRINE. Artist in Detroit, 1896–1900+. Sister of Katherine S. McEwen (q.v.). Education: Detroit Art Academy; Chase School of Art, New York; Charles Woodbury School, Ogunquit, Maine; and abroad. Charter member, Detroit Society of Women Painters and Sculptors. Exhibits: DIA, 1905–07, 1909–11; showed miniatures, bookplates, and watercolor designs at Michigan State Fair, 1916. —*Ref.: 51 (1896–1900+); 60 (June 6, 1906); 66 (Sept. 9, 1916); 157; 163; 164*

McEWEN, KATHERINE S. (1875– ?). Artist in Detroit 1896–1900+. Painted many murals and landscapes. Sister of Alexandrine McEwen (q.v.). Born in Nottingham, England, July 19, 1875. Education: Detroit Art Academy; Chase School of Art, New York; Charles Woodbury School, Ogunquit, Maine; and studied portraiture under William M. Chase in Spain. Exhibits: DIA, 1905–07, 1909–11, 1914–26, 1928–29. Memberships: Charter member, Detroit Society of Women Painters and Sculptors, and its president, 1915–18; American National Society of Mural Painters; National Association of Women Painters and Sculptors; Detroit Society of Arts and Crafts. Represented at DIA; and by frescoes in Christ Church, Cranbrook; Arts and Crafts Building, Detroit, and Cranbrook School for Boys. —*Ref.: 3 (vol. 30, 1933); 51 (1896– 1900+); 60 (June 6, 1896), 66 (Sept. 2, 9, 1916); 101; 109; 163; 164; 165*

McGARRY, CORA L. Artist in Detroit, 1899–1900. —*Ref.: 51 (1899, 1900)*

McGARRY, FANNIE (or FRANCES) E. (Mrs. Thomas J.). Teacher of art in Detroit public schools, 1870–1900+. Exhibits: Michigan Artists' showing, Angell's Gallery, Detroit, 1879 and 1880; Western Art Association, 1870. —*Ref.: 51 (1870–1900+); 56 (Apr. 17, 1879, Apr. 13, 1880); 65 (Apr. 14, 1870); 157; 164*

McGRAW, ESTHER LONGYEAR (Mrs. F. Towsley Murphy) (1882– ?). Artist in Detroit, ca. 1900–1929+. Memberships: Detroit Society of Women Painters and Sculptors; president, Detroit Society of Arts and

Crafts, 1918–29. Exhibits: Detroit area, and at the Michigan State Fair, 1916. —*Ref.: 66 (Sept. 16, 1916); 164; 1665*

MACHATTIE, ADELAIDE. Artist in Grand Rapids, 1899–1902+. —*Ref.: 86 (1899–1900+)*

MACHEN, (Miss) ? . Young artist in Michigan, 1885. At sixteen, won an award for an amateur painting. Michigan State Fair, 1885. Possibly related to William H. Machen (q.v.). —*Ref.: 112 (Oct. 27, 1885)*

MACHEN, WILLIAM H. (1832–1911). Painter of still life, water fowl and game birds, portraits and landscapes, in Detroit, 1881–94. Born in Arnheim, Holland, Feb. 10, 1832. Came to America, 1847. Moved to Washington, D. C., 1894. Exhibits: Detroit Museum of Art, 1883, 1886, 1890; Detroit Artists Association, 1886; Michigan State Fairs, 1884–87. Died in Washington, D. C., June 19, 1911. —*Ref.: 51 (1881–93); 56 (Apr. 6, 1883); 60 (May 3, June 8, 1893); 64 (Aug. 17, 1884, Sept. 19, 1885); 65 (Dec. 17, 1882); 68 (Oct. 10, 1886, Mar. 27, 1893); 112 (Nov. 4, 1884, Oct. 27, 1885, Nov. 2, 1886, Oct. 1, 1887); 118 (1883–93); 163; 164*

McINTOSH, KATHLEEN M. Artist in Detroit, 1895–97. —*Ref.: 51 (1896–97); 118 (1895)*

MACK, FRANCIS (or FRANCES) ASBURY. Portrait artist in Detroit, 1877–84. —*Ref.: 51 (1877–84); 56 (Feb. 9, 1877); 118 (1883, 1885); 164*

MACKAY, EDWIN MURRAY. (1869–1926). Painter of portraits and genre subjects, and an etcher, in Detroit. Painted portraits of many Michigan notables. Born in Sebewaing. Pupil of Laurens, Blanche, and Kenyon Cox, Paris. Memberships: Connecticut Society of Artists; Hopkin Club, Detroit; and others. Represented in Paris Salon; NAD; PAFA; Carnegie Institute; and many European galleries and private collections. Died in Detroit, Feb. 28, 1926. —*Ref.: 3 (vol. 23, 1926); 79; 109; 162, 163, 165*

McKAY, THOMAS. Artist in Grand Rapids, 1880–81. —*Ref.: 86 (1880); 118 (1881)*

McKEE, (Miss) E.S. Artist in Kalamazoo, 1885. Exhibit: Michigan State Fair, 1885. —*Ref.: 112 (Oct. 27, 1885)*

McKEE, J. E. Artist in Plainwell, 1877. Possibly is John E. McKee, artist of Saugatuck. —*Ref.: 118 (1877,1887)*

McKEE, JOHN E. *See* McKEE, J. E.

McKENNA (or McKENNEY), AGNES. Artist in Detroit, 1890–91. Related to Peter R. McKenna (q.v.), of the same address. —*Ref.: 51 (1890–91)*

McKENNA, PETER R. (or PETER R. McKENNEY, or PERRY R. Mc-

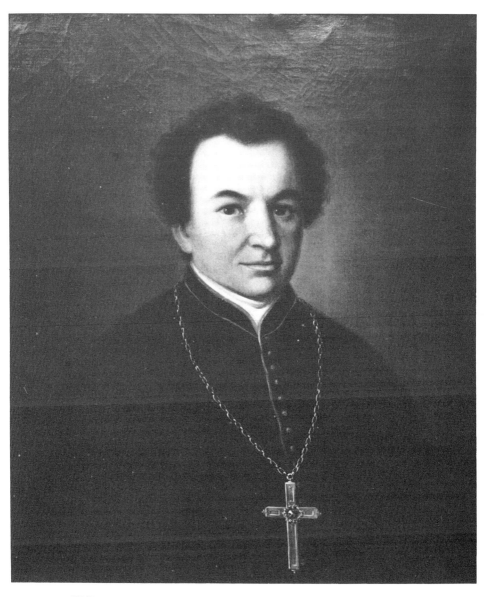

William Machen, *Portrait of Bishop Frederick Rese*. Oil. From the collection of the Detroit Historical Museum.

KENNY). Artist in Detroit, 1890–91. Listed variously as McKenna and McKenney and as Perry R. McKenny. Related to Agnes McKenna (q.v.). *–Ref.: 51 (1890–91); 118 (1891)*

McKENNEY, AGNES. *See* McKENNA, AGNES.

McKENNEY, PETER R. *See* McKENNA, PETER R.

McKENNY, PERRY R. *See* McKENNA, PETER

McKNIGHT, SARAH M. ADAMS (Mrs. Sheldon) (ca. 1806–1879). Artist in Detroit, mid-nineteenth century. Exhibits: Michigan State Fairs, 1857 and 1859. Married in Detroit, Jan. 1833. Died in London, England, Dec. 31, 1879. *–Ref.: 112 (Nov. 1857, Oct. 1859); 164*

McLAUGHLIN, W. L. Painter of miniatures in Detroit, early nineteenth century. *–Ref.: 57 (July 6, 1821)*

McLAULIN, J. D. (1834– ?). Teacher and amateur artist in Detroit 1877–99. Born in Fort Ann, Washington County, N. Y. Taken to Detroit in infancy. Exhibit: India ink drawing, Michigan State Fair, 1879. *–Ref.: 51 (1877–99); 112 (Feb. 10, 1880); 164*

McLELLAND, M'LELLAND. *See* McCLELAND.

McMASTER, MARY. Artist and teacher in Detroit, 1889–1900+. Studied in Philadelphia, and with Corinne Dunsmore (q.v.) and A. Nelson Lawrence (q.v.) in Detroit. Teacher of sketching, Detroit Museum of Art school. Exhibits: Great Art Loan in Detroit, 1895; many local galleries. Memberships: Detroit Water Color Society; Art Club of Detroit; Detroit Society of Women Painters and Sculptors. *–Ref.: 51 (1889–1900); 60 (Dec. 13, 1895); 61 (Dec. 1, 1889); 62 (Jan. 19, 1896); 118 (1891–99); 163; 164*

McMASTERS, WILLIAM H. Artist in Grand Rapids, 1876. *–Ref.: 86 (1876)*

McNAMARA, NETTIE. Artist in Brighton, 1895–97. *–Ref.: 118 (1895, 1897)*

McNAUGHTON, BELLE (Mrs. M. A.). Artist and engraver in Jackson. Exhibits: Michigan State Fairs, 1876, 1877. *–Ref.: 112 (Nov. 14, 1876, Oct. 30, 1877)*

McNEIL, AMBROSE. (1840?–). Landscape and portrait artist who exhibited and painted portraits in Detroit apparently before 1893. A Tuscola County farmer of the same name was born in Canada, June 29, 1840. Since Tuscola county is relatively close to Detroit may be the same person. *–Ref.: 68 (Mar. 5, 1893); 94*

McNULTY, JAMES F. Artist and painter in Detroit, 1870–72. Exhibited a religious painting locally. *–Ref.: 50 (Feb. 9, 1870); 51 (1871/72)*

MACOMB, ALEXANDER (1782–1841). Soldier and amateur artist in Detroit. Born in Detroit, Apr. 3, 1782. Soldier in the War of 1812,

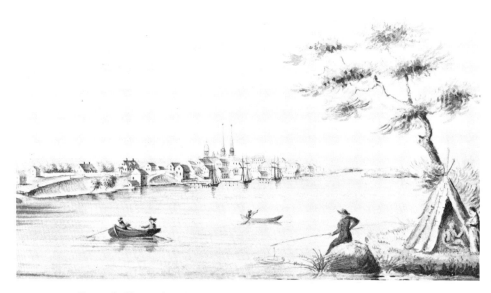

General Alexander Macomb, *Detroit as Seen from the Canadian Shore in 1821.* Watercolor and pencil, 4″ x 6¼″. From the collection of the Detroit Institute of Arts. Gift of Mrs. Robert L. Stanton.

promoted to Major-General and awarded a gold medal; Commander in Chief, United States Army, 1835. Died in Washington, D.C., June 25, 1841. —*Ref.: 71 (vol. 6); 125 (vol. 2); 164*

McPHEE, ANGUS J. Painter and artist in Detroit, end of the nineteenth century. —*Ref.: 51 (1893–1900)*

McPHERSON (or MacPHERSON), (Mrs.) M.E. Crayon and pastel artist. Exhibit: Michigan State Fair, 1879. —*Ref.: 56 (Sept. 18, 1879); 65 (Sept. 18, 1879)*

McQUESTEN (or McQUESTON), FANNIE M. Music teacher and artist in Detroit, 1871–92. —*Ref.: 51 (1871/72, 1892)*

McRAE, NELLIE C. (Mrs. Bertram C.). Artist in Detroit, latter part of the nineteenth century. —*Ref.: 51 (1898–1900+); 118 (1899, 1901)*

MANIATES, (Miss) MARION. Amateur artist in Jackson, 1882. Awards: two prizes, Michigan State Fair, 1882. —*Ref.: 112 (Oct. 17, 1882)*

MANN, AUSTIN FLINT (1856–1935). Pencil and crayon artist-photographer in Detroit, 1886–96, and Mt. Clemens, 1899. Born in Ottoville, Ontario, Nov. 2, 1856. Died in Birmingham, Jan. 26, 1935. —*Ref.: 51 (1886–96); 56 (Jan. 28, 1935); 118 (1899); 164*

MANN, JOSEPHINE (Josie) B. Artist in Jackson, 1886–87. Award for an oil painting, Michigan State Fair, 1886. —*Ref.: 98 (1887); 112 (Nov. 2, 1886); 118 (1887)*

MANVILLE, CLARA. Artist and art teacher in Benton Harbor, 1895 and 1897. —*Ref.: 118 (1895, 1897)*

MARGAH, KATHERINE CONELY (Mrs. Lewis H.) (1868–1950). Artist and sculptor in Detroit, 1896–1910+. Born Katherine I. Conely in Washtenaw County (probably Ann Arbor), June 14, 1868. Daughter of William Brewster Conely (q.v.), a portrait, still life, and landscape painter. Started painting ceramics, then landscapes, and then began sculpting. Educated in Detroit public schools; Chicago Academy of Arts; New York School of Art; and at Cranbrook Art Academy under Marshall Fredericks. Art director, Highland Park school system for twenty-seven years. Won sculpture prize of Michigan Women Painters Association, 1943. Member: Detroit Society of Women Painters and Sculptors. Died in Detroit, Jan. 2, 1950. —*Ref.: 51 (1896–1910+) 56 (Jan. 4, 1950); 60 (Mar. 24, Dec. 21, 1894); 61 (Jan. 4, 1950); 112 (Oct. 16, 1883); 118 (1891–99); 122; 164*

MARSCHNER, ARTHUR (1884–1950). Artist, etcher, and illustrator in Detroit. Painter of landscapes and marines in oil and watercolors. Born in Detroit, Apr. 11, 1884, the son of Adolph F. and Mathilda (Lanberg) Marschner. Pupil of John Palmer Wicker (q.v.), Joseph Gies (q.v.), Gari Melchers (q.v.) in Detroit; later studied in Paris. On the art staff of the

Detroit News; instructor, Wicker School of Art, Detroit; instructor of drawing and painting, University of Michigan. Married Gertrude C. Clark of Austin, Minn., June 3, 1926. Exhibits: DIA, 1912–22, 1924–30, and 1932–33. Member and award winner, Scarab Club, Detroit. Died in Detroit, Sept. 14, 1950. *–Ref.: 3 (vol. 30, 1933); 61 (Sept. 14, 1950); 101; 109; 155; 163; 164; 165*

MARSH, ALICE RANDALL (Mrs. Fred Dana). Miniature painter. Born in Coldwater. Studied at Chicago Art Institute; and in Paris under Merson, Collin, Whistler, and MacMonnies. Resided in Nutley, N. J., and Sakonnet Point, R. I. Member: American Society of Miniature Painters. *–Ref.: 3 (vol. 20, 1928); 79; 109; 163; 165*

MARSH, HELEN. Art student in Detroit. Pupil of Maud Mathewson (q.v.) at Detroit School of Arts, exhibiting at studio showings, 1893 and 1894. *–Ref.: 60 (June 22, 1893, June 20, 1894)*

MARSH, MARTHA R. (Mattie). Schoolteacher and amateur artist in Detroit, 1876–1900+. Exhibit: first showing, Art Association, 1876. *–Ref.: 51 (1877–1900+); 56 (Feb. 1, 1876)*

MARTELLI, PAUL F. Painter and ornamental plaster decorator in Detroit, 1885–1900+. Partner of Adolph G. Giardini (q.v.) 1893–1894, under the firm name of Martelli & Giardini (q.v.). *–Ref.: 51 (1885–1900+) 118 (1893)*

MARTELLI & GIARDINI. Fresco and stucco decorators, and manufacturers of religious statuary and decorative ornamentation in Detroit, 1893–94; Paul F. Martelli (q.v.) and Adolph G. Giardini (q.v.). *–Ref.: 51 (1893–94); 63; 118 (1893)*

MARTIN, ? (probably A.). Youthful artist in early Detroit, ca. 1850–56. Referred to as "Young Mr. Martin," and commended on landscape works. A comparison of addresses indicates that his initial was "A" and that he was a son of J. E. Martin, a Daguerrean photographer. *–Ref.: 51 (1850, 1855/56); 56 (Dec. 22, 1849, May 18, 1853); 164*

MARTIN, EDWARD B. K. Artist with the *Detroit News* at the end of the nineteenth century. *–Ref.: 51 (1895–1900+); 118 (1899)*

MARTIN, LORENZO D. Proprietor of Detroit Portrait Studio, 1896–97; a blacksmith prior to that. Undetermined whether he was a photographer or an artist, although listed as the latter in 1897 and 1898. *–Ref.: 51 (1892–98); 118 (1897)*

MARTIN, STEPHEN I. Amateur artist in Detroit, 1870–85. Exhibit: landscape in oils, Michigan State Fair, 1879. *–Ref.: 51 (1870–85); 56 (Sept. 18, 1879); 65 (Sept. 18, 1879)*

MARTINDALE, LUCY (or LUCY M.). Artist in Detroit, 1890–91). *–Ref.: 51 (1890–91)*

MARTY, EMIL F. (1868–1926). Wood-carver in Detroit, 1884–99. In 1894–97, associated with Alfred F. Nygard (q.v.) and Ernst Mildner (q.v.) under the firm name of Nygard, Marty & Mildner (q.v.); and in 1899 with Mildner as Mildner & Marty (q.v.). Died in Detroit, Dec. 29, 1926. *–Ref.: 51 (1884–1900+); 61 (Dec. 31, 1926)*

MARVIN, (Miss) E. Exhibit: two pencil drawings, Michigan State Fair, 1854. *–Ref.: 112 (Nov. 1854)*

MARZOLF, EMMA. Milliner and artist in Knotmaul, Cato Township, Montcalm County. *–Ref.: 118 (1899)*

MASON, MAUDE. Artist in Detroit, 1891. *–Ref.: 51 (1891)*

MATHEWSON (MATTHEWSON), MAUD (or MAUDE). Teacher and artist in Detroit, 1893–97. Director, Detroit School of Art. Painted mostly studies of figures in oils and watercolors. Pupil and member, Art Students League, New York. Exhibits: Detroit area, and at Cleveland Art Club. *–Ref.: 51 (1893–97); 60 (Mar. 27, 1893, June 22, 1893); 62 (Jan. 19, 1896); 118 (1897); 163*

MATHISON, ANZOLETTIE (Mrs. Joseph). Artist in Detroit, 1893. *–Ref.: 51 (1893)*

MATSON, ALICE K. Artist in Detroit, 1895–1900. *–Ref.: 51 (1895–1900); 118 (1897)*

MATTESON, (Mrs.) R.R. Artist in Jackson, 1877. Exhibit: Michigan State Fair, 1877. Probably the wife of Rinaldo R. Matteson of Jackson. *–Ref.: 112 (Oct. 30, 1877)*

MATTHEWSON, MAUDE. *See* MATHEWSON, MAUD

MATTISON, JOHN D. Artist in Saginaw, 1887–95. *–Ref.: 118 (1887–95)*

MATZEN, HERMAN (1861–1938). Wood-carver in Detroit, 1877–86. Born in Loit Kjerkeby, Denmark, July 15, 1861. Pupil of Munich and Berlin Academies of Fine Arts. Carved wooden Indians in Detroit under tutelage of Julius T. Melchers (q.v.). After working in Detroit, moved to Cleveland for further studies and became a sculptor. Work includes the design and execution of the Schiller Monument on Belle Isle, Detroit; War and Peace Monument, Indianapolis, Ind.; Wagner Monument and Court House, Cleveland; Indianapolis Soldiers and Sailors Monument. Memberships: Cleveland Society of Artists; National Art Club; National Sculptors Society. Represented in Munich and Berlin Academies of Fine Arts. Died in Cleveland. *–Ref.: 3 (vol. 30, 1933); 51 (1877–86); 61 (May 8, 1938); 79; 144 (Oct. 1928); 156; 163; 164*

MAXFIELD, JAMES E. JR. (1848– ?). Portrait and genre artist in Detroit, 1871–76. Born in Detroit. Exhibit: Michigan State Fair, 1872; frequent exhibiter at Detroit galleries. In 1874 and 1875, associated with Charles Harry Eaton (q.v.) in the firm of Maxfield & Eaton (q.v.).

Member: Detroit Artists Association. —*Ref.: 13; 51 (1871–76); 54 (Sept. 30, 1872); 55 (Feb. 24, 1873); 56 (Sept. 24, 1874, June 26, 1875, Feb. 1, 1876); 112 (Oct. 24, 1872); 118 (1873); 149; 156; 163; 164*

MAXFIELD & EATON. Artist partnership in Detroit, 1874–75. James E. Maxfield, Jr. (q.v.) and Charles Harry Eaton (q.v.). —*Ref.: 51 (1874/75)*

MAXIM, NANCY E. (wid. Charles H.). Artist in Grand Rapids, 1888–1900. Had an art school there. —*Ref.: 86 (1888–1900); 118 (1889–95)*

MAXWELL, KATHLEEN C. Artist in Detroit, 1899–1900. —*Ref.: 51 (1899–1900)*

MAY, LELIA M. Artist in Detroit, 1899. —*Ref.: 51 (1899)*

MAY, THOMAS (1860–1927). Detroit artist and internationally known cartoonist. Associated for many years with Detroit newspapers. Born in Detroit, June 30, 1860, the son of Thomas and Margaret E. (Shannon) May. Educated in public schools. Received M.A., University of Michigan. Married Maria L. Hollings, May 17, 1887. Exhibited locally. Memberships: Fine Arts Society, Hopkin Club, and Scarab Club, Detroit. —*Ref.: 3 (vol. 25, 1928); 56 (Apr. 13, 1880); 110; 157; 164*

MAYER, ANNETTE PHIPPS (Mrs. Ignatz L.). Artist in Detroit at the end of the nineteenth century. —*Ref.: 51 (1899–1900+); 60 (Apr. 27, 1934); 61 (Apr. 28, 1934); 163; 164*

MAYHEW, ? . Art student in Detroit, 1893. Exhibit: oil and watercolor paintings, Detroit School of Art. —*Ref.: 60 (June 22, 1893)*

MAYWOOD, C. G. Artist in Menominee, 1893. *Ref.: 118 (1893)*

MEHLING, GEORGE FREDERICK (1830–1929). Artist and artisan in Detroit, 1862–1900. Painter of floral pieces, and in business many years producing mantels, columns, and tables of imitation marble or wood. Born in Birkenfeld, Bavaria, Oct. 24, 1830. Came to America as an infant with his parents, who settled in Detroit. Wife's name was Madalin or Madelin. Died in Detroit, Dec. 31, 1929. —*Ref.: 51 (1862–1930); 61 (Oct. 18, 1925, Jan. 1, 1930); 164; 165*

MEISSNER, LEO JOHN (1895– ?). Painter and engraver. Born in Detroit. Active in New York, 1935. Exhibit: DIA, 1930. —*Ref.: 109; 156; 163*

MELCHERS, CORRINE LAWTON MACKALL (Mrs. Gari) (1880– ?). Artist in Detroit. Spent much time abroad, where she and her husband Gari Melchers (q.v.) painted together. Married in 1903. —*Ref.: 109; 165*

MELCHERS, GARI (JULIUS GARIBALDI) (1860–1932). Portrait, genre and mural artist in Detroit, but spent much time abroad. Born in Detroit, Aug. 11, 1860. Son of Julius Theodore Melchers (q.v.), sculptor and art teacher, and Marie Bangetor Melchers. Studied with Van-

Gebhardt at Dusseldorf; and with Lefebvre and Boulanger at École des Beaux Arts, Paris. Married Corinne Lawton Mackall Melchers (q.v.), 1903. Lived at Egmonddaan-Zee, Holland, for several years. Honors: Chevalier, later Officier (1904), Légion d'Honneur de France; Knight of the Order of St. Michael, Bavaria; Knight of the Red Eagle, Germany; Blue Ribbon of Art, Légion d'Honneur de France, previously won by only two Americans, Whistler and Sargent. Awards: honorable mention, Paris Salon, 1886; medals of honor, Amsterdam, Antwerp, Munich, and Vienna; First Class Medal, Munich 1888; Grand Prize, Exposition Universelle, Paris 1889; First Prize, Art Institute of Chicago, 1891; Medal of Honor, Berlin, 1891; Gold Medal, Philadelphia Art Club, 1892; Medal of Honor, Antwerp 1894; Temple Gold Medal, PAFA, 1896; First Class Medal, Vienna 1898; Gold Medal, Pan-American Exposition, Buffalo 1901; Gold Medal, St. Louis Exposition, 1904. Memberships: Paris Society of American Artists; International Society of Painters, Sculptors and Gravers, London; Secession, Munich; NAD; Société Nationale des Beaux Arts, Paris; Hopkin Club and Scarab Club, Detroit. Represented: National Gallery, Berlin; Musée de Luxembourg, Paris; Freer Collection, Smithsonian Institution and murals in Library of Congress, Washington, D. C.; Metropolitan Museum, New York; DPL; Missouri State Capitol. Died in Falmouth, Va., Dec. 1, 1932. *—Ref.: 3 (1898); 13; 56 (Feb. 1, 1876, Feb. 2, 1879); 60 (Apr. 19, 1877, June 15, Nov. 9, 1893, Jan. 5, Sept. 29, 1894); 61 (Dec. 1, 1932); 79; 101; 125; 129 (Dec. 1, 1932); 149; 156; 157; 162; 163; 164; 165*

MELCHERS, JULIUS THEODORE (1829–1908). Carver, sculptor, and art teacher in Detroit, 1857–1908. Born in Soest, Westphalia, Prussia, and learned carving there under Ministerman, a sculptor. Studied at École des Beaux Arts, Paris, under Carpeaux and Etex. Worked as a modeler at the Crystal Palace, London. Carved figureheads for ships in Europe. In 1855 came to Detroit, where he later married Marie Bangetor. After settling in Detroit became well-known for his life-sized carvings of cigar-store Indians, and later for marble and stone sculpture. Partner of Henry A. Siebert (q.v.) in the firm of Melchers & Siebert (q.v.), 1891–95. In Detroit taught many students who later became noted, including his son Gari Melchers (q.v.). Died in Detroit, Jan. 14, 1908. *—Ref.: 51 (1857–1907); 56 (Apr. 4, June 17, 1871, Apr. 3, 1873, Feb. 18, 1906, Jan. 15, 1908); 63; 109; 112 (Oct. 1859); 118 (1863–97); 141; 144 (Oct. 1928); 156; 162; 163; 164*

MELCHERS & SIEBERT. Sculptors and wood-carvers in Detroit, 1891–95: Julius Theodore Melchers (q.v.) and Henry A. Siebert (q.v.). *—Ref.: 51 (1891–93); 63; 118 (1891–95)*

MELLIS, ? . Male artist in Detroit, 1860. Born in Michigan. *—Ref.: 128*

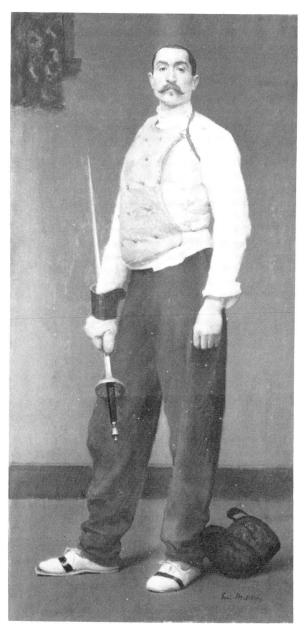

Gari Melchers, *The Fencing Master.* Oil on canvas. 81¼″ x 39½″. From the collection of the Detroit Institute of Arts. Gift of Edward G. Walker.

174

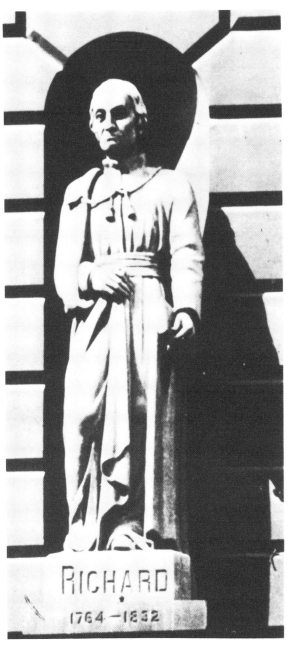

RICHARD

1764 — 1832

Julius Melchers, *Father Gabriel Richard.* Wayne State University.

MELZER, THEODORE. Amateur artist in Detroit, 1877–88. A portrait painter, 1877 and 1888, but known to have had other occupations. –*Ref.: 51 (1875–1900)*

MEREDITH, DAVID. (? –1809). Amateur artist stationed with British Army in Detroit, 1790. Captain and later Lieutenant Colonel, Royal British Artillery. Married Archange Askin, daughter of John and Marie (Barthe) Askin. Executed a wash drawing of Detroit while stationed there. Recalled to England and later was sent to Halifax, Nova Scotia. Died there Mar. 4, 1809. –*Ref.: 10; 164*

MERINE, A. Portraitist and miniaturist in Detroit, 1842. Active in South Bend, Ind. 1841. –*Ref.: 53 (May 12, 1842); 109; 128; 156*

MERKENICH, PAUL. Student, Detroit Art Academy, 1896. Employed in illustrating and designing. –*Ref.: 60 (June 6, 1896)*

MERRIAM, CHLOE E. (or CLOETTA). Artist in Detroit, 1893–1900+. –*Ref.: 51 (1893–1900+); 118 (1897, 1901)*

MERRIAM, JAMES A. Artist in Detroit, 1897–1900+. –*Ref.: 51 (1897–1900+); 118 (1899–1901)*

MERRILL, SUSIE B. Pupil in Maud Mathewson's (q.v.) art and sketch classes, Detroit, exhibited at the school, 1894. –*Ref.: 51 (1894); 60 (June 20, 1894)*

MERRIMAN, ? (Mrs. Dwight). Amateur artist in Jackson, 1872. Exhibit: oil floral or fruit piece, Michigan State Fair, 1872. –*Ref.: 112 (Oct. 24, 1872)*

MERRIMAN, LIZZIE. Artist in Kalamazoo, 1885. Awards: several premiums for works, Michigan State Fair, 1885. –*Ref.: 112 (Oct. 27, 1885)*

MESEROLL (or MESRELL), ? (Mrs. D. C.). Artist in Jackson, 1886–87. Exhibits: Michigan State Fair, 1886 and 1887. –*Ref.: 112 (Nov. 2, 1886, Oct. 31, 1887)*

MESRELL, ? (Mrs. D. C.). *See* MESEROLL, ? (Mrs. D. C.)

METZER, GEORGE B. Artist in Detroit, 1890–99. –*Ref.: 51 (1890–98); 118 (1893–99)*

MEYERS, HENRY. Artist in Lansing, 1887–89. –*Ref.: 102 (1887); 118 (1889)*

MEYERS, WILLIAM. Wood-carver and chairmaker in Detroit, 1863–80. –*Ref.: 51 (1863–80); 118 (1863/64)*

MILDNER, ERNST (or ERNEST) (? –1938). Carver in Detroit, 1885–1900+. Born in Kemnitz, Germany. Worked for Julius Melchers (q.v.), Edward Q. Wagner (q.v.), and Melchers & Siebert (q.v.). Later was associated with Emil F. Marty (q.v.), Alfred F. Nygard (q.v.), and Henry Steinman, Jr. (q.v.) under the firm names of Nygard, Marty & Mildner (q.v.), Mildner & Marty (q.v.), and Mildner & Steinman (q.v.).

Died in Detroit, Jan. 1938. *—Ref.: 51 (1885–1900+); 56 (Jan. 24, 1938)*

MILDNER & MARTY. Sculptors, modelers, and carvers in Detroit, 1899: Ernst Mildner (q.v.) and Emil F. Marty (q.v.) *—Ref.: 51 (1899); 118 (1899)*

MILDNER & STEINMAN. Wood-carvers in Detroit, 1900: Ernst Mildner (q.v.) and Henry Steinman (q.v). *—Ref.: 51 (1900)*

MILLARD, HATTIE E. Artist in Lapeer, 1891–95. *—Ref.: 118 (1891, 1893, 1895)*

MILLER, KATHERINE SPROAT TROWBRIDGE (Mrs. Sidney D.) (1829–1905). Artist in Detroit. Born in Detroit, October 9, 1829, the daughter of C.C. and Katherine W. Trowbridge. Married Sidney D. Miller, July 25, 1861. Active in the Detroit Decorative Society in the 1880s. Died in Detroit, July 16, 1905. *—Ref.: 51; 164*

MILLER, LILLIAN L. Artist in Utica, 1891; and Oxford, 1895–99. *—Ref.: 118 (1891, 1895–99)*

MILLS, HORACE A. Artist in Jackson, 1877. Award: prize for a work, Michigan State Fair, 1877. *—Ref.: 112 (Oct. 30, 1877)*

MILLS, WILLIAM H. Portrait painter in Grand Rapids, 1889–1900+. *—Ref.: 86 (1889–1900+); 118 (1895)*

MILNE, ROBERT H. Artist in Detroit, 1892–99. *—Ref.: 51 (1889–1900+); 118 (1895, 1897)*

MINER, MERRITT M. Artist in Muskegon, 1891–99. *—Ref.: 118(1891–99)*

MISNER, (Mrs.) MARION. Artist in Detroit, 1893. *—Ref.: 118 (1893)*

MITCHELL, AGGIE. Artist in Howell, 1891–92. *—Ref.: 118 (1891, 1892)*

MITCHELL, CHARLES J. Fresco painter in Detroit, 1867–76. *—Ref.: 51 (1859–76)*

MODERN MANUFACTURING CO. *See* BUELOW, HUGO V.

MOLASKEY, JOHN DEWEY (ca. 1864–1938). Artist in Detroit, 1887–1900+. Painter of game birds and fish. Born in Jerseyville, Ontario. Exhibits: locally, 1893, 1894, and 1895. Member: Art Club of Detroit. Died in Detroit, Feb. 8, 1938. *—Ref.: 51 (1888–1900+); 56 (Feb. 9, 1938); 60 (Dec. 22, 1893, May 21, Oct. 22, 1894, May 21, 1895); 118 (1897, 1899)*

MONFORT, MARY A. Artist in Detroit, 1873–99. *—Ref.: 51 (1873–99); 118 (1891, 1895, 1897)*

MONGET, FRANCOIS. Artist in Detroit, 1889. *—Ref.: 51 (1889)*

MONK, CARRIE M. Artist in Detroit, 1892–93. Exhibit: one floral painting, Angell's Gallery, 1893. *—Ref.: 51 (1892–93); 68 (Mar. 27, 1893); 118 (1893)*

MONNIER, CHARLES S. Artist in Detroit, 1896–98. *—Ref.: 51 (1893–1900); 118 (1897)*

MONTAGUE, ENOS. Painter in Detroit, 1877. Credited with a painting of

the Andrews Railroad Hotel, Detroit, in 1877. *–Ref.: 51(1877);163;164*

MONTAGUE, WALTER. *See* MONTAIGNE, WALTER

MONTAIGN, (or MONTAIGU) EMILE DE. Artist in Detroit, 1873–92. *–Ref.: 51 (1873–92); 118 (1883)*

MONTAIGNE (or MONTAGUE), WALTER. Artist in Detroit, 1877–78. Exhibited a portrait of Stephen Martin, a well-known citizen. *–Ref.: 50 (Aug. 30, 1865); 51 (1877–78)*

MONTAIGU, EMILE DE. *See* MONTAIGN, EMILE DE

MONTGOMERY, MARY L. (wid. George W.). Amateur artist in Detroit, 1887–1900+. *–Ref.: 51 (1887, 1890, 1900+)*

MONTRESOR, JOHN (1736–1799). Captain, British Army Engineers. Led the expedition which broke Chief Pontiac's siege of Detroit in 1763. While in Detroit, made a watercolor manuscript map "Plan of Detroit with its Environs–1763." Later, Colonel, British Army Engineers. Returned to England, 1778. Died there in 1799. *–Ref.: 163; 164*

MONTY, AUGUSTUS. Artist in Detroit 1852–54. *–Ref.: 51 (1852/53, 1853/54)*

MOODY, SAMUEL BROADLY (? –1923). Amateur artist in Detroit. Exhibits: Art Club of Detroit, 1895. Detroit Artists Association, 1895 and 1896. Died in Detroit, May 10, 1923. *–Ref.: 51 (1875–1923)*

MOOERS, ? (Mrs. J. H.). Artist in Charlotte, 1899. *–Ref.: 118 (1899)*

MOORE, CHARLES F. Portrait artist in Grand Rapids, ca. 1852. Later moved to Florida. *–Ref.: 163; 164*

MOORE, (Mrs.) E. & SON. Artists and wax modelers in Detroit, 1880–81: Emilia or Emelia A. Moore (q.v.) and Frederick C. Moore (q.v.). *–Ref.: 51 (1880–81)*

MOORE, EMILIA (or EMELIA A.). Artist and wax modeler in Detroit, 1875–89. Probably the mother of John D. Moore (q.v.) and Frederick C. Moore (q.v.). *–Ref.: 51 (1875/76–89)*

MOORE, FREDERICK C. Artist in Detroit, 1875–90. Later moved to Chicago. Probably a brother of John D. Moore (q.v.) and son of Emilia Moore (q.v.), with whom he was associated under the firm name of Mrs. E. Moore & Son (q.v.). *–Ref.: 51 (1875/76–90); 118 (1885–89)*

MOORE, JOHN D. Artist and wax modeler in Detroit, 1883–89. Probably a brother of Frederick C. Moore (q.v.) and son of Emilia Moore (q.v.). *–Ref.: 51 (1883–89); 118 (1887, 1889)*

MOORE, ORLANDO H. Young portrait painter in Kalamazoo, 1854. Exhibit: Michigan State Fair, 1854. In 1855 left Michigan for further study. *–Ref.: 53 (Mar. 19, 1855); 112 (Nov. 1854); 164*

MORAN, FRANCES A. DESNOYERS (Mrs. William B.). Amateur artist in Detroit, 1880s. Student, O'Connor Art School. *–Ref.: 164*

MORELL, T. J. Artist in Detroit, 1885. *–Ref.: 51 (1885)*

MOREY, LOREN S. Photographer and crayon artist of landscapes and portraits, in Mt. Pleasant, 1891–93. –*Ref.: 118 (1891, 1893)*

MORGAN, BENJAMIN B. Portrait painter in Ann Arbor and Detroit, 1880–89. Two awards: Michigan State Fair, 1880. –*Ref.: 51 (1886/87); 112 (Oct. 12, 1880); 118 (1887, 1889)*

MORGAN, DAYTON. Artist in Detroit, 1892. –*Ref.: 51 (1892)*

MORGAN, J. A. Artist in Detroit, 1899. –*Ref.: 51 (1899)*

MORGAN, JAY L. Artist in Grand Rapids, 1895–1900+. –*Ref.: 86 (1895–1900+)*

MORSE, ? (Mrs. M. B.). Artist in Saginaw, 1875. Exhibit: Michigan State Fair, 1875. Probably the wife of Moses B. Morse. –*Ref.: 142 (1868/69, 1871/72); 164*

MORSE, JOHN A. (1867–1956). Artist, etcher, and lithographer of landscapes, marines, and portraits, in Detroit. Born March 22, 1867. Exhibits: Scarab Club, DIA, and Royal Oak Public Library. Charter member, Scarab Club and one time president. Died in Detroit, July 23, 1956. –*Ref.: 61 (Dec. 9, 1928, May 7, 1939, Feb. 8, 22, 1942, Mar. 10, 1946); 67 (July 24, 1956); 163*

MORSE, NANCY (Mrs. Joshua). Artist in Lansing, 1892–97. –*Ref.: 102 (1892, 1894); 118 (1893–97)*

MOSELEY, EMMA M. Artist in Saginaw, 1883–1900+. –*Ref.: 80 (1883–1900); 118 (1897); 142 (1883–1900)*

MOSHER, ? (Mrs. H.W.). Artist in Albion, 1881, 1893. Exhibit: Michigan State Fair, 1881. –*Ref.: 112 (Oct. 25, 1881); 118 (1893)*

MOSS, REUBEN. Artist in Montrose, 1889–91. –*Ref.: 118 (1889–1891)*

MOULTON, SARAH A. (Mrs. Luther V.). Artist and teacher in watercolors, ink, and pastel, in Grand Rapids, 1876–83. –*Ref.: 86 (1876–83); 118 (1881, 1883, 1887); 164*

MOULTON, MAY, Artist in Menominee, 1893–97. –*Ref.: 118 (1893–97)*

MOVIUS, MARY L. (Mrs. Julius). Artist in Ypsilanti and Detroit, 1850–51. Later moved to Buffalo, N. Y. Exhibit: Michigan State Fair, 1851. –*Ref.: 51 (1850); 112 (Dec. 1951); 164*

MOWER, BLANCHE J. Artist in Saginaw. –*Ref.: 118 (1895–1899)*

MOYNAHAN, JOHN S. Designer and craftsman of hand wrought ornamental iron work for private homes, banks and other buildings, in Detroit. Started in business in 1885. –*Ref.: 51 (1890); 61 (Dec. 13, 1925); 165*

MUELLER, JOHN U. (also J. F., J. N. and J. W.). Watercolor and India ink artist in Detroit, 1871–79. Exhibit: Michigan State Fair, 1878. Member: Detroit Artists Association. –*Ref.: 51 (1871–79); 56 (Aug. 11, 1876, Apr. 20, 1879); 65 (Sept. 21, 1878); 112 (Oct. 24, 1878); 164*

MUELLER, ROSE. Artist in Detroit, 1877. Exhibit: one crayon drawing, Angell's Art Gallery, 1877. *—Ref.: 164*

MUIR, HELEN. Student of Maud Mathewson (q.v.). Displayed work at a Detroit studio exhibition of the class, 1893. *—Ref.: 60 (June 22, 1893)*

MUMMERY, CLARENCE. Amateur artist in Detroit, 1879–80. Award for an animal drawing, Michigan State Fair, 1880. *—Ref.: 51 (1879–80); 112 (Oct. 12, 1880)*

MUMFORD, I. GERTRUDE. Artist in Detroit, 1894–1900. Studied under Maud Mathewson (q.v.). Member: Detroit Society of Women Painters and Sculptors. *—Ref.: 51 (1899–1900); 60 (June 20, 1894); 118 (1899); 164*

MUNDT, HENRY H. Wood-carver and modeler in Detroit, 1870–1900+. *—Ref.: 51 (1870–1900+)*

MURPHY, ADIS C. Artist in Fenton, 1881. *—Ref.: 118 (1881)*

MURPHY, ESTHER LONGYEAR McGRAW. *See* McGRAW, ESTHER LONGYEAR.

MURRAY, ALEXANDER. Artist in Detroit, 1890–93. Exhibit: Michigan Artists Exhibit, DIA, 1890. *—Ref.: 51 (1890–93); 101 ; 118 (1893)*

MUTTI, AUGUSTUS. (? –ca. 1873). Wood-carver, sculptor, and modeler in Detroit, 1864–72. *—Ref.: 51 (1863–73); 164*

MYERS, ELIJAH E. (1831–1909). Architect and artist in Detroit, 1872–1909. Born in Philadelphia, Pa. Studied at Franklin Institute, Philadelphia. Settled in Detroit, 1872. Designed the state capitols of Michigan, Texas, Colorado, Idaho, and Utah; the Parliament Buildings in Rio de Janeiro, Brazil; and an asylum in Mexico City. Exhibits: Michigan State Fair, 1878. Died in Detroit, Mar. 6, 1909. *—Ref.: 51 (1873–1909); 56 (Mar. 6, 1909); 112 (Oct. 24, 1878)*

MYLL, HENRY (? –1886). Wood-carver in Detroit, 1870–86. Died in Detroit Oct. 9, 1886. *—Ref.: 51 (1870–86); 118 (1885)*

MYLNE, WILLIAM M. (? –1903). Artist in Detroit, 1870–1903. Born in Scotland, where he studied with his stepfather, John Brown, a professor in the Dollar Institute, Edinburgh. Exhibits: local galleries; Detroit Museum of Art, PAFA, and in Cleveland, Ohio. Memberships: Detroit Water Color Society; Detroit Artists Association, of which he was president, 1891. Died in Detroit, Feb. 2, 1903. *—Ref.: 51 (1870–1903); 56 (Apr. 13, 1880, Apr. 24, 1883); 60 (Apr. 18, Dec. 8, 1893, Dec. 15, 1894); 61 (Dec. 1, 1889); 64 (Aug. 17, 1884); 118 (1891); 157; 163; 164*

N

NADEAU, WINGFIELD L. Artist in Detroit for a short time at the end of the nineteenth century. *—Ref.: 51 (1898–99)*

NASH, FREDERICK C. (ca. 1876–1939). Caricaturist, cartoonist, and landscape and portrait artist in Detroit. Born in Adrian. As a boy went to Detroit with his parents. Employed by the local newspapers. Director of art studies, University of Detroit. Author of several books of caricatures and portraits. Married Helen W. Nash. Executed portraits of many Detroit and Michigan notables. Represented in the Detroit Historical Museum. Died in Detroit, June 19, 1939. —*Ref.: 51; 56 (June 20, 1939); 61 (June 20, 1939); 109; 164*

NASH, PERCY CUTHBERT. Portrait artist in Detroit, 1889–1900+. In 1896 and 1897, associated with Bruno Ertz (q.v.), painter of birds and insects, under the firm name of Nash & Ertz (q.v.), portrait artists. Moved to Portland, Oreg. 1902. —*Ref.: 51 (1889–1900+); 118 (1899)*

NASH & ERTZ. Portrait artists in Detroit, 1896–97: Percy Cuthbert Nash (q.v.) and Bruno Ertz (q.v.). —*Ref.: 51 (1896–97); 118 (1897)*

NATHAN, ISADORE. Artist in Detroit, ca. 1890–1913+. In the 1890s, studied under Percy Ives (q.v.) in Detroit. Spent several years in Europe studying under Jean Paul Laurens, Jules Adler and Guilamie Seignac. Exhibit: Hopkin Club, 1913. Represented in DIA. —*Ref.: 163*

NATUS, CHARLES. Wood-carver in Detroit, 1877–1900+. —*Ref.: 51 (1877–1900+)*

NATUS, JOHN, SR. Portrait painter in Detroit, 1872–76. Associated with Frederick A. C. Beyer (q.v.), under the firm name of Beyer & Natus (q.v.). —*Ref.: 51 (1862–76); 118 (1863/64)*

NATUS, JOHN, JR. Decorative painter and amateur artist in Detroit, 1878–79. —*Ref.: 51 (1878–79); 56 (Feb. 6, 1875)*

NEALE, EMILY CAMPBELL (Mrs. Maurice H.). (? –1896). Artist in Battle Creek, 1895–96. Married Maurice H. Neale, Aug. 15, 1858. Died Feb. 14, 1896. —*Ref.: 118 (1895); 164*

NEEDHAM, FRANCES (or FANNY) (1850–1927). Artist in Detroit, late nineteenth century. Born in Detroit. Died there Apr. 22, 1927. —*Ref.: 51 (1901); 61 (Apr. 26, 1927); 118 (1891)*

NEEDHAM, OSCAR N. Artist in Lexington. Possibly was Otis N. Needham (q.v.) of Detroit. —*Ref.: 118 (1893, 1895)*

NEEDHAM, OTIS N. Artist and proprietor of Needham's Art School in Detroit, 1891. Possibly was Oscar N. Needham (q.v.) Lexington, 1893 and 1895. —*Ref.: 51 (1891); 118 (1891)*

NEELAND, MINNIE I. D. Artist in Grand Rapids, 1895–1900+. —*Ref.: 86 (1895–1900+); 118 (1897, 1899)*

NETSCHKE, OSCAR. Engraver in Detroit, 1891–1900+. Studied at Detroit School of Art, receiving honorable mention in an exhibit at Rembrandt Hall. —*Ref.: 51 (1891–1900+); 60 (June 24, 1893)*

NETTLETON, JAMES BURRITT (1864–1927). Architect and artist in

Detroit. Born near Medina, Ohio, the son of Noble and Mary Anna (Blakeslee) Nettleton. Educated in Medina schools. Received B.S., Cornell University, 1886. Settled in Detroit, 1887. Taught at Detroit School of Arts. Married Kitty M. Wilder of Medina, June 25, 1889. Member: American Institute of Architects. Died in Detroit, Apr. 28, 1927. *—Ref.: 51 (1887—1900+); 56 (Apr. 30, 1927); 60 (Nov. 24, 1894, Mar. 16, Sept. 28, 1895, Sept. 19, 1896); 61 (Apr. 29, 1927); 110; 164*

NEWCOMB, LUCINDA. Portrait artist in Detroit, 1887—90. Moved to Chatham, Ontario, 1890. *—Ref.: 51 (1887—90)*

NEWELL, GEORGE GLENN (1870—1947). Painter of cattle and landscapes. Born in Berrien County. Resided in New York City. Studied at National Academy of Design under Ward, and at Teacher's College with Will S. Robinson. Memberships: New York's Salmagundi Club, Country Sketch Club, and Lotus Club; National Art Club; Allied Artists of America; American Water Color Society. Represented in National Art Gallery; Detroit; Dallas, Texas; Seattle, Washington; Youngstown, Ohio. Died May 7, 1947. *—Ref.: 3 (1898, 1933); 13; 79; 101; 109; 149; 156; 157; 163; 164; 165*

NEWELL, MARY HELEN (or MAY). Student, Detroit School of Arts under Maud Mathewson (q.v.). *—Ref.: 60 (June 24, 1893)*

NEWTON, LUCIA B. Artist in Detroit, 1897—1900+. *—Ref.: 51 (1897—1900+); 118 (1899)*

NICHOLS, ELIZABETH TRUAX SLOCUM (Mrs. James Benton) (? — 1917). Artist in Detroit, 1877—1900+. Born in Wayne County. Married September 6, 1876. Exhibits: Michigan State Fair, 1878; Angell's Gallery, Detroit, Apr. 1880. Died in Detroit, Jan. 22, 1917. *—Ref.: 51 (1877—1900+); 56 (Apr. 13, 1880); 61 (Jan. 23, 1917); 112 (Oct. 24, 1878); 164*

NICHOLS, LILLIE M. Artist in Ann Arbor, 1891—99. *—Ref.: 118 (1891—99)*

NICKERSON, MATTIE. Artist in Hannah, 1897—99. *—Ref.: 118 (1897, 1899)*

NIMS, ? (Mrs.) Artist in Jackson, 1870. Exhibits: two oil paintings, Michigan State Fair, 1870. *—Ref.: 112 (Oct. 8, 1870)*

NIXON, FLOYD SHERMAN (1890—). Caricaturist, artist, and woodcarver in Detroit, after 1910. Director of the art department, *Detroit Free Press.* Painted landscapes and marines in oils and watercolors. Born near Ovid, May 9, 1890. Student of John Palmer Wicker (q.v.) and Joseph Gies (q.v.) at the Detroit Art Academy. Member: Scarab Club, Detroit. Exhibited at DIA frequently, 1914—27. Represented in Huntington Galleries, San Marino, Calif. *—Ref.: 56 (Oct. 11, 1925, Mar. 31,*

1946, Oct. 12, 1958); 61 (Apr. 14, 1929); 109; 153 (vol. 2, 1938/39); 163; 164; 168

NIXON, JANETTE T. Artist in Detroit, 1853. Exhibited a watercolor, Michigan State Fair, 1853. *—Ref.: 112 (Dec. 1853, supplement)*

NORDSTROM, PAUL L. Art student and assistant instructor, Detroit Museum of Art school, 1896. *—Ref.: 60 (Sept. 19, 1896)*

NORMAN, FRED. Painter and artist in Whitehall, 1889. *—Ref.; 118 (1889)*

NORRIS, (Miss) R. B. Artist in Ypsilanti, 1852–59. Awards: premiums, Michigan State Fair, 1852 and 1859. *—Ref.: 112 (Oct. 1852, Oct. 22, 1859)*

NORTHRUP, L. L. Artist in Bangor, 1873. *—Ref.: 118 (1873)*

NORTHRUP, REBECCA S. Artist in Grand Rapids, 1886–91. *—Ref.: 86 (1886–90); 118 (1885–91)*

NORTON, CHARLES WARDLOW (1843–1901). Vessel agent and marine artist in Detroit, 1863–1901. A watercolor painter of Great Lakes vessels. Born in Detroit, June 11, 1843, the son of Captain John Norton. Died in Detroit, Feb. 18, 1901. *—Ref.: 51 (1863–1900+); 61 (June 24, 1881); 68 (Feb. 19, 1901); 118 (1873); 163; 164; 165*

NORTON, MILTON. Artist in Pine Creek, 1877. *—Ref.: 118 (1877)*

NOVRA, CARL H. Artist in Battle Creek, 1887. *—Ref.: 118 (1887)*

NUTE, LOUISA A. Artist variously reported in Detroit, Bay City, and Saginaw, 1875–94. *—Ref.: 51 (1893–94); 56 (July 30, 1875); 118 (1883, 1891); 164*

NUTTY, ALFRED HEBER. Artist in Grand Haven. Received awards for works exhibited at various showings. *—Ref.: 164*

NYGARD, ALFRED F. Sculptor and carver in Detroit, 1894–1919+. Worked in wood, marble, stone, and bronze. Born in Denmark. Executed gold medal of the Scarab Club of Detroit; a statuette of Justine, the winner of the Detroit News Spelling Bee; and a model for the bronze doors of the Edsel Ford home. Associated with the Detroit School of Art. Exhibits: DIA, 1915, 1916, 1918, 1919. Partner of Emil F. Marty (q.v.) and Ernst Mildner (q.v.) in the firm of Nygard, Marty & Mildner (q.v.). *—Ref.: 51 (1894–1900+); 118 (1899); 163; 165*

NYGARD, MARTY & MILDNER. Sculptors, modelers, and carvers in Detroit, 1894–98: Alfred F. Nygard (q.v.), Emil F. Marty (q.v.) and Ernst Mildner (q.v.). *—Ref.: 51 (1894–99); 118 (1897, 1899)*

O

OAKES, KATIE L. Artist in Saginaw, 1895. *—Ref.: 118 (1895)*

O'CONNOR, JOSEPHINE. Artist in Detroit, 1882–90. In 1883 with her

sister, Minnie O'Connor (q.v.), founded the first art school in Detroit, the O'Connor Art School. Later (1890s?) taught drawing in the Jackson public schools. —*Ref.: 51 (1882–90); 68 (Oct. 22, 1894); 118 (1883, 1897); 164*

O'CONNOR, MINNIE. Artist in Detroit, 1882–92. Sister of Josephine O'Connor (q.v.), with whom she founded the O'Connor Art School, the first of its kind in Detroit, 1883. Later (1890s?) taught in the Jackson public schools. Exhibited in the Great Art Loan of 1883, Detroit Museum of Art. —*Ref.: 51 (1882–92); 68 (Oct. 10, 1886); 118 (1883, 1885, 1897); 163; 164*

OLIVER, L. BLANCHE. Artist in Charlotte, 1887–89. —*Ref.: 118 (1887, 1889)*

OPPENHEIM, ROSETTA. Artist in Jackson, 1876–77. Exhibit: landscapes and portraits in oil, Michigan State Fair, 1876–77. —*Ref.: 112 (Nov. 14, 1876, Oct. 30, 1877)*

ORCHARDSON, CHARLES. Amateur artist in Spring Lake, 1884. Exhibit: Michigan State Fair, 1884. —*Ref.: 112 (Nov. 4, 1884)*

ORCHARDSON, O. Artist in Detroit, 1873. —*Ref.: 118 (1873)*

ORCUTT, EMILY A. Artist in Kalamazoo, 1873, 1884. Exhibit: works in oil, Michigan State Fair, 1884. —*Ref.: 99 (1873); 112 (Nov. 4, 1884)*

ORCUTT, INA. Artist in Ann Arbor, 1895–97. —*Ref.: 118 (1895, 1897)*

O'REILLY, (Miss) A. F. Artist in Detroit, 1879. Award: premium for the best landscape drawing in pencil, Michigan State Fair, 1879. —*Ref.: 112 (Feb. 10, 1880)*

ORSETTI, ALEXANDER. Statuary modeler in Detroit, 1892–1900+. Employed by Reuther & Co. (q.v.). Later had his own business. —*Ref.: 51 (1892–1900+); 118 (1895)*

OSBOLD, ANTHONY, JR. (1856– ?). Wood-carver, sculptor, and designer of altars and other church furniture in Detroit and elsewhere, 1880–94. Born in Detroit. —*Ref.: 51 (1880–94); 61 (May 19, 1923); 118 (1883–93); 164*

OSGOOD, MARY. Artist in Lake Ridge, Lenawee County, 1891–95. —*Ref.: 118 (1891–95)*

OTTLEY, ALBERT E. Wood engraver in Detroit, 1877–1900+. Son of Oswald S. Ottley (q.v.), with whom he was a partner in Ottley & Son (q.v.). Brother of George Oswald Ottley (q.v.). —*Ref.: 51 (1877–1900+); 164*

OTTLEY, GEORGE OSWALD (ca. 1872–1939). Artist, designer, and engraver in Detroit, 1890–1900+. Son of Oswald S. Ottley (q.v.) and brother of Albert E. Ottley (q.v.). Born in Detroit. Died there Feb. 10, 1939. —*Ref.: 51 (1890–1900+); 56 (Feb. 12, 1939); 118 (1893, 1897, 1899); 164*

OTTLEY, OSWALD S. Wood engraver and artist in Detroit, 1849–1900. Born in England. Father of Albert E. Ottley (q.v.) and George Oswald Ottley (q.v.). Settled in Detroit 1849. Partner with his son Albert E. Ottley (q.v.) and Nicholas Mamer, a sign painter, as Ottley & Co., 1876; name changed to Ottley & Son (q.v.), 1891. *–Ref.: 51 (1870–1900+); 164*

OTTLEY & SON. Detroit partnership originally formed in 1876 as Ottley & Co., by Oswald S. Ottley (q.v.) and his son Albert E. Ottley (q.v.), artists, and Nicholas Mamer, a sign painter. In 1891, partnership became Ottley & Son: Oswald S. Ottley (q.v.) and Albert E. Ottley (q.v.), artists and engravers. *–Ref.: 51 (1877–1900+); 164*

OUTHOUSE, CORA A. Artist in Grand Rapids, 1889. *–Ref.: 86 (1888–92)*

OWEN, BELLE C. Artist in Detroit, 1891–95. *–Ref.: 51 (1891–95); 118(1893, 1895)*

OWEN, E. (or ELLA). Artist in Detroit, 1885; bookkeeper, 1893–95. *–Ref.: 51 (1893–95); 118 (1885)*

OWEN, ELLA W. Artist in Saginaw, 1875. Awards: premiums for a landscape in oils, and an animal drawing in crayon, Michigan State Fair, 1875. *–Ref.: 112 (Oct. 12, 1875)*

OWEN, JOHN. (ca. 1836–1895). Watercolor artist, illuminator, and engrosser in Detroit. Born in Liverpool, England. Settled in Detroit, ca. 1881. Exhibited many times in DIA. Memberships: Detroit Water Color Society; Detroit Artists Association. Died Jan. 4, 1895. *–Ref.: 51 (1882–95); 56 (Jan. 5, 1895); 60 (Apr. 18, 26, Sept. 22, Nov. 4, 17, 25, Dec. 15, 1893, Jan. 19, Apr. 30, May 7, Dec. 15, 21, 1894, Feb. 13, 1895); 61 (Dec. 1, 1889, Jan. 4, 1895); 68 (Oct. 10, 1886, Mar. 27, 1893, Jan. 5, 1895); 112 (Nov. 2, 1886); 118 (1883–93); 163; 164*

P

PACKBAUER, EDWARD JOHN (1862–1948). Landscape and portrait artist in Detroit, 1880–1900+. Born in Koenigsburg, Germany, in June 1862. Came to America with his parents. Memberships: Michigan Artists Association; Art Club of Detroit; Detroit Water Color Society; Society of Associated Artists; Scarab Club. Exhibits: Detroit Museum of Art, 1886, 1890–1911, 1912, 1918; Detroit Artists Assn., 1891, 1893, 1896; Society of Associated Artists, 1894; Detroit Art Club, 1895; Detroit Water Color Society, 1895. Died in Detroit, Oct. 21, 1948. *–Ref.: 51 (1880–1900+); 60 (Apr. 18, 1893); 68 (Jan. 22, 1893); 118 (1891, 1893); 163*

PADBURG, AMANDA. Student of Maud Mathewson's (q.v.), 1893.

Daughter of John B. and Catherine (Ulrich) Padberg. *—Ref.: 60 (June 22, 1893); 110*

PADLEY, PHILLIS DONNISON (Mrs. Richard). Landscape artist in Bay City. Native of England. Married in London on July 18, 1891, and thereafter moved to Bay City. Prior to coming to America, exhibited annually in London, Edinburgh, Glasgow, Liverpool, Manchester, and Newcastle-on-Tyne. *—Ref.: 83; 118 (1895)*

PAINE, FRANK A. Artist in Charlotte, 1889. *—Ref.: 118 (1889)*

PALMATARY, JAMES T. Townscape artist in mid-1800s. Executed a panoramic view of Indianapolis, Ind., in 1854, and one of Washington, D. C. Published proposals to do the same at Columbus, Ohio, and Detroit; no indication found that work was completed. *—Ref.: 128; 156; 164*

PALMER, FRANCES. Artist in Alma, 1897–99. *—Ref.: 118 (1897, 1899)*

PALMER, GEORGE D. Artist in Bennington, 1885, and in Henderson, 1889–95, both towns near Owosso. *—Ref.: 118 (1885, 1889–95)*

PALMER, JAMES L. Itinerant artist in Detroit, 1889. Resided in a local hotel. *—Ref.: 51 (1889)*

PALMER, JAMES P. Portrait artist in Union City, 1889–99. *—Ref.: 118 (1889–99)*

PALMER, M. ELLA. Artist in Jackson, 1887. *—Ref.: 98 (1887); 118 (1887)*

PALMER, P. Artist in Detroit, 1857. Award: premium for a landscape, Michigan State Fair, 1857. *—Ref.: 112 (Nov. 1857)*

PALMER, R. D. Artist in Brooklyn, 1856. Award and diploma for a drawing of cattle, Michigan State Fair, 1856. Possibly is Russell D. Palmer (q.v.). *—Ref.: 112 (Nov. 1856)*

PALMER, RUSSELL D. Portrait painter in Ann Arbor, 1868. Possibly is R.D. Russell (q.v.). *—Ref.: 6 (1868)*

PALMIERI, PASQUALE (or PASCAL). Artist, fresco painter, and decorator in Detroit, 1875–1900+. Migrated from Italy in mid-century. *—Ref.: 51 (1875–1900+); 113 (vol. 2, 1918); 118 (1881, 1895, 1897)*

PALMITER, CHARLES. Artist in Kalamazoo, 1887. *—Ref.: 118 (1887)*

PARK, MARIAN E. Artist in Detroit, 1891–92. *—Ref.: 51 (1891–92)*

PARKE, JOSEPH R. Artist in Lansing, 1879. *—Ref.: 118 (1879)*

PARKER, C. W. & SON. Artists in Battle Creek, 1893. Charles A. Parker (q.v.) and Charles W. Parker (q.v.). *—Ref.: 118 (1893)*

PARKER, CHARLES A. Artist in Battle Creek, 1893. Associated with his father, Charles W. Parker (q.v.), in the firm of C. W. Parker & Son (q.v.). *—Ref.: 118 (1893)*

PARKER, CHARLES W. Artist in Battle Creek, 1893. Associated with his

son, Charles A. Parker (q.v.) in the firm of C. W. Parker & Son (q.v.). —*Ref.: 118 (1893)*

PARKER, FRANK R. Artist in Battle Creek, 1893–99. —*Ref.: 118 (1893–1899)*

PARKER, HARRY F. Artist in Jackson, 1897. Partner with Myron H. Swartwout (q.v.) in the firm of Swartwout & Parker (q.v.). —*Ref.: 118 (1897)*

PARKER, JULIUS G. Painter of signs and decorations in Detroit, 1870. Associated with John Atkinson (q.v.) under the firm name of Atkinson & Parker (q.v.). —*Ref.: 56 (Aug. 5, 1870)*

PARKER, LAWTON S. (1868– ?). Portrait painter and teacher. Born in Fairfield, Aug. 7, 1868. As a boy, won a prize for the best drawing by a person who had no artistic instruction, which later won for him a scholarship to the Chicago Art Institute. Later, studied in Paris under Gérome, Laurens, Benjamin-Constant, Besnard, and Whistler. Became Director of Art, Beloit College, 1893; president, New York School of Art, 1898; director, Parker Academy, Paris, 1900; president, Chicago Academy of Fine Arts, 1903. Associate member, NAD, 1916. Received numerous medals and awards. First foreigner to win the Gold Medal, Société des Artistes Francais, 1913. Maintained permanent residence in Paris. —*Ref.: 3 (vol. 30, 1933); 13; 79; 101; 109; 119 (1924 ed.); 125 (vol. 3); 149; 156*

PARKER, THOMAS. Artist in Detroit, 1863–64. —*Ref.: 51 (1863/64)*

PARKINSON, IDA J. Artist in Detroit, 1899–1900+. —*Ref.: 51 (1899–1900+)*

PARKS, ? (Mrs. M. E.) Clay modeler in Detroit, 1893. —*Ref.: 51 (1893)*

PARKS, J. W. Artist. —*Ref.: 118 (1881)*

PARSONS, ? (Mrs. A. A.). Amateur artist in Saginaw, 1875. Award: Michigan State Fair, 1875. —*Ref.: 112 (Oct. 12, 1875)*

PARSONS, EVANS J. House and sign painter, 1878–83; artist, 1884–86 in Detroit. —*Ref.: 51 (1878–86)*

PARSONS, JENME C. Artist in Kalamazoo, 1872. Award: prize for a floral piece in oils, Michigan State Fair, 1872. —*Ref.: 112 (Oct. 24, 1872)*

PARSONS, LELIA (or LEILA). Artist in Detroit, 1898–99. —*Ref.: 51 (1898–1899); 118 (1899)*

PARTRIDGE, SARA. Artist in Flushing, 1887–89. —*Ref.: 118 (1887, 1889)*

PARTRIDGE, WILLIAM K. Artist in Detroit, 1889. —*Ref.: 118 (1889)*

PASCO, RICHARD A. *See* PASCOE, RICHARD A.

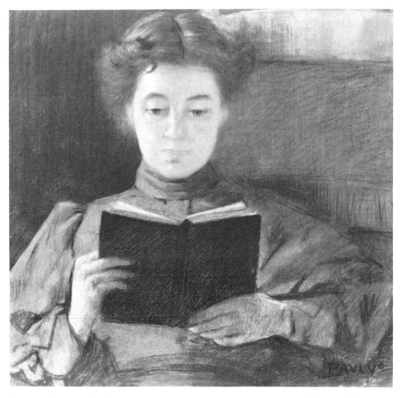

Francis Petrus Paulus, *Mary Chase Stratton.* Pastel, 17½" x 20¼". From the collection of the Detroit Institute of Arts. Bequest of Mary Chase Stratton.

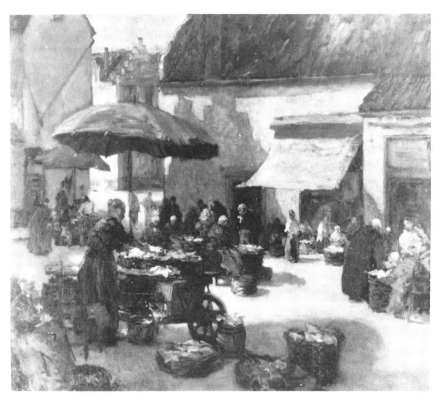

Francis Petrus Paulus, *Fish Market at Bruges*. From the collection of the Detroit Institute of Arts. Gift of Mrs. William R. Kales and David Gray.

PASCOE, JAMES. Artist in Humboldt, 1877. *–Ref.: 118 (1877)*

PASCOE (or PASCO), RICHARD A. Artist in Detroit, 1875–76. Previously a painter and harness maker. *–Ref.: 51 (1856–59, 1871/72, 1873/74, 1875/76)*

PASSMORE, WILLIAM H. Taxidermist and artist in Detroit, 1890–94. *–Ref.: 51 (1890–94)*

PASTERNACKI, VETOLD H. (1897– ?). Artist in Detroit. Born in Detroit. Still active there in 1934. Exhibit: DIA, 1930. *–Ref.: 109; 163*

PATEE, FRANCIS. *See* PATTEE, FRANCIS.

PATTEE (or PATEE), FRANCIS. Crayon artist in New Boston, 1889–99. *–Ref.: 118 (1889–99)*

PATTERSON, DAVID. Marble and stone designer and sculptor in Detroit, 1870–1900+. *–Ref.: 51 (1870–1900+); 118 (1889–93)*

PATTON, BESSIE E. Artist in Detroit, 1890. *–Ref.: 51 (1890)*

PAUL, ? (Mrs. W. S.). Artist in Flintsteel, Ontonagon County, 1899. *–Ref.: 118 (1899)*

PAULUS, FRANCIS PETRUS (1862–1933). Artist and etcher. Works include portraits, interiors, landscapes, and genre subjects in all media, including pastels. Born in Detroit, Mar. 13, 1862, the son of Charles and Catherine Paulus. He and Joseph W. Gies (q.v.) founded the Detroit Fine Arts Academy, 1895. Married Adele Frutig of Detroit, 1903. Always considered Detroit his home, though lived many years in Bruges, Holland. Studied at PAFA; with von Lofft in Munich; Bonnat in Paris (École des Beaux Arts); also in Italy, Portugal and The Netherlands. Associate director, Detroit Fine Arts Academy, 1895–1903; Ann Arbor Art School; and director, Bruges (Holland) School of Art, 1905. Memberships: Chicago Society of Etchers; National Arts Club; La Gravure Originale en Noir; Société Internationale des Beaux Arts et Lettres. Represented: DIA; Herron Art Institute, Indianapolis, Indiana; Library of Congress; Musée Moderne, Bruges, Holland; Royal Academy of Fine Arts, Munich; and museums of New York, Washington, and Oakland, Calif., and others. *–Ref.: 3 (vol. 1, 1898, vol. 30, 1933); 13; 56 (Feb. 3, 1933); 60 (Apr. 21, Sept. 18, Oct. 13, Dec. 15, 21, 1894, Jan. 12, Mar. 16, May 21, Sept. 21, Nov. 23, Dec. 13, 1895, Feb. 24, June 2, Sept. 12, Nov. 13, Dec. 7, 1896); 61 (Feb. 3, 1933); 65 (Sept. 16, 1880); 79; 101; 109; 118 (1895, 1897); 149; 156; 163; 164; 165*

PAYMENT, RICHARD C. Dentist and amateur portrait painter in Detroit, 1878–1900+. Executed portraits of numerous well known personages. *–Ref.: 51 (1878–1900+); 118 (1885, 1885–97); 164*

PAYNTER, SIMEON (or SIMON C.) Artist in Marlette, 1893–1901. *–Ref.: 118 (1893–1901)*

PEABODY, ? (Mrs. John O.). Artist in Hanover, 1875–77. Exhibits: Michigan State Fair, 1875, 1876, and 1877. *–Ref.: 112 (Oct. 12, 1875, Nov. 14, 1876, Oct. 30, 1877)*

PEASE, ALONZO. Portrait painter in Detroit, 1860–61. Reported to have been in Cleveland, Ohio, 1859. *–Ref.: 51 (1861); 53 (July 12, Dec. 29, 1860); 68 (Aug. 14, Oct. 24, Dec. 24, 1860); 128; 163*

PECK, HELEN M. Artist in Allegan, 1884–85. Exhibit: several oil, water-color, and crayon pieces, Michigan State Fair, 1884–85. *–Ref.: 112 (Nov. 4, 1884, Oct. 27, 1885)*

PEEBLES, FRANK M. Portrait painter in Detroit, 1873. Associated with A. J. Baldwin (q.v.) and Albert Jenks (q.v.), portrait painters, as Jenks, Peebles and Baldwin (q.v.), 1873. *–Ref.: 56 (May 10, Oct. 16, 1873)*

PEEL, FRANK W. Carver, sculptor, and designer of marble and stone monuments and memorials in Detroit, 1882–1900+. *–Ref.: 51 (1882–1900+); 118 (1897)*

PENDLETON, WILLIAM H. Artist in Jackson, 1885. *–Ref.: 118 (1885)*

PENFIELD, ANNIE. Artist in Detroit, 1875. Exhibited a painting at a local gallery. *–Ref.: 56 (May 6, 1875)*

PENNY, MARY FRANCES (Mrs. Henry C.). Artist in Detroit, 1876. Exhibit: Detroit Art Association, 1876. *–Ref.: 56 (Feb. 1, 1876)*

PEREIRA, JOHN M. Portrait painter in Detroit, 1896. *–Ref.: 51 (1896)*

PERRAULT, IDA MARIE (1874–) Artist in Detroit, 1894–1900+. Specialized in paintings of children. Born in Detroit. Studied under John Ward Dunsmore (q.v.) at the Detroit School of Art; and at the Detroit Museum of Art school; and for seven years in Paris, The Hague, and Brussels. Also noted as a maker of manikins with molded clay bodies, representing characters from mythology and history, as well as modern children. Member of several art clubs abroad. *–Ref.: 3 (vol. 1, 1898); 51 (1894–1900); 56 (Oct. 15, 1911); 60 (Sept. 29, Dec. 15, 1894); 62 (Jan. 19, 1896); 118 (1895, 1899); 119 (1924 ed.); 163; 164; 165*

PERRIN, INEZ. Artist in Detroit, end of the nineteenth and beginning of the twentieth century. *–Ref.: 51 (1900+)*

PERRIN, JOHN H. Artist and photographer in Detroit, 1893–1900+. *–Ref.: 51 (1893–1900+); 118 (1895)*

PERRING, IRA O. Portrait artist in Grand Rapids, 1894–95. *–Ref.: 86 (1894); 118 (1895)*

PERRY, EMMA E. (Mrs. Walter S.). Artist in Ann Arbor, 1891–95. President, Ann Arbor Art School, 1895. Might be the sculptor and genre painter Emilie S. Perry, born in New Ipswich, N.H. Dec. 18, 1873, who died in Ann Arbor July 16, 1929. *–Ref. 13; 118 (1891–95)*

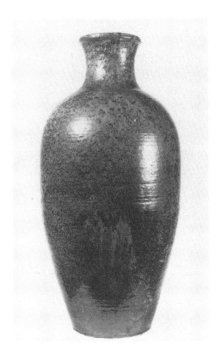

Pewabic vase selected by Charles Freer for his Peacock Room at the Freer Art Gallery, Washington, D.C. From the collection of the MSU/Pewabic Pottery, Detroit.

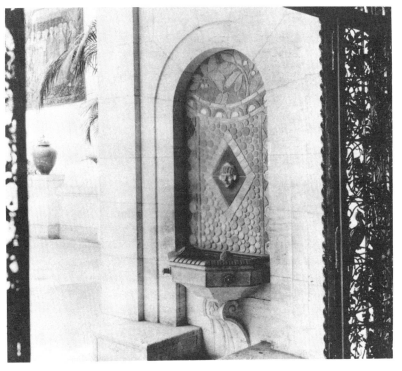

Pewabic Fountain at the Detroit Institute of Arts. From the collection of the MSU/Pewabic Pottery, Detroit.

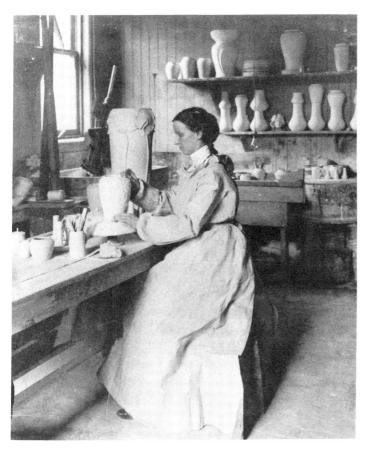

Mary Chase Perry in her Studio, early 1900s. Photograph. From the collection of the MSU/Pewabic Pottery, Detroit.

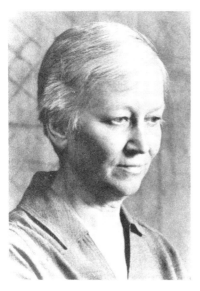

Mary Chase Perry, founder of the Pewabic Pottery Company. From the collection of the MSU/Pewabic Pottery, Detroit.

Albert E. Peters, ca. 1903. Photograph. From the collection of A. E. Peters, Jr., Albion.

PERRY, MARY CHASE (Mrs. Wm. H. Stratton) (1867–1961). Portrait and figure painter on canvas and ceramic tiles, in Detroit, 1893–1900+, manufacturer of fine ceramic pottery and tiles. Born in Hancock, Mar. 15, 1867. Studied at Detroit Museum of Art School and in New York. In partnership with Horace James Caulkins (q.v.) founded the Pewabic Pottery Co., using the Indian name of a river in the Copper Country of northern Michigan. Her products decorate many churches, shrines, and public buildings throughout the United States. Married Wm. H. Stratton, a Detroit architect, 1918. Exhibit: Detroit Art Club, 1895. Charter member, Detroit Society of Women Painters and Sculptors. Died Apr. 15, 1961. —Ref.: 51 (1894–1900); 56 (Aug. 3, 1967); 60 (Sept. 19, Nov. 7, 1893, Sept. 29, Nov. 3, 1894); 66 (Sept. 2, 9, 1916); 109; 118 (1895); 162; 163; 164; 165

PETERHANS, WILLIAM G. Artist in Plymouth, 1899. —Ref.: 118 (1899)

PETERS, ALBERT EDWARD (ca. 1865–1939). Business executive and landscape painter in Detroit. Born in London, Ontario. Studied at Chicago Institute of Art, and under Joseph W. Gies (q.v.), Detroit. Exhibited frequently at local galleries. Memberships: Hopkin Club, Scarab Club. Died in Birmingham, July 9, 1939. —Ref.: 56 (July 10, 1939); 61 (July 10, 1939); 163; 164; 165

PETERSON, AMELIA. Artist in Grand Rapids, 1897–1900+. —Ref.: 86 (1897–1900+); 118 (1899)

PETERSON, MILLIE. Artist in Jackson, 1887–91, and Grand Rapids, 1895. —Ref.: 118 (1887–91, 1895)

PETRIE, R. G. Artist in Cheboygan, 1889. —Ref.: 118 (1889)

PETTETTE, (Mrs.) C. S. Artist in Bay City, 1897. —Ref.: 118 (1897)

PETTIT, DELLA (Mrs. William). Teacher of painting in Grand Rapids, 1886. —Ref.: 86 (1886)

PEWABIC POTTERY COMPANY. See PERRY, MARY CHASE.

PFEIFFER, FRANK A. Artist in Monroe, 1877–89. Award: premium for a crayon drawing of an animal, Michigan State Fair, 1878. —Ref.: 112 (Oct. 24, 1878); 118 (1877–89)

PHELPS, MARY C. (Mrs. Wm. M.) (ca. 1833–99). Artist in Detroit, 1890s. Member: Detroit Water Color Society; exhibited there, 1895. Died Nov. 17, 1899. —Ref.: 51 (1895–1900); 60 (Dec. 13, 1895)

PHELPS, MARIE LOUISE. Artist in Detroit, 1879–84. Award: Michigan State Fair, 1879. —Ref.: 51 (1884); 112 (Feb. 10, 1880)

PHILLIPS, CAROLINE A. (Mrs. James H.). Artist in Detroit, 1897–1900+ —Ref.: 51 (1897–1900+)

PHILLIPS, DELOS. Probably Colonel Delos Phillips of Kalamazoo. Submitted a painting on wood, Michigan State Fair, 1885. Died at Kalama-

Lendall Pitts, *The Grand Finale*. Pastel, 21½″ x 25¾″. From the collection of the Detroit Institute of Arts. Gift of Mrs. Arthur M. Parker.

zoo, Feb. 23, 1887. —*Ref.: 112 (Oct. 27, 1885); 115 (vol. 11, 1887); 164*

PHILLIPS, JOHN (1822– ?). New York artist who painted several portraits of Detroit residents, while he was visiting friends and temporarily residing in Detroit, ca. 1863. Born in Paisley, Scotland. Immigrated to America, 1837. Represented in Chicago Historical Society. —*Ref.: 56 (Aug. 21, 1863); 109; 128; 156; 164*

PHINNEY, ALTA H. Artist in Tecumseh, 1887–91. —*Ref.: 118 (1887– 91)*

PICARD, JOSEPH. Wood-carver in Detroit, 1863–64. —*Ref.: 118 (1863/64)*

PICKART, JOSEPH. Portrait artist in Detroit, 1889. Moved to Chicago, Ill. —*Ref.: 51 (1889); 118 (1889)*

PIERCE, ANTOINETTE A. Artist in Detroit, 1897–1900. Member: Society of Western Artists; and Detroit Water Color Society, 1897–1900. —*Ref.: 3 (vol. 1, 1898); 51 (1897–1900); 164*

PIERSON, LUCIUS S. Artist in Saline, 1889–91. —*Ref.: 118 (1889, 1891)*

PIERSON, ? (Mrs. J. A.). Artist in Kalamazoo, 1884. Award: premium for the best painting on silk, Michigan State Fair, 1884. —*Ref.: 112 (Nov. 4, 1884)*

PITKIN, ANNA DENIO (? –1929). Watercolor and crayon artist (portraits and animals) in Detroit. One of three daughters of Rev. T.C. Pitkin. Exhibits: Great Art Loan, 1883; Detroit Museum of Art, 1886; at local galleries, and at the Michigan State Fair, 1879. Died in Tyron, N. C., in Oct. 1929. —*Ref.: 56 (Apr. 19, 1877, Apr. 20, Sept. 18, 1879); 61 (Nov. 19, 1933); 65 (Sept. 18, 1879); 78; 112 (Feb. 10, 1880); 164*

PITTS, LENDALL (1875–1938). Artist and etcher in Detroit. Born in Detroit, Nov. 20, 1875, the son of Thomas and Louise (Strong) Pitts. Painted portraits and landscapes at first, but later mostly pastels and a self-developed color print without lines called *pastelographs.* Educated in France, Germany, Switzerland, and in Paris under Jean Paul Laurens and Benjamin-Constant. Married Elizabeth McCord, also an artist, in 1921. Maintained residence in Paris for many years, with frequent returns to Detroit. During World War I, did extensive camouflage projects for the United States government. Represented in museums of the United States and France. Died in Boston, Mass., Mar. 9, 1938. —*Ref.: 66 (Aug. 25, 1917); 101; 109; 163; 164; 165*

PLATT, ? (Mrs. Joseph S.). Painting teacher in Port Huron, 1885. —*Ref.: 118 (1885)*

PLATT, ELSIE H. (Mrs. Cyril). Landscape artist in Port Huron, 1885–91. —*Ref.: 118 (1885–91)*

PLETSCH, GEORGE (1850–1919). Shoemaker and, for a short time, a portrait artist in Detroit. Died in Detroit in 1919, survived by wife Catherine. *—Ref.: 51 (1870–1900+); 118 (1893); 164*

POATS, ? (Mrs. Wm. W.). Artist in Benton Harbor, 1887–89. *—Ref.: 118 (1887, 1889)*

POHL, HUGO D. (1878– ?). Painter of murals, genre subjects, and historical scenes. Born in Detroit, Mar. 11, 1878. Pupil of Jean Paul Laurens, Paris, and European art schools. Apparently in Detroit, 1896–1900+; subsequently resident of Texas. Member: Texas Fine Arts Society. *—Ref.: 3 (vol. 30, 1933); 13; 51 (1896–1900+); 109; 156; 165*

POND, CHARLES. Credited with painting a portrait of Mrs. T. W. Palmer of Detroit. *—Ref.: 130*

POOLE, FLORA. Artist in Grand Rapids, 1889. *—Ref.: 86 (1889)*

POPE, HARRIET BISSELL. Teacher in Detroit, 1886–1900+. Co-founder with Anna M. Cutcheon (q.v.) of the Pope & Cutcheon Art School (q.v.). *—Ref.: 51 (1886–1900+)*

POPE & CUTCHEON ART SCHOOL. Detroit art school organized by Harriet Bissell Pope (q.v.) and Anna M. Cutcheon (q.v.). *—Ref.: 60 (Oct. 22, 1894); 164*

PORTEOUS, ROBERT. Artist in Detroit, 1896. Exhibited a painting, Detroit Artists Association, 1896. *—Ref.: 60 (June 2, 1896)*

PORTER, FREDERICK BISSELL (? –1905). Attorney and portrait artist in Detroit, latter half of the nineteenth century. Son of John Savage Porter (q.v.). Died in Detroit, Feb. 21, 1905. *—Ref.: 51 (1855/56–1889); 56 (Apr. 20, 1879); 118 (1879, 1889); 164*

PORTER, JENNIE C. Artist in Grand Rapids and Jackson, 1878–1900+. *—Ref.: 86 (1878/79); 98 (1912); 118 (1879)*

PORTER, JOHN SAVAGE. Miniaturist in Boston and Detroit. Father of Frederick Bissell Porter (q.v.). *—Ref.: 13; 53 (June 16, 1843, Feb. 8, 1845); 109; 149; 156; 164*

PORTER, MARY S. (Mrs. Oscar D.). Amateur artist in Detroit. *—Ref.: 51 (1879–93); 68 (Mar. 27, 1893); 118 (1893)*

POST, NELLIE A. Artist in Alpena, 1897–99. *—Ref.: 118 (1897–1899)*

POTTER, HARRY SPAFFORD. (1870–). Illustrator. Born in Detroit. Pupil of Benjamin-Constant, Laurens, and Simon in Paris. Established residence in New York City. Member: Society of Illustrators, N.Y. *—Ref.: 3 (vol. 30, 1933); 13; 79; 109; 149; 156*

POTTER, JOHN B. (1864– ?). Artist in Lansing, 1886. Born in Lansing. Exhibits: Detroit Museum of Arts, first annual show, 1886; Michigan State Fair, 1886. *—Ref.: 109, 112 (Nov. 2, 1886); 163*

POTTS, GERTRUDE EARLY. Artist and vocal instructor in Detroit,

1896–99. Painted landscapes and figures in oil and watercolor. Studied in Detroit and Boston. *–Ref.: 51 (1896–99); 62 (Jan. 19, 1896); 118 (1897,1899)*

PRAGLER, ESTELLA J. Artist in Grand Rapids, 1883. *–Ref.: 118 (1883)*

PRINCE, THOMAS. Artist in Grand Rapids, 1893. Partner of Martin Tromp (q.v.), under the firm name of Tromp & Prince (q.v.). *–Ref.: 86 (1893); 118 (1893)*

PRINDLE, MARY V. Artist in Grand Rapids, 1889. *–Ref.: 86 (1889)*

PULCHER, THERESA S. (Essie). Artist in Grand Rapids, 1894–1901. Moved to Chicago, Ill. in 1901. *–Ref.: 86 (1894–1901); 118 (1897)*

PUTNAM, ? Female artist in Flint, 1880. Exhibited one oil painting, Seventh Annual Artists' Exhibition, Angell's Gallery, Detroit. *–Ref.: 56 (Apr. 13, 1880)*

R

RADLEY, WILLIAM J. Portrait artist or photographer in Detroit, 1892– 98. *–Ref.: 51 (1892, 1893, 1898); 118 (1893)*

RAINEY, CATHERINE S. (Kate) (Mrs. Wm. J.). Artist in Detroit, 1880– 1900+. Exhibits: Detroit Art Association, 1875–76; Angell's Gallery, Detroit, 1877; DIA, 1883 and 1886; Michigan State Fair, 1880. *–Ref.: 51 (1880–1900+); 56 (Apr. 17, 1879, Apr. 13, 1880); 65 (Sept. 16, 1880); 118 (1889)*

RALSTON, ALEXANDER. House, shop, sign, and ornamental painter in Detroit, 1853–56. Associated with Robert Hopkin (q.v.) in the firm of Hopkin & Ralston (q.v.). *–Ref.: 51 (1853–56)*

RANDALL, CORYDON CHANDLER. Artist and photographer in Detroit, 1861–1900+. Exhibits: Detroit Art Association, 1875–76; other galleries; Michigan State Fair, 1880. Married Ellie C. Rose, Oct. 12, 1864. *–Ref.: 51 (1861–1900+); 60 (May 31, 1893); 112 (Oct. 12, 1880); 164*

RANKIN, GRACE. Artist in Detroit, 1875–77. Exhibits: Detroit Art Association, 1875–76; Angell's Gallery, 1877. *–Ref.: 50 (Feb. 27, 1875); 56 (Apr. 19, 1877); 163; 164*

RANNEY, (Mrs.) E. H. Artist in Kalamazoo, 1884. Exhibit: several paintings in oil and watercolor, and decorated porcelain, Michigan State Fair, 1884. *–Ref.: 112 (Nov. 4, 1884)*

RASEY, ROSE. Artist in Nashville, 1887–99. *–Ref.: 118 (1887–99)*

RAYMOND, WILLIAM ASA (1819–1853). Dry goods merchant and amateur artist in Detroit, 1852–53. Executed a number of drawings of early Detroit and environs. Exhibit: Gallery of Fine Arts, Detroit

Firemen's Hall, 1852 and 1853. *—Ref.: 56 (Oct. 16, 1853); 78; 163; 164*

READ, HELEN M. Artist in Allegan, 1884. Exhibit: landscape in oils, Michigan State Fair, 1884. *—Ref.: 112 (Nov. 4, 1884)*

READ, JAMES B. (ca. 1803–). Portrait artist in Detroit. Opened a studio in Detroit, 1846. Born in Pa. *—Ref.: 53 (July 30, 1846); 128; 156; 164*

REBER, L. O. Artist in Jackson, 1886. Exhibit: one India Ink drawing, Michigan State Fair, 1886. *—Ref.: 112 (Nov. 2, 1886)*

REDDICK (or RETTICK), OTTA M. Artist in Grand Rapids, 1898–99. *—Ref.: 86 (1898, 1899)*

REDMOND, SIBLEY H. Portrait artist in Detroit, 1870–74, 1892–1900+. *—Ref.: 51 (1870–1874, 1892–1900+); 118 (1893–97)*

REED, GEORGE W. Portrait artist in Kalamazoo, 1873–95. Partner of U. Eugene Crane (q.v.), under the firm name of Reed & Crane (q.v.), 1881. *—Ref.: 118 (1873–95)*

REED, (Mrs.) I. N. Artist in Kalamazoo, 1885. Exhibit: a painting on plush, Michigan State Fair, 1885. *—Ref.: 112 (Oct. 27, 1885)*

REED, MELTON. Artist in Jackson, 1882. Award: premium for the best crayon drawing of an animal, Michigan State Fair, 1882. *—Ref.: 112 (Oct. 17, 1882)*

REED & CRANE. Portrait artists in Kalamazoo, 1881: George W. Reed (q.v.) and U. Eugene Crane (q.v.). *—Ref.: 118 (1881)*

REHN, HENRY C. Scenic artist in Detroit and Ann Arbor, 1882–1900+. *—Ref.: 6 (1886/87); 51 (1882/83, 1888–1900+); 118 (1883)*

REIBLING, FRED A. Artist in Port Huron, 1889–91. *—Ref.: 118 (1889, 1891)*

REID, ? (Mrs. E. C.) Artist in Allegan, 1884. Exhibit: several oil paintings and an India ink drawing, Michigan State Fair, 1884. *—Ref.: 112 (Nov. 4, 1884); 164*

REIMER, HARRY (or HENRY) (ca. 1880– ?). Decorative glass hobbyist in Detroit, 1893–1900+. Made artistic impressions by tapping lightly on a carboloy-tipped rod, tracing the design of a pattern placed beneath the glass. Formed birds, flowers and large inscriptions of the Lord's Prayer by hundreds of small impressions made by the rods. Still practicing hobby at seventy-two. *—Ref.: 51 (1893–1900+); 61 (Mar. 23, 1952)*

REMINGTON, (Mrs.) M. Artist in Detroit, 1855. Exhibit: oil painting, Michigan State Fair, 1855. *—Ref.: 112 (Nov. 1855)*

RETTICK, OTTA M. *See* REDDICK, OTTA M.

REUTHER, RICHARD G. (1859–1913). Wood-carver and sculptor in

Detroit, 1876–1913. Pupil of Julius Melchers (q.v.), later associated with Edward Q. Wagner (q.v.) as Wagner & Reuther (q.v.), sculptors, 1885–87; Reuther & Co. (q.v.), wood-carvers, 1888; the Wilton, Reuther Co. (q.v.), architectural sculptors and carvers, 1899–1900+. Died in Detroit. —*Ref.: 51 (1876–1913); 56 (Feb. 2, 1879); 157; 164*

REUTHER & CO. Carvers and sculptors in Detroit, 1888–98: Richard G. Reuther (q.v.), Richard H. Krakow, Sr. (q.v.) and Joseph Jungwirth (q.v.). —*Ref.: 51 (1888–98); 118 (1889–99); 157*

REVENAUGH, AURELIUS O. (1840– ?). Oil and crayon portrait artist in Jackson, 1871–87. Born in Zanesville, Ohio, the son of John and Clarinda (Blake) Revenaugh. Studied under John Mix Stanley (q.v.), Detroit. In 1867, married Lavina Mason of Elmira, N. Y. Partner with William H. McCurdy (q.v.), as Revenaugh & McCurdy (q.v.), 1879. Exhibit: Michigan State Fair, 1876. —*Ref.: 92; 98 (1887); 118 (1875–87)*

REVENAUGH & McCURDY. Artists in Jackson, 1879: Aurelius O. Revenaugh (q.v.) and William H. McCurdy (q.v.). —*Ref.: 118 (1879)*

REXFORD, BLANCH. Exhibited a painting, Detroit Art Association, 1876. —*Ref.: 56 (Feb. 1, 1886)*

RICE, JOHN J. Artist in Detroit, 1883. Exhibit: crayon drawing, Michigan State Fair, 1883. —*Ref.: 51 (1882); 112 (Oct. 16, 1883); 118 (1883)*

RICH, CHARLES A. Wood-carver in Detroit, 1893. Probably the same person who was married to Augusta Roch, Detroit, July 11, 1866. —*Ref.: 118 (1893); 164*

RICHARDS, MARGARET A. (Mrs. Samuel D.). Watercolor artist in Detroit, 1871–1905. Studied under John Owen (q.v.), Detroit, and in New York City under Smiley. Exhibits: in Detroit, 1893, 1895, 1897. Memberships: Detroit Water Color Society and Art Club of Detroit. Moved to Ypsilanti in 1905. —*Ref.: 51 (1871–1905); 60 (Apr. 25, Dec. 8, 1893; Dec. 13, 1895); 163; 164*

RICHARDSON, ? (Mrs. Evans T.). Member: Rembrandt Etching Club, Detroit, 1893. —*Ref.: 51 (1893, 1894); 60 (Apr. 26, 1893)*

RICHARDSON, MARCELLA. Artist in Pontiac, 1854–55. Exhibit: watercolor paintings, Michigan State Fair, 1854–55. —*Ref.: 112 (Nov. 1854; Nov. 1855)*

RICHARDSON, MARIA. Watercolor artist in Pontiac, 1855. Exhibit: Michigan State Fair, 1885. —*Ref.: 112 (Nov. 1855)*

RIDER, MYRA BELL CHAMBERLAIN (Mrs. William F.) (ca. 1839– ?). Miniature artist in Detroit, 1870–98. Born in Middletown, Conn. Married in Detroit, May 19, 1869. Member: Detroit Water Color Society. —*Ref.: 51 (1870–94, 1896–98); 118 (1897); 164*

RILEY, SAMUEL S. Portrait artist in Lansing, 1892–94. *–Ref.: 102 (1892–94); 118 (1893–97)*

RITTER, NICHOLAS. Panoramist in Detroit, 1871–72. *–Ref.: 51 (1871/72)*

RIVARDI, JOHN JACOB ULRICH (? –1808). Major, Corps of Artillerists and Engineers, U. S. Army, stationed in Detroit, 1797. Made a watercolor manuscript map of the old fort and settlement of Detroit, dated March 29. 1799. *–Ref.: 163; 164*

ROBERTS, EPHRIAM A. Wood-carver in Grand Rapids, 1876–77. *–Ref.: 86 (1876–77)*

ROBERTS, JAMES H. Portrait painter in Grand Rapids, 1876. *–Ref.: 86 (1876)*

ROBERTS, ? (Mrs. Nelson L.). Artist in Port Huron, 1889–91. *–Ref.: 118 (1889, 1891)*

ROBERTS, CORNELIA HOWARD (Mrs. Robert E.). Artist in Detroit. Exhibits: Michigan State Fair, 1879, Detroit Museum of Art, 1886; local galleries, 1886–90. Member: Detroit Water Color Society. *–Ref.: 51 (1887–89); 61 (Dec. 1, 1889); 65 (Sept. 18, 1879); 61; 163; 164*

ROBERTS, R. E. Artist (presumably in Detroit, 1851). Exhibit: crayon still life piece, Michigan State Fair, 1851. *–Ref.: 112 (Dec. 1851)*

ROBERTSON, DAVID D. Artist in Detroit, 1870–90. Employed as a scenic painter on Pullman passenger coaches. Exhibits: two still life pieces and several Scottish landscapes, Michigan Artists Association showing, Angell's Gallery, 1878. Moved to New York City, 1890. *–Ref.: 51 (1870–90); 65 (Apr. 7, 1878)*

ROBERTSON, HENRY M. Artist in Detroit, 1875–76. *–Ref.: 51 (1875/76)*

ROBERTSON, ? . A pencil sketch of Detroit in April, 1809, initialed I. A. R., L. A. R. or J. A. R., is attributed to him. *–Ref.: 164*

ROBINSON, (Mrs.) A. A. (probably Albert A.). Artist in Detroit, 1895. Exhibit: a floral painting, Great Art Loan, 1895. *–Ref.: 60 (May 21, 1895); 164*

ROBINSON, C. & CO. Artists in Detroit, 1889. Charles Robinson (q.v.) and Carrie Rowe (q.v.). *–Ref.: 118 (1889)*

ROBINSON, CHARLES. Artist in Detroit, 1889. Partner of Carrie Rowe (q.v.), under firm name of C. Robinson & Co. (q.v.). *–Ref.: 118 (1899)*

ROBINSON, CHARLOTTE. Watercolor and pastel artist in Detroit, 1879–83. Exhibits: Michigan State Fairs, 1879 and 1883. *–Ref.: 56 (Sept. 18, 1879); 65 (Sept. 18, 1879); 112 (Oct. 16, 1883)*

ROBINSON, KATE. Young artist in Jackson, 1876–82. Exhibits: oil paintings, Michigan State Fairs, 1876, 1877, and 1882. *–Ref.: 112 (Nov. 14, 1876; Oct. 30, 1877; Oct. 17, 1882)*

ROBINSON, S. Artist in Albion, 1886. Exhibit: Michigan State Fair, 1886. *—Ref.: 112 (Nov. 2, 1886)*

ROBINSON, SUSANNE ANTROBUS. *See* ANTROBUS, BIRDY.

ROBY, HELEN E. Artist and teacher in Detroit, 1881–99. Painter of flowers, landscapes, marines, and interiors. Studied three years in Paris. Exhibits: Detroit, 1886, 1890, 1893–98; New York City, 1896; also in Cleveland and Cincinnati, Ohio. Memberships: Detroit Water Color Society; vice-president, Rembrandt Etching Club; Society of Western Artists. *—Ref.: 3 (vol. 1, 1898); 51 (1881–99); 56 (Apr. 13, 1880, Apr. 18, Dec. 8, 1893, Dec. 13, 1895, Dec. 7, 1896); 60 (Apr. 18, 1893; Mar. 17, 24, Dec. 21, 1894; Sept. 21, 1895, June 2, Dec. 7, 1896); 68 (Feb. 20, Mar. 5, 27, 1893; Jan. 19, 1896); 72 (Dec. 1885); 118 (1893–97); 163; 164*

ROCKWELL, JENNIE. Portrait artist in Bay City, 1893–99. Partner of Anna Carrier (q.v.), under the firm name of Carrier & Rockwell (q.v.), 1897–99. *—Ref.: 118 (1893–99)*

ROGERS, KATE J. Portrait artist in Ann Arbor, 1886–99. *—Ref.: 6 (1886/87, 1899); 118 (1893)*

ROGERS, RANDOLPH (1825–1892). Sculptor. Designer and builder of the Soldiers and Sailors Monument, and many other building ornamentations in Detroit. Born in Waterloo, N. Y., June 7, 1825, the son of John and Sara McCarthy Rogers. Taken to Ann Arbor at an early age and attended school there. Later, his employer sent him to Florence, Italy, where he studied under Lorenzo Birtolini, sculptor. Resided in Rome, where he was professor of the Academy of St. Luke, but always considered Ann Arbor his home. Executed many noted statues and memorials in the United States, including the bronze doors for the U.S. Capitol. Married Rosa Gibson of Richmond, Va. 1857. Died in Rome, Jan. 15, 1892. Willed all of his original casts to the University of Michigan, where they are in the Museum of Art and Architecture. *—Ref.: 13; 61 (Mar. 17, 1918); 64 (Aug. 7, 1869); 71 (vol. 8); 79; 109; 125 (vol. 3); 128; 149; 156; 163; 164; 165*

ROLFE, EDMOND (or EDMUND). Painter and art craftsman in Detroit, (1877–1917). Born in Detroit. Exhibit: Michigan State Fair, 1916. Died in Woodstock, N. Y., Mar. 30, 1917. *—Ref.: 13; 66 (Sept. 9, 1916); 109; 149; 156*

ROLSHOVEN, JULIUS C. (1858–1930). Portrait, landscape, and genre artist. Born in Detroit, Oct. 28, 1858, the son of Frederick and Maria Hubertina (Hellings) Rolshoven. As a youth, attended art classes at Cooper Union and Plessman Academy, New York. In 1878, registered at Dusseldorf Academy, Germany, under Hugo Crola. A year later, was at Munich under Ludwig Loefft and Frank Duveneck. Also studied

Julius Rolshoven, *Self Portrait.* Oil on canvas, 19¾" x 15 ⅝". From the collection of the Detroit Institute of Arts. Gift of Mrs. Julius Rolshoven.

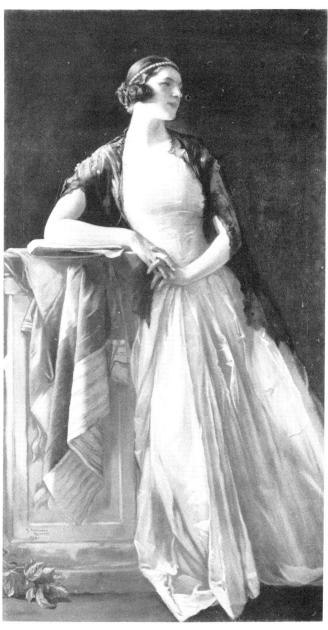

Julius Rolshoven, *Donna Tosca.* Oil on canvas. 73½″ x 40″. From the collection of the Detroit Institute of Arts. Gift of Mrs. Julius Rolshoven.

under Tony Robert-Fleury and Adolphe William Bourgereau in Paris. Resided mostly in Paris and London. Married Anna Eliza Channing at Florence, Italy; and in 1915, Harriette Haynes Blazo. Exhibits: landscapes and genre paintings at the Paris Salon and Société Nationale des Beaux Arts, Paris; Munich Secession; Chelsea Art Club, London; and elsewhere. Awards: Medal, Paris Exposition, 1889, and Honorable Mention, 1900; Medal, Pan-American Exposition, Buffalo, N.Y., 1901; Medal, Louisiana Purchase Centennial Exposition, 1904; and medals, seasonal exhibits of Munich, Berlin, Brussels, Florence, and Chicago. Memberships: NAD: National Arts Club, New York; Secession, Munich; Société des Arts et Lettres, Paris; Foreign Arts Club and Bene Merensa Societe di Belle Art, Florence; International Fine Arts Congress; Taos Society of Artists; Detroit Fine Arts Association. Represented: DIA; Cincinnati Art Museum; museums at Brooklyn New York, Baltimore, Minneapolis, and Sante Fe. Died in New York City, Dec. 7, 1930. *–Ref.: 3 (vol. 1, 1898); 13; 56 (Apr. 18, 1893; Mar. 24, 1894; Dec. 10, 1895); 71 (vol. 8); 79; 101; 109; 119 (1924 ed.); 125 (vol. 3); 149; 156; 163; 164*

ROMANELLI, CARLO (1872– ?). Sculptor in Detroit at the end of the nineteenth century. Native of Florence, Italy, where he studied under Augustus Rivalta, sculptor. Winner of the Grand Prize, a certificate of honor, and 12,000 lire, at his academy. In Detroit, executed a bust of Bishop Foley. Exhibit: DIA, 1908–12. *–Ref.: 51 (1900, 1901); 56 (Nov. 6, 1903); 62 (July 28, 1901); 163*

ROOKER, ELDA. Artist in Otsego, 1893. *–Ref.: 118 (1893)*

ROOKS, CHARLES. Artist in Coldwater, 1881, and in Detroit, 1887. *–Ref.: 118 (1881, 1887)*

ROOT, ALICE. Artist in Detroit, 1879–87. *–Ref.: 51 (1879–87); 118 (1883)*

ROOT, FLORENCE. Artist in Honor, 1899. *–Ref.: 118 (1899)*

ROOT, JENNIE. Artist in Grand Rapids, 1900–05. *–Ref.: 86 (1900–05)*

ROPES, GEORGE L. Watercolor artist in Detroit, 1896. Vice-president, Detroit Architectural Sketch Club. *–Ref.: 60 (Oct. 17, 1896)*

ROSE, GEORGE W. Artist in Detroit, 1883; later in Manistee. *–Ref.: 118 (1883, 1891, 1893)*

ROSE, MINNIE. Artist in Grand Rapids, 1891–94. *–Ref.: 86 (1891–94)*

ROSE, WILLIAM S., SR. (ca. 1846–1938). Portrait, landscape, and marine artist in Detroit. Born on Long Island, N. Y. while his English parents were in the U.S.A. on a mission for Queen Victoria. Returned to England with his parents. Later studied under Sir William Laighton. Returned to America about 1883 and finally settled in Detroit. Exe-

cuted portraits of President William McKinley; Detroit's mayor, William Maybury; Hiram Walker of Walkerville, Ontario; and many other prominent persons. Died in Florida, Oct. 23, 1938, and was buried in Detroit, survived by his wife, Rose, and their son, William S. Rose, Jr. (q.v.) —*Ref.: 51 (1893–1900+); 56 (Apr. 5, 1895, Oct. 29, 1938); 61 (Oct. 28, 1938); 118 (1895,97); 165*

ROSE, WILLIAM S., JR. Artist in Detroit, 1900–05. Son of William S. Rose, Sr. (q.v.). —*Ref.: 51 (1900–05+)*

ROSEN, MOSES. Portrait artist in Detroit, 1898–1900+. —*Ref.: 51 (1898–1900+); 118 (1899)*

ROSS, D. R. Portrait artist in Muskegon, 1895. —*Ref.: 118 (1895)*

ROSS, H. M. Youthful artist in Allegan, 1884. Awards: premiums for two drawings, Michigan State Fair, 1884. —*Ref.: 112 (Nov. 4, 1884)*

ROSS, R. D. Artist in Sherwood, 1881. —*Ref.: 118 (1881)*

ROSS, WILLIAM. Artist in Detroit, 1891–92. —*Ref.: 51 (1891, 1892)*

ROSS, WILLIAM ALLEN (1843– ?). Lithographer and engraver in Detroit, 1866–1900+. Born in Glasgow, Scotland, Apr. 25, 1843. Came to Detroit, 1866. Employed by the Calvert Lithographing & Engraving Company, later becoming its vice-president and director. Married Ellen Brennan of Detroit, 1870. —*Ref.: 51 (1870–1900+); 164*

ROTE, WILLIAM H. Portrait artist in Detroit, 1889–1900+. Associated with the Peoples Portrait Company, 1896–97. —*Ref.: 51 (1889–1900+); 118 (1899)*

ROTH, HEINRICH (or HENRY) (ca. 1874– ?). Artist and engraver in Detroit, 1885–96. Born in Detroit. Studied at Detroit Museum of Art School with Joseph Gies (q.v.) and Gari Melchers (q.v.). Started work with *Detroit Free Press*. Earned fame as a dry point illustrator in Boston, New York, and Cincinnati. Illustrations for *Collier's, Harper's Weekly, Success, Pearson's* and *Metropolitan* were a part of his works. —*Ref.: 51 (1885–96); 56 (May 17, 1908); 60 (Jan. 15, 1896); 164*

ROTHVILLE, JAMES W. Portrait painter in Hudson. —*Ref.: 118 (1863/64)*

ROWE, CARRIE A. (or CARRIE W.). Artist in Detroit, 1889, 1893–97. Partner of Charles Robinson (q.v.), under the firm name of C. Robinson & Co. (q.v.), 1889. —*Ref.: 118 (1889, 1893–97)*

ROY, M. J. ANTOINE. Artist in Detroit, 1888–91. —*Ref.: 51 (1888–91); 118 (1889)*

ROYS, MARY G. Artist in Grand Rapids, 1897–98. —*Ref.: 86 (1897–98)*

RUMMLER, ALEXANDER J. Lithographic artist in Detroit, 1884–89. Then moved to New York City. —*Ref.: 51 (1884–89)*

RUSSELL, ERNEST L. Artist in Bay City, 1895. —*Ref.: 118 (1895)*

RYDER, (Mrs.) W. F. Miniaturist, presumably in Detroit, ca, 1893. Exhibit: Detroit Water Color Society, probably ca. 1893. —*Ref.: 69*

RYPSAM, FRED W. (1880–1969) Artist in Detroit, 1899–1969. Originally employed in commercial work in the automotive industry. Following retirement, devoted himself to oil and watercolor paintings of landscapes (particularly snow scenes and marines), and private yachts. Exhibited frequently in local galleries. Upon his death, was the oldest member of Detroit's Scarab Club. Died in Detroit, Apr. 6, 1969. —*Ref.: 51 (1899–1900+); 56 (Apr. 8, 1969); 61 (Feb. 14, 1932, July 25, 1962); 163; 164*

RYTHER, MARY. Artist in Three Oaks, 1882. Award: premium, Michigan State Fair, 1882. —*Ref.: 112 (Oct. 17, 1882)*

S

ST. ALARY, A. *See* ST. ALARY, CHARLES EMILE.

ST. ALARY, CHARLES EMILE (? –1865). Portrait and landscape artist in Detroit, 1855–65. Also spent some time in Chicago. Taught French and drawing in Detroit high schools, 1860. Asssociated with George Watson (q.v.) under firm name of St. Alary & Watson (q.v.). Exhibits: Michigan State Fairs, 1854, 1856, 1858; and one Illinois State Fair. Died in Bordeaux, France, July 24, 1865. —*Ref.: 51 (1855/56, 1857/58–1865/66); 56 (Aug. 11, 1865); 112 (Nov. 1854, Nov. 1856, Nov. 1858); 118 (1863/64; 156; 164*

ST. ALARY & WATSON. Photographers and portraitists in Detroit, 1864–65: Charles Emile St. Alary (q.v.) and George Watson (q.v.). —*Ref.: 51 (1864/65–1865/66)*

ST. MARS, ALPHONSE DE. Language and drawing teacher in Detroit, 1852–53. —*Ref.: 51 1852–53)*

SANBORN, JULIA CRAWFORD. Artist in Ossineke, 1890s. Painted Great Lakes vessels and harbor scenes. —*Ref.: 161*

SANTEE, FRANKLIN. Portrait artist in Bay City, 1889. —*Ref.: 118 (1889)*

SANTEE (or SANTER), MINER. Artist in Bay City. —*Ref.: 118 (1893)*

SANTER, MINER. *See* SANTEE, MINER.

SARTWELL, E. Artist in Ypsilanti, 1890. Exhibit: oil painting, Detroit Museum of Art. 1890. —*Ref.: 163*

SAUNDERS, AGNES J. Artist in Detroit, 1875–76. Member: Detroit Art Association. Exhibited crayon portraits at the association's second showing, 1875/76. —*Ref.: 51 (1875/76); 164*

SAUNDERS, MAUDE (Mrs. Joseph). Artist in Detroit, 1886–89. —*Ref.: 51 (1886–88); 118 (1889)*

SAUNDERS, THEODORE. Amateur artist in Detroit, 1882–91. –*Ref.: 51 (1882–91); 118 (1887, 1891)*

SAVIGNY, FRANK W. Artist in Lansing, 1887, and Detroit, 1887–1900+. –*Ref.: 51 (1891–1900); 102 (1887); 118 (1887, 1893–99)*

SAWYER, JOSEPH B. Resident of Detroit, 1870–97, with various occupations including "artist," 1889. –*Ref.: 51 (1870–97)*

SCHAFER, JOHN J. Wood-carver in Grand Rapids, 1899–1900. –*Ref.: 86 (1899–1900); 118 (1899)*

SCHAFFER, HENRY. Artist in Coldwater, 1882. Award: premium, Michigan State Fair, 1882. –*Ref.: 112 (Oct. 17, 1882)*

SCHELLENBERG, BATESON P. Portrait artist in Detroit, 1893. –*Ref.: 118 (1893)*

SCHELLENBERG, PLUM B. Artist in Detroit, 1894–99. Exhibit: marine painting, Detroit Museum of Art, 1894. –*Ref.: 51 (1894–1899); 60 (Jan. 5, 1894); 118 (1895, 1897); 164*

SCHERMERHORN, (Mrs.) B. B. Artist in Hudson, 1899. –*Ref.: 118 (1899)*

SCHIEL, MARY. Artist in Saginaw, 1897–99. –*Ref.: 118 (1897, 1899)*

SCHILLER, FREDERICK. Portrait artist in Detroit, 1898–1900+. –*Ref.: 51 (1898–1900+)*

SCHIMMEYER, LUDWIG. Wood-carver in Saginaw, 1893. Designed and carved animals for carousels and decorative parts for organs. –*Ref. 118 (1893)*

SCHIPANSKI, AUGUST. Artist in Detroit, 1887–98. –*Ref.: 51 (1887–1898)*

SCHLICKUM, CHARLES, SR. (? –1869). Artist in Bloomfield Township, Saginaw County. Born in Prussia and brought to the U.S.A. by his parents. Exhibits: Michigan State Fairs, 1854 and 1855. –*Ref.: 112 (Nov. 1854; Nov. 1855); 164*

SCHMIDTS, CLARA. Floral artist in Detroit. Exhibits: Detroit Art Association, 1875–76; Angell's Gallery, Detroit, 1877. –*Ref.: 51 (1877); 164*

SCHMITZ, HENRY. Carver and modeler in Detroit, 1873. Associated with Theodore Crongeyer (q.v.) as Schmitz & Crongeyer (q.v.). –*Ref.: 51 (1873)*

SCHMITZ & CRONGEYER. Modelers and wood-carvers in Detroit, 1873: Henry Schmitz (q.v.) and Theodore Crongeyer (q.v.). –*Ref.: 51 (1873)*

SCHNAPLE, FREDERICK A. (ca. 1872–1948). Watercolor artist and designer in Detroit. Born in Germany. Came to America as a boy. Exhibit: DIA. Died in Detroit, Feb. 2, 1948. –*Ref.: 56 (Feb. 3, 1948); 163; 164*

SCHOBER, FREDERICK A. (1806–1869). Printer in Detroit, 1855–59.

Born in Germany. Partner of Robert Burger (q.v.), lithographer, 1855–56, under the name of Burger & Schober (q.v.). Died in Detroit, Feb. 4, 1869. *–Ref.: 51 (1855–59)*

SCHOTT, IGNATIUS (? –ca. 1882). Painter of church interiors and religious subjects in Detroit, 1870–82. Decorated the interior of the Holy Trinity Church with murals and window panels. *–Ref.: 51 (1870–82); 118 (1877, 1881, 1883); 164*

SCHROTTKY, EDWIN. Artist in Negaunee, 1893. *–Ref.: 118 (1893)*

SCHUBERT, WILLIAM. Artist in Detroit, 1864–65. *–Ref.: 51 (1864–65).*

SCHUELLER, FREDERICK. Portrait artist in Saginaw, 1887, 1891–99. *–Ref.: 118 (1887, 1891–99)*

SCOTFORD, J. H. Artist in Bay City, 1877. *–Ref.: 118 (1877)*

SCOTT, JAY H. Portrait artist in Albion, 1895. *–Ref.: 118 (1895)*

SCOTT, WINFIELD LIONEL (ca. 1839– ?). Artist, poet, and craftsman in Detroit, 1885–1900+. Born in northern New York. Moved to Detroit, 1885. Exhibit: Detroit Museum of Art's first annual exhibit, 1886. *–Ref.: 51 (1885–1900+); 60 (June 30, 1911); 118 (1899); 163*

SCOTTEN, BESSIE MARJORIE. Student of Maud Mathewson's (q.v.) school, Detroit. Exhibited at the school's spring showing, 1894. *–Ref.: 60 (June 20, 1894); 164*

SCRANTON, LYDIA M. Artist in Detroit, 1898–1900. *–Ref.: 51 (1898, 1900)*

SEBRING, (Mrs.) F. W. Artist in Saginaw. Exhibit: pastel animal picture, Michigan State Fair, 1875. *–Ref.: 112 (Oct. 12, 1875)*

SEEGMILLER, JANETTE. Artist in Grand Rapids, 1885. *–Ref.: 118 (1885)*

SEELEY, B. F. Artist in Saginaw, 1875. Exhibit: India ink drawing, Michigan State Fair, 1875. *–Ref.: 112 (Oct. 12, 1875)*

SEITZ, CHARLES B. (ca. 1832– ?). Wood and ivory turner in Detroit, 1864–1900+. Born in Germany, where he received his training. Settled in Detroit, 1864. Associated for a short time with Bernard Hellenberg (q.v.) as Charles B. Seitz & Co. (q.v.), after which he did business under his own name for many years. *–Ref.: 51 (1864–1900+); 63; 74; 164*

SEITZ, CHARLES B. & Co. Woodturners in Detroit, 1865–66: Charles B. Seitz (q.v.) and Bernard Hellenberg (q.v.). *–Ref.: 51 (1865/66)*

SELZER, FRANK E., SR. Artist and instructor of drawing and oil and watercolor painting in Grand Rapids, 1880–1900+. Partner of Delos G. Henry (q.v.) in the firm of D. G. Henry & Co. (q.v.). Later with Harry Smith (q.v.) under the firm name of Smith & Selzer (q.v.). *–Ref.: 86 (1880–1900+); 118 (1881, 1883)*

SELZER, FRANK E., JR. Fresco painter, etcher, and engraver in Grand Rapids, 1891–1900+. *—Ref.: 86 (1891–1900+)*

SELZER, LOUIS. Fresco painter and decorator in Grand Rapids. Probably related to Frank E. Selzer, senior (q.v.) and junior (q.v.). *—Ref.: 86 (1891–1900)*

SHAFER, ELLA M. (Mrs. Simon P.). Fruit and floral painter in Detroit, 1892–97. Wife of Simon P. Shafer (q.v.). Settled in Detroit about 1885. Worked and exhibited with husband in local galleries. Moved to Earlville, Ohio, 1898. *—Ref.: 51 (1892–97); 60 (Aug. 13, 1894; Feb. 9, 1895); 62 (Jan. 19, 1896); 118 (1893–97)*

SHAFER, SIMON P. Still life and figure painter in Detroit, 1885–98. Husband of Ella M. Shafer (q.v.). Settled in Detroit, 1885. Exhibited in local galleries. Moved to Earlville, Ohio, 1898. Worked and exhibited with wife in local galleries. *—Ref.: 51 (1885–98); 60 (May 17, 1893, Jan. 5, 1894, Feb. 24, Dec. 12, 1896); 62 (Jan. 19, 1896); 118 (1889, 1891, 1895, 1897)*

SHAW, GEORGE. Youthful artist in Detroit, 1879. Pupil of Daniel J. Gray (q.v.). Exhibit: landscape, spring show, Michigan Artists Association, 1879. *—Ref.: 65 (Apr. 13, 1879)*

SHAW, HORATIO (1847–1918). Farmer and amateur landscape and animal painter in Adrian. Born in Adrian and lived his whole life in that area. Studied two years with Thomas Eakins in the Philadelphia Academy. Married a cousin, Susie Shaw, in 1868. Died in Cadmus, near Adrian. An exhibition of his works was shown at Detroit in 1940. *—Ref.: 56 (May 31, 1942); 61 (Feb. 18, Mar. 10, 1940)*

SHEAR, GEORGE W. Artist in Morenci, 1879. *—Ref.: 118 (1879)*

SHEARER, CATHERINE (or KATHERINE). Artist in Detroit, 1899–1900+. Possibly Chrissie Shearer, an artist in Jackson, 1897. *—Ref.: 51 (1899–1900+); 118 (1897)*

SHERIFF, CHARLES E. Credited with two watercolors exhibited at the Detroit Museum of Art, 1886. *—Ref.: 163; 164*

SHERMAN, NICHOLAS S. Portrait artist in Grand Rapids, 1888–93. *—Ref.: 86 (1888–91); 118 (1891, 1893)*

SHEWCRAFT, RICHARD TURNER (ca. 1869– ?). Portrait, landscape, and still life artist in Detroit. Born in Windsor, Ontario, of English, Indian, and Negro ancestry. Family moved to Detroit when he was a boy. Studied at the Detroit Museum of Art school during its first year, 1885. Later while studying medicine in Louisville, Ky. taught drawing and painting in neighboring New Albany, Ind. Exhibited portraits of prominent persons in local Detroit galleries. *—Ref.: 51 (1887–97); 60 (Oct. 8, 1894); 118 (1893, 1895); 163; 164*

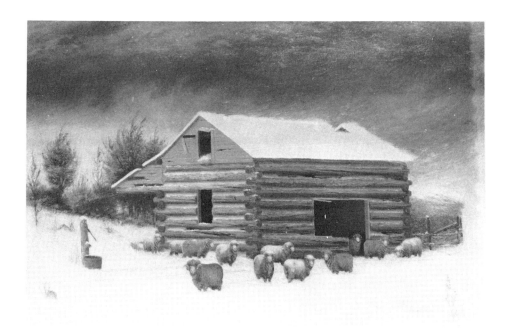

Horatio Shaw, *Winter Dawn*. Oil on canvas, 21¼″ x 27″. From the collection of the Detroit Institute of Arts. Gift of Mrs. John Lowth.

Horatio Shaw, *Out of the Storm*. Oil on canvas, 54″ x 36″. From the collection of Adrian College, Adrian.

Horatio Shaw in his Studio. Photograph. From the Photo Archives of the
Detroit Historical Museum.

SHIREFFE, MATTIE. Artist in Chesaning, 1899. *—Ref.: 118 (1899)*

SHORE, ? (Mrs. Robert). Exhibit: spring show, Michigan Artists Association, 1879. *—Ref.: 65 (Apr. 13, 1879)*

SIDWAY, G. D. Portrait and animal painter in Detroit, 1855–1858. Studied under Alvah Bradish (q.v.). Exhibit: Michigan State Fair, 1855. *—Ref.: 51 (1855–58); 112 (Nov. 1855); 164*

SIEBERT, HENRY A. Sculptor and wood-carver in Detroit, 1891–95. Partner of Julius Theodore Melchers (q.v.) in the firm of Melchers & Siebert (q.v.). *—Ref.: 51 (1891–93); 63; 118 (1891–95)*

SIEDENBURG, ANNIE. Artist in Detroit, 1890. Exhibit: floral and fruit painting, Detroit Floral and Musical Charity Festival, 1890. *—Ref.: 51 (1890); 164*

SIMONTON, EMILY M. Artist in Detroit, 1895–1901. *—Ref.: 51 (1895–1901)*

SIPLE (or SIPOE), (Mrs.) JESSIE. Artist in Otsego, 1897–99. *—Ref.: 118 (1897, 1899)*

SIPOE, (Mrs.) JESSIE. *See* SIPLE, (Mrs.) JESSIE

SKEELS, BERTRAND (or BURTON A.). Portrait artist in Adrian, 1887–97. *—Ref.: 118 (1887–91, 1895, 1897)*

SLATER, JOHN. Amateur artist in Detroit, also a book binder, seller, and stationer, 1845–54. *—Ref.: 51 (1845–54); 164*

SLOCUM, DELENER. Crayon artist in Jamestown *—Ref.: 118 (1879, 1881)*

SLOCUM, ELIZABETH TRUAX (Libbie T.) (Mrs. J. B. Nichols). *See* NICHOLS, ELIZABETH TRUAX SLOCUM

SMITH, ALEXANDER B. Artist in Brighton. *—Ref.: 118 (1895)*

SMITH, ALLEN, JR. (or ALVIN J.) (1810–1890). Portrait and genre painter in Detroit, ca. 1837. Born in Rhode Island, N. Y., July 10, 1810. Studied in New York. Associate, National Academy of Design, 1833. In Detroit by 1837. His painting of Michigan's first governor, Stevens T. Mason, hangs in the House of Representatives, Lansing. Credited with designing the first Michigan flag, which was presented to the Brady Guards, 1837. After a short time in Detroit, moved to Cincinnati, Ohio, and later to Cleveland, Ohio, where he died. *—Ref.: 13; 51 (1837); 79; 101; 109; 128; 156; 162; 163; 164*

SMITH, ALVIN J. *See* SMITH, ALLEN, JR.

SMITH, ANNA P. Artist in Muskegon, 1887–93, 1899. *—Ref.:118 (1887–93, 1899)*

SMITH, BELLE EARLE. Artist in Detroit, 1891–1900+. Exhibit: at DIA, 1933. *—Ref.: 51 (1891–1900+); 118 (1895–99); 163*

SMITH, BERTA A. Artist in Jackson, 1895–99. *—Ref.: 118 (1899)*

SMITH, BLANCHE E. Artist and teacher in Grand Rapids, 1899. *—Ref.:* *118 (1899)*

SMITH, CHARLES. Artist in Grand Rapids, 1893. *—Ref.: 86 (1893)*

SMITH, EDWIN M. Artist in Grand Rapids, 1899. *—Ref.: 86 (1899)*

SMITH, EGBERT. Artist in Detroit, 1895. *—Ref.: 118 (1895)*

SMITH, EMMA. Artist in Detroit, 1900–06. *—Ref.: 51 (1900–06)*

SMITH, HARRY. Painter in Grand Rapids, 1888. Partner with Frank E. Selzer, Sr. (q.v.) under the firm name of Smith & Selzer (q.v.). *—Ref.: 86 (1888)*

SMITH, JUDSON DE JONGE (1880–1962). Mural painter in Detroit. Born in Grand Haven, July 4, 1880. Studied at Detroit Art Academy under Joseph Gies (q.v.) and John Wicker (q.v.). Won a scholarship to the Art Students' League, New York, where he studied under Twachtman, Kenyon Cox and La Farge. Awards: Gold Medal, Scarab Club, 1926; First Honorable Mention, International Exhibition, Carnegie Institute, 1931. Later settled in Woodstock, N. Y., where he died Dec. 29, 1962. Memberships: Woodstock Art Association; American Society of Painters, Sculptors and Gravers. Represented at Detroit Free Press Building; DIA; Whitney Museum of American Art, New York. *—Ref.: 13; 61 (Jan. 3, 1926); 67 (Jan. 10, 1926); 101; 109; 149; 163; 164*

SMITH, KATHERINE CONELY. *See* CONELY, KATHERINE.

SMITH, LETITA CRAPO (1862–1921). Genre and floral artist in Detroit, ca. 1894–1916. Born in Flint, July 4, 1862. Studied at Julien Academy, Paris, and in Brittany, Holland, Japan, and England. Also a pupil of Wm M. Chase, George Hitchcock, and Julius Rolshoven (q.v.). Awards: Bronze Medal, Louisiana Purchase Centennial Exposition, St. Louis, 1904, for "The First Birthday," which had previously been exhibited at the Paris Salon, the first painting by a Michigan woman so honored. Memberships: president, Detroit Society of Women Painters and Sculptors, 1908–15; member, Detroit Water Color Society, and Society of Associated Artists. Represented in New York, Philadelphia, Washington, D. C., and at DIA. Died in Boston, Mass., Mar. 17, 1921. *—Ref.: 19; 60 (Dec. 15, 29, 1894; May 21, 1895); 66 (Sept. 9, 1916); 101; 114 (vol. 7, 1916); 119; 122; 163; 164*

SMITH, MORTIMER L. (1840–1896). Architect and landscape painter in Detroit. Born in Jamestown, N. Y. Moved early with his parents to Detroit. Educated in Oberlin and Sandusky, Ohio. Architect of many of Detroit's finest buildings; painted for his own pleasure. Exhibits: DIA; local galleries; Michigan State Fairs, 1868, 1878, and 1879. Died in Detroit, Jan. 19, 1896. *—Ref.: 56 (Sept. 16, 1868, Sept. 18, 1879, Apr. 13, 1880, Oct. 15, 1881); 60 (Apr. 18, 1893); 65 (Sept. 21, 1878,*

Mortimer L. Smith, *Landscape,* 1877. Oil on canvas, 25½" x 35½". From the collection of Mr. and Mrs. James L. Greaves, Detroit. Photograph by Joseph Klima, Jr.

Sept. 18, 1879); 112 (Feb. 10, 1880); 118 (1885–89); 163: 164

SMITH, SARAH E. Award: premium, best India ink drawing, Michigan State Fair, 1851. *–Ref.: 112 (Dec. 1851)*

SMITH, WILLIAM. Artist and art dealer in Saginaw, 1895. *–Ref.: 118 (1895)*

SMITH, WINIFRED (or WINNIFRED). Artist in Saginaw, 1897–99. *–Ref.: 118 (1897, 1899)*

SMITH & SELZER. Sign, fresco, and ornamental painters in Grand Rapids: Harry Smith (q.v.) and Frank E. Selzer, Sr. (q.v.). *–Ref.: 86 (1888)*

SNYDER, W. H. Artist of Battle Creek. *–Ref.: 118 (1897)*

SOMMER, WILLIAM (1867–1949). Artist born in Detroit; later worked in Cleveland, Ohio. Studied under Julius Melchers (q.v.), Detroit, and later in Munich. Moved to Cleveland, Ohio, in 1890 and lived there until his death. Exhibits: Great Art Loan, 1883; Great Lakes Exhibit, Detroit, 1939. *–Ref.: 109; 163; 165*

SOPER, JAMES H. GARDNER (1877– ?). Artist in Detroit, 1893–1900. Later worked in New York City. Born in Flint. Exhibits: Society of Western Artists, 1898; DIA intermittently 1905–15; and at local societies. Awards: Bronze Medal, Louisiana Purchase Exposition, St. Louis, 1904. Memberships: Detroit Artists Association; Detroit Water Color Society; Scarab Club; Society of Western Artists. *–Ref.: 51 (1893–1900); 79; 156; 163; 164; 165*

SOULE, E. C. H. Artist in Plainwell, 1884. Awards: premiums for pastel and pencil drawings, Michigan State Fair, 1884. *–Ref.: 112 (Nov. 1884)*

SPALTHOFF, ANTONIA. Sculptor in Saginaw, 1895–99. *–Ref.: 118 (1895–99)*

SPARROW, HENRIETTA M. Art student in Detroit, 1891–94. Studied under Maud Mathewson (q.v.). Exhibited at the Studio's annual spring showing, 1891. *–Ref.: 51 (1894); 60 (June 20, 1891); 164*

SPECK, JOHN J. Fresco painter and wood-carver in Detroit, 1875–1900+. *–Ref.: 51 (1875–1900+); 118 (1887, 1889)*

SPECK, WALTER EDWARD (1895– ?). Lithographer, painter, and decorator in Detroit. Born in Detroit. Still active there in 1948. Exhibit: DIA, 1930. Represented in DIA permanent collection. *–Ref.: 109; 156; 163*

SPENCER, FREDERICK W. Artist in Jackson, 1885–93. Exhibits: several pastel and watercolor paintings, Michigan State Fair, 1887. *–Ref.: 98 (1887); 112 (Oct. 31, 1887); 118 (1885–93)*

SPENCER, JOB (JOSEPH) B. (1829–1899). Fruit, flower, animal, and

Howard F. Sprague, *The City of Alpena and the City of Detroit II,* 1896. Watercolor (detail). From the collection of the Dossin Great Lakes Museum, Detroit.

landscape painter in Grand Rapids, latter third of 1900s. Born in Salisbury, Conn. Worked in New York City, and Scranton, Pa., before settling in Grand Rapids. Exhibit: National Academy of Art, New York, 1858. Died Mar. 15, 1899, probably in Grand Rapids. —Ref.: 13; 56 (Apr. 13, 1880); 79; 86 (1891–99); 128; 156; 165

SPICER, ETTA M. Artist in Battle Creek, 1887. —Ref.: 118 (1887)

SPINNING, HESTER JOHNSON (Mrs. Daniel J.) (1848–1915). Painter, writer, and poet in Detroit, latter 1900s. Work primarily of flowers, animals, landscapes, and some portraits. Born at Niagara Falls, Ontario, in Sept. 1848. When very young, taken to Detroit, died in Detroit August 1, 1915. Was married in Detroit about 1880. —Ref.: 51 (1881–1900+); 60 (Sept. 29, 1894); 61 (Jan. 19, 1896); 118 (1893–97); 164

SPOONER, ALICE M. Artist in Greenville, 1891–97. Sister of Fannie H. Spooner (q.v.). —Ref.: 118 (1891–97)

SPOONER, FANNIE H. Artist in Greenville, 1891–97. Sister of Alice M. Spooner (q.v.). —Ref.: 118 (1891–97)

SPRAGUE, ? (Mrs. M. U.). Artist in Wayland, Allegan County, 1887–93. —Ref.: 118 (1887–93)

SPRAGUE, HAROLD. Artist in Detroit, 1896. —Ref.: 51 (1896)

SPRAGUE, HOWARD F. (? –1899). Young marine artist and illustrator in Detroit, 1895–98. Moved from Cleveland, Ohio, to Detroit, 1895. Portrayed ships of the Great Lakes during the late nineteenth century. Several of his works were published by Harper's Weekly. Painted marine pictures for vessel owners and local newspapers. A number of his oil paintings are in the Dossin Great Lakes Museum on Belle Isle, Detroit. In 1898, he was in Lorain, Ohio, a tuberculosis victim. Died May 15, 1899. —Ref.: 51 (1896); 56 (Dec. 23, 1898); 149; 156; 162; 164; 165

SPRINGSTEIN, ARTHUR W. Artist and illustrator in Detroit. Exhibit: DIA, 1936. —Ref.: 51 (1894, 1895); 118 (1895); 163

SPRUNK, ROBERT GODFREY (1862–1912). Portrait artist in Detroit in the 1880s; later in Ridgefield, N. J. Born in Kröxen, Germany, Nov. 19, 1862. Studied under Jakobidies in Germany; Bougereau and Robert-Fleury in Paris; and Thomas Eakins in Philadelphia, Pa. Exhibited two portraits at the Michigan State Fair, 1880. Member: PAFA. Died in Ridgefield, N. J., Apr. 9, 1912. —Ref.: 3 (1898, 1918); 65 (Sept. 16, 1880); 68 (Jan. 29, 1893); 146; 149; 156; 163; 164

SPRY, ROBERT J. Artist, sign painter, and carver in Detroit, 1894–1900. An exhibition of Michigan artist-craftsmen at DIA, 1951, included work by a Robin Spry, who is possibly the same person. —Ref.: 51 (1894–1900); 163

SPURGIN, JAMES LINDSAY. Interior decorator of many Detroit build-

John Mix Stanley, *Western Landscape*. Canvas, 18½" x 30". From the collection of the Detroit Institute of Arts. Gift of Dexter M. Ferry, Jr.

John Mix Stanley, *A Morning in Milk River Valley*. Canvas, 7 7/8" x 10". From the collection of the Detroit Institute of Arts. Gift of Mrs. Blanche Ferry Hooker.

ings. Had a Detroit studio for many years, and painted landscapes, portraits and still life subjects. —*Ref.: 165*

STAFFORD, LULU C. (wid. Andrew). Artist in Detroit, latter part of the nineteenth century. —*Ref.: 51 (1887–96); 118 (1897)*

STANDISH, ? (Mrs. Albert H.). Artist in Grand Rapids, 1881. —*Ref.: 118 (1881)*

STANLEY, JANE C. MAHON (Mrs. Louis Crandall Stanley) (1863–1940). Watercolor artist in Detroit. Specialized in buildings, street scenes, bridges, and landscapes. Born in Detroit, July 21, 1863. Daughter-in-law of John Mix Stanley (q.v.). Worked and studied in many foreign countries: Spain, France, Guatemala, and Canada. Exhibits: Corcoran Gallery, Washington, D. C.; DIA; PAFA; and Memorial Hall, Ann Arbor. Memberships: Detroit Society of Women Painters and Sculptors; Detroit Water Color Society; Art Club of Detroit; Ann Arbor Art Association; American Federation of Artists. Died in Ann Arbor, Oct. 31, 1940. —*Ref.: 13; 56 (Nov. 2, 1940); 60 (Dec. 13, 1895); 79; 101; 109; 156; 163; 164; 165*

STANLEY, JOHN MIX (1814–1872). Artist in Detroit, 1837–72. Painter of portraits and Western scenes, particularly portraits of Indians, of whom he painted over 150, including many tribal chiefs. Born in Canandaigua, N. Y., Jan. 17, 1814. Moved to Michigan, 1834. Painted many portraits in Detroit. Worked in New York, Philadelphia, Baltimore, and in Arkansas, New Mexico, California, Oregon, Washington, and Hawaii. In Hawaii, executed portraits of King Kamehameha III and his Queen. Organizer and president, Western Art Association; member, Detroit Artists Association. Died in Detroit, Apr. 10, 1872. —*Ref.: 13; 51 (1837–72); 56 (Mar. 14, 1867, Sept. 16, 1868, Sept. 24, 1874, June 26, 1875, Sept. 18, 1879); 60 (Apr. 15, 18, 1893, Jan. 5, 1894); 64 (Sept. 11, 13, 14, 1867); 65 (Sept. 19, 1878, Sept. 18, 1879); 71; 101; 109; 112 (Oct. 24, 1872); 118 (1867/68); 128; 149; 156; 162; 163; 164*

STANSBERRY, JENNIE M. Artist in Detroit, 1872–73. —*Ref.: 54 (Sept. 30, 1872); 55 (Feb. 2, 1872); 118 (1873)*

STARR, N. B. Artist in Port Huron, 1873; formerly in Cincinnati, Ohio. —*Ref.: 118 (1873); 128*

STARR, WILLIAM W. Artist in Grand Rapids, 1879–80. —*Ref.: 86 (1879–80)*

STEARNS, ROBERT L. (ca. 1871–1939). Businessman and hotel owner in Ludington. As a hobby, painted caricatures and satires of humans. Studied art in New York and Paris. Some of his works were published in *Life* and *Judge.* He was dubbed the "Mark Twain of Art." —*Ref.: 56 (Apr. 30, 1950); 165*

STEDMAN, WILLIAM E. Artist in Fennville, 1895–97. *–Ref.: 118 (1895, 1897)*

STEELE, BRANDT (1870– ?). Artist in Indianapolis, Ind. Born in Battle Creek, the son of Theodore Clement Steele, artist. Pupil of his father, and of Aman-Jean in Paris. Instructor, Herron Institute, Indianapolis. Member: Indianapolis Architectural Association. *–Ref.: 79*

STEERS, L. MAY. Artist in Wayne, 1885. *–Ref.: 118 (1885)*

STEINMAN (or STEINMANN), HENRY, JR. Modeler and wood-carver in Detroit, 1888–1900+. Associated in 1900 with Ernst Mildner (q.v.) under the firm name of Mildner & Steinmann. *–Ref.: 51 (1888–1900+)*

STEINMANN, HENRY, JR. *See* STEINMAN, HENRY, JR.

STEINMETZ, ALBERT. Artist in Grand Rapids, 1896. Partner of Alexander A. Eichman (q.v.), under firm name of Eichman & Steinmetz (q.v.). *–Ref.: 86 (1896)*

STEPHENS BROTHERS. Artists in Flint, 1897: John Stevens (q.v.) and William H. Stevens (q.v.). *–Ref.: 118 (1897)*

STEPHENS, JOHN. Artist in Flint, 1897. Associated with his brother William H. Stephens (q.v.) as Stephens Brothers (q.v.). *–Ref.: 118 (1897)*

STEPHENS, WILLIAM H. Artist in Flint, 1897. Associated with his brother John Stephens (q.v.) under the firm name of Stephens Brothers (q.v.). *–Ref.: 118 (1897)*

STERLING, REGINA M. (Mrs. George F.). Portrait artist in Detroit, 1896–97. *–Ref.: 51 (1896); 118 (1897)*

STEVENS, LIZZIE. Amateur artist in Detroit, 1883. Award: premium for the best painting on a plaque, Michigan State Fair, 1883. *–Ref.: 112 (Oct. 16, 1883)*

STEVENS, LUMAN S. Artist in Alma, 1895. *–Ref.: 118 (1895)*

STEVENSON, HANNAH M. (wid. Thomas H.). Portrait artist in Detroit, 1887–90. Moved to Cleveland, Ohio, thereafter. *–Ref.: 51 (1887–90); 118 (1887)*

STEWART, ? (Mrs. Jarvis K.). Artist in Flint, 1893–99. *–Ref.: 118 (1893–99)*

STEWART, DAVID. Artist in Detroit, 1896–1900. *–Ref.: 51 (1896–1900); 118 (1897)*

STEWART, DONALD F. Student and artist in Detroit, 1899–1900. *–Ref.: 51 (1899–1900)*

STEWART, (Miss) MAI. Art student in Detroit, 1893. Award: honorable mention in an exhibition of the Detroit School of Art, 1893. *–Ref.: 60 (June 22, 1893); 164*

STIERLE, MAX M. Photographer and crayon artist in Menominee, 1895. *–Ref.: 118 (1895)*

STILES, JOHN R. Portrait painter in Niles, 1863–64. –*Ref.: 118 (1863/64)*

STILSON, WILLIAM W. Artist and illustrator in Detroit, 1893–96. Did landscapes and figure studies. Studied at Detroit Art Academy. –*Ref.: 60 (June 22, 1893; Jan. 15, 1896); 164*

STOCKING, ELIZABETH LYMAN (Mrs. William). Portrait and figure painter in Detroit, 1878–80. Exhibits: Angell's Gallery; Detroit Art Association; Michigan State Fair, 1878. –*Ref.: 51 (1879–1900); 56 (Apr. 13, 1880); 65 (Sept. 21, 1878); 164*

STOEBBE, FRED. Fresco painter in Detroit, 1876–77. Associated in Detroit with Frederick A. C. Beyer (q.v.), as Beyer & Stoebbe (q.v.). –*Ref.: 51 (1876–77)*

STONE, ? (Mrs. C. W.). Artist in Detroit, 1880–91 (?). Exhibit: Michigan State Fair, 1880. Possibly was Mrs. Charles W. Stone or Catherine, widow of Urban W. Stone. –*Ref.: 51 (1883–91); 112 (Oct. 12, 1880)*

STONE, CARRIE. Artist in Kalamazoo, 1871. Awards: premiums, Michigan State Fair, 1871. –*Ref.: 112 (Oct. 7, 1871)*

STOW (or STOWE), EDWIN C. Artist and ornamental decorator in Detroit. Exhibit: a fruit piece, Gallery of Fine Arts, 1852. Later employed as an interior and exterior decorator of Pullman Palace cars. –*Ref.: 51 (1852–87); 164*

STOWE, EDWIN C. *See* STOW, EDWIN C.

STRAIGHT, JENNIE. *See* VOORHEES, JENNIE STRAIGHT.

STRANG, NORA. Artist of Addison, 1895. –*Ref.: 118 (1895)*

STRATTON, MARY CHASE PERRY (Mrs. William). *See* PERRY, MARY CHASE.

STRICKLAND, HARRY L. India ink artist in Detroit, 1895–96. –*Ref.: 51 (1895–96)*

STRICKLAND, LILLY TERESA. Young art student of Maud Mathewson (q.v.) in Detroit 1893. Exhibited in a studio showing. –*Ref.: 60 (June 22, 1893); 164*

STRONG, F. O. Artist in St. Joseph, 1885. –*Ref.: 118 (1885)*

STRONG, LOUISE. Artist in Marshall, 1883. –*Ref.: 118 (1883)*

STRONG, M. LOUISE (wid. James). Artist in Grand Rapids, 1890. –*Ref.: 86 (1890)*

STUART, ALEXANDER T. (or ALEXANDER J.). Artist in Detroit, 1881–82. –*Ref.: 51 (1882–82)*

STUMM, WILLIAM. Artist in Detroit, 1897. –*Ref.: 118 (1897)*

STURTZ, O. L. Watercolor and crayon artist in Calumet, 1893. Operated under the name Calumet Art Gallery. –*Ref.: 118 (1893)*

SUCKERT, ROBERT F. Artist and lithographer in Detroit, 1878–1900+.

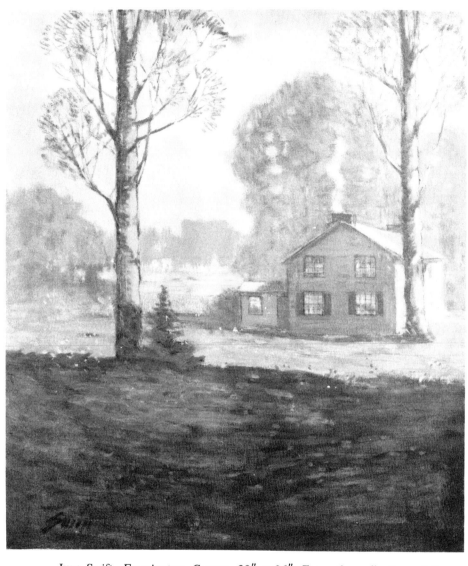

Ivan Swift, *Farmington.* Canvas, 30″ x 26″. From the collection of the Detroit Institute of Arts. Gift of friends of the artist.

With the Calvert Lithographing Company of Detroit for many years. —*Ref.: 51 (1878–1900+)*

SULLIVAN, FRANCIS. Born in Port Huron in 1876. Member: Federation of Arts. —*Ref.: 156*

SURY, ERNST. Artist in Ann Arbor, 1893. Partner with Richard F. Kaiser (q.v.) in firm of Kaiser & Sury (q.v.). —*Ref.: 118 (1893)*

SUTHERLAND, CHARLES E. Portrait artist in Detroit. Exhibit: Michigan State Fair, 1879. —*Ref.: 56 (Sept. 18, 1879); 65 (Sept. 18, 1897); 112 (Feb. 10, 1880)*

SUTTON, M. (probably Moses). Photographer, daguerreotypist, and portrait artist in Detroit. Exhibit: Michigan State Fair, 1857. —*Ref.: 112 (Nov. 1857)*

SUTTON, P. A. Jackson exhibitor of six oil paintings at the Michigan State Fair, 1876. Unknown whether these were original works or a collection. —*Ref.: 112 (Nov. 14, 1876)*

SWAIN, SYLVIA B. Artist in Detroit, end of the nineteenth century. —*Ref.: 51 (1900+)*

SWAN, JAMES (1864–1940). Attorney, watercolor artist, art enthusiast and patron in Detroit, 1890–1900+. Born in Hawick, Scotland, June 10, 1864, the son of James and Isabella (Taylor) Swan. Educated in a private school in Scotland. Came to America, 1881. Graduated from the University of Michigan, 1890. Established residence at Grosse Ile, where he married Emma Groh. One of the original founders of the Detroit Art Club, and also of the Hopkin Club of Detroit, where he exhibited his work. Died at Grosse Ile, July 4, 1940. —*Ref.: 51 (1881–1900+); 60 (Mar. 28, 1895); 109; 164; 178*

SWARTWOUT, MYRON H. Artist in Jackson, 1897. Partner with Harry F. Parker (q.v.) in the firm of Swartwout & Parker (q.v.). —*Ref.: 118 (1897)*

SWARTWOUT & PARKER. Artist-partnership of Jackson, 1897: Myron H. Swartwout (q.v.) and Harry F. Parker (q.v.). —*Ref.: 118 (1897)*

SWAYZE, DELLA F. Artist in Grand Haven, 1897. —*Ref.: 118 (1897)*

SWEET, PERRY C. India ink and watercolor portrait artist, and photographer in Mason, 1879, 1881. —*Ref.: 118 (1879, 1881)*

SWIFT, IVAN (1873–1945). Artist, etcher, and writer in Harbor Springs. Born at Wayne, June 24, 1873, the son of John and Jennie (Birge) Swift. Pupil of Art Institute of Chicago, and of von Freer, von Sulza, Ochtman and Chase in New York. Memberships: National Art Club; Michigan Academy of Science, Arts and Letters, Ann Arbor; Midland Authors, Chicago; Executive Council of Michigan Authors. Represented at DIA and DPL. Died in Detroit, Oct. 5, 1945. —*Ref.: 3 (vol. 30,*

1933); 13; 56 (May 8, 1933); 61 (Oct. 5, 1945); 79; 109; 149; 163; 165

SWIKERT, LURA (or LORA). Artist in Detroit, 1893. —Ref.: 51 (1893)

SZCZEPANSKI, AUGUST. Artist in Detroit, 1896–99. —Ref.: 51 (1896–97); 118 (1897, 1899)

T

TABER, PHOEBE CLEMENTS. Artist in Detroit and Grand Rapids, 1871–93. Originally listed as Phoebe T. Clements, Detroit, prior to 1874; and thereafter, Phoebe Clements Taber. After 1886, resided in Grand Rapids, although exhibited at DIA until 1889. —Ref.: 51 (1871–77); 86 (1886); 118 (1875–93); 163

TALBOT, CHARLES J. Artist in Detroit, 1889. —Ref.: 118 (1889)

TALFORD, FLORENCE L. Art student at the Detroit Art Academy, 1896. From Grand Rapids. —Ref.: 60 (Oct. 17, 1896)

TALLMAN, NELSON H. Artist in Detroit, 1894–99. Moved to Chicago, Ill. —Ref.: 51 (1894–99); 118 (1895)

TALLMAN, PERRY. Artist in Grand Ledge, 1889. —Ref.: 118 (1889)

TANDLER, RUDOLPH FREDERICK (1887– ?). Illustrator and painter. Born in Grand Rapids. Active in St. Louis Mo., 1934. Exhibit: DIA, 1930. Member: Society of Independent Artists. —Ref.: 109; 156; 163

TAYLOR, EDWIN C. (1874– ?). Landscape and figure artist. Born in Detroit. Pupil of Art Students League, New York, under Kenyon Cox, who selected him, after two years study, to assist in compiling a series of drawings for the Library of Congress. Member: Painters and Crafts Club at Yale School of Fine Arts, New Haven, Conn. 1926. —Ref.: 60 (Jan. 15, 1896); 79; 109; 164

TEEPLE, GEORGE W. Artist in Corunna and Detroit, 1883–85. —Ref.: 51 (1884); 118 (1883, 1885)

TERRY, RALPH. Bone-carver in Plymouth, 1891. —Ref.: 118 (1891)

THIEBOUT, PETER. Artist in Grand Rapids, 1899. —Ref.: 86 (1899)

THIEME, FERNANDO J. Wood-carver in Adrian, 1895–99. —Ref.: 118 (1895–99)

THOMAS, ? (Mrs. N. E.). Artist in Port Huron, 1889–93. Probably Mrs. Nahum (or Nehum) Thomas. —Ref.: 118 (1889–93)

THOMAS, BURT R. (1882–1964). Cartoonist. With the Detroit News for forty-eight years. Born in Cleveland, Ohio. Died in Berkeley, Calif., July 3, 1964. —Ref.: 61 (July 4, 1964)

THOMAS, EDWARD KIRKBRIDE (1817–1906). Artist and interior decorator in Detroit, 1850s; and 1868–98, following retirement from an intermittent military career. Born in Philadelphia, Pa., June 26,

1817, the son of Hartshorn R. and Mary B. (Kirkbride) Thomas, both of colonial ancestry. At age twenty-one, joined General Winfield Scott's Artillery and fought in the Seminole War, 1838–42. Married Mary Eliza Weldrick of Detroit, 1840. Fought in the Mexican War, 1846–48. Then settled in Detroit and returned to painting, which he had begun at an early age; yet several years later, joined the armed forces in the Civil War. Was in Detroit for some thirty years after retiring from military service about 1868. Was generally identified as "painter" or "artist", and once as "interior decorator." Probably was engaged primarily in interior decorating: a craftsman-artist with some portrait work and other incidental painting. The only known examples of his work are a self-portrait done in Detroit at the age of seventy-six; several views of Fort Snelling, Minn., one of which is in the Minneapolis Institute of Arts; and drawings or sketches made for the Army Ordnance Department in South Carolina. Died in Detroit, Jan. 12, 1906. *–Ref.: 51 (1868–98); 60 (Jan. 12, 1906); 61 (Jan. 12, 1906); 118 (1887, 1891–95); 160; 173; 176; 177*

THOMAS, EMERY H. Artist in Saginaw, 1889. *–Ref.: 118 (1889)*

THOMAS, JOHN BALDWIN (1856–1937). Lithographic designer and artist in Detroit, 1880–1900+. Born in Shrewsbury, England, Dec. 8, 1856. Came to Detroit, 1864. Employed for fifty years by the Calvert Lithographing Company. Died in Detroit, Nov. 28, 1937. *–Ref.: 51 (1880–1900+); 56 (Nov. 30, 1937); 61 (Nov. 30, 1937)*

THOMAS, NELLIE. Art student in Detroit, 1870. Pupil of Mrs. Fannie E. McGarry (q.v.). Exhibit: Western Art Association, 1870. *–Ref.: 164*

THOMPSON, ? (Mrs. John H.). Artist in Detroit. Exhibits: at local galleries; the Detroit Museum of Art's first annual showing 1886; Michigan State Fair, 1878. *–Ref.: 56 (Apr. 13, 1880); 112 (Oct. 24, 1878); 163; 164*

THORNE, ANNA LOUISE (1878– ?). Painter and engraver in Detroit, beginning ca. 1900+, and in Toledo, Ohio. Born in Toledo, Dec. 21, 1878. Pupil of Chicago Academy of Fine Arts, Art Institute of Chicago; Art Students League, New York; and of Delacluse, Castolocio and L'hote in Paris. Exhibit: Paris Salon; Philadelphia Museum of Art; New York Miniature Society; Toledo Museum. Awards: prizes, Toledo Museum and Detroit Scarab Club. Memberships: Detroit Society of Women Painters and Sculptors; Michigan Academy of Science, Arts and Letters. *–Ref.: 3 (vol. 30, 1933); 56 (Apr. 1, 1929); 109; 163; 165*

THURBER, ALICE HAGERMAN (Mrs. Thomas L.) (1871– ?). Artist and etcher in Birmingham. Born in Birmingham, June 21, 1871. Pupil of Joseph Gies (q.v.), Detroit; Detroit Commercial Art School; Chicago

Art Institute. Memberships: Detroit Society of Women Painters and Sculptors; Detroit Society of Independent Artists; Michigan Academy of Sciences, Arts and Letters; New York Society of Independent Artists. *—Ref.: 3 (vol. 30, 1933); 13; 109; 156; 165*

THURLOW, SARAH W. (wid. Jeremiah). Portrait artist in Grand Rapids, 1886–94. *—Ref.: 86 (1886, 1894); 118 (1888)*

THURSTON, IDA. India ink artist in Three Oaks, 1885. Exhibit: Michigan State Fair, 1885. *—Ref.: 112 (Oct. 27, 1885)*

TIBBITTS, HENRY B. Amateur artist in Vassar, 1895–97. *—Ref.: 118 (1895, 1897)*

TICKELL, FREDERICK A. Artist in Grand Rapids, 1893–94. *—Ref.: 86 (1893–94)*

TINKHAM, ? (Mrs. J. F.). Artist in Grand Rapids, 1881. *—Ref.: 118 (1881)*

TITUS, ELLEN. Artist in Jackson, 1876. Award: premiums for three oil paintings, Michigan State Fair, 1876. *—Ref.: 112 (Nov. 14, 1876)*

TOBEN, ELIZABETH (Lizzie). Amateur artist in Detroit, 1885–91. *—Ref.: 51 (1885–91)*

TOMLINSON, FRANK N. (ca. 1839– ?). Artist and photographer in Detroit, 1885–91. Executed portraits in India ink, crayon and watercolors. Born in Connecticut. Active in New York City, 1860. *—Ref.: 51 (1885–91); 118 (1885); 128; 156*

TOMPKINSON, FLORA. Portrait artist in Kalamazoo, 1885. Exhibit: Michigan State Fair, 1885. *—Ref.: 112 (Oct. 27, 1885)*

TORREY, HELENA J. (wid. Lewis). Artist in Detroit, 1891, and Grand Rapids, 1896–97. *—Ref.: 51 (1891); 86 (1896–97)*

TORREY, KATE S. Artist in Grand Rapids, 1899. *—Ref.: 118 (1899)*

TORRY, EUGENE. Oil and watercolor painter in Kalamazoo, 1883–87. Painted portraits, animals, and landscapes. Exhibits: Detroit's Great Art Loan, 1883. Awards: premiums, Michigan State Fair, 1885. *—Ref.: 101; 112 (Oct. 27, 1885); 118 (1887)*

TREEGER, MORRIS. Artist in Detroit, 1894. *—Ref.: 51 (1894)*

TREGO, D. D. (Mrs. Jonathan K.). Still life artist in Detroit, 1874–80. Former college teacher. Wife of Jonathan Kirkbridge Trego (q.v.). Mother of William Thomas Trego (q.v.). Exhibits: local galleries. Member: Detroit Art Association. *—Ref.: 51 (1880); 56 (Aug. 25, Sept. 24, 1874, Feb. 1, 1876; Apr. 17, 1879); 164*

TREGO, JONATHAN KIRKBRIDGE (1817– ?). Portrait, animal, and genre painter in Detroit, 1870s; in Pennsylvania before that. Born in Bucks County, Pa., Mar. 11, 1817, of Quaker parents. Husband of D. D. Trego (q.v.), and father of William Thomas Trego (q.v.). Frequent exhibitor at PAFA, locally, and at Michigan State Fairs. Member:

Detroit Artists Association. Three national reference works indicate that he died about 1868, but he was listed in Detroit city directories from 1874 to 1879 and exhibited at the Michigan State Fair, 1880. *—Ref.: 13; 51 (1874–79); 56 (Sept. 24, 1874, June 26, 1875, Feb. 1, 1876, Feb. 2, Apr. 13, Sept. 18, 1879, Apr. 13, 1880); 60 (Apr. 18, 1893); 65 (Sept. 21, 1878, Sept. 18, 1879, Sept. 16, 1880); 79; 112 (Oct. 8, 1870, Oct. 24, 1878, Feb. 10, Oct. 12, 1880); 118 (1875); 128; 156; 163; 164*

TREGO, WILLIAM THOMAS (1859–1909). Artist in Detroit and Pennsylvania, late 1800s. Portrait and genre painter who painted many battle scenes. Born at Yardley, Bucks County, Pa., Sept. 15, 1859, the son of Jonathan Kirkbridge Trego (q.v.) and D. D. Trego (q.v.). Studied with his father, at PAFA and in Paris under Fleury and Bougereau. Exhibits: local galleries, Michigan State Fairs, 1878 and 1879. Award from the Pennsylvania Academy. Died in North Wales, Pa., June 24, 1909. *—Ref.: 13; 56 (Apr. 13, Sept. 18, 1879, Apr. 13, 1880); 65 (Sept. 21, 1878, Sept. 18, 1879, Jan. 12, 1893); 79; 112 (Oct. 24, 1878, Feb. 10, 1880); 128; 149; 164*

TRICKEY, JAMES H. Stone and marble sculptor in Detroit in the 1880s and 1890s. *—Ref.: 51 (1887–93); 118 (1891)*

TROMP, MARTIN. Artist in Grand Rapids, 1891–93. Partner of Thomas Prince (q.v.), under the firm name of Tromp & Prince (q.v.), 1893. *—Ref.: 86 (1891–92); 118 (1893)*

TROMP & PRINCE. Artists in Grand Rapids, 1893: Martin Tromp (q.v.) and Thomas Prince (q.v.). *—Ref.: 118 (1893)*

TRUAX, CHARLES. Portrait artist in Detroit, 1881–1900+. *—Ref.: 51 (1881–1900+); 118 (1897)*

TRUE, GEORGE A. (1863– ?). Industrialist and artist in Detroit. Painted in oils and watercolors, but was particularly interested in etching. Born at Funchal, Island of Madeira, Sept. 16, 1863, the son of George True (U. S. Consul) and Susan Laughrey True. Settled in Detroit, 1889. Memberships: Detroit Fine Arts Society, Detroit Water Color Society, Hopkin Club, Scarab Club. *—Ref.: 51 (1889–1900); 163; 164; 165*

TRUE, JOHN J. Artist in Detroit, 1870–71. *—Ref.: 51 (1870/71)*

TRUMP, LIZZIE C. Artist in Bay City, 1883. *—Ref.: 118 (1883)*

TUCK, FRANK L. Artist in Lansing, 1887–89. *—Ref.: 102 (1887); 118 (1889)*

TURNER, EDWARD (or EDWIN) A. (ca. 1854–1899). Artist in Muskegon, 1885–87, and Grand Rapids, 1889–99. Died June 18, 1899. *—Ref.: 86 (1889–99); 118 (1885–89, 1895–99)*

TURNER, LOTTIE B. Artist in Saginaw, 1897–99. Probably in Brooklyn,

N. Y. in the early twentieth century. *–Ref.: 109; 118 (1897–99)*

TURNER, NELLIE D. Artist in Kalamazoo, 1885. Exhibit: Michigan State Fair, 1885. *–Ref.: 112 (Oct. 27, 1885)*

TUTHILL, ABRAHAM G. D. (1776–1843). Portrait painter in Detroit, 1825. Born in Oyster Pond, Long Island, N.Y. in 1776. Studied under West in England, and also a year in Paris. Returning to America, he travelled considerably and was in New York City, 1808–10; Pomfret, Vt., ca. 1815; Plattsburg or Utica, N. Y. 1819–20; Buffalo, N. Y. 1822; Detroit, 1825; Cincinnati, Ohio, 1831; and back to Buffalo, 1837–40. Died in Montpelier, Vt., June 12, 1843. *–Ref.: 128; 156; 163; 164*

TUTHILL, JOSHUA. Watercolor and pastel artist in Saginaw, 1875. Exhibit: Michigan State Fair, 1875. *–Ref.: 112 (Oct. 12, 1875)*

TUTTLE, R. He or she exhibited: Art Loan, Detroit, 1853. *–Ref.: 101*

TWAROCK, HERMAN A. (1861–1900). Artist and dealer in pictures in Detroit, 1883–1900. Died in Detroit, July 10, 1900. *–Ref.: 51 (1883–1901)*

TWEEDALE, FLORENCE. Artist in Salem, 1893–95. *–Ref.: 118 (1893, 1895)*

TYLER, FRANC M. Artist in Lansing, 1894–95. *–Ref.: 102 (1894); 118 (1895)*

TYLER, JEAN. Sculptor in Bloomfield Hills. *–Ref.: 109*

U

UFER, CHARLES C. Wood-carver in Saginaw, 1893. *–Ref.: 118 (1893)*

ULBER, JULIUS E. Portraitist, landscape painter, and etcher in Port Huron and Detroit 1883–94. *–Ref.: 51 (1889–94); 56 (Apr. 13, 1880); 118 (1883–93); 132 (1887–88)*

ULBER, NELLIE. Artist in Detroit, 1887. *–Ref.: 51 (1887); 118 (1887)*

ULLMER, WILLIAM. Artist in Grand Rapids, 1886. Partner of Robert Heuel (q.v.) in the firm of Heuel & Ullmer (q.v.) *–Ref.: 86 (1886)*

UNDERWOOD, MATTIE. Artist in Detroit, 1893. Exhibited locally. *–Ref.: 68 (Mar. 5, 1893)*

UPTON, ADA. Artist in Big Rapids, 1882. Exhibit: Michigan State Fair, 1882. *–Ref.: 112 (Oct. 17, 1882)*

V

VAILLARD, IDA V. Artist in Grand Rapids, 1900. *–Ref.: 86 (1900)*

VAN ALLEN, E. Artist in Grand Rapids, 1883. Possibly is Eleanor Van Allen (q.v.). *–Ref.: 118 (1883)*

VAN ALLEN, ELEANOR. Artist in Saginaw, 1887. Possibly is E. Van Allen (q.v.). —*Ref.: 118 (1887)*

VAN ALLSBURG, ARIE G. Artist and picture frame dealer in Grand Rapids, 1896–1900. —*Ref.: 86 (1896–1900); 118 (1897, 1899)*

VAN BUREN, AMELIA C. Artist and photographer in Detroit, 1880, 1890–1900. Exhibit: drawings and crayons, Angell's Galleries, 1880. —*Ref.: 51 (1890–1900); 56 (Apr. 13, 1880); 118 (1887)*

VANDERPOELE, CHARLES. Sculptor in Detroit, 1870–80. In 1870–71, in partnership with Joseph Aerts (q.v.), as Aerts & Vanderpoele (q.v.). —*Ref.: 51 (1870/71–1880)*

VAN DOPPLE, VICTOR. Artist in Detroit, 1889. —*Ref.: 51 (1889)*

VAN DYKE, E. Artist in Detroit, 1858. Award: premium for a crayon drawing, Michigan State Fair, 1858. —*Ref.: 112 (Nov. 1858)*

VAN FOSSEN, ABIGAIL B. Watercolor artist in Detroit, 1852. Award: prize, Michigan State Fair, 1852. —*Ref.: 112 (Oct. 1852)*

VAN HUSEN, LORENZO C. Artist in Burr Oak, 1883. —*Ref.: 118 (1883)*

VAN NESS, FRANK W. (or FRANK LEWIS). Portrait artist in Detroit, 1885–87. Pupil of J. P. Healey. Award: medal, Art Loan Exhibition, 1885. —*Ref.: 3 (1898); 118 (1887)*

VAN OSTRAM, JULIA. Artist in Fowlerville, 1899. —*Ref.: 118 (1899)*

VAN OVERMEER, FRANK E. Wood-carver in Detroit, 1885–1900+. Worked with Julius Melchers (q.v.). —*Ref.: 51 (1885–1900+); 118 (1895)*

VANSELOW, OTTO. Wood-carver in Grand Rapids, 1892–99. Partners with Adolph C. Bodelack (q.v.), 1892–97, as Bodelack & Vanselow (q.v.). —*Ref.: 86 (1892–97); 118 (1899)*

VAN SLYKE, CHARLES W. Photographer and crayon artist in Mason, 1889. —*Ref.: 118 (1889)*

VAN STAVOREN, ? . Daguerrotypist and portrait painter in Niles, 1851. Operated Van Stavoren's Daguerrotype & Painting Gallery at Niles. Exhibited portraits there, 1851. Previously active in Cincinnati, Ohio, 1846. —*Ref.: 156; 161*

VAN SYCKLE, SARAH E. Artist in Grand Rapids, 1889. —*Ref.: 118 (1889)*

VAN VOORHEIS, (Mrs.) H. M. Artist in Jackson, 1876. Exhibit: water-color paintings, Michigan State Fair, 1876. —*Ref.: 112 (Nov. 14, 1876)*

VIGUS, MARY S. Artist in Grand Rapids, 1888–1900+. —*Ref.: 86 (1888–1900); 118 (1895–97)*

VOLBRACHT, HEINRICH (1841–1897). Carver and sculptor in Detroit, 1890–97. Associated with Edward Q. Wagner (q.v.) under the firm name of Wagner & Volbracht (q.v.). Instructor, Detroit Museum of Art

school. Died in Detroit, Jan. 2, 1897. *–Ref.: 51 (1890–97); 60 (Oct. 1, 1894); 164*

VON BRANDIS, H. FERDINAND (ca. 1820–1851). Painter of military subjects. Born in Hanover, Germany. Exhibited at Detroit galleries. Accidentally killed while hunting near Kenosha, Wis., Aug., 1851. *–Ref.: 54 (Aug. 14, 1851); 128; 164*

VON ERNST, OTTO. Artist in Detroit, 1887. Partner with Gustave Wendling (q.v.) and Paul Wilhelmi (q.v.) in the New Academy of Fine Arts, Detroit, 1887. *–Ref.: 118 (1887)*

VON FELSEN, ALFRED. Artist in Detroit, 1900+. *–Ref.: 51 (1900–07)*

VON HILDEGAR, ? . Painter. In 1850, executed three portraits of a prominent Detroit family which were sold at auction in the twentieth century. *–Ref.: 164*

VONIER, MARIE. Artist in Detroit, 1895. *–Ref.: 118 (1895)*

VON MACH, MAXIMILIAN E. Fresco, scenery, and interior church painter in Detroit, 1880–1900+. Born in Germany. Settled in Detroit, 1880. *–Ref.: 51 (1885–1900+); 63; 118 (1899); 164*

VOORHEES, JENNIE STRAIGHT (Mrs. George V.) (1861–1940). Artist and teacher in Coldwater, Adrian, and Detroit. Born near Coldwater, the daughter of Seymour and Mary Jane (Tilton) Straight. Her father, a young Civil War soldier, was killed when she was a baby. Raised, educated, and married in Coldwater. After studying with Frank Fowler in New York City, returned to Coldwater, to do still life and portrait works, one of which is in the Coldwater Library. She and her husband, a doctor, moved to Adrian, where she was head of Adrian College's Art Department. Later they moved to Detroit where she died May 4, 1940. *–Ref.: 37 (Jan. 20, 1962)*

W

WAGNER, EDWARD Q. (1855–1922). Sculptor and wood-carver in Detroit, 1871–1900+. Born in Bildhauer, Germany. Associated with Richard G. Reuther (q.v.) as Wagner & Reuther (q.v.), 1885–87, and with Heinrich Volbracht (q.v.) as Wagner & Volbracht (q.v.), 1890–95. Ornamented churches and public buildings in Detroit and at Chicago World's Fair with stone carvings. With the Brazilian government for five years in Rio de Janeiro. Died in Detroit, Feb. 1922. *–Ref.: 13; 51 (1871–1900); 79; 109; 118 (1889, 1897,1899); 149; 163; 165*

WAGNER, HUGO E. Sculptor in Detroit, 1897–99. *–Ref.: 51 (1897–99)*

WAGNER, MARY L. (wid. Robert). Watercolor and pastel artist in Detroit, 1878–83. Exhibits: local galleries; Michigan State Fairs, 1878,

1879, 1883. —*Ref.: 51 (1888–97); 56 (Sept. 18, 1879); 65 (Sept. 18, 1879); 112 (Oct. 24, 1878, Feb. 10, 1880, Oct. 16, 1883); 118 (1897); 164*

WAGNER, ROBERT LEICESTER (1872–1942). Artist, illustrator, and motion picture director. Active in Detroit, 1890s, and later in California. Born in Detroit, August 2, 1872, probably the son of Mary L. Wagner (q.v.). Studied at the University of Michigan, and at the Julien Academy, Paris. Awards: Silver Medal, Seattle Exposition, 1909; Bronze Medal, Panama-Pacific International Exposition, San Francisco, 1915. Writer and illustrator for *Saturday Evening Post, Collier's* and *Liberty*. Member: California Art Club. Died in Santa Barbara, Calif. in August 1942. —*Ref.: 3 (vol. 30, 1933); 13; 51 (1891–97); 61 (Aug. 9, 1914); 79; 109; 118 (1897); 149; 156*

WAGNER & REUTHER. Sculptors and carvers in wood and stone, in Detroit, 1885–87: Edward Q. Wagner (q.v.) and Richard G. Reuther (q.v.). —*Ref.: 51 (1885–87); 118 (1887)*

WAGNER & VOLBRACHT. Carvers in Detroit, 1890–95: Edward Q. Wagner (q.v.) and Heinrich Volbracht (q.v.). —*Ref.: 51 (1890–94); 118 (1891–95)*

WALCOTT, MATTIE (Mrs. George D.). Artist in Jackson. Exhibits: Michigan State Fairs, 1877 and 1881. Probably the mother of Mattie Walcott, (q.v.), who also exhibited in 1881. —*Ref.: 65 (Sept. 21, 1881); 112 (Oct. 30, 1877, Oct. 25, 1881)*

WALCOTT, MATTIE. Artist in Jackson. Exhibit: Michigan State Fair, 1881. Probably the daughter of Mrs. Mattie Walcott (q.v.), who also exhibited works there. —*Ref.: 112 (Oct. 25, 1881)*

WALDEN, MATTIE E. Artist in Saginaw, 1877–85. —*Ref.: 118 (1877, 1879, 1885)*

WALKER, BRYANT (1856– ?). Attorney and artist in Detroit, 1881–1900+. Born July 3, 1856. Exhibit: Michigan Artists Spring Show, 1879. Member: Founder's Society, Detroit Museum of Art. —*Ref.: 51 (1881–1900+); 164*

WALKER, EDWARD. Artist in Detroit, 1875. Locally exhibited a large marine painting in oils. —*Ref.: 56 (Aug. 12, 1875); 164*

WALKER, MAY M. Artist in Detroit, 1891. —*Ref.: 51 (1891)*

WALKER, S. He or she exhibited at the spring show of Michigan Artists, April 1879. —*Ref.: 65 (Apr. 13, 1879)*

WALKLEY, O.E. Artist in Grand Haven, 1890. Exhibit: fruit piece in oils, Detroit Museum of Art, 1890. —*Ref.: 163*

WALLACE, CHARLES R. Crayon artist in Jackson, 1879–95. —*Ref.: 118 (1879–95)*

Charles Waltensperger in his Studio, ca. 1932. Photograph. From the collection of George R. Waltensperger, Detroit.

WALLACE, JOHN W. Artist in Detroit. *–Ref.: 51 (1891)*

WALLACE, ROBERT W. Portrait artist in Unionville. *–Ref.: 118 (1887)*

WALSH, EDWARD (1756–1832). Topographical painter in watercolors. Served as a surgeon with the British 49th Regiment in Upper Canada. Made a number of watercolor views of Lake Erie and Buffalo Creek, N. Y. On June 22, 1804, made a painting of the Detroit settlement, from a point on the Canadian side of the Detroit River. Represented by this and other paintings in a portfolio of his paintings in the William L. Clements Library, University of Michigan. *–Ref.: 156; 163; 164*

WALSH, J. JOSEPH (or JOHN JOSEPH). Probably John J. Walsh, printer and later artist in Detroit, 1881–1900+. *–Ref.: 51 (1881–1900+); 118 (1891)*

WALTENSPERGER, CHARLES E. (1871–1931). Landscape and genre painter, illustrator, and designer in Detroit. Illustrated for many books, magazines, and newspapers. Born in Detroit, April 10, 1871. Studied under Joseph Gies (q.v.), Julius Melchers (q.v.) and at Detroit Museum of Art School, and in Paris under Jean Paul Laurens and Benjamin-Constant. Won a two-year European scholarship at the Detroit Museum of Art School. In New York and in Holland for some time. Returned to Detroit, and was a designer for the Calvert Lithographing Company. Exhibits: DIA, 1886–1929; and in many European galleries, where he won awards. Died in Detroit, Dec. 12, 1931. *–Ref.: 56 (Dec. 13, 1931); 60 (Aug. 3, Sept. 29, Dec. 15, 1893, Dec. 29, 1894); 61 (Dec. 1, 1929); 101; 109; 163; 164; 165*

WALTHEW, ADAM (? –1886). Portrait painter and scenic artist, designer of flags and banners, in Detroit, 1868–86. In 1879 in partnership with his son, Thomas A. Walthew (q.v.) under the firm name of A. Walthew & Son (q.v.). Later firm expanded to A. Walthew & Sons (q.v.) to include two other sons, George W. Walthew (q.v.) and James H. Walthew (q.v.); continued thus until Adam's death, June 26, 1886. *–Ref.: 51 (1868–87); 164*

WALTHEW, GEORGE W. Scenic artist in Detroit, 1882–89. Son of Adam Walthew (q.v.), with whom he and his brothers, James H. Walthew (q.v.) and Thomas A. Walthew (q.v.), were associated in the firm of A. Walthew & Sons (q.v.). In 1889, associated with his brother Thomas A. Walthew (q.v.) as Walthew Brothers (q.v.). *–Ref.: 118 (1883, 1885, 1889)*

WALTHEW, JAMES HASTINGS. Scenic and fresco artist in Detroit, 1882–86. Associated with his father, Adam Walthew (q.v.), and his brothers, George W. Walthew (q.v.) and Thomas A. Walthew (q.v.) in the firm of A. Walthew & Sons (q.v.). *–Ref.: 118 (1883, 1885)*

WALTHEW, THOMAS A. Fresco and scenic artist in Detroit, 1879–1889. Associated in 1879 with his father, Adam Walthew (q.v.), under the firm name of A. Walthew & Son (q.v.). Firm later expanded to include his brothers George W. Walthew (q.v.) and James Hastings Walthew (q.v.), as A. Walthew & Sons (q.v.) In 1889, associated with his brother George W. Walthew (q.v.) as Walthew Brothers (q.v.). —*Ref.: 51 (1879–89); 118 (1883, 1885, 1889)*

WALTHEW, A. & SON. Scenic and fresco artists in Detroit, 1879: Adam Walthew (q.v.) and Thomas A. Walthew (q.v.). —*Ref.: 51 (1879–89); 118 (1883, 1885)*

WALTHEW, A & SONS. Father-sons partnership in Detroit, 1882–86: Adam Walthew (q.v.), George W. Walthew (q.v.), James Hastings Walthew (q.v.) and Thomas A. Walthew (q.v.). —*Ref.: 51 (1882–86); 118 (1883–85)*

WALTHEW BROTHERS. Scenic artists in Detroit, 1889: George W. Walthew (q.v.) and Thomas A. Walthew (q.v.). —*Ref.: 118 (1889)*

WALTON, CHARLES. Artist in Detroit, 1884. Partner in the firm of Wanless & Walton (q.v.) —*Ref.: 51 (1884)*

WALTON, SIDNEY (or SIDNEY W.) (ca. 1876–1940). Watercolor and still life artist in Detroit, ca. 1909–1940. Born in Ontario, Canada. Worked in commercial art lines for some years; then devoted himself to easel painting. Studied with Joseph Gies (q.v.), Francis Paulus (q.v.) and Judson Smith (q.v.) in Detroit; also in Chicago and Toronto. Member: Scarab Club, where he exhibited frequently. Died in Detroit, Dec. 1940. —*Ref.: 56 (Feb. 6, 1920); 61 (Feb. 7, 1920, Dec. 30, 1940); 165*

WAND, JOHN M. Artist in Kalamazoo, 1871. Exhibit: one animal painting, Michigan State Fair, 1871. —*Ref.: 112 (Oct. 7, 1871)*

WANLESS, WILLIAM J. Artist in Detroit, 1884. Partner in the firm of Wanless & Walton (q.v.). —*Ref.: 51 (1884)*

WANLESS & WALTON. Firm of Detroit artists, 1884: William J. Wanless (q.v.) and Charles Walton (q.v.). —*Ref.: 51 (1884); 118 (1884)*

WARD, BENJAMIN F. Artist in Detroit, 1887. —*Ref.: 118 (1887)*

WARE, (Miss) LOE M. Artist in Grand Rapids, 1894–95; Imlay City, 1899; Detroit, 1900–01. —*Ref.: 51 (1900–1); 86 (1894–95); 118 (1899)*

WARNER, JOSEPH (1831– ?). Landscape painter and portraitist in Holland, where he lived and worked most of his life. —*Ref.: 61 (June 2, 1918); 165*

WARNER, JOSEPH WILBUR. Artist in Grand Rapids, 1898–1900+. —*Ref.: 86 (1898–1900)*

WARRANT, HARVEY C. Artist in Saginaw, 1887. —*Ref.: 118 (1887)*

WARREN, ASA COOLIDGE (1819–1904). Engraver, illustrator, and painter. Born in Boston, Mass. Several views of early Detroit, most bearing his initials, published in *Appleton's Journal*, July 27, 1872. Died in New York City. *—Ref.: 13; 79; 109; 128; 149; 156; 164*

WATERMAN, ? (Mrs. N. T.) Artist in Grand Rapids, 1881. *—Ref.: 118 (1881)*

WATERMAN, FLORENCE Z. (ca. 1870–1940). Landscape artist in Detroit, 1887–1900. Born in Detroit. Memberships: Detroit Society of Women Painters and Sculptors; Bohemian Club. Exhibit: Michigan State Fair, 1878; Bohemian Club, 1894. Died in Detroit, Apr. 26, 1940. *—Ref.: 51 (1887–1900+); 56 (Apr. 30, 1940); 60 (Apr. 30, May 7, 1894); 68 (Oct. 10, 1886); 112 (Oct. 24, 1878); 118 (1887–99); 164*

WATKINS, CHARLOTTE ELIZABETH (Lottie) (1865–1938). Art teacher in Bay City. Worked in oils and watercolors, and excelled in fine China painting. Born in Bay City, July 13, 1865. Later moved to Florida. Received awards from many galleries in the South. Died in Tampa, Fla., Oct. 8, 1938. *—Ref.: 167; 179; 181*

WATSON, GEORGE (ca. 1817–1892). Portrait artist in Detroit, 1850–92. Born in Yorkshire, England. Partners with John Baird (q.v.), as Watson & Baird (q.v.), in 1857–58; with Charles Emile St. Alary (q.v.) as St. Alary & Watson (q.v.), 1864–65; and with William H. Brummitt (q.v.), 1869–71, under the firm name of Watson & Brummitt (q.v.). Died in Detroit, Sept. 28, 1892. *—Ref.: 51 (1850–93); 56 (Sept. 24, 1874, June 26, 1875, Sept. 18, 1879); 65 (Sept. 18, 1879); 118 (1870–71, 1875–77, 1881–93); 164*

WATSON & BAIRD. Portrait artists in Detroit, 1857–58: George Watson (q.v.) and John Baird (q.v.). *—Ref.: 51 (1857/58)*

WATSON & BRUMMITT. Photographers and portrait painters in Detroit, 1869–71: George Watson (q.v.) and William H. Brummitt (q.v.). *—Ref.: 51 (1869–71)*

WATTLES, ? (Mrs. I. N.). Artist in Kalamazoo, 1885. Exhibit: Michigan State Fair, 1885. *—Ref.: 112 (Oct. 27, 1885)*

WEBB, ? (Mrs. W. B.). Artist in Jackson, 1887. Awards: premiums, Michigan State Fair, 1887. *—Ref.: 112 (Oct. 31, 1887)*

WEBSTER, BESSIE. Artist in Detroit, 1868. Exhibit: oil paintings, Michigan State Fair, 1868. *—Ref.: 56 (Sept. 18, 1868)*

WEBSTER, (Miss) W. A. Art student in Detroit, 1894. Studied under Maud Mathewson (q.v.) in Detroit, where she participated in the annual showing at the studio, 1894. *—Ref.: 60 (June 20, 1894)*

WEHNER, CARL HERMAN (ca. 1847–1921). Sculptor in Detroit. Settled in Detroit, 1854, probably with his parents. Executed statues of Detroit

notables, including Governor Bagley, Mayor William C. Maybury, Rev. S. S. Marquis, Rev. Francis A. Blades, and General John Pulford. Studied with H. K. Brown in Newburg-On-the Hudson, and with J. Q. A. Ward in New York City. Died in Memphis, Mich., Oct. 21, 1921. *—Ref.: 51 (1887—99); 56 (Feb. 2, 1919); 61 (Oct. 23, 1921); 62 (Aug. 29, 1897, Oct. 23, 1921); 118 (1883, 1887—89, 1893); 164; 165*

WEIKERT, EMANUEL (or EMANUEL I.) (ca. 1820—1889). Wood-carver in Detroit, 1876—89. Probably a brother of Frederick E. Weikert (q.v.), since both had the same street address. Died in Detroit, Aug. 14, 1889. *—Ref.: 51 (1876—89)*

WEIKERT, FREDERICK E. Wood-carver in Detroit, 1873—1900+. Probably related to Emanuel Weikert (q.v.). *—Ref.: 51 (1873—1900+); 118 (1885—89, 1893—97)*

WEIKERT, GUSTAV R. Wood-carver, and furniture and regalia manufacturer in Detroit. *—Ref.: 51 (1877—1900+); 118 (1873, 1895, 1897)*

WEINGARTEN, CALMAN. Crayon artist and proprietor of Union Art Company, Detroit. *—Ref.: 51 (1895—1900)*

WEISMAN, WILLIAM H. Artist in Detroit, 1865—66. *—Ref.: 51 (1865/66)*

WEISS, ALOYSIUS FRIEDERICH (ca. 1871— ?). Maker of stained glass windows for churches in Detroit and elsewhere in the United States. Born in Detroit. Carried on the Detroit Stained Glass Works founded by his father (name unknown) in 1861. *—Ref.: 61 (June 7, 1953); 165*

WELTE, GEORGE. Portrait artist and photographer in Owosso, 1893—95. Executed watercolor and crayon portraits. *—Ref.: 118 (1893—95)*

WELTON, GRACE B. Art student in Detroit, 1894. Studied with Maud Mathewson (q.v.). Exhibited at the studio's annual spring showing, 1894. *—Ref.: 60 (June 20, 1894); 164*

WENDELL, ? (Mrs. E.). Artist in Detroit, 1876. Exhibit: first Detroit Art Association showing, 1876. Perhaps the wife of Emory Wendell, a prominent Detroit banker, 1870—1900+. *—Ref.: 51 (1870—1900+); 56 (Feb. 1, 1876)*

WENDLER, ADOLPH H. Crayon artist in Detroit, 1891—1900. *—Ref.: 51 (1891—1900); 118 (1895)*

WENDLING, GUSTAVE (1862— ?). Artist in Detroit, 1887—88. Born in Germany. Partner of Otto Von Ernst (q.v.) and Paul Wilhelmi (q.v.) in the New Academy of Fine Arts, Detroit, 1887. In Paris in 1900. *—Ref.: 51 (1887—88); 109*

WENZEL, ALBERT BECK (1864—1917). Noted illustrator, mural painter, and still life and landscape artist in Detroit and New York. Born in Detroit, Jan. 1, 1864, the son of Andrew and Caroline (Beck) Wenzel. Studied under Robert Hopkin (q.v.) in Detroit before going to Europe,

where he studied under Stahuber and Loefft in Munich, and Boulanger and Lefebvre in Paris. Illustrator for *Harper's, Life, Ladies Home Journal,* and *Saturday Evening Post;* and of books for various publishers. Exhibits and awards: Paris Exposition, 1890; Silver Medal, Pan-American Exposition, Buffalo, 1901; Silver Medal, Louisiana Purchase Centennial Exposition, St. Louis, 1904. Died in Englewood, N.J., Mar. 4, 1917. *—Ref.: 3 (1898); 51 (1888–89); 56 (Apr. 13, 1880, Apr. 6, 1883); 60 (Apr. 18, 26, 1893, Feb. 19, 1920); 61 (Mar. 5, 1917); 79; 101; 109; 119; 156; 163; 164; 165*

WERNER, GUSTAV A. Portrait artist and photographer in Marquette, 1893. *—Ref.: 118 (1893)*

WESTBROOK, (Mrs.) M. Artist in Kalamazoo, 1885. Awards: premiums for paintings on glass and for a plaque, Michigan State Fair, 1885. *—Ref.: 112 (Oct. 27, 1885)*

WESTERLIND, AXEL D. Watercolor artist in Detroit. Exhibit: Detroit Museum of Art, 1890. *—Ref.: 56 (1888–90); 163; 164*

WESTLAKE, EDWARD B. Artist in Detroit, 1886. *—Ref.: 51 (1886)*

WESTNEDGE (or WESTNEYE), (Mrs.) M. B. Artist in Kalamazoo, 1885, 1895–99. Exhibit: painting on an ebonized panel, Michigan State Fair, 1885. *—Ref.: 112 (Oct. 27, 1885); 118 (1895–99)*

WESTNEYE, (Mrs.) M.B. *See* WESTNEDGE, (Mrs.) M.B.

WESTON, GEORGE F. Artist in Lansing, 1887, and Buchanan, 1891–93. *—Ref.: 102 (1887); 118 (1891; 1893)*

WETHERBEE, BERTHA C. Artist in Detroit, 1894. Studied under Maud Mathewson (q.v.) in Detroit. Exhibited at annual spring studio showing, 1894. *—Ref.: 60 (June 20, 1894); 164*

WETMORE, HELEN. Artist in Ann Arbor, 1897. *—Ref.: 118 (1897)*

WHEELER, JANET D. (Jennie). Portrait artist. Born in Detroit. Student of O'Connor Art School, Detroit (see O'Connor, Josephine). Also studied in Paris under Bougereau and Courtois. Worked in Philadelphia and in Long Beach, Calif. Exhibits: PAFA; Paris Salon. Memberships: American Federation of Artists; PAFA; Plastic Club. Award: Gold Medal, PAFA, 1902. *—Ref.: 3 (vol. 30, 1933); 13; 60 (Oct. 22, 1894); 109; 156; 164*

WHEELER, LAVERN F. Artist in Tecumseh, 1885–87. *—Ref.: 118 (1885, 1887)*

WHEELER, WILLIAM R. (1832–ca. 1894). Portrait and miniature artist. Studied in Detroit under Alvah Bradish (q.v.). Married in 1855, and moved to Hartford, Conn. Exhibits: Michigan State Fair, 1852; first showing, Detroit Art Association, 1872. Died in Hartford. *—Ref.: 13; 79; 101; 109; 112 (Oct. 1852); 128; 156; 164*

Seth Arca Whipple, *Night Scene on the Detroit River.* Canvasboard, 12″ x 18″. From the collection of the Detroit Institute of Arts. Gift of John W. Miller.

Seth Arca Whipple, *The Atlantic.* From the collection of the Dossin Great Lakes Museum, Detroit.

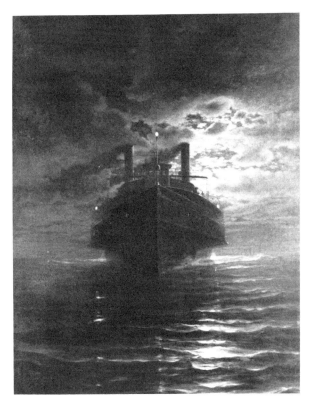

Seth Arca Whipple, *The City of Detroit II*, 1889. From the collection of the Dossin Great Lakes Museum, Detroit.

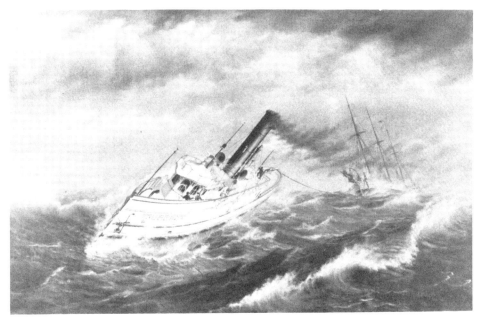

Seth Arca Whipple, *Rescue of the Schooner Merrimac, Nov. 1883*, 1884. From the collection of the Dossin Great Lakes Museum, Detroit.

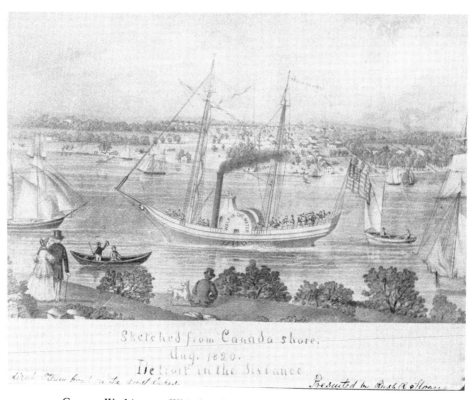

George Washington Whistler, *Detroit in 1820, Showing the Walk-in-the-Water.* From the collection of the Dossin Great Lakes Museum, Detroit.

242

WHINNERY, JOSEPH. Artist in Adrian, 1891. *–Ref.: 118 (1891)*

WHIPPLE, SETH ARCA (ca. 1855–1901). Marine artist in Detroit. Made paintings of vessels on the Great Lakes, a number of which are in the Dossin Great Lakes Museum, Detroit. Born near New Baltimore. Exhibits: Michigan State Fair, 1880; Great Art Loan, 1883; Detroit Museum of Art, 1886; Art Club of Detroit, 1895. Died in Detroit, Oct. 10, 1901. *–Ref.: 51 (1873–1900); 56 (Mar. 16, Apr. 17, 1879; Apr. 3, 1880, Oct. 11, 14, 1901); 65 (Sept. 16, 1880); 112 (Oct. 12, 1880); 118 (1891, 1899); 163; 164; 165*

WHISTLER, GEORGE WASHINGTON (1800–1849). Topographer and railroad engineer in the United States Army. Born in Fort Wayne, Ind. In 1820, during Detroit tenure, executed a painting of Detroit, showing the steamer *Walk-in-the-Water*. Assistant professor of drawing, West Point Academy, 1821–22. Father of James McNeill Whistler. Died in St. Petersburg, Russia, after completing the construction of a railroad between St. Petersburg and Moscow. *–Ref.: 128; 156; 164*

WHITAKER, ALICE J. Artist in Big Rapids, 1891–93. *–Ref.: 118 (1891, 1893)*

WHITE, THERESA. Exhibited paintings, Michigan State Fair, 1858. *–Ref.: 112 (Nov. 1858)*

WHITE, THOMAS GILBERT (1877–1939). Mural and portrait painter. Born in Grand Haven or Grand Rapids. Worked in Grand Rapids; Fairfield, Connecticut; and Paris, France. Pupil of Julien Academy, Paris under Constant and Laurens; also studied with Whistler and MacMonies. Memberships: American Painters League; officeer, Légion d'Honneur, Paris; officer, Académie des Beaux Arts. Represented in many United States museums and in the Luxembourg Palace, Paris. Died in Paris, Feb. 17, 1939. *–Ref.: 3 (vol. 30, 1933); 61 (Feb. 17, 1939); 79; 101; 109; 164; 165*

WHITEHEAD, DEBORAH. Artist in Lansing, 1890s. Studied under Maud Mathewson (q.v.), Detroit, 1894; and with Joseph Gies (q.v.) and Francis Paulus (q.v.) at the Detroit Art Academy, *–Ref.: 60 (June 20, 1894, Oct. 17, 1896); 164*

WHITNEY, MARY. Artist in Detroit, 1891–93. *–Ref.: 51 (1891, 1893); 118 (1893)*

WHITNEY, ORLANDO H. Artist in Detroit, 1884–87. *–Ref.: 51 (1884, 1887); 118 (1885)*

WICKENDEN, ROBERT J. (1861–1931). Portrait and genre painter, lithographer, and writer in Detroit, 1880s. Born in Rochester, England, July 8, 1861. Came to America as a young boy. Lived first in Toledo, Ohio. About 1880, moved to Detroit, where he held art classes, did land-

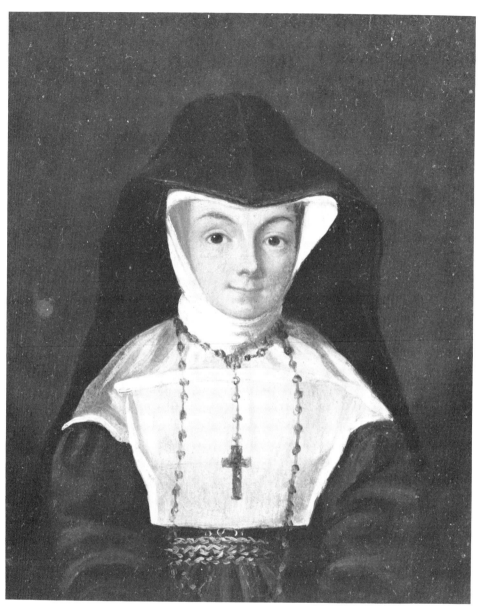

William Heatley Wilder, *Marie Françoise Vindevogel, 1st Abbess—St. Clair Sisters of Detroit.* Oil on artist board, 11¾″ x 10″. From the collection of the Detroit Institute of Arts. Gift of Mrs. A. Campau Thompson.

scapes of local scenes, and painted portraits of several notables including ex-Governor John J. Bagley, the wife of ex-Governor Hazen S. Pingree, and industrialist James E. Scripps. Later moved to New York City, and eventually to Paris. After some twenty years, during which he exhibited in numerous European galleries, settled in Brooklyn, N.Y. Painted portraits of many notables, including King Edward VII. Represented: DIA, Parliament Houses, Ottawa, Ontario; and elsewhere. Death followed a heart attack at his Brooklyn home, Nov. 28, 1931. —*Ref.: 13; 51 (1886); 109; 118 (1883); 129 (Nov. 29, 30, 1931); 149; 163; 164*

WICKER, JOHN PALMER (1860–1931). Portrait artist and teacher in Detroit, 1890–1900+. Born in Ypsilanti, Feb. 23, 1860, the son of William W. and Charlotte Adelaide (Palmer) Wicker. Studied seven years in Paris under Bougereau and Cormon. Taught with Joseph Gies (q.v.) at Detroit Museum of Art School, 1890. Superseded Francis Paulus (q.v.) as associate director of the Detroit Fine Art Academy, which later became the Wicker School of Fine Arts. Exhibits: Paris Salon; Louisiana Purchase Centennial Exposition, St. Louis, 1904; Hopkin Club, Detroit, 1911. Award: Gold Medal, Scarab Club, 1925. Died in Detroit, Feb. 12, 1931. —*Ref.: 56 (Feb. 13, 1931); 60 (Sept. 19, 1896); 61 (Feb. 12, 1931); 101; 118 (1897, 1899); 163; 164*

WICKER (or WIEKER), (Professor)(?). Artist in Port Huron, 1887. —*Ref.: 118 (1887)*

WICKERTS, AREND (1876–1965). Landscape painter and art teacher in Birmingham. Active in the Detroit metropolitan area for fifty years. Born at Madison, Ill. Studied at Chicago Institute of Arts. Operated an art school in Royal Oak. Died at Birmingham, June 27, 1965. —*Ref.: 56 (June 29, 1965); 61 (June 29, 1965); 40 (June 29, 1965)*

WIEKER, (Professor) (?). *See* WICKER, (Professor) (?)

WILBUR, ELVIRA A. Artist in Detroit, 1889–91. —*Ref.: 51 (1889–91); 118 (1889, 1891)*

WILBY, RICHARD C. (1850–1936). Broker and amateur artist in Detroit, 1873+. Born in Cincinnati, Ohio, Jan. 10, 1850. Exhibited locally in Detroit. Memberships: Detroits Art Association, Detroit Water Color Society. Died in Detroit, May 14, 1936. —*Ref.: 51 (1873–91); 56 (Feb. 1, 1876, May 15, 1936); 65 (Apr. 19, 1878); 164*

WILDER, WILLIAM HEATLEY (1813–1898). Portrait painter in Detroit, 1833–41. Born in Beaufort, S. C., Mar. 25, 1813. Died in New Orleans, La., July 6, 1898. —*Ref.: 163; 164*

WILDNER, RICHARD. Watercolor artist in Detroit, 1890s. Exhibit: Detroit Museum of Art, 1896. Treasurer, Architectural Sketch Club. —*Ref.: 60 (Oct. 17, 1896) ; 164*

WILEY, GERTRUDE. Portrait artist and teacher at Detroit Art Academy, 1897–1900+. *—Ref.: 51 (1897–1900+); 118 (1897, 1899)*

WILHELMI, PAUL. Artist in Detroit, 1887–88, 1899–1900+. Partner of Gustave Wendling (q.v.) and Otto Von Ernst (q.v.) in the New Academy of Fine Arts, 1887. *—Ref.: 51 (1887–88, 1899–1900+); 76*

WILHELMI, WENDLING & VON ERNST. Proprietors of the New Academy of Fine Arts, Detroit, 1887: Paul Wilhelmi (q.v.), Gustave Wendling (q.v.), and Otto Von Ernst (q.v.) *—Ref.: 118 (1887)*

WILKINSON, JESSIE. Artist in Detroit, 1898–1900+. Resided in Windsor, Ontario. Probably a relative of Ruby A. E. Wilkinson (q.v.), active at the same time and also a resident of Windsor. *—Ref.: 51 (1898–1900+) 118 (1899)*

WILKINSON, (Miss) M. J. Artist in Kalamazoo. Exhibit: landscapes in oil, Michigan State Fair, 1871. *—Ref.: 112 (Oct. 7, 1871)*

WILKINSON, RUBY A. E. Artist in Detroit, 1897–1900. Resided in Windsor, Ontario. Probably related to Jessie Wilkinson (q.v.) active at the same time and also a resident of Windsor. *—Ref.: 51 (1897–1900)*

WILLIAMS, CHARLES. Artist in Detroit, 1898. *—Ref.: 51 (1898)*

WILLIAMS, DOROTHY (or DOROTHEA) A. Artist in Detroit, 1889–97. Possibly involved in ceramics. Probably related to Kate E. Williams (q.v.), china decorator, who resided at the same address and was active at the same time. *—Ref.: 51 (1889–96); 118 (1893–97)*

WILLIAMS, ETTA M. Artist in Grand Rapids, 1889–1900. *—Ref.: 86 (1889–1900); 118 (1893, 1895)*

WILLIAMS, JOHN (ca. 1870–). Artist and interior decorator of theaters and other public buildings in Grand Rapids. Born in Grand Rapids about 1870–75. *—Ref.: 180*

WILLIAMS, JULIUS I. Artist in Flint, 1893–99. *—Ref.: 118 (1893–99)*

WILLIAMS, KATE E. China decorator in Detroit, 1889–97. Probably related to Dorothy Williams (q.v.) who resided at the same address and was active at the same time. *—Ref.: 51 (1889–96); 118 (1893–97)*

WILLIAMS, MAMIE A. Artist and engraver in Grand Rapids, 1894–99. *—Ref.: 86 (1894–99)*

WILLIAMS, MARGARET R. Teacher and artist in Detroit, 1895–1900+. *—Ref.: 51 (1895–1900+)*

WILLIAMS, MARY. Young artist in Kalamazoo, 1871. Received a special mention for two oil paintings exhibited at the Michigan State Fair, 1871. *—Ref.: 112 (Oct. 7, 1871)*

WILLIAMS, MYRA T. (wid. Oscar A.). Amateur artist in Detroit, 1899–1902. *—Ref.: 51 (1899–1902); 118 (1899)*

WILLIM, CHARLES (ca. 1875–1960). Scenic artist in Detroit. Born in New York. Died in Detroit. *—Ref.: 51 (1891–99); 182*

WILLIS, ? (Mrs. R. S.). Likely Mrs. Richard Storrs Willis of Detroit. Probably involved in china decorating, 1880s. President, Decorative Arts Society, Detroit, 1885–87. *–Ref.: 51 (1877–87)*

WILLOVER, J. CLAUDE. Artist in Fenton, 1895. Exhibit: Art Club of Detroit, 1895. *–Ref.: 163*

WILLSON, BENJAMIN F. Monochrome artist and teacher of penmanship in Detroit, 1871–72. Exhibited in Detroit, 1872, before leaving for California. *–Ref.: 51 (1871/72); 56 (June 6, 1872)*

WILMOT, ANNA C. Artist in Grand Rapids, 1899. *–Ref.: 86 (1899)*

WILSON, ? (Mrs. E.) Artist in Grand Rapids, 1880. Exhibit: Michigan State Fair, 1880. *–Ref.: 112 (Oct. 12, 1880)*

WILSON, ANNIE L. Art student in Detroit, 1893. Studied under Maud Mathewson (q.v.), Detroit. Work shown in a studio exhibition, 1893. *–Ref.: 60 (June 24, 1893); 164*

WILSON, EMERY (or EMORY) J. Artist in Detroit, 1890–91. Partners with Frank J. Harper (q.v.) under the firm name of Harper & Wilson (q.v.) *–Ref.: 51 (1890–91); 118 (1891)*

WILSON, JOHN. Artist in Detroit, 1855–56. *–Ref.: 51 (1855/56)*

WILSON, THOMAS E. Portrait artist in Detroit, 1885–1900+. *–Ref.: 51 (1885–1900+); 118 (1899)*

WILSON, T. W. Exhibited at the Art Loan, Firemen's Hall, Detroit, 1853. *–Ref.: 101; 164*

WILSON, W. Artist in Detroit, 1845. *–Ref.: 51 (1845)*

WILTON REUTHER COMPANY. Decorative and ornamental carvers, modelers, and designers in Detroit, 1899–1904. H. Leonard Wilton, president; Richard G. Reuther (q.v.), vice-president; Richard H. Krakow, Sr. (q.v.), secretary; and Joseph Jungwirth (q.v.), treasurer. *–Ref.: 51 (1899–1904)*

WINEMAN, JACOB H. Artist, crayon artist, and painter in Detroit, 1885–1900+. *–Ref.: 51 (1885–1900+); 118 (1887)*

WING, H. A. Artist in Detroit, 1857–58. *–Ref.: 51 (1857/58)*

WINN, ADELBERT H. Dentist and artist in Manistique, 1897. *–Ref.: 118 (1897)*

WINSLOW, FRANK S. Artist in Battle Creek, 1897–99. *–Ref.: 118 (1897, 1899)*

WINTER, EZRA AUGUSTUS (1886– ?). Illustrator, painter, and muralist, twentieth century. Born in Manistee, Mar. 10, 1886. Pupil of Chicago Academy des Beaux Arts; and American Academy, Rome. Later worked in New York City and Gloucester, Mass. Memberships: Chicago Society of Mural Painters; NAD; Palette and Chisel Club; Salmagundi Club; New York Architects League. Painted numerous murals in public monuments. *–Ref.: 3 (vol. 30, 1933); 13; 79; 109; 119 (1924 ed.); 149; 156*

WISE, SAMUEL LORD. Artist in Lansing, 1883–99. Exhibit: Detroit Water Color Club. *–Ref.: 102 (1883–94); 118 (1883–99); 164*

WISEMAN, C. S. Artist and actor. Painted a portrait of John Wilkes Booth while both were performing in Detroit, 1864. Later went to Philadelphia. *–Ref.: 56 (Jan. 8, 1899)*

WISSMUELLER, CHARLES J. Artist in Saginaw, 1895. *–Ref.: 118 (1895)*

WITHERELL, JULIA A. *See* LACEY, JULIA A. WITHERELL.

WITTENBERG, MAX. Portrait painter in Grand Rapids, 1900. *–Ref.: 86 (1900)*

WONNINK, EGBERT. Carver and woodturner in Grand Rapids, 1893–97. *–Ref.: 118 (1893–97)*

WOOD, KATHRYN LEONE (1885–1934). Painter of the American school. Born in Kalamazoo. Exhibit: DIA, 1930. Died in Los Angeles, Calif. *–Ref.: 109; 156; 163*

WOODEN, CARRIE. Artist in Stony Point, Monroe County, 1899. *–Ref.: 118 (1899)*

WOODHOUSE, HARRY VALENTINE (1865–1939). Portraitist and figure painter in Detroit, 1887–1900+. Born at Villa Nova, Ontario, Feb. 14, 1865. Studied under Bougereau and Robert-Fleury in Paris; and at the Royal Academy, Munich. Except for European studies, spent most of his life in Detroit. Exhibits: DIA; also in Canada and Europe. Represented in museums of Atlanta, Ga., New Orleans, La., and Mobile, Ala., and in the Oklahoma State Capitol. Died in Detroit, Apr. 8, 1939. *–Ref.: 51 (1887–97); 56 (Apr. 10, 1939); 60 (Apr. 18, Nov. 17, Dec. 8, 1893, Apr. 30, May 7, Sept. 29, Dec. 15, 1894, Feb. 24, June 2, 1896); 61 (Apr. 10, 1939); 68 (Oct. 10, 1886, Feb. 5, Mar. 27, 1893); 118 (1887, 1893–97); 163; 164; 165*

WOODIN, FRANK E. Artist, caricaturist, and drawing teacher in Grand Rapids, 1886, and Detroit, 1887–93. *–Ref.: 51 (1887–93); 86 (1886)*

WOODIN, LILLIAN G. Artist in Detroit, 1895. *–Ref.: 51 (1895)*

WOODMAN, LUCY (wid. Bailey). Artist in Grand Rapids, 1892–93. *–Ref.: 86 (1892–93); 118 (1893)*

WOODRUFF, (Miss) ? . Artist in Detroit, 1868–72. Credited with two paintings, one of which was exhibited at the Michigan State Fair, 1868. *–Ref.: 54 (Sept. 20, 1872); 56 (Sept. 16, 1868)*

WOODRUFF, ALBERT M. Artist in Athens, 1885. *–Ref.: 118 (1885)*

WOODRUFF, JOHN B. (1876– ?). Landscape artist in Detroit, early 1900s. Born in Ypsilanti. Came with his parents to Detroit as a small child. Education: Detroit schools, Michigan State Normal School. Studied with Joseph Gies (q.v.), Chicago Art Institute, and in Munich.

President, Pallette and Chisel Club, Chicago, 1914–15. Member: Scarab Club, Detroit. —*Ref.: 143*

WORCESTER, ALBERT (1878–1935). Painter and etcher in Detroit, 1894, 1900+. Born in West Compton, N. H. Studied in Detroit under Maud Mathewson (q.v.), in whose studio he exhibited, 1894. Also studied in New York City, in Italy, and in Paris under L. O. Merson and Jean Paul Laurens. Spent considerable time in Holland and finally returned to Detroit. Died as the result of a fall in Barcelona, Spain, Dec. 18, 1935. —*Ref.: 13; 56 (Dec. 19, 1935); 60 (June 20, 1894); 79; 109; 149; 156; 165*

WORDEN, WILLIAM. Artist in Detroit, 1862–63. —*Ref.: 51 (1862/63)*

WRIGHT, D. E. Artist in Howell, 1899–1901. —*Ref.: 118 (1899, 1901)*

WRIGHT, WILLIAM. Interior and ornamental decorator in Detroit. Associated with Robert Hopkin (q.v.) in the firm of Laible, Wright & Hopkin (q.v.), 1863–66. —*Ref.: 51 (1863–66)*

WRIGHT, WILLIAM E. Artist in Bay City, 1885–93. Apparently was proprietor of an art school in Grand Rapids, 1891–92. —*Ref.: 86 (1891–92); 118 (1885–93 [Bay City]; 1891 [Grand Rapids])*

WYBLE, WILLIAM A. Artist in Detroit, 1895–99. —*Ref.: 51 (1895–99)*

WYCOFF, J. R. (or J. H.). Artist in Jackson, 1882–87. Awards: oil, pastel, and crayon portraits and landscapes, Michigan State Fairs, 1882 and 1887. —*Ref.: 112 (Oct. 17, 1882, Oct. 31, 1887)*

WYLIE, (Miss) ? . Art student in Detroit, 1896. Studied at the Detroit Art Academy, 1896. —*Ref.: 60 (June 6, 1896)*

Y

YOUNG, ISAIAH. Artist in Detroit, 1861. —*Ref.: 51 (1861)*

YOUNG, THERESA E. Artist in Detroit, 1899. —*Ref.: 51 (1899)*

Z

ZABLOCKI, ERNEST J. Amateur artist in Detroit, 1895–1900. —*Ref.: 51 (1895–1900)*

ZABROSKY, CARL F. Artist in Detroit, 1881–1900+. —*Ref.: 51 (1881–1900+); 118 (1897, 1899)*

ZEMUS, GEORGE. Artist in Middleville, 1891. —*Ref.: 118 (1891)*

ZILLICOUX, ? (Mrs. F. J.). Artist in Jackson, 1887. Exhibit: Michigan State Fair, 1887. —*Ref.: 112 (Oct. 31, 1887)*

ZWALD, ANDREW. Carver, sculptor, and modeler in Detroit, 1885. —*Ref.: 118 (1885)*

Arthur Hopkin Gibson (1888–1973) was a self-educated artist, author, and businessman in Detroit. Various local art galleries have exhibited his paintings, and several of his works are in the permanent collection of the Detroit Historical Museum. He was the author of a biography of his grandfather, Robert Hopkin, a well-known marine and landscape painter.

The manuscript was edited by Jean Spang. The book was designed by Richard Kinney. The typeface for the text is Times Roman designed by Stanley Morison about 1931; and the display face is Bookman Italic.

The text is printed on Edwards Brothers Booknatural text paper. The book is bound in Columbia Mills' Bayside Vellum cloth over binders' boards. Manufactured in the United States of America.